Public
Art *A Reader*

PublicArt

A Reader

edited by
Florian Matzner

Hatje Cantz Publishers

Contents

Art and Architecture

Art and History

Art and Society

Art and the Exhibition

Foreword

Few topics of debate in the visual arts over the last thirty years have caused such controversy as the importance and potential of what has become known as public art. After the euphoria of the economic miracle that unfolded during the 1950s and the 1960s when "art and architecture" was also riding high, it started to become clear in the early 1970s how disheartening the results of that particular endeavor generally proved to be: it seemed they were neither of interest to artists, nor an improvement to often mediocre architecture, nor even a particular visual pleasure for ordinary members of the public with an interest in art.

Despite this, with the advent of Land Art, Minimal Art, and, to a certain extent, Pop Art, a form of art had emerged—notably in the USA—which was now venturing outside the hallowed institutional shrines to art, with the intention of entering into dialogue with the outside world and society at large. This new art therefore seemed positively predestined to have a fruitful aesthetic impact on public spaces. At the same time museum directors and exhibition makers were discovering that the public's knowledge of modern art could no longer be increased by traditional institutional exhibitions, which in any case usually only attracted those already in the know. The only way to raise the public's awareness was by taking the products of contemporary art out into the public arena, out into the towns and cities. Such undertakings may have seemed unusual, even odd, in post-1945 Europe, yet we would do well to remember that when the art of building, frescos and easel painting, sculpture and reliefs, music, literature, and the theater came together as one in the Baroque era, this was not in fact the first appearance of the *Gesamtkunstwerk*. More so even than the central perspective of the Renaissance, the world acquired a new order through the notion of the Baroque *Gesamtkunstwerk*. It seems that the subsequent separation of architecture, painting, and sculpture was the result of rather different bourgeois notions in the late nineteenth century, when the—fatal—assumption was made that the various artistic media were utterly distinct from one another, which in turn led to pleas for the autonomy of each.

Not until over a hundred years later, towards the end of the by-now departed twentieth century, did art and architecture come together once again in a desire for new aesthetic strategies. These were seen above all in interventions in public spaces, most memorably in the *Sculpture Projects* that took place in Münster every ten years, starting in 1977. A unique experiment, this initiative provided an open forum for public discussion. The intention of this exhibition project, unparalleled anywhere else in the world, is that internationally experienced artists should engage in concrete terms with the urban, architectural, historical, social, and psychological circumstances of the town: "site specificity," an actual connection to the place and the context, now replaced the "drop sculptures" of recent years that at times

appear to have descended from on high, landing in this public space or that. But by art in public places, or "public art" as it is more aptly known, we do not mean the sculpture paths and parks or even boulevards that seem to be mushrooming on all sides, where art is all too often reduced to no more than a form of decorative atonement for the sins of certain town planners, architects, and landscape gardeners. Nor do we mean the art and architecture projects, more often than not commissioned pieces that the major insurance companies, banks, and financial institutions feel they must foist upon the public. The Swiss artist Roman Signer, for one, has produced his own pertinent comment on the theme of "Big Fountains and Little Fountains," by turning an Italian vegetable van into a mobile fountain. This creation—extremely noisy and extravagantly wasting water, therefore as politically incorrect as it is ecologically unsound—constantly seeks out new sites for itself in the town. Now the citizen no longer has to go to the fountain, the fountain will come to the citizen. For, as Daniel Buren has put it: "By now it should be clear that—leaving humor aside for the moment—public art today, under the many-facetted guise of contemporary art— is not just a matter of putting up the three-hundred-and-fifty-seven-thousandth Männeken Piss."

The dialogue of the past and the present, the identification of space as place, the momentary captured in the monumental, the pursuit of subtlety in banality leading to the discovery of the non-everyday in the everyday: these have been amongst the main points of reference for the artists of the 1990s, perhaps— as the Slovenian artist Marjetica Potrč has said—precisely because "we like sublimating

reality, don't we? It's not reality that's there— what's there is what we take for reality."

"The idea of repeating the exhibition at regular intervals would certainly be questionable and perhaps doomed to failure from the start." That was the conclusion drawn by Klaus Bussmann, Director of the Landesmuseum in Münster and co-curator with Kasper König (Cologne) of the *Sculpture Projects* in Münster, in a summative report in 1988 on "Two Sculpture Exhibitions in Münster—Taking Stock." Despite or perhaps because of these (self-)critical sentiments on the part of the organizers, the sculpture exhibition was given a third airing in 1997, again concurrently with the *documenta* in Kassel. Without anyone noticing, what Walter Grasskamp called an "experimental field" had become an institution—and an authority—as we can see looking back nearly four years later and bearing in mind the many similar exhibitions since the 1980s both at home and abroad.

Thus after a good twenty years of satisfying returns from public art—with occasional, terrifyingly inflationary swings—this publication aims to take a critical look at the bottom line, to sharpen our focus on the issues that matter, and to discuss the opportunities and the risks facing public art today. Klaus Bussmann once famously said: "Better no art than bad art in public places, better just to plant a few trees," and yet—as Neil Jenney has said— "art has the capacity to lay things bare, long before society recognises that indeed they should be laid bare," albeit with the proviso that "the function of art is that it does *not* function" (Heimo Zobernig). Therefore this publication never set out to be a handbook of public art. It is precisely the diversity of the concepts, methods, and themes in the individ-

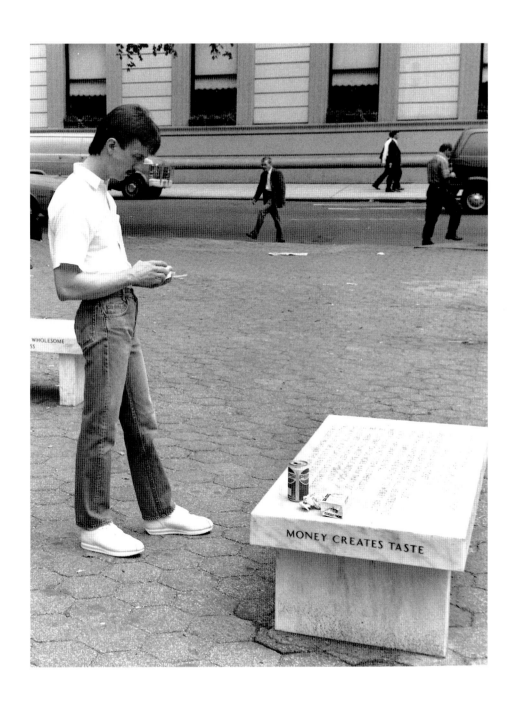

ual contributions that creates a "puzzle" of statements and reports, of opinions and experiences, of (self-)criticism and motivations, which highlights the many-facetted nature of the elusive subject of "public art—art in public spaces," although never in the spirit of persuasion or edification—and always mindful of Pablo Picasso's comment in a conversation in 1943: "Why cling to outdated definitions, as though it were not precisely the task of the artist to invent anew."

So we have produced a book that specifically has different aspirations to the glossily colorful exhibition catalogues and artbooks that have increasingly become the order of the day in recent years and which look so deceptively like promotional materials from commerce and industry: so not a *picture* book, but a *reading* book, for—as the film-maker Wim Wenders once said—life is colored, but reality is black and white.

The inspiration for this publication came initially from an international congress with the title "Public Art—The State of Play" at the Akademie der Bildenden Künste in Munich, in February 2000, which I organized with Bert Theis from Milan, who was guest professor in the Akademie at the time. At the same time, this volume is published in honor of Klaus Bussmann, long-standing Director of the Landesmuseum in Münster, founder and spiritus rector of the *Sculpture Projects* that started in 1977. Klaus Bussmann has in fact been one of the few to create the necessary conditions and to stand surety for the highest of artistic standards in public art—and not only in Germany.

My heartfelt gratitude goes to the all the authors who have contributed to this book: over fifty artists, art historians, and curators have worked under immense pressure of time on this project. Moreover, without our numerous sponsors—many who would rather remain nameless—this book could never have been realized.

An editorial team, both accurate and fast—above all Elke Neumann (Munich) and Sonnja Enzenhofer (Munich) with Petra Haufschild (Münster)—have made texts from words, have ordered and sorted images, have conjured up legible contributions from mysterious data disguised as e-mails.

Last but not least, Saskia Helena Kruse (Munich) has, with tireless commitment, not only designed the layout, but has seen the whole production through to the final stage of readiness for publication.

Published for the first time in the summer of 2001, the bilingual edition of Public Art was quickly sold out. This in itself was a sure sign that this handbook—a handbook which is in no way to be understood as a set of "directions" or "instructions for use"—satisfied a noticeable need on the international book market. This is why both the publisher and I have decided to reissue the German and English versions in two separate editions this time, making this compilation more compact. I would especially like to thank Tas Skorupa at Hatje Cantz for his assistance in revising this second edition.

Florian Matzner
Mazzanta/Munich, in August 2003

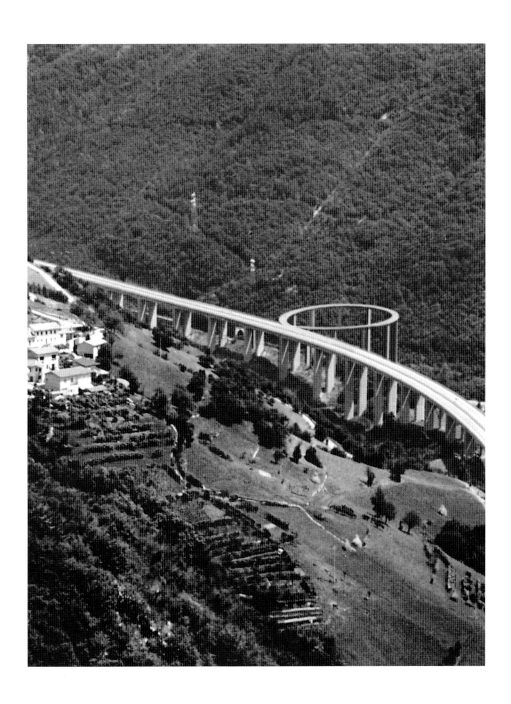

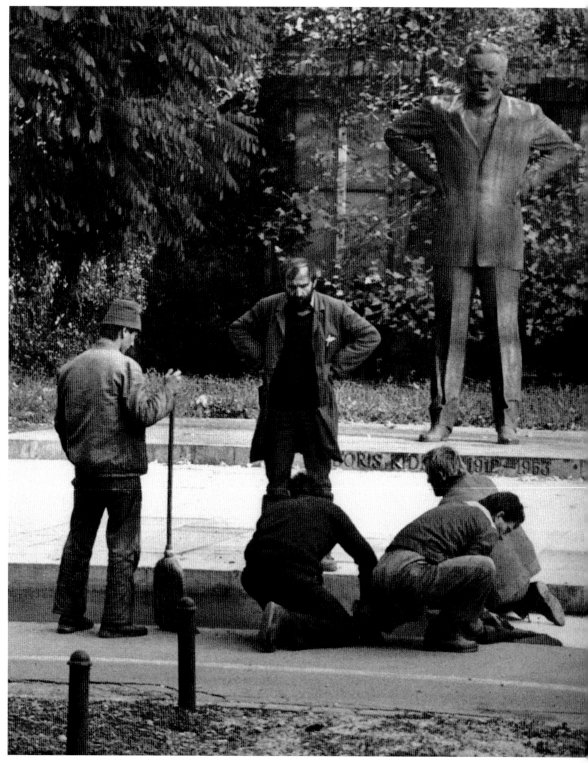

Before the political changes, I missed abstract sculptures in Ljubljana city space. Then, their existence would have meant that the space itself was democratic and not ideological. Today, I am relieved that Ljubljana is spared of all these abstractions that crowd the average German city. No one seems to need them anyway.

/democratic space/

Public Space in Contemporary City

MARJETICA POTRČ

There is a certain uneasiness currently in the on going debates regarding public art. Everyone seems to agree that public art is an important part of everyday urban life. All the more since we fought hard for the meager one percent which goes into the implementation of public arts. However, now that the money is circulating in the system, we are suddenly not sure how to spend it. I believe that the reasons for this apprehension lie mainly in public space and in what is happening to it today. Therefore I will talk about public space in contemporary city.

Sculpture on the Main City Square

First I'd like to relate a story to you that happened to me in Vilnius, Lithuania, a few years ago. A monument to a national hero was to be put up in the main square of Vilnius, the capital city, and it was to celebrate the independence of Lithuania. This incident must have taken place around 1995. The monument depicted a figure sitting on horseback mounted on an enormous artificial rocky slope, it was quite a big thing. I thought it was humorous how the sculpture searched for its place. A life-size model of the sculpture was moved about the square for weeks in order to determine the most appropriate location. Of course, there was no correct place for the sculpture since between commissioning and implementation, something had happened to the space where it should have been situated. Nothing physical, of course. It was just a change in and of perception. We all know there is no such thing as neutral space, and once the desire which shapes it—in this case a national state—becomes reality, the desire moves elsewhere. Maybe the Lithuanians did not need the impersonation of independence in equestrian figure after all. Europeans are in a similar position today. I will return to this later.

Europeans and the Global City

It has slowly dawned on Europeans that the world is not just happening in our backyards. Every three days, more than a million people move to urban areas. However, they don't move to cities like Ljubljana or Munich. I'm speaking about Southeast Asia or South America, the third world countries. Also, the tissue of conventional cities is changing. American cities are still spreading out, but at the same time parts of it are contracting into gated communities. The two fastest growing forms of contemporary city are gated communities and shanty towns. Both are initiated by individuals and usually the space there is private, not public. And they don't incorporate the idea of public art.

Shantytowns

Favelas, barrios, or shantytowns, as they are generally called, are unregulated sites of cities where newcomers who long for employment in the nearest large city build homes without obtaining any legal city permits. Shantytowns are a common feature of third-world urban areas. Besides the obvious problems, they have many positive aspects. They obey informal real-estate market, in which ownership of land is not particularly relevant, but homes are continually rented and sold, as well as improved by residents. Though people build with any material at hand, structures get eventually upgraded both physically and technically. Most incorporate running water and electricity. Residents enjoy the proximity of major urban centers and have strong sense of place and belonging, not frequently achieved in more formal areas of the city. One-third of the world's population lives in similar structures like those found in shantytowns. Now, anyone who ever set an eye on a favela knows that its residents don't need public art. Favelas do incorporate public space but this is not playground for public authority, such as a city government or corporations' interests. Public space in a favela is privately negotiated. In short, favelas are all about private space. This is why there is no need for public messages.

Gated Communities

Gated communities are fortified spaces of contemporary city. They proliferate in places affected by globalization, both in "civilized" and developing countries. It is in this environment that cities grow fast and people and races mix. Fertile ground for gated communities is, for instance, post-apartheid South Africa. If I would go for the simplest expla- nation, I would say that gated communities are guarded enclaves where people move voluntarily.

They range from high-security compounds in São Paulo and Moscow to remote-control communities in the US, where residents swipe a card to gain access. More than eight million Americans isolate themselves behind walls, thus expressing their will for personal control, safety, and the pleasures of sharing time with like-minded people. There is no doubt that gated communities are successful. Personally, it struck me that an urban form which evokes ghettos, the World War II "scare syndrome," is desirable today. I have no doubts that the idea of law and order along with firm societal structure is what is so attractive to people. Gated communities advocate private space. Public space is firmly controlled, a good example are simply the gates. It is in disguise, too. Similar to shopping malls which have an air of public space but where public activities are limited to leisure, gated communities transform public parks into golf courses. This fact has a consequence for public art. On a golf course, people take art for decorations, not public messages. There is nothing wrong with that. In Norway, I heard an unpretentious word-construction naming public art "public decorations." It first struck me as a degrading term. Today I think this kind of frame of mind is OK. Maybe I used to see more than what was actually there in public art.

Never-ending Cities

Every 3 days, more than a million people move to cities. But they don't move to cities like Ljubljana or Munich.
/fear of globalization/

Whatever Happened to the Public Park

I personally believe gated communities are an outdated social form. Nevertheless, they are a contemporary urban form and should be accepted as such. Their life style reminds me of the current initiative of residents of the NYCHA (New York City Housing Authority). A critical element in their struggle is the redefinition of ill-defined public space, a so-called public park, which is encircling highrise apartment buildings. Most tellingly, these are now called towers-in-the-wasteland. Residents demand that gates, fences, walls, and locks be implemented in public areas to help clearly define this no-man's land. In short, they are in a sense demanding that public spaces become less abstract and that they come closer to their bodies.

We used to think automatically that public park meant public benefit. It had a face value in our societies because it elevated space as public quality. The public space itself was considered ordered, an obvious plus. Unregulated city surfaces like urban voids and favelas were usually overlooked. If debated at all, they were thought of in terms of revitalization and not as urban quality. After all, we take pride living in functional societies. In fact, until 1987, maps of cities in Venezuela did not even show favelas. Green open spaces were drawn in their places. Today, individual initiatives are pushing for the redefinition of public space. What once seemed to have an obvious quality is now being put under question. See what James Holston has to say about the impact of modernist urban space: "Consider, for example, the modernist system of traffic circulation. When we analyze it in terms of what it systematically set out to eliminate—the traditional street system of public spaces and the urban crowds and outdoor political domain of social life the street supports—its social conse-

quence becomes clear ... It encourages a privatizing of social relations. That privatization allows greater control over the access to space which almost invariably stratifies the public that uses it. The empty no-man's spaces and privatized interiors that result contradict modernism's declared intentions to revitalize the urban public and render it more egalitarian."[1]

Shifting Ground

Lately, I spend more time in European cities. Walking the streets of Ljubljana where I am based, I don't encounter many abstract sculptures. In fact, there are very few. Recently I decided that Ljubljana residents are lucky to be spared of all these geometrical abstractions that crowd the average German city. This, however, is not what I used to think before the political changes. Then, modernist public sculpture seemed to guarantee that urban space was democratic, not ideological. Today, I believe we live in post-democratic space. This is why I think abstract public sculptures are not necessarily desired for. Half a year ago, I experienced a telling story about the power of geometry, stability, and order—which, in my mind, are linked in a consequential order, like when playing dominos. I was an artist-in-residence at the Flaxart Studios in Belfast, Northern Ireland. On my daily walk to the studio, I passed the court and jail, both abandoned. So much structure and geometry was embedded there. Not that they necessarily guaranteed a success. I did not fail to notice the irony of the jail being sold recently to a developer for one pound. There is nothing wrong with that. I believe that cities, or better, the emerging global city matter today more than centralized nation states and the idea of the ordered society that they represent.

Gated Communities

In gated communities, a public park becomes a golf course and public art is turned into mere decoration. Nothing is wrong with that. I like to put on my lipstick too, just to feel fine.
/individual initiative / private space/

Shantytowns

Shantytowns and gated communities are the two fastest growing forms
in the contemporary city. Does a shantytown need public art? I don't
think so.
/individual initiative / private space/

By 2100, the organizing principle of the world will be the city-state, along with the urban radians of prosperity that follow major trade routes. Likewise, I believe that contemporary cities breed new forms of life, which are different from those of historical and planned cities. What draws my attention most today is based on individual initiative. Again, in Belfast I encountered many. One of the city's curiosities is the container culture. Containers and the similar no-style structures are widely in use. Those who use them say they feel fine, too. Someone I know said: "We want our children to be in a nice place," while talking about a school located in a cluster of containers.

Un-official Tourist Tours and Urban Voids

I believe that our perception and desires for both public structures and places are changing. One poignant example of this shift of feelings regarding public values is the popularity of what I call un-official tourist tours. As an alternative to viewing the city from the top of a siteseeing bus, tourists rather choose uncomfortable and sometimes dangerous choices. Instead of viewing the monuments, both architectural and sculptural, people desire and go see favelas in São Paulo, tent cities in the Gaza Strip, Soweto in Johannesburg, the underworld in Vienna, Munich, and Berlin. Recently I took a tour of the gates and walls of Belfast. A taxi driver took me around. He told me he guided people through the scary landscape quite frequently.

I predict another shift of feelings within contemporary cities, this time regarding empty space. Empty space on earth is contracting, being lost to fast developing metropolises, which then produce more empty space, embodied in urban voids. Today, it's hard to envision enjoyment of unregulated city spaces and abandoned city districts. But then, I have already experienced it. Though it seems everyone considers that it's really bad to look at a deserted house from one's own dining room window, this turned out to be a pleasurable experience for tourists touring the bombed Sarajevo. They enjoyed filming and photographing the disaster, which of course was not their own. For me, the *Herald Tribune* photograph depicting the event was proof that we would soon start enjoying urban voids. They are comfortably close to where we live and indeed close to our bodies.

This, in fact, is a good metaphor for the shifting ground of today's city-space values. I believe nothing disappears, everything that exists just mutates. The uneasiness that follows when this happens feels unpleasant. It might seem like stepping into the void. This is what happened to the unfortunate sculpture in Vilnius searching for its place, and this is what is happening today to the notion of public space, and public sculpture along it. Do we desire it at all? What kind of art do you need while navigating space on a highway?

You Cannot Avoid It

Last week I saw the eviction of Elian Gonzales from his Miami relatives' home. I tried to figure out which street it was, as I have stayed with a friend nearby. And when I visited Belfast last summer, I bumped into the Orange men walking down the street, what the locals call Marching Season. What I want to say is that space elsewhere became less exotic, less an image on TV, less "this is someplace else, this doesn't concern me." It became more personalized and desirable, a homely image. It got closer to our bodies. Also, it became

less important as a category. Modern states were organized on defined space and they used the space well. Though we are familiar with their forms of presentation, it does not necessarily mean that they fit contemporary experience. In the future I expect to see more of the individual initiative. I believe individuals will determine representation. I am not sure that monuments are desired today. We desire decorations and maybe also memorials, because they touch our bodies.

1 James Holston: "Spaces of Insurgent Citizenship," Section 2: "Subversion and Engagement," *Architectural Design*, Vol. 66, No. 11/12, Nov.–Dec. 96, p. 56.

Maroni Stand

A nice woman from the city planning office told me that they don't like too many maroni kiosks in Basel. After all, she said, people want to know they are in Basel and not somewhere in the Middle East. I thought, how strange, do residents of Basel feel their identity by looking at the right amount of maroni stands?
/identity / temporary architecture/

Unofficial Tourist Tours

There must be a reason that so many unofficial tourist tours exist in different cities. People desire and go see favelas in São Paulo, tent cities in the Gaza Strip, Soweto in Johannesburg, the underworld in Vienna, Munich and Berlin. Recently I took a tour of the gates and walls of Belfast. It felt both scary and enjoyable.
/pleasure / individual initiative/

Leaving Home
Notes on Insertions into the Public
VITO ACCONCI

A museum is a "public place," but only for those who choose to be a museum public. A museum is a "simulated" public space; it's auto-directional and uni-functional, whereas a "real" public space is multi-directional and omni-functional. When you go to a railroad station, you go to catch a train; but, in the meantime, you might be browsing through a shop, or having a drink in a bar, or sitting in a lounge. When you go to a museum, on the other hand, all you are doing is going to the museum. In order to go to the museum, you have to be a museum-goer; you go to the museum in order to continue to be a museum-goer.

What do museum-goers want?
What are you doing here anyway?

The built environment is built because it's been allowed to be built; it's been allowed to be built because it stands for and reflects an institution or a dominant culture. The budget for architecture is a hundred times the budget for public art, because a building provides jobs and products and services that augment the finances of a city. Public art comes in through the back door, like a second-class citizen. Instead of bemoaning this, public art can use this marginal position to … public art can present itself as the voice of marginal cultures as the minority report, as the opposition party. Public art exists to thicken the plot.

Public space is made and not born. What's called "public space" in a city is produced by a government agency (in the form of a park) or by a private corporation (in the form of a plaza in front of an office building, or an atrium inside the building). What's produced is a "product": it's bartered, by the corporation, in exchange for air rights, for the rights to build their building higher—it's granted, by the government agency, to people as a public benefit, as part of a welfare system. What's produced is a "production": a spectacle that glorifies the corporation or the state, or the two working together. The space, then, is *loaned* to the public, *bestowed* on the public—the people considered as an organized community, members of the state, potential consumers. Public space is a contract: between big and small, parent and child, institution and individual. The agreement is that public space belongs to them, and they in turn belong to the state.

The building of spaces in the city has already been assigned to established disciplines: the vertical is allotted to architecture, the horizontal to landscape architecture, and the network of lines between and through them to engineering. The city has all the design it needs for another category—"public art"—to have a function in the design of city spaces, "art" has to be brought back to one of its root meanings: "cunning." Public art has to squeeze in and fit under and fall over what already exists in the

Vito Acconci, *Courtyard in the Wind*, 1997–2000, Munich, Buildings Department Administration

city. Its mode of behavior is to perform operations—what appear to be unnecessary operations—upon the built environment: it adds to the vertical, subtracts from the horizontal, multiplies and divides the network on in-between lines. These operations are superfluous, they replicate what's already there and make it proliferate like a disease. The function of public art is to de-design.

"Finding shelter" is: living under an overhang, a rock. "Finding shelter" happens by chance: you're walking—it's raining, suddenly—you walk faster, you look around, there's a rock—it was there all the time—you crawl in under out of the rain. "Finding shelter" is an act of adaptation; you take your hat off to nature, no "self" is asserted in nature's face. "Making shelter" (as we know it in Western culture) is, by contrast, the act of taking over nature, placing something on top of nature. "Making shelter" is male.

"Land ho!": the sailor's cry of discovery, from high up on the mast, as the ship approaches its goal after a life at sea. This is the beginning of the word "landscape." In order for discovery to be possible, land has to be considered first as far away; land has to be far off so that it can be seen all at once, as a panorama. Land recedes and becomes "landscape." "Landscape" equals "land-*escape*"; the land escapes, out of your reach: the word "landscape" pulls the land away, or pushes you back away from the land.

"Landfall": (def.) a sighting of land when at sea, the first sight of land after a voyage. The word "landfall" implies that, when land is come upon for the first time, it's the land that comes upon you; "landfall" is like a rainfall, a snowfall—the land comes down the way snow and rain come down. For the land to come down, it has to first rise up. As the ship approaches the shore, the shore bulges; the shore swells up, like a whale, over the ship—the land engulfs the ship and the sea. The word "landscape" guards against the word "landfall." So that the land doesn't come up like thunder, it's kept in place and at a distance. "Landscape" is land made passive, and subjected to operations.

A view *of* the landscape can be replaced by a view *into* the landscape and *through* the landscape. The landscape, instead of being an object for the eyes, becomes an object for the body; instead of being an object of sight, it's an object of touch—an object of the body's insertion into the landscape. Instead of being the passive receiver of sight, the landscape becomes the active agent of motion: the landscape moves as it's subjected to motion, as it's moved into and moved through. The landscape rises and falls; it can be considered as a series of horizontal planes, parallel horizontal planes going from below ground to above ground. These parallel horizontal planes are the infrastructure of behavior; they cut through the body as the body cuts through them. The body drifts through parallel planes of landscape, while parallel planes of landscape are driven through the body.

"Landscape" is an attempt to keep land in place, to keep land in one piece, lest it be fragmented and blown to bits by "land mines"—(def.) cavities in the earth that contain explosive charges, just below ground surface, and that are designed to go off from the weight of persons passing over them. On a "landscape," you're in the world of science-fiction; passing

over the earth in a space-ship, you have a vantage point from which to explore the earth, map the earth. On a "land mine," you're in the world of detective-fiction, *film noir*: you don't have the luxury of looking around you and looking ahead, you have to keep looking at exactly where you are—one look to the side or to the front takes your mind off the earth at your feet, one look away and the earth takes over, the ground comes up from under you and blows you up off the ground.

Time is fast, and space is slow. Space is an attempt to place time, and understand time; space is a need to have something to see and solid ground to stand on; space is a desire to follow the course of events, and to believe in cause and effect. The electronic age obliterates space, and overlaps places. You travel by airplane: you're in one place, then it's all white outside the window, and then—zap!—you're in another place, with nothing in between. You're switching channels on a TV set, re-winding and fast-forwarding a videotape, instead of watching a movie from beginning to end. The electronic age establishes the primacy of time. The video game, versus the pinball machine. The push button phone versus the rotary phone. The digital watch versus a clock whose hands travel around a field in which each individual second has a place. In a fast time, public space—in the form of an actual place with boundaries—is a slowing-down process, an attempt to stop time and go back in history and revert to an earlier age. The plaza, bounded by buildings and owned by a corporation, is a nostalgia for nineteenth-century nationalism.

On the one hand, our projects *perform* a site: it's as if we're trying to coax the project out of the site, as if it's been there all the time— the site provides not only the place for the project but also the matter of the project—the project is built *with* the site, *by means of* the site—the architecture grows out of the space around it. On the other hand, it's as if our projects build a scaffolding over the site: it's this scaffolding that can support another site, either on top of or within the old one— a future city, a city in the air, precisely because it *wasn't* there all the time.

Public space, in an electronic age, is space on the run. Public space is not space *in* the city but the city itself. Not nodes but circulation routes; not buildings and plazas, but roads and bridges. Public space is leaving home, and giving up all the comforts of the cluster-places that substitute for the home. Space on the run is life on the loose. There's no time to talk; there's no need for talk, since you have all the information you need on the radio you carry with you. There's no need for a person-to-person relationship, since you already have multiple relationships with voices on your radio, with images of persons in store windows and on billboards; there's no time to stop and have a relationship, which would be a denial of all those other bodies you're side-by-side with on the street, one different body after another, one body replacing another. There's no time and no need and no way to have "deep sex": in a plague year, in a time of AIDS, bodies mix while dressed in condoms and armored with vaginal shields—the body takes its own housing with it wherever it goes, it doesn't come out of its shell. The electronic age and the age of AIDS become intermixed in an age of virus, whether that virus is infor-

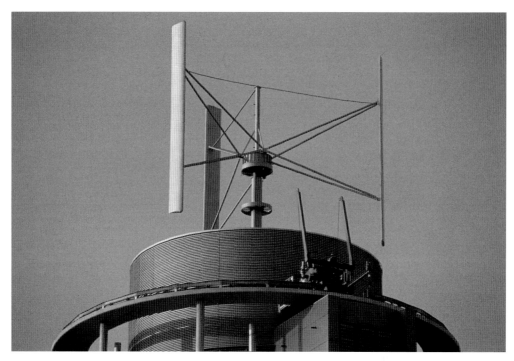

Vito Acconci, *Courtyard in the Wind*, 1997–2000, Munich, Buildings Department Administration

mation or disease. Each person becomes too infected, either with information or with disease, to be with another. You come to visit, not to stay.

The operation was a success: not only is the patient alive—the patient wakes up twice the man he used to be.

You feel the cold in your bones: the cold steel hardware implanted into your skeleton ...

As your skeleton carries your body, your body carries an exoskeleton, a paraskeleton ...

Like an arm-splint, like a neck-brace, like a prosthetic limb, the infrastructure of your house & car & furniture is screwed into your bones ...

Kit of parts on your body: 1. Nuts & bolts in your bones; 2. Hinged framework; 3. Telescoping tubes; 4. Wheels & suction-cups; 5. Backpack & head-gear (closed) ...

Like a monkey on your back and at your limbs and over your head ...

You learn to live with your second skeleton, as you learn to live with a wart or a pregnancy or a cancer ...

It moves with you as you move, like a shadow, a mirror-image, a dancing partner, a double ...

Your side-and-back splints lock into place; you lie back stiff as a board, as your tubes telescope out beneath you: you are your own bed ...

Stretch your legs as you sit, lean back, swivel your tubes out and unlatch the wheels: you are your own vehicle ...

From the closed-up fan screwed to your temples, a micro-shell splays out over your head ...

Your head is your office; your body is your chair ... A microphone and projector are screwed to your skull: Talk—the inside of your helmet is a computer screen ...

Like a turtle, you carry your home on your back; your house is folded up into a back-pack that fits onto your supplementary backbones ...

Pivot out your back-pack, and slide it down your backbone pipes; telescope the pipes out, down to the ground—the back-pack falls down with them, rotating outwards as it descends ...

Your back-pack telescopes; it stretches out behind you; you make a place for yourself, you've set down the foundations of your house ...

The back-pack opens like a fan; from your extended spine, a macro-shell flares out over your body ... You are your own house; your house is your second skin (as you light your house from within, your skin glows) ...

Your house is your car (your head is your windshield and your rear-view mirror, your environment is projected inside your head) ...

When you come back home, visitors can enter your house, as if coming inside your clothes; they get under your skin ... Not everyone is invited inside; but, as long as you keep your lights on, everyone gets to see: your house is an X-ray ...

There's a world out there: grab it as it goes by ... You stick onto a stretched limousine, a tractor truck, a cruise ship; you ride for free ...

You take your apartment with you as you move from city to city, from town to country ... Your house is a leech that feeds off a building ...

Vito Acconci, *Courtyard in the Wind*, 1997–2000, Munich, Buildings Department Administration

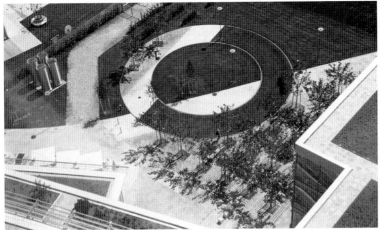

Flashbacks, 1991

PER KIRKEBY

The kneaded clay emerged like an endless sausage from the opening. Packaging material from the high-class suburbs was pressed like a stamp into the indecently soft-solid, moist clay. Cut with steel wire like sausages, the bricks went on their way to consumers. Mr. Meier was a man with a soft hat and a bluish-gray smock, a man who knows what a brick is. A normal stone. A stone that had to be produced with considerable effort and required many changes. But it could be done. Not like the salespeople at the United Brickworks. That was in Münster. For the catalogue, I thought, it would be a good idea to have them write Rossi.

There was occasion to think of Rossi and Mendelsohn in Bremen. The reason the director of the Building Department had called me to Bremen—although he didn't mention it on the telephone—was a traffic control tower. "If I had told you that up front, you wouldn't have come," said Mr. Kulenkampff. And took off on a stiff leg through the city, strolling between the streetcar tracks to the cathedral square, with its view of the familiar City Hall. It was supposed to be given a stucco finish, but that never happened. All buildings constructed of such cheap material as bricks are destined to be stuccoed, he said. Here, the city lies on a sand bank along the river Weser. Everything of importance in this area is situated up on the ridge and extends along the river. A few vertical accents would help. I worried the whole time about being run over by a streetcar, thinking about the screaming man

lying beneath the streetcar on Frederiksborggade in Copenhagen. Shortly after the Germans left Denmark.

When you looked out of the windows in Kulenkampff's little city house, you saw red bricks. Large stones, heavy tectonics. The house was by Spitzweg, a labyrinthine, hole-in-cheese progression on which green and red twining plants ascended from unknown subterranean depths.

As did his thoughts about city planning. He talked about his ideas over an excellent vegetarian meal he had prepared himself. The first had already been realized, for the most part. It bored him, he said, that all public parks and gardens had to look well kept. The only reason for freshly mowed lawns with trimmed edges was to convinced people that nothing can happen and that everything is under control. Why not just let everything grow naturally? I had already noticed at several points during my walk that not everything looked quite so North-German, concluding, of course, that things hadn't been brought under control there—things left over from the war, renovation ... what do I know—some temporary state of disorder, at any rate. That gives people something to write about, he said, half of them angry and indignant about a spot left in that condition, the other half enthusiastically welcoming the sight of rare plants and hedgehogs.

The second idea was for a secret society that would buy up lots in various different cities, first and foremost in Bremen. The soci-

ety would buy a lot. Then workers would come and build a wall a little more than two meters high around the property. The heavy gate would be closed. They would put a bench outside and hang a mailbox on the wall. Often, of course, one or two pensioners would sit on the bench and chase kids away. You couldn't see over the wall, and rumors would begin to circulate. Even when they climb onto the bench, when the pensioners aren't there, the younger children would still be unable to get over the wall. But the older ones, mostly the boys, would finally conquer the wall, only to discover that there is absolutely nothing there except for tall grass, a few bushes with twigs they can break off at will. Trees would grow, higher than the wall. Are they going to start building soon, or is there something there already? "There aren't enough secluded, mysterious, rumor-generating places in our cities," he said. The letters that land in the mailbox never get answered. But the children read them.

It has been many years since my first visit in Münster. I think that was ten years ago. I know my daughter wasn't very old at the time. She accompanied me on my journey to Germany, which was anything but an everyday event for me back then. Kasper König had asked if I wouldn't like to have a look around Münster. There might be a new exhibition coming up, he told me, similar to an earlier one, with sculptures and projects distributed throughout the city.

Intent upon seeing and learning as much as we could, we traveled first to Düsseldorf. On the night train from Copenhagen. The Kunsthalle was showing a Poussin exhibition I wanted very much to see. Poussin suggested new possibilities back then. The crystalline transparency of his cool colors, figures as building blocks in the landscape. The trip from the railway station to the Kunsthalle took forever, because my daughter had brought along a little sketch pad and insisted upon drawing every single modern-style steel or bronze sculpture erected outside banks and insurance company buildings. It was a sort of compensation for many boring, wordless visits to museums and churches in the company of a father bent upon drawing. When we finally arrived at Grabbeplatz, we found the Kunsthalle closed. We were a day late. And so Poussin lives on in my mind. A shrouded mystery nourished from time to time in the course of a traveling life by a picture seen here or there. We went walking in Münster, looking at things. We walked too much for such a little girl. In the cathedral, we sat side by side drawing details. We ate cake and drank cocoa with whipped cream. One place I thought would be just right for bricks was very idyllic and mysterious. In something one would probably refer to as a very large villa we found an old-style museum of natural history. In front of it stood a huge ammonite. And there were strange ruins in the park. Remains of fortifications, I thought, but they were oddly undersized. There was a fragment of a building that might have been a kind of garden house once. Why shouldn't I put a mysterious, impenetrable, rootless building here as well?

I later learned that there had been a zoo here before the war. That made the ruins easier to read, but it didn't make them a great deal more interesting. And the plans weren't realized at the time, either.

Last year I came to Münster again to select a site. This time I was alone. And instead of drawing details in the cathedral, I observed its architectural obsession and tried to discover the relationship between the heavy, simple columns and vaults and the delicately

patterned buttresses and columned corners. I was intent upon avoiding excessively well-groomed, romantic parklike surroundings for my brick sculptures. What I sought was an unusual location. Worn, used, and furnished only with a meager inventory—lamps and the like. A perfectly ordinary spot, as I said. A place which, like all other places, has its own history and its own atmosphere.

I found the site where the sculptures now stand. The shift from one locality to another is also an expression of the long journey taken by my brick sculptures. The intellectual content of the sculptures seeks its proper place. Once that place is found, intellectual content also finds its proper form.

What did this place in Münster look like? It was first necessary to take another journey. From Karlsruhe, with an early train. The broadly flowing Rhine, a church high on a hill, pouring rain. I soon know every tree along this route. From Holland I read about the iconoclasts and Marten van Heemskerck. I think of the Royal Print Collection. The Rhine Valley in the colors of late fall, the vineyards radiating their own light. "Of time and the river." Thomas Wolfe, who wrote novels like life writing itself.

Change of trains. Onto the train to Rotterdam. The grand, sad landscape west of Cologne, massive clouds of smoke from the plant near the autobahn on the horizon, fields in the foreground, small and pinched, defying the expansive industrial areas. The view reminds one of the "active" landscape paintings of the Third Reich, in which alleged energy and alleged realism more or less consciously give way to penetrating melancholy. Tending most clearly and deliberately to travesty in the case of an Otto Dix, of course, but also among his more or less adaptive colleagues.

The landscape turns Dutch. Black skies ahead. Flat, with ditches and canals, trees standing in rank and file, and a sky like one from a seascape: gray with wind-driven clouds. The many arms of the river near Rotterdam. We are in the delta.

The museum in Rotterdam: I was struck by the *Three Crosses* in the room with the many Rubens sketches. It is a small painting. The only sketchlike quality it has is its vigorous immediacy; otherwise it glows throughout with color, and its composition, with the three crosses close together and a fourth in the background, is utterly audacious. Jesus and the two robbers, that we already know, but there are only three people, and there is room for more. The small format poses the great question and professes its faith at the same time: Why do people do such things to other human beings made of flesh and blood— and when they do, what does it mean? Such platitudes really say very little about the powerful radiance of this painting, this sense of being in the presence of a structure that expresses, indeed is, everything upon which our culture painfully builds.

In The Hague the next morning. It is pouring rain and foggy, but the cloud cover is patchy, and the clouds move across the sky. The sea must be over there, behind the trees, and we stand near the seascapes. Yesterday I went to an opening at a gallery next to the Café Spinoza. Mozart wrote his Symphony in B-minor (KV 22) in The Hague in December 1765. All of Mondrian's early paintings are hung in the museum. They also deal with faith.

While we waited outside for a taxi, we talked about what it is that makes the Dutch so different. They are delta people, Helen says. They are a kind of transitional link, always looking to the future, always having to save.

Along the coast is a veritable open-air market, interspersed with high-rise buildings and full ... of carnival activity all the way to the sand beach. Nature reveals itself in the rough weather, in the great, gray waves with their earth-colored foam. Genuinely threadbare and melancholy, with a hint of mortality and decay. We had lunch in the presence of this prospect, since Helen still likes being a little bit Chinese. She is interested in ancient Chinese porcelain and dreams of purchasing that dream piece, holding it in her hands, examining it with her connoisseur's eyes and then letting it fall with a crash to the floor.

On the way to Münster I had a one-hour stop-over in Amsterdam. A boring railway station, totally devoid of style. But I had another un-expected wait in Duisburg as well. That is not much fun. Obviously, neither of the young women at the Dutch railway offices in The Hague and Amsterdam was capable of reading a train schedule. Both had advised me to change trains either in Oberhausen or Duis-burg. But the Oberhausen train ran only on Sundays—this was a Saturday—and the one from Duisburg ran daily, except for Saturdays. This generation has evidently never gotten proper instruction anywhere. I chose not to go into the only place that was still open, a so-called bistro. Full of smoke and beer, no doubt serving warmed-over food and danger-ous sausages that gave one a case of diar-rhea. So all I got was a couple of apples and pears and a bar of Toblerone chocolate from a delicatessen. I couldn't wash the fruit, so I had to eat something bad after all. The dan-gerous life of the traveler ...

Sunday in Münster. Heavily Catholic. It was probably a very holy Sunday. At any rate, peo-ple yelled at Myko because he was working. But he just went on laying bricks for the flat

sculpture outside the Zoological Institute, which also housed the Institute for Applied Botany and the "Department of Plant Bio-chemistry and Institute for Research in Paleo-botany." There is a large gap between the city center and the castle and row of institute buildings—it's called Hindenburgplatz. Kasper claims that it is the largest city square in northern Europe. But it isn't actually a real square but more of a stretch of open ground. An urban freeway separates the rows of build-ings in the heart of the city. Most of the square is in a miserable state: a paved parking lot, the site of an occasional open-air market. Rows of trees and paths subdivide the whole area into different, indeterminate sections. One of these sections is formed by the lawns in front of the institute buildings. And there is a rondel outside the building where we were working. An elliptical patch of lawn in front of a set of stairs that lead from both sides to the main entrance. These stairs form the endpoint of an axis the runs across the grounds to a street in the city center. The flat brick sculp-ture shaped like a squat cross is positioned in the middle of the rondel and thus along this axis. Myko hadn't started working on the tall sculpture yet.

In Münster again. Arriving in the late afternoon on the train from the south. It is early Decem-ber, but the weather is mild for this time of year. The darkness makes no difference. It is a clear day, and even dusk comes in clear pas-tels. For a brief moment, everything looks like a terrific, supernatural photograph. And then it is just dark.

The streets are full of Christmas shoppers, although it is still early December. But that's what the city center is for. Department stores and crowds. High in the church tower hang the three cages in which the mutilated Anabaptists

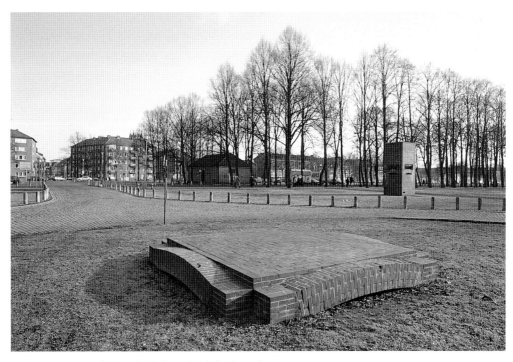

Per Kirkeby, *Backstein-Skulptur* (Brick Sculpture), on the occasion of the exhibition *Sculpture-Projects in Münster 1987*

met their end. Three, once again. Another of these ecstatic movements driven to the outer limits by its own impetus and by pressure from outside. Pleasures of the flesh, experienced as pure nudity. Until the bishop's experts tore living noses and genitals from their bodies and threw what was left into the three cages, of which replicas now hang silently over the streets full of Christmas shoppers. Now they are wounds that will not heal.

Parcifal tumbles down the street.

And I am on my way to the grounds along the city wall. There are streetlights, but I have obviously lost my night vision completely. I rely totally on my glasses and can't even go about my nightly rounds. I want to look at my blocks on the big, empty square in front of the institute buildings. There they stand, mystical and oversized. The large one, a massive block without a trace of usefulness. And in the middle on each side a stone stuck and clamped into its hollow in the engraved arch, like Michelangelo's reclining figures in the austere architecture of the Medici crypt. I felt rather proud. I had done quite a lot of walking that day, and my feet began to hurt. It was late in the evening before I was able to take of my English shoes. Damned warm feet: The nail on the little toe had gnawed all day on the toe next to it. Blood in my sock.

The hotel was outside the city wall in a quarter full of normal, middle-class residential streets, empty and dreary in the evenings, of course. The hotel itself was one of those decadent, semi-modern structures in which one whole wall of the room was a window, from floor to

ceiling. I opened the curtains and turned off the light. Sat there looking down at the street. Desolate, street lights and façades. I wondered how long it had been since I had experienced such a dismal place. I no longer live on a street myself, and most hotels these days are situated in enclaves of their own. And when I do find a hotel located along a city block, I end up with a room facing the back.

I have taken measurements at the museum for the exhibition sculpture. Yellow stones, of a dangerous size: Perhaps they were too small, but any idiot can make things big enough to be entirely certain. I had just seen a Macke exhibition with only half of the paintings hung. I have been thinking a lot lately about affinities between Macke and Weie, but the thing is—as I realized—that I wanted to glean something in the work of both that is not there. But the poor German had only a few years left, and Weie didn't resume his work in earnest until after Macke's death during World War I.

Another journey to Bremen and Münster. To Münster to finalize, to bring that chapter to an end. Bremen still goes on.

By train. Parcifal's days were done. I passed by the scene of the crime in Bremen. My tower was right.

Before I got that far, there was quite an uproar in Hellerup. Of course Absalon woke up as usual in the middle of the night, clambering for his bottle of mother's milk. Sophus wanted to be awakened at six o'clock, with a wet cloth if need be, to listen to the Christmas program on the radio. And then she had to leave, and the chimney-sweeps came.

I had Hans Christian Andersen's vignettes with me and read in parallel to my journey, so to speak: We both arrived in Lübeck at the same time. I had only two minutes on the platform, but Andersen's images also change rapidly. Andersen traveled along with Baggesen, and so we all tried to bite each other's tails. That evokes a great many associations. With Andersen, for example, who gets into a discussion while leaving Hamburg about whether the Germans have potato faces or not. The image of those potato faces is from Heine, another link, but I was amazed and thought of the potato-heads in Braunschweig. And once again I felt the urge to believe that everything is interrelated.

In Bremen, Kulenkampff saw fit to pass on some more instruction on his views about urban planning. Architects and artists, he said, are always trying to achieve comprehensive, "integrated" solutions. They want to rule and exercise their benevolent power. So far so good, but the urban planner's job is always to stop the process, to introduce new, opposing elements. For when everything fits together, when everything is "integrated," then there is no room left, and that is not good for the people. I considered the fact that the urban planner has just as many problems with the big machines, the department stores, the banks and insurance companies, and so on, that leave behind integrated, dead spots on the city map.

In Münster, at the museum, the new brick sculpture was almost finished. It stood in the outdoor courtyard, a covered interior courtyard with walkways encircling three floors, columns and weak engraved arches, all in cream-colored sandstone. I was nervous, because I had been experimenting, to the extent possible, with "minimalist" tension, and I wasn't sure if that was enough. Up to the very last minute I had measured and considered and argued and sweat, for the sculpture seemed small.

Would it look insignificant? On the other hand, of course, any idiot can put up something huge. There's no art in that. And, for the first time in my life, I had chosen to use yellow stones, at the smallest possible distance from the surroundings. And it was right. Everything was just as I had hoped. Precisely because it was a bit too small, it challenged the entire space, making room for itself, and at the same time the color conveyed a sense of "stratigraphic" delicacy. In the office I found a clipping from a local newspaper with a photograph of the sculptures in front of the institute buildings, and in the columns next to it was an article about Pirandello.

I walked through the museum. I entered rooms I had never seen before. Strange. And here was another coincidence: I suddenly found myself standing in front of a still life by Pieter Claesz, one I had painted from many times, one of the paintings that really has meaning for me. And another thing, the other side of the coin, so to speak: It was a strange feeling. I had been in this museum so often before. How could I have missed seeing these rooms? Were there secret doors, deceptive labyrinthine walls? Emerging from the labyrinth, I found the explanation. These were new rooms that had just been opened for the first time. When we returned after lunch we were greeted by an unusual noise. Unusual for a museum, anyway. A thundering roar like that produced by a small mountain waterfall. And that's what it was. The water rushed down the stairs into the foyer, flowing down the walls where the Macke watercolors were hung. They were rescued. A worker had damaged a water line serving the fire extinguisher system on the top floor. It took a long time for the system to empty. But then it was also going to be impossible to put out a fire for a while.

Two Very Beautiful Things That You Might Encounter in the City

TOBIAS REHBERGER

When you arrive at Donmaung international airport, at the edge of Bangkok, you usually get into a taxi whose air conditioning smells like spearmint gum, and have yourself driven via expressway in the direction of the river. Quickly, the taxi threads its way into the slow moving traffic on the main street, in order to get onto the elevated toll expressway. Having left behind the buildings, most of which are built directly up to the edge of the six-lane street, underneath him, the happy driver most likely quickly gets the car going as close to the highest speed it is capable of.

The only things that are still on the same level are the beautiful, giant (even bigger than the American, you think) advertising billboards featuring Eva Airlines, Sony, and Thai mobile phone companies. You fly through them. The most beautiful billboards are the ones that are for rent, where the telephone numbers of the advertising agencies are given.

Back on the ground, a little further through the city, and you've reached Chaopraya. The large hotels are there: the Ramada, the Royal Orchid Sheraton, and the Oriental. If you're staying in a private home, or have rented an apartment in Baan Chaopraya, it's best to get out of the taxi precisely between Rivercity and the Royal Orchid Sheraton, in order to take the Klongsan ferry for 1.50 baht to the other side of the river. The bridges are usually too jammed to drive over in a taxi. When you get off the ferry, you find yourself at the beginning of what is, by local standards, a small street market.

Go straight through this to the end, and there, where there's a big intersection, go left for a little while, over the pedestrian bridge with the steep stairs, and then another fifty meters down the street, you'll get to Mr. and

Mrs. Saesim's restaurant. Here, the best thing to do is to sit down at a table directly next to the street. Because at the row of tables on the side closest to the sidewalk, it often happens that the air conditioning units on the houses in front of which you've placed yourself drip into the aluminium cups filled with ice and water that you get as soon as you've sat down. As a side dish, you choose between steamed rice and rice soup. When you've got all of that behind you, you can finally order two unbelievable dishes. One is a salad made of sweet pork sausages and the other is the fried thousand-year eggs. The salad is basically very simple, consisting of small red onions, red chillies, lemon juice, sugar, and slices of grilled Chinese pork sausage.

The so-called thousand-year eggs, which are sliced into small pieces, are actually only a few months old. Mr. Saesim fries these black eggs, drizzles a sweet brown sauce over them, and serves them mixed with fried Thai basil, garlic, and red chillies. Mrs. Saesim, who, by the way, is actually one of the loveliest persons you might ever meet, finally brings the meal to the little, bright blue Formica folding table. You should, however, be careful not to arrive at the airport after seven in the evening. Because although the restaurant opens at five p.m., almost everything is sold out by ten.

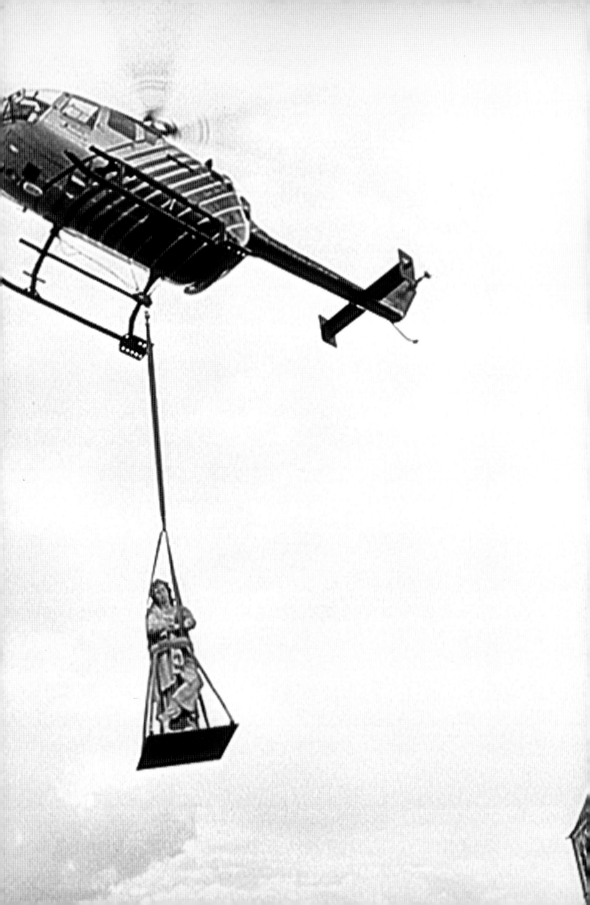

Art in Space
AYŞE ERKMEN

For me "public space" has a different meaning because for many years I worked only in public space—not that I was commissioned or asked to do so, but because there (Istanbul), there had been no other chance/space to show the kind of work I was doing. There were not many art spaces anyway, and the existing few were not interested to show my work. This is still the case even today. Therefore to be able to show my work, I always had to find my own space and my own means. This space could be a billboard, a vitrine, an apartment building, entrances, corners, etc. Almost everything for me had to happen out of the exhibition space. Through years of working like this, this fact has become so much part of me and my work that even now when I am showing in an "art space," the first thing I do is to find a space out of the normal limits of exhibiting or try to work with the exhibition space itself, and this is definitely more interesting and seductive for me. I have done works for and over the windows (Künstlerhaus/Graz, Kunsthalle Bern, Helsinki), on staircases and with elevators (Kunsthalle Bern, Kunstmuseum Bonn, Istanbul Biennial), in offices and storage rooms (Fridericianum/Kassel, ifa galerie/Bonn), and with lighting systems (DAAD galerie/Berlin, etc.).

The last work I have shown in Istanbul follows the same procedure of a self-made exhibition in terms of finding and getting a place which in this case was a huge electronic billboard.

I wanted to show a certain work there which I thought was very urgent to be seen in that city after having travelled to so many cities in different forms. This work *Am Haus* (1994) was originally made for Berlin/Oranienstrasse 18 in Kreuzberg on an appartment building. Syllables made of plastic letters installed on the building refers to a special past tense of Turkish, which made me think it should go back to the place where it came from. Coming back to Istanbul, the work was installed in film form (video) on an electronic billboard which had already been used for advertisements in the city center. The film became a guest in their daily program schedule by being shown in between each loop of their already existing program. This time the work was titled *Conversations* (1997). The first version in Kreuzberg, *Am Haus*, was supposed to be just a visual experience for those who are not familiar with the language, and for the Turkish community living there, it would be a chance create sentences. Whereas in Istanbul it could start conversations since most people were acquainted with the language.

I like it, and it is important for me to be a guest in a place as is the case with this work, that the film is shown in between the normal program of the billboard and that the place is not reserved only for myself or the artwork. Another example of being part of the system is *Warm Benches* (1997) made for the power plant of BEWAG in Berlin. Here are eight

Ayşe Erkmen, *Sculptures on Air*, 1997, on the occasion of the exhibition *Sculpture. Projects in Münster 1997*

benches made of stainless steel tubes which function as heaters and are placed on the promenade between the Spree River and the buildings of the power plant. These chairs are being heated up by this power plant which is already responsible for the heating of the district. Here again the benches are working with the program of the power plant in the way that they are warm in winter when the power plant is heating the neighborhood and cold in summer when the heating stops in the houses. The work follows the principles of its surrounding, the schedule of BEWAG's heating program, and weather conditions as well. It is also crucial here that the work's permanency is reduced by losing the quality of being an artwork in the summertime when the benches are cold. This way of giving a working schedule to the work, making it change by the changes around it or decisions made by others, I think gives energy to the work and keeps it alive.

I did another installation using chairs, a work which looks permanent but not permanent, for the exhibition *Arte all'Arte* in Tuscany where each artist was asked to make a work in and for one small town in the region. The overly historical character of the town assigned to me (Casole d'Elsa) made me think in terms of working against this historical aspect but at the same time to work with something that is happening there.

Marble workmanship was important and alabaster gift objects were the main tourist attraction. I decided to do something cheerful, colorful, and up to date and very sculptural at the same time. I chose four well-known chairs designed by Italian designers (Castiglioni, Scarpa, Pesce, Giatano) and had them made in alabaster stone by the craftsman in the region, painted afterwards to their original colors in the traditional way of painting alabaster. The *Alabaster Chairs* (1998) were then placed outside at different places in the city: one in front of a church, one in between a church and a childrens' playground overlooking a landscape, one at the dead end of a street, and another one in the main square. In the historical setting of the city, the chairs looked very much part of the space and at the same time out of place like aliens.

A permanent sculpture I have done, *Tünel Column* (1994) in a busy, small square in Istanbul, is also thought to be a work which would work as part of that space in a different way. This is a column made out of iron ornaments of six parts over one another. Each part has a different design and each design is taken from the design of ornaments found in the balconies or entrances of the buildings in that same area. Its transparency and lacelike appearance does not allow it to take up much space in that small and tight square which is surrounded by tall gray buildings, and the fact that everything is taken from what is already existing there makes it look as if the sculpture had always been there.

A permanent public work, *Name Tablets* (1999), has been realized recently in Recklinghausen for the new university campus buildings of the University of Gelsenkirchen. It is installed on the glass façade of the entrance. It is a new school, the architecture is new and the students are new. My idea was to make something for and with the students as they would be the first ones to study in this school. I made use of the very basic idea of engraving names of important people on a surface. The surface in this case was the huge glass façade in the entrance, and the names were the names of all the students. The glass was sandblasted, keeping only the names transparent and other spaces opaque so that from

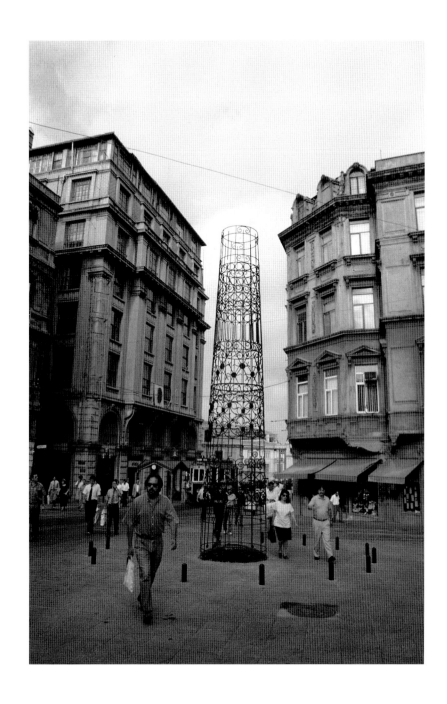

Ayşe Erkmen, *Tünel Column*, 1994, Istanbul, Tünel Square

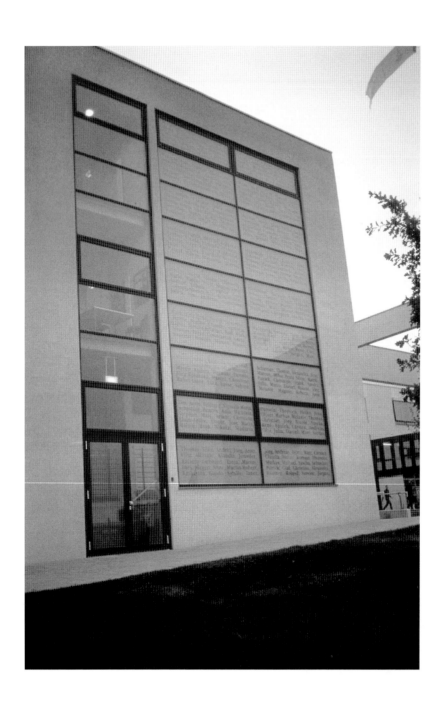

Ayşe Erkmen, *Name Tablets*, 1999, Recklinghausen, for the University Gelsenkirchen

inside you could look out only through the names. The names listed on the façade are only first names—not family names—in order to make it more personal and special for the students who have their names engraved. This will make it possible for future students to be able to find names similar to theirs as well and (as this work will stay) to say something about the trends of the period concerning names and nationalities.

Two works, both realized in public space and at the same time part of museum exhibitions are titled *Sculptures on Air* (1997) and *Weather Report* (1999).

Sculptures on Air, the work I have done for *Münster Sculpture Project '97* is an outside and inside work which visually functions outside but in fact comes from inside to the outside of the institution and back and forth. It is once again a work with a program: one sculpture from the antique collection of the museum being taken from the storage of the museum, placed on the roof of the museum

by a helicopter, where it stays until the next sculpture arrives with the same procedure of being carried and placed to stay. During this procedure the sculpture can be seen on the roof of the museum overlooking the Domplatz. This work is about staying, travelling, carrying, being carried, waiting, being exhibited, shifting places …

Weather Report is a work I made for the exhibition *Under the Same Sky*, again organized by a museum as an urban project in Helsinki. The exhibition was staged in four different parts of the city and in four different seasons with four artists in each of them. I worked for the winter season when there was very little daylight and therefore a perfect situation for using video projection outside. This darkness and weather conditions and the exhibition—with the topic of sky, air, being under the same sky—made me work directly with weather symbols common everywhere in the world to all professionals working with weather.

Ayşe Erkmen, *Conversations*, 1997, Istanbul

I used almost all the signs available, which means all weather conditions, and everything that was happening in the air was available in the work. With this material I made four similar films of one sign following the other with the only difference of slight animation techniques to give rhythm to the films playing on four parallel windows, which were at the entrance of a big office building on the outskirts of Helsinki in an open, windy landscape.

What is most enjoyable for me when I am working on a public artwork or any installation is the visit I make to the place where the work is going to be. I believe that everything is there in the place already and that there are so many possibilities, and the hardest job is to choose the most urgent one and let the others stay.

Ayşe Erkmen, *Alabaster Chairs*, 1998, Casole d'Elsa, Mensano, on the occasion of the exhibition *Arte all'Arte*

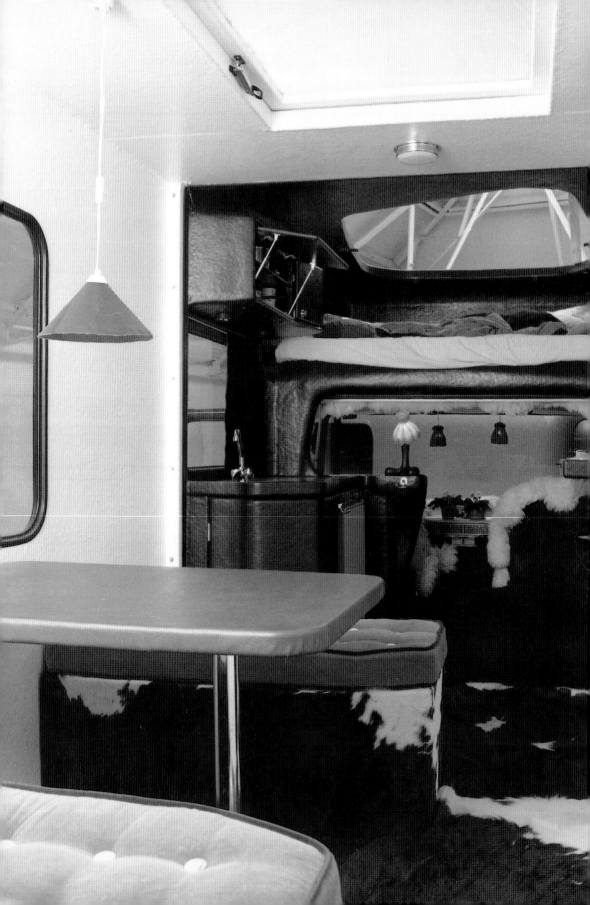

The Public Art of AVL-Ville

ATELIER VAN LIESHOUT

A couple of years ago AVL (Atelier Van Lieshout) received a commission to design a city planning project for Almere, a rapidly growing new town in the middle of the Netherlands. We chose not to build yet another boring building or block of houses. Instead we wanted to stop the regulations and zoning restrictions, and proposed to make "Free-State Almere." The idea was to convert Almere into an independent state within a united Europe. Why not seal off Almere from the rest of the country? Almere is in fact an island, built on a site where the sea used to be. The easiest way to develop its own economy, based on freedom and mobility, would be the manufacturing of illegal products, such as alcohol, medicines, and weaponry. The inhabitants of Almere could settle anywhere they wished on the island in mobile homes and survival wagons, and thus live a self-sufficient life, totally independent from the rest of the Netherlands. Unfortunately these plans were never carried out because they were considered to be too extreme. But it did give us the idea to build an actual city of our own, for ourselves to work and live in: we called it *AVL-Ville. AVL-Ville* is open to anyone who works at AVL or has worked for AVL in the past. It took several years for *AVL-Ville* to be finally realized, but the produced artworks had always been related to each other and were all built to ultimately function inside *AVL-Ville*. The artworks are functional, simple, and sturdy, and they make a statement about life and society. When the artworks are put together inside the village they represent a new artwork in itself: a so called *Gesamtkunstwerk*.

An important part of *AVL-Ville* is the pirating and freebooter aspect. AVL represents *the Good, the Bad, and the Ugly,* and combines in its art the three characters represented by the three outlaws in Sergio Leone's spaghetti western. We take control of all situations by getting around all the rules and regulations. We can outrun the bureaucrats because we're faster than they are. We avoid building codes for instance. They are very strict, but by making everything mobile, the rules are suddenly much more flexible. We're not easily daunted and we'll think of a way to solve any problem or situation. This is part of the AVL spirit: to be creative and inventive with the means that are available. And if they are not available, we'll simply create them. We describe *AVL-Ville* more as a "heterotopia" than a "utopia," since "utopia" means according to the dictionary "an ideal that cannot be realized." Whereas the more realistic "heterotopia," which literally means "a different place," can in fact be executed.

Atelier Van Lieshout, *Modular House Mobile,* view from inside, 1995–97
This camper can take you anywhere you want to go. It is equipped with a bed, a small kitchen, and a toilet and shower. The interior looks very slick and is partly covered with sheep skin and cow fur. The polyester shapes are very sensual and colorful.

So far AVL has built several mobile living units, offices to work in, a complete farm, a canteen, bar and restaurant, an emergency hospital, a city heating system, a power plant, compost toilets, and many more artworks to put in *AVL-Ville*. We're still working on a lot of other items, such as a sex-robot-unit, a water purification system, and wind and solar energy. One of the characteristics of *AVL-Ville* is the fact that it will keep on developing and will never be entirely finished.

Besides making artworks, we have also created our own money which is only valid inside *AVL-Ville*, plus we made our own flag and a constitution. Basic element of the constitution is the fact that in *AVL-Ville* anything is possible and that inhabitants can realize things that cannot normally be realized under the regular legal systems. For instance, building your own house. Anyone living in *AVL-Ville* can build his or her own house and create his or her own way of life. Provided of course that he/she respects the environment and the other people living in *AVL-Ville*.

The no-nonsense and do-it-yourself mentality is an important aspect of working at AVL and living in *AVL-Ville* as well. We do a lot of things ourselves. This ranges from growing our own vegetables and slaughtering pigs for food, to producing medicines and alcohol, and the fabrication of weapons and bombs for defence purposes. If these things must still be called art or not is not up to us to decide. AVL has always presented itself on the borderline between art, architecture, and design. We feel that all AVL artworks should be part of life itself. Whether you want to call it art, design, architecture, or something else is up to you. We think there should not be any boundaries between (public) art and life. This is one of the objectives of *AVL-Ville*, to integrate everything you do and everything you make into a lifestyle: the AVL way of life.

Some facts: *AVL-Ville* is situated in the harbor area of Rotterdam and presently has two locations: *AVL-Ville 1* is located next to the AVL workshop at Keilestraat 43. *AVL-Ville 2* is located nearby, on Vierhavenstraat. In the year 2001 *AVL-Ville* will be part of the program of Rotterdam 2001 Cultural Capital of Europe. It will be open throughout the year. For more information call + 31 10 2440971.

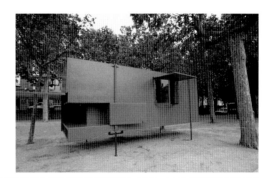

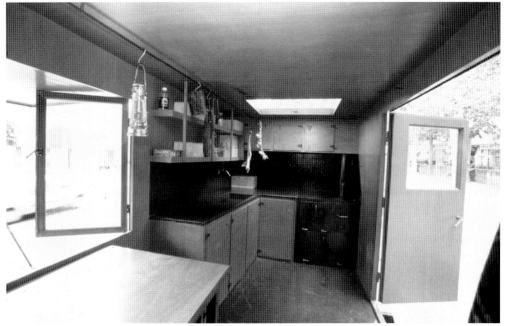

Atelier Van Lieshout, *Autocrat*, 1997
This mobile home has a more spartan nature than the *Modular House Mobile*. Although it has facilities such as a bed and a small kitchen, it is not decorated as luxuriously as the camper. The *Autocrat* is designed for the survivalist to live in.

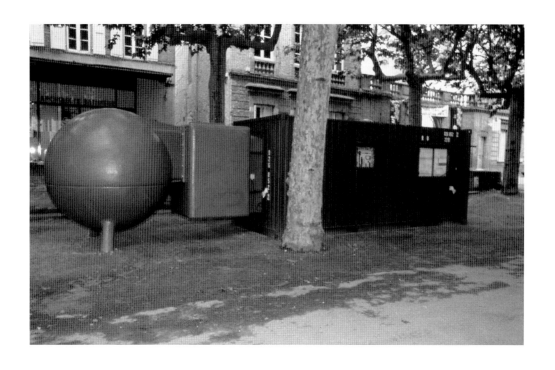

Atelier Van Lieshout, *Atelier des Armes et des Bombes* (Arms and Bomb Studio)
with Sleep/Study Ball, 1998
The *Atelier des Armes* is a refurbished shipping container, and is a workshop for terrorists. One side of the container houses the "hardware area" where weapons and machine guns can be fabricated. The other side is the chemical area with all the necessary ingredients to make bombs. At the far end a polyester ball is attached where the terrorist can spend time studying and sleeping.

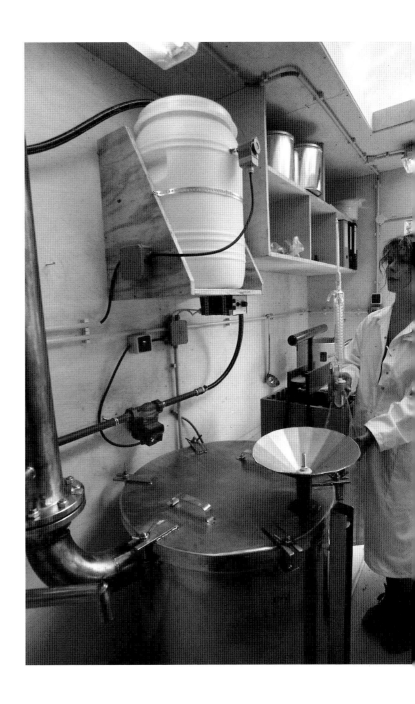

Atelier Van Lieshout, *Atelier de l'Alcool et des Médicaments* (Alcohol and Medicine Studio), 1998
Inside this shipping container AVL made a workshop for distilling alcohol and for the fabrication of medicines.
Besides the necessary chemicals there is a rather impressive still.

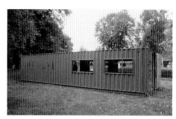

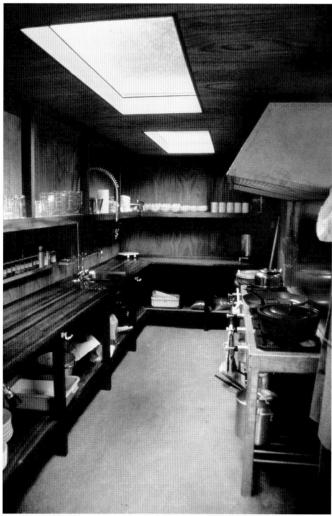

Atelier Van Lieshout, *AVL Canteen*, 1999
The canteen for *AVL-Ville* is also made of a container. One side is a fully-equipped large kitchen, and on the other side there is a dining room. Everything is covered with wood to give it a warm and friendly atmosphere.

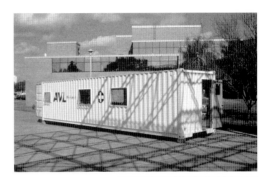

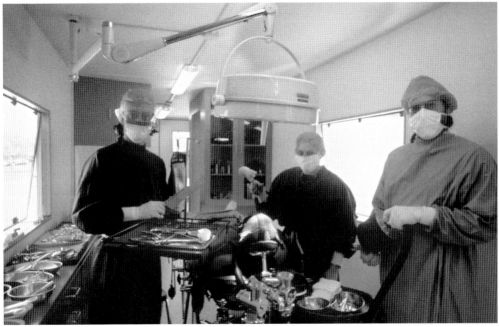

Atelier Van Lieshout, *AVL Hospital*, 1998

This field hospital can be used to heal the sick and injured. Besides an actual operating room with all the necessary surgical equipment there are several beds for the patients to rest in, and also a toilet and waiting area.

Atelier Van Lieshout, *AVL Boiler*, 2000
The *AVL Boiler* provides heating and hot water in *AVL-Ville*. You can incinerate wood or waste inside the huge boiler.
This heats up the water inside the buffer tanks that is attached to pipes that run to radiators. Thus the whole
village can be heated.

Atelier Van Lieshout, *Compost Toilet*, 2000

This system of vertical composting is a new one. The collected excrements are mixed with straw and turn to compost within several months. Once a year it can be emptied and the compost can thus be used for agricultural purposes. The toilet can either be placed inside an existing building or can be placed into a separate unit.

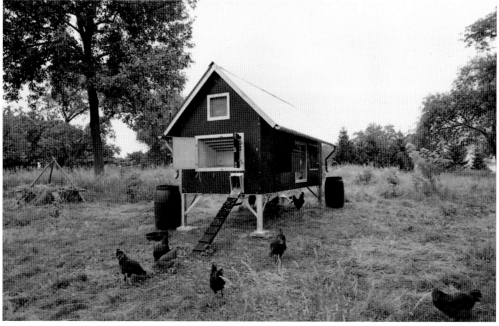

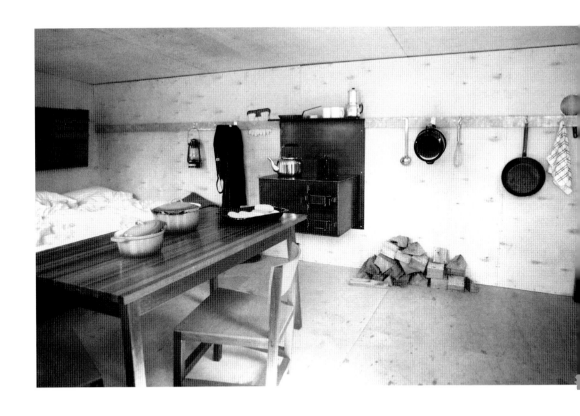

Atelier Van Lieshout, *Pioneer Set*, 1999–2000
The *Pioneer Set* is a prefab farm. All the parts fit inside a shipping container. It consists of a farm house, stable, chicken coop, pig pens, and rabbit hutches.

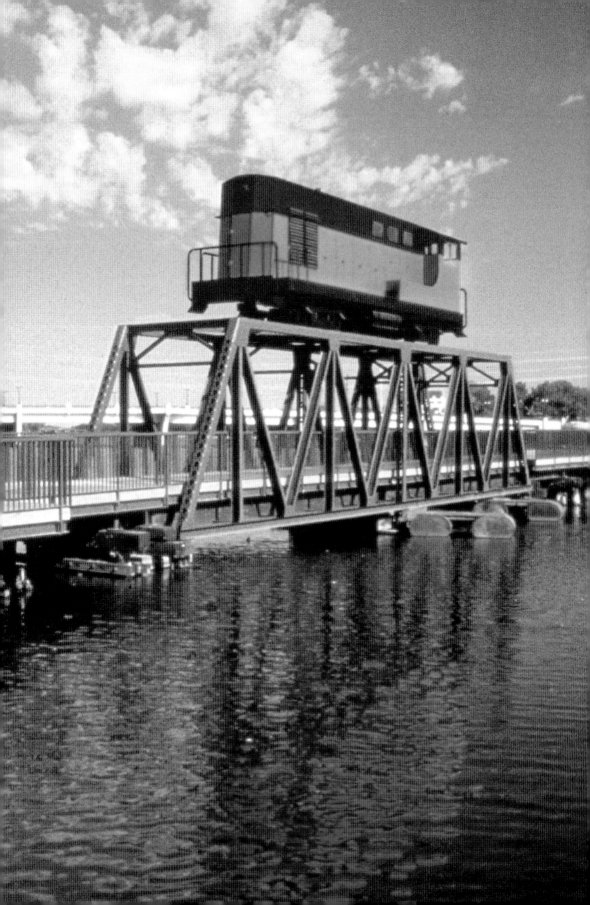

Public Art and the City

SIAH ARMAJANI

"Back to the things themselves." Edmund Husserl

"As long as art is the beauty parlor of civiliza-tion, neither art nor civilization is secure."
John Dewey

"A work of art elicites and accentuates the quality of being a whole and belonging to the larger all-inclusive whole which is the universe in which we live." John Dewey

"For the passionate spectator, it is an immense joy to set up house in the heart of the multitude, amid the ebb and flow of the movement, in the midst of the fugitive and infinite. To be away from home and yet to feel oneself everywhere at home; to see the world, to be at the center of the world, and yet to remain hidden from the world ... The lover of universal life enters into the crowd as though it were an immense reservoir of electrical energy." Charles Baudelaire

"One need never leave the confines of New York to get all the greenery one wishes—I can't even enjoy a blade of grass unless I know there's a subway handy, or a record store or some other sign that people do not totally *regret* life." Frank O'Hara

The Square

"Stretched wide arbitrarily by things past: By rage and riot, by the motley mix that accom-panies the condemned to death, by stalls, by the market-crier's mouth, and by the duke who rides past and by the arrogance of Burgundy (on all sides background).
The square constantly invites the distant win-dows to enter its expanse, while the entourage and escorts of emptiness slowly assume a place. In the ranks of commerce. Climbing into the gables, the small houses try to see every-thing, uneasily concealing from one another the towers that loom ever-massively behind them." Rainer Maria Rilke

"... What a wonderful building, moving inside itself, held up by itself, forming figures, giant wings, canyons, and high mountains, before the first star and suddenly, there: a door so far off that maybe only birds have ever felt that kind of distance ..." Rainer Maria Rilke

"In and of themselves, these offices, furnished rooms, bars, city streets, railway stations, and factories are ugly, incomprehensible, hopelessly sad. Or rather: They were so and seemed so, until film came along. Film then exploded this entire dungeon-world with the dynmite of the tenth of a second, so that now, among its far-flung debris, we set out on long adventurous journeys." Walter Benjamin

Siah Armajani, *The Beloit Fishing Bridge*, 1997, Beloit, Wisconsin

"The city turns into a labyrinth for the new-comer. Streets that he had located far apart are yoked together by a corner like a pair of horses in a coachman's fist. The whole exciting sequence of topographical dummies that deceives him could only be shown by a film: The city is on its guard against him, masks itself, flees, intrigues, lures him to wander its circles to the point of exhaustion."
Walter Benjamin

"An essential feature of the petty-bourgeois interior ... was completeness: Pictures must cover the walls, cushions the sofa, covers the cushions, ornaments fill the mantelpiece, colored glass the windows. (Such petty-bourgeois rooms are battlefields over which the attack of commodity capital has advanced victoriously: Nothing human can flourish there again.) Of all that, only a part here or there has been indiscrimtnately preserved. Weekly the furniture in the bare rooms is rearranged— that is the only luxury indulged in with them, and at the same time a radical means of expelling 'cosiness' along with the melancholy, with which it was paid for, from the house."
Walter Benjamin

"May, if life is sheer toil, a man lift his eyes and say: So I too wish to be? Yes. As long as kindness, the pure, still stays with his heart, man not unhappily measures himself against the godhead. Is god unknown? Is he manifest like the sky? I'd sooner believe the latter. It's the measure of man. Full of merit, yet poetically man dwells on this earth. But no purer is the shade of the starry night, if I might put it so, than man, who's called an image of the godhead. Is there a measure on earth? There is none." Friedrich Hölderlin

To Measure Public Art in the City
We must leave private for public esoteric for exoteric.
Metaphysics for anthropology.
Heroic and bombastic for the common and the ordinary.
The antique and the future for the present.
Myth for allegory.

Philosophy for Poetry
The questioning of public art needs poetic language. Poetry is a systematic rejection of all logic and all reason. We can simply accept poetry as it exists, and turn away from questioning it and move toward the everyday of life. The entire history of public art has been the working out of a certain set of false assumptions, conceptual confusions and distortions of reality. What is out there is just another average day.

What is Public?
Everything which is in the public. Everything which belongs to the public. Everything which is de-privatized and set in the public reality. The noun "public" expresses the totality of life, work, buildings, streets, shops, factories, offices, and drugstores around which people move and live. The relationship between architecture, landscape architecture, and public sculpture exists because all are in public places; being in public places makes the relationship possible. Public art and architecture have different languages, different histories, and different sensibilities. Neither one can replace the other. They coexist.

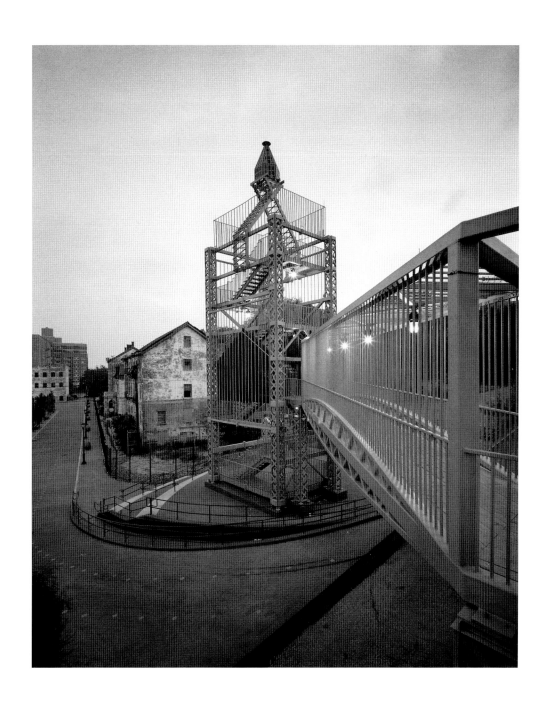

Siah Armajani, *The Lighthouse and Bridge*, 1996, Staten Island, New York

What is Public Art?

It is not about the myth of the artist but it is about its civicness. It is not to make people feel diminished and insignificant, but it is to glorify them. It is not about the gap between culture and public, but it is to make art public and artists citizens again.

Public art is not mass art. It is not Nazi art or Stalinist art. It is not Hegelian absolute-seeking vertical interpretation of history, but rather it is Paul Tillich's horizontal interpretation of history which means that at any given time there are many conflicting ideas coexisting, and each has the possibility of becoming a "new being."

Public art depends upon some interplay with the public based upon some shared assumptions. Public art should not intimidate, assault, or control the public. It should be neighborly. All of the philosophers and all of the critical writers, except a very few, have neglected to develop the concept of public space. Those few who have written on the concept of public space are Walter Benjamin, Henri Lefèvre, and Fredric Jameson.

Public art has social functions. It has moved from large-scale, site-specific art into work with social content. Its language is a hybrid of the social sciences, art, architecture, and city planning.

Public sculpture should reject the idea of the universality of art and assert that culture is detectable geographically and that the idea of region is understood as a term of value. The context of culture and use is always implicit when anything is made.

It is difficult to separate one context from another … For each context conceals the other and each has it own "shadowy" side. Context is not a visual index. Context is not a spatial boundary. Context is a "thing" like "jar is a thing" which gathers and unites. Context is partly "always empty" and partly "to be filled-in." Emptiness is a state of being. There is no negation in it. Like the space immediately before and after the door which should be always empty for the door to function. Context never shapes a pure space as it would in geometry.

The way art has historically been viewed since the eighteenth century is the result of the philosophical tradition of the Kantian view of art. The Kantians say: "Since art has no function which it could perform better than anything else, then art could only be defined as being beyond use. Useless." Kantian philosophers believe art is good because it is useless. Public art is good because it is useful and serves some social function.

Although Kantian philosophers gave art its independence, sovereignty, and autonomy and freed artists from monarchy and the church, nevertheless at the end of the century there is no sign of any attempt to fill in the great gap between low and high culture. Kant's theory of disinterest has left the people forsaken and isolated from being part of one great culture. From the eighteenth century up to the present time, all the philosophers and all of the critical writers, except a very few, have declared a permanent separation between culture and life. From their remote hideouts they critically observe the affairs of life and sanction and culturalize everything and then suspend people between the sun and geography. They believe culture belongs to the constructed sky and life is a geometry under a thousand snows. And since everything is now cultural then we should ask what Fredric Jameson has already asked: "What is the political function of culture when everything is cultural?"

Public art belongs to the cities. It is for the cities. It is of the cities. The future of public art in America is the future of American cities. The relationship between critical urban situations and public art is complicated and confusing.

The hallmark of the modern urban experience is the encounter with the people. Public art believes in the city and its orthodoxy. Public space is always political and public art is always predisposed to politics. Producing a social space has no meaning or value unless the people are the users. In space nothing ever disappears. In space what came continues to condition what follows. In space one has to look for traces of people. In social space the people become the essential part of its content. Space is not an inner experience.

The word "art" in "public art" does not mean large works of art in large public spaces.

"When I was teaching at Cooper Union in the first years of the fifties, someone told me how I could get on the unfinished New Jersey turnpike. I took three students and drove from somewhere in the meadows to New Brunswick: It was a dark night and there were no lights or shoulder markers, no lines, railings or anything at all except the dark pavement moving through the landscape of the flats, but punctuated by stacks, towers, fumes, and colored lights. This drive was a revealing experience. The road and much of the landscape was artificial, and yet it could not be called a work of art. On the other hand, it did something for me that art had never done. At first I did not know what it was but its effect was to liberate me from many of the views I had had about art. It seemed that there had been a reality there which had not had any expression in art.

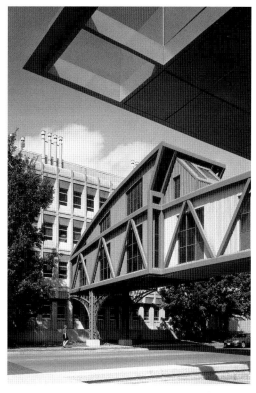

Siah Armajani, *Bridge for Iowa City*, 2000

I thought to myself, it ought to be clear that's the end of art. Most painting looks pretty pictorial after that. There is no way you can frame it, you just have to experience it." Tony Smith

Finally, public art is a logical extension of the American Midwestern progressive populist movement. Long live public art!

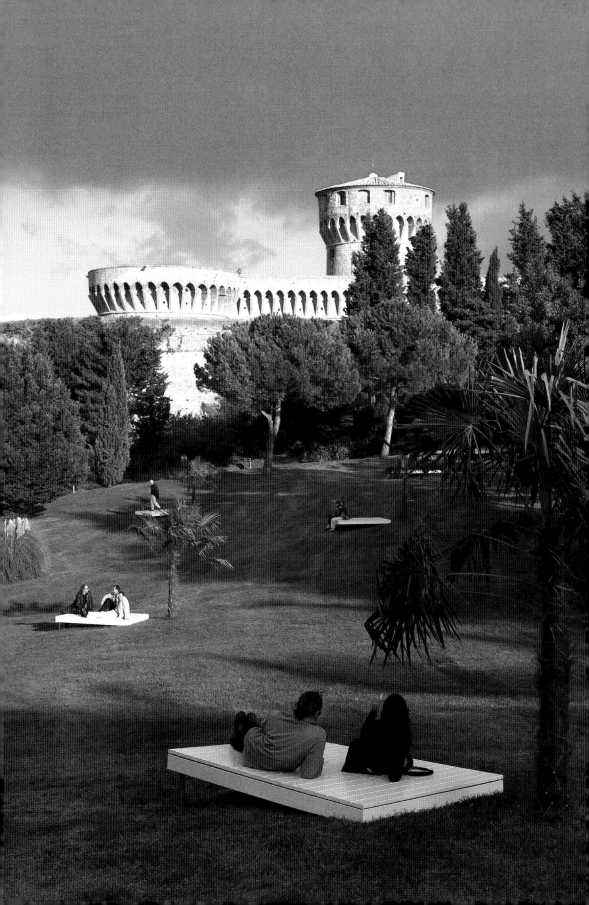

A Few Samples
BERT THEIS

Public Space—An Ontological Problem?
"In order to think our thoughts, we'd like to translate ourselves into stone and plants; when we turn into these halls and gardens, we'd like to go walking inside ourselves."
Friedrich Nietzsche

A prerequisite for the right philosophic design of public space would be to clear up the question of who or what are we. Paul Verhoeven, in the film *Total Recall* indicates how difficult it is to answer this question. "Watch out, you're not you!" the astonished Douglas Quaid is informed, when he learns of his virtual *doppelgänger*. His comment is understandable: "Oh shit!"

Art in the Public Space, Public Space in Art
"The quality of architecture can best be measured by the amount of blue sky left open between buildings." Massimiliano Fuksas

Good. But at some point, the gaze sinks down to the areas where people live. My contribution to the Venice Biennial in 1995 was a simulation of a national pavilion that consisted only of a façade and outer walls. A great deal of nature and blue sky was visible behind the roofless façade. It was also the only place in the gardens at the Biennial where one could see that people live behind the walls: a campanile, TV antennas, laundry lines ... *Potemkin Lock* created a limited public space, an enclave inside that world of the Biennial, filled with optical attractions. The visitors understood this intuitively and accordingly adapted their behavior to the situation.

Prêt à porter
"The artist doing the production doesn't know anything about what he's producing. He's the last one who is able to judge his product."
Marcel Duchamp

The question remains: who can judge the product? The specialists? The art historians, curators, art dealers, critics, collectors? Or the masses, the tourists? Or the ironic, critical view from outside? A point of view like Robert Altman's view of the fashion world in the film *Prêt à porter*? For *Potemkin Lock,* Duchamp's voice was sampled in order to produce the *Potemkin Lock Venice Rap*. Singing as the alternative to programmatic silence.

Geopolitics of Laziness
"In the countries that have a harsher climate than the one around the Mediterranean, being

Bert Theis, *Le dita della mano* (The Fingers of the Hand), 1998, Volterra, on the occasion of the exhibition *Arte all'Arte*

Bert Theis, *Enclave 1879*, 1998, on the occasion of the exhibition *Subway*, Milan

lazy is a very difficult matter. So in order to achieve it, we would have to start a far-reaching propaganda campaign."
Bertrand Russell, 1935

In the meantime, globalization's neo-liberal stress society has also reached the Mediterranean. In Milan, after work, employees run heatedly through the subterranean hallways of the subway. For the exhibition *Subway*, I built an island of calm and relaxation there, entitled *Enclave 1879*, and dedicated it to Paul Lafargue. Being lazy is still not an easy matter. It is a task that can only be managed with great effort.

And the Dentists?
"The art that I dream of is balanced, pure, still, without disturbing or worrisome elements. It should have the effect of a painkiller, a soothing balm on the brain of all intellectual workers, from salesman to poet.

It should resemble something like an easy chair in which one relaxes after physical effort." Henri Matisse

After a while isn't that deadening, like a soporific? And why exclude the others? And isn't an easy chair too ponderous, too ungainly? In comparison, deck chairs are classless and mobile. In Venice, they were used by the Biennale security guards, among others; in Milan, by the employees of the city traffic department and travelers of all classes.

Rather Ten Palms than a Thousand Oaks
No doubt, the archetypical position in the area near Volterra is horizontal. In the Etruscan museum, a man lying with his wife on the *Urna degli sposi* gestures a curse with the fingers of his hand. Who is he cursing? Maybe all of those who force us to get up in the morning? In his honor, and in remembrance of Boccaccio's *Decameron*: *Le dita della mano*, ten

palms give shade and ten wooden double beds are in the archaeological city park.

Word, Work, World

"The prevailing conflict within all linguistic forms has to do with what is said and can be said, with what cannot be said and with what remains unsaid." Walter Benjamin

"Whoever has something to say, step forward and be silent!" Karl Kraus

It appears to me that the recipient's freedom is rooted in what is unsaid. So-called misunderstandings contain creative potential. The *Philosophische Plattform (Philosophical Platform)* for the *Sculpture. Projects in Münster 1997* was created as a result of an exploration of

Pragmatic Aesthetics and the epistemological question of whether a philosophy can exist outside of language. Expressed otherwise: is it possible to express a philosophic concept without words?

Sun on the Beach, Mist in the Schlosspark

Every evening, the tourists in Ia on Santorini applaud the sunset. Accordingly, it might be possible that in this place, the sun sets for esthetic reasons. Every evening after sundown in Münster, the *Philosophische Plattform (Philosophical Platform)* created a new, fleeting shape out of white mist.

Bert Theis, *Potemkin Lock*, 1995, *Biennale d'Arte di Venezia*

Bert Theis, *M'ambo*, design for downtown Munich, 2000, not realized

A Void, a Lesson

"Neither existentialism nor futurism—my art is 'absenteeism.' All of my works are missing something!" Naples comedian Totò, playing a sculptor in the film *Totò cerca moglie*, 1950

a. When something is missing, it can be added. By others. The Münsteraners shaped their lives on the flat surface of the platform in very different ways: skateboarding, picnicking, dancing the tango, getting married, holding lectures, playing music, hanging out, celebrating birthdays, bike riding, discussing things ... Steiner's followers from the Waldorf School used the platform for cult rituals, surrounding it with candles and singing a Latin "Kyrie eleison." Gradually, a community of about 200 was formed, which met every evening at sundown at the platform. These "Friends of the Platform" later organized a campaign against tearing it down.

b. Some people seem to think that a white surface is unendurably empty. By the end of the exhibition in Venice, thousands of visitors had, unasked, covered every white surface on the deck chairs and wooden walls with commentary, drawings, and graffiti.

God in France, Bananas on the Place de la République

"I lie silently nearby, let the sun warm me until I'm red-hot, squint at a vintner's family, and chew on a blade of grass. There's not a thought in my head, but in my body, there is one single feeling: lord, how beautiful the world and life are!" Rosa Luxemburg, Chailly sur Clarens, France.

Strasbourg, also in France. Place de la République. Used to be the Kaiserplatz, built during German occupation. Used to be a Jewish ghetto. In its midst: a "monument to the dead." The burden of the past. My suggestion: a *monument to the living*. A playful, dynamic element in the solemn severity of the square. A spiral that looks as if a curly lock of hair had fallen onto the city map. In its center: a Japanese banana plant. City planners never use spirals because they hinder the flow of

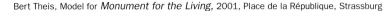

Bert Theis, Model for *Monument for the Living*, 2001, Place de la République, Strassburg

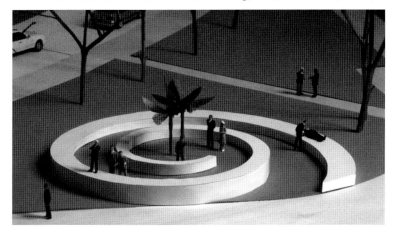

traffic and free circulation. If you get into a spiral, you can't go any further at some point and have to turn around. Spirals produce a time loss; that means time is won. A sixty-meter-long white wooden bench presents itself as a vanishing point to pedestrians and bike riders coming from the Passerelle des Juifs or the Avenue de la Marseillaise, optically closing off the newly finished pedestrian zone. Like the new streetcars, it is available to wheel-chair users, bike riders, baby strollers, roller skaters, etc. You can sit on it, in order to wait for the next streetcar, to rest, to think, to read, to watch passers-by. You can use it as a vista point, since it is raised in the center, allowing for different views of the surroundings. You can use the inner circle as a gathering place for a group. You can lie down to waste some time, to dream, to sunbathe ... just like Rosa in Chailly sur Clarens.

Less and More
"Life is what happens when we're thinking about something else." Oscar Wilde

Be there and yet be somewhere else in thought. Mobile phones and the World Wide Web appear to strengthen this tendency. *M'ambo*, a plan for Munich's city center, starts with the assumption that the development of communications technology and the decrease in forced mobility connected with it simultane-ously opens up unthought-of possibilities for redesigning the public space. A more intense and sensual life can once again be imagined.

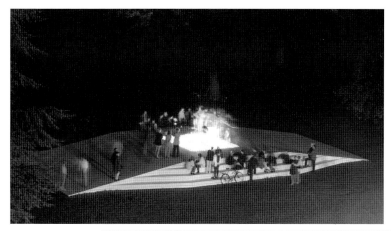

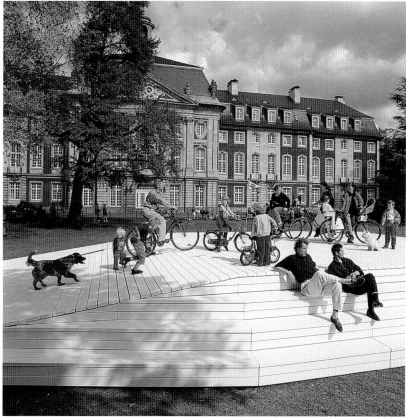

Bert Theis, *Philosophische Plattform* (Philosophical Platform), on the occasion of the exhibition *Sculpture. Projects in Münster 1997*

what, why, wherefore
HERMAN DE VRIES

how lonesome they often look—sculptures in pedestrian zones or parks, unnoticed, cut off from their surroundings, offering no recognizable reason for why they are there. in parks, they even turn attention away from what lives and grows around them, exploiting the trees as a background for their presentation. yet art can work in public space, can even be important. but what kind of art?

the equestrian monument, the monument to authoritarian rule, no longer has a place in democratic thinking—and that is just as well. fortunately, victory columns and princes on pedestals now belong to the past. their hierarchical status is out of place in our society. yet when they do stand there, as monumental relics of a past age, they have a purpose after all. they remind us of a past of which we thus become conscious. a concentration camp from the nazi era needs no monument; it *is* a monument. a memorial within—for jews,

for the dutch or the poles—extracts these identities from their collective history of suffering. the decent people were gathered together in the concentration camps.

the social function of art, particularly in public space, is its contribution to awareness. what else should it be for us? hans haacke's sculpture *der bevölkerung* (to the people) in the german bundestag is a marvelous work that both clarifies and accomplishes something through the discussions it generates. a genuine contribution to the growth of awareness at precisely the right place.

a lot of good things have been done in münster. how i love nam june paik's *tv buddha for ducks* (1987) on the banks of the aa. how many people have asked themselves why the massive stone—george brecht's foundling—can be a *void*. this is a place for recognition, where questioning can set a process of growing aware in motion. as sur-

Ancient equestrian statue of Emperor Marcus Aurelius on the Capitoline Hill in Rome

herman de vries, *sanctuarium* (sanctuary), Münster 1997

prise or provocation, art in the city also represents an invitation to intellectual involvement. the world represents what it is, and art can play a part in that process. it does *not* serve the purposes of urban beautification. a poorly designed environment and inferior architecture are not improved by art, and bad urban planning is just what it represents. the better the city, the more art it can accommodate. if it is not properly placed, art can lose much of its meaning. equally important is the right scale. oversaturation can obscure, blocking perception and even causing irritation. the placement of works of art in urban space requires a fine sense of relationships. i originally wanted to erect my *sanctuarium* on a square in front of a church in münster, as a deliberate juxtaposition. it would have destroyed the space with its great size. in the part, where it now stands, its function has changed somewhat. the heavy wall protects the living, growing interior space against the lawn mowers and the tree-trimmers from the city's so-called greenery service. green, an ugly bureaucrats' word that lumps all plant life together. the park, nature impoverished by culture. imagine how things would look if wild growth were to take possession of such space. nature, which fills every conceivable niche with life, always optimizing. it is nature that has the most to tell us. it is our origin—which we should always remember.

nature itself is public space, not of people but for people as well. nature needs no art; it is art. when we do introduce art into nature, it must be done with great sensitivity. my *sanctuaire de roche rousse* in the haute provence can grow into the surrounding natural environment comprising roughly twenty hectares of woods, a *bois sacré* in which no tree can be felled, no animal shot. where a sign at the entrance path asks visitors to be quiet—so that people enter with respect and are able to hear. the sanctuary encloses no building ruins; it shows that both humankind and its culture are transient. trees growth forth again, wild roses bloom, birds nest, lizards live—all from its past.

herman de vries, *sanctuarium* (sanctuary), Münster 1997

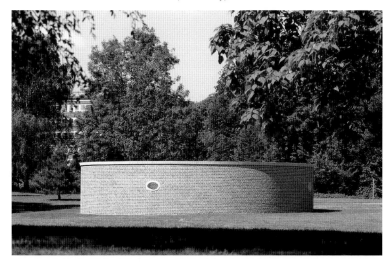

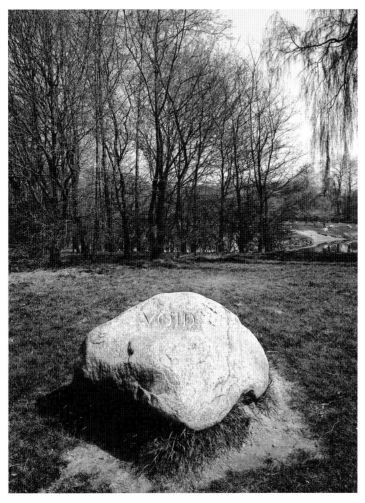

George Brecht, *VOID-Stone*, Münster 1987

i am planning a memorial to the german philosopher and physicist gustav theodor fechner (1801–1887) in the de weerribben national park in the netherlands. it is a pond with yellow water lilies. a plain platform allows us to be close to the water lilies, and a text by fechner about the reality of the lilies reminds us of him. a footpath leads past the site and gives access to the memorial.

art in the city, in public space, can be enriching; it depends upon what kind of art it is— on the why and the wherefore.

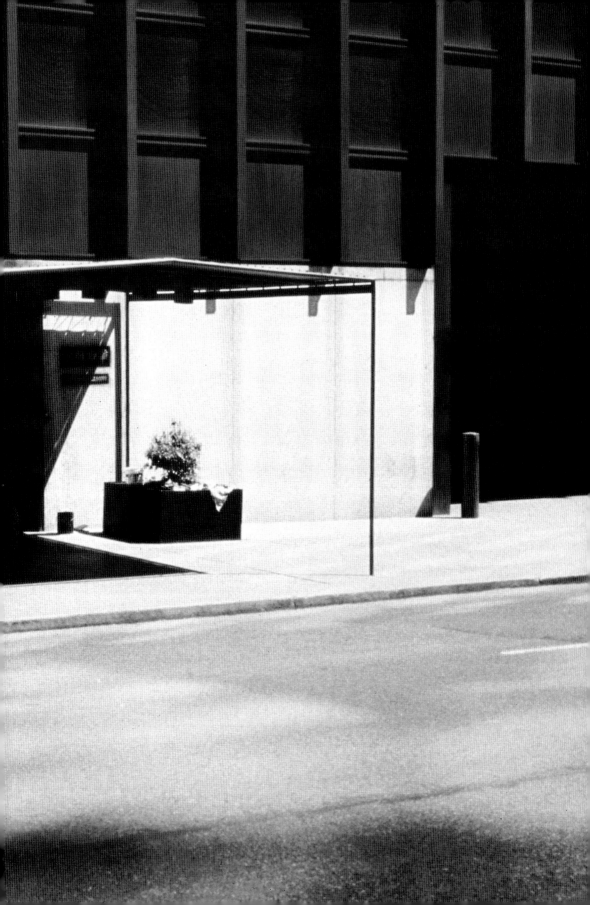

"Try again, fail again, fail better"
STEPHEN CRAIG

A good example of "Art in public space" is the *Seagram Building* by Mies van der Rohe in New York. This building is for me "Art in Architecture." It stands in a realm which to my mind can be seen as public space. Public space, as I see it, taken at its basic, is an *open area*. Accessible—circumstances permitting—to every member of a given society at any given time. An area in which every person is afforded *access*, so long as a certain set of rules, set up by this society, is adhered to by its individual members. A space constituted by an elective democracy, for example. I believe that the idea of "Art in public space" is best suited to, and best reserved for that part of the world which could be categorized as the "Western Democracies." Simply because the concept as such seems to have evolved from, and is therefore determined by the basic political ideology of this type of society. If we try to apply the concept to another culture which may have no inclination toward such a way of thinking, then I believe that it becomes very easy to run into the trap of cultural imperialism.

At any rate we would have to confine the idea of public space to an area which can be walked through, driven through (skated, rolled, flown, or *surfed* through) without it being necessary (directly) to ask permission of any given authority (private or public). And where it is not necessary to pay (directly) an entrance fee. A space of experience, to while in, or to be experienced on the way to somewhere else. Bearing in mind that all further discussion pertains to the stipulations which have been mentioned above. The question which poses itself automatically then is: what is "public space," in relation to "private space"? The two hypotheses, in order to co-exist, would necessarily have to intertwine and interact with one another. Ultimately overlap and merge with one another.

In a concrete political sense, this means the interaction of democratically state-owned territory with that of commercially occupied space. It could in these terms be possible to argue that most public space finds itself in private hands, and this would most probably be true! It could also be possible to say that the state may even to a large extent be in the hands of private (commercial) interests. Commercial global company interests for example! This may also be most true.

But still, if we are to assume the existence of, and thereafter, recognize the essential quality of the concepts, public and private, then we necessarily have to be able to hold them in some way apart.

If we are to go on talking about "public space" as something *real*, and eventually to talk about "art" as something to be experienced within it, then it would seem to me that these aforementioned factors are those needed to constitute the idea of "potential public space," and in turn the potential of "art in public space."

"Seagram"

When experiencing the *Seagram Building* by Mies van der Rohe, it becomes immediately apparent that the architecture constitutes much more than the sum of all its parts. "The building serves not only a technological but also a basic intellectual need."

There are many other things which could have been taken as examples of "Art in public space," but I have chosen this one because out of the things, which I have in recent years personally experienced, it is one which remains most potent in my memory.

It also seems a good example, because to my mind the building reveals a basic spirit which should I think exists as part of any further thinking about and continuing development of the concept of "Art in public space." It would seem to me to encourage a way of thinking which leaves many avenues open for exploration. I believe that such a structure encompasses a spirit which cannot be so easily isolated or programmed into purely temporary cultural events.

This spirit can serve as a basis in attempts to integrate, in a fundamental way, a concept of "Art in public space," into wider social structures.

It allows the possibility, for instance to be functional while being creative.

To "construct with" and not *only* to mirror, or "work within."

The thinking about this building provokes consideration of a potentially very interesting problem. A problem which we arrive at by asking ourselves certain questions such as: how do we reconcile the excellence of this architecture—firstly with the immediate environment in which it stands. And hence ultimately with the society in which it finds its place.

At the present time, it is evident that the spirit in which the building was conceived, coupled with the excellence of the realization, far outweighs the quality of all other structures in its nearer vicinity. In principle and in consequence with the quality of the wider based Social Structures with which it needs to be seen in comparison.

What would it mean, for example, to have more such buildings in Manhattan, in New York, or to have other similar quality buildings in other larger or smaller cities? (By this I do not mean copies of course, but rather—and more importantly—building structures which might stem from a comparitive spirit of thought!) How much does such a singular building necessitate a rather less excellent environment, in order to remain excellent in its own right? At which point could we achieve the right balance? And at which point would we lose it again? By that I mean: at which point would too much excellence become unhealthy and, or less inducive to life, in social terms, in general.

One thing is sure: one is not enough and especially one which has been made such a long time ago!

Another contemporary example which could be named in this same vein of thought is the *Educatorium* in Utrecht, by Rem Koolhaas. Another two examples which allow a somewhat different approach to the idea, but which I also would consider good works of "Art in public space," are—the *Tîrgu-Jiu Complex* in Romania by Brancusi. Or also *Die Aluskulpturen* in various locations. For instance the *Sitzwüste* or perhaps especially the *Spairos* in the Schlosspark Ambras in Innsbruck, by Franz West. There occurs to me another example which I would just like to mention. Perhaps just to prevent some other possible misunderstandings about *this* so-called art and architecture phenomenon. That is the museum by Frank O.

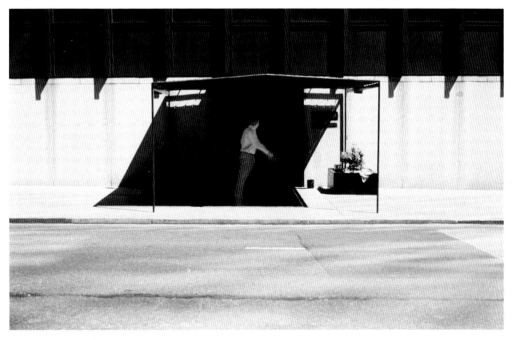

"Seagram"

Gehry in Bilbao. For me the problem with this building (and with others of a similar nature) is that it would seem too often to get categorized as an "Art Building" (whatever that could be!). This building would seem to encompass some sort of general attitude (between "lays," artists and architects alike) of defining certain structures which look in some way "sculptural" as art. This way of concieving things as art is in my opinion much too superficial and serves only to confuse the already general issue even further.

Most of the time the art is there where you might least expect to find it. Perhaps even in a straight line or in a right angle, certainly also often in the right sort of curves, but just as probable, in something quite functional. Most architects would seem to think that artists make the art (and should stick to that) and architects should be left to do the archi-tecture. But they are wrong—most of the time unfortunately for all of us, on both counts. My humble opinion of the matter is, if the architecture is good then there is art in it. If it is bad, then it has been unfortunately a lot of the time made by "architects." Adolf Loos, a man more competent than most, had the extreme good sense to deny his being an artist (which of course he was). And to be appalled by the notion that he might be put in the same barrel with his architectural con-temporaries.

What I was really meaning to say though, is that this museum by Gehry is not of course necessarily a bad building. On the contrary, I have not yet experienced it! But I think that it could even be a good functional sculpture. The point is that it is just a plain bad general example for "Architectural Art."

Another good example of "Art in public space" is for me a public library. This social institute contains (amongst other things) literature, and that is art. And it allows general access without entrance fee.

A bad or rather inaccurate example of a possible attempt to define not only "public space" but also "Art in public space" would be to my mind to say, for example, that the *Galerie der Gegenwart* (museum for contemporary art) in Hamburg would also fall into this realm of categorization. (This is an argument which I have personally heard put forward by more than one "museum person.") It is an argument which may be, some of the time at least, well intended. But one which shows unfortunately a certain lack of precision of thought!

On the one hand such a definition may seem logical and justified. Within this building there are also (amongst other things), as in a public library, "art works" to be experienced. The institute offers therefore also a public service. I see it though as an inaccurate example of "Art in public space," because the "concept" on which the institutional structure is based, is the support and interest of a minority sector of public society. People go there with the special aim and intention to see art. The "House" must therefore, to some degree at least, cater for the expectations of this more or less minority public.

An entrance fee must be paid.

In the case of the *Galerie der Gegenwart* it is also a bad example for "Art in Architecture." This particular building itself contains no art as part of its architecture. Which means that it cannot be experienced as such from without. By walking around or driving past it, for example. In fact, the aesthetic of the building is such that it actually detracts from the general quality of its immediate environment, and to some extent to that of the city of Hamburg as a whole.

The rooms within the building, for instance, are of such a design that they cannot be said to offer any benefit to the artworks to be presented within them.

It could in fact be said that the interior spaces detract from the artworks, in a similar manner to the way the exterior presence of the building detracts from the quality of its surrounding environment in general. Thus, as already said, offering no beneficial cultural addition to the city of Hamburg as a whole.

For these reasons (amongst others) it can I think be seen that such an institute cannot be attributed the ability of making any contribution toward the idea of "Art in Architecture" or of "Art in public space" in general.

Omitting of these particular *details* in regard of this one building, it would still not seem to be essentially correct or plausible to accept such an institute as another possible example of "Art in public space." It we were to do so, then it would also be just as plausible to accept other possible examples, such as cinema, theater, music concerts (of various kinds), or (depending on the quality of the players) football matches.

Street musicians, open-air film screenings (or other projections of various kinds), perhaps certain types of graffiti, or quite possibly a good story teller (in a pub for instance) would actually though, all to my mind, seem to be more precise possible examples.

Museums, galleries, and other art institutions are all contributors to the notion of art-based culture within the public realm. But they are none of them good examples for the idea of "Art in public space."

These institutions have been tried and tested and would seem to work quite well in their own

right. They are also very necessary in their function of trying to create and develop a dialogue of culture (art culture) within the public realm. Interestingly though they seem also simultaneously to make us aware of a lack of something. They seem to be (as do also in a similar sense art schools for instance) necessary for the survival of certain, let's say, "wandering free spirits" within a society which otherwise would have no place for them. They make apparent that there would seem to be some sort of "missing link."—They are, for instance, not rooted within the society which make them so necessary. They have no roots because there is in that sense no substantial culture-based society in which they could take up roots.

There may be something which could work "aside from" perhaps in another way even better than these preexisting structures—we need to be open to find and to test them. But what is certain is that museums, galleries, and other "art culture" based institutions do not need alternatives, and they do not need successors.

(As institutions they could be made a little bit more transparent to general public and artists alike, but that is a whole other matter.) If anything, they need to become part of a different political system, with broader based cultural interests (whatever that could be!)—fact is, that there is very little chance (if the need is felt at all, by an art-culture-interested individual or group of individuals) of rearranging, let alone changing the very tightly woven, seemingly ever-expanding fabric of our present (western, increasingly global) monetary/practical Science-based society.

So long as artists who may be concerned with the idea of "Art in public space" know this and have accepted it as fact, then there is no problem in continuing the very necessary work of trying to develop possibilities to create a dialogue of culture (art culture, at least perhaps) outside of already tried and trusted institutional methods. And, of course, also by working together with such institutions!

To sum up on what has been said until now, I would like to refer to an extract from a letter correspondence between El Lissitzky and his wife in the twenties of the last century. The basic content of which I think we could still perhaps (certainly on another level—less direct—but not necessarily less authentic) project onto out present contemporary world view.

"Moscow, September 8, 1925.... You complain that the impact of the new movement doesn't go deep enough. Yes, you are right, from our point of view, but what can we really see? We ourselves are directly affected by it and are therefore egocentric. Hanover, ah, Hanover is just the kitchen. The point is whether art plays an active creative role or merely 'reflects.' If it is only the latter, then it is no more than child's play. And there are other toys around, stronger ones. Cocaine and jazz at five-o'clock tea, where you actually rub thighs. So what's the sense of another *Nue* (nude) on the wall? Pardon my malicious tone.

But every movement in art has been penetrated by another one in the next phase of its development. You don't need to read Vollard, van Gogh, or Gauguin to know that. What matters is conviction. That is why the art dealers get nothing done. No one cares where the works end up today. It doesn't matter at all how snobbish they are. They just have to be well preserved. And then the day will come for the living things."

"Washed Up"

The difference is now though, that not only Hanover is nothing but the kitchen, but unfortunately at least half of our contemporary global society (and cocaine consumption is no longer reserved for a few and confined to five-o'clock tea).

I believe that it remains very important in this sense to continue with attempts at creating a physical "object character" (sculpture, if you like) type of works in open public spaces.

It remains as important as ever, if not more so now than ever, to offer a public the chance of a *physical*-bodily contact experience. In order to channel other potentially latent intellectual exchanges.

Art has always to do with emotions. The exchange of emotions. And the physical bodily object presence should to my mind always remain an important part of this exchange. After all that has been said till now, I believe we should nevertheless never over-intellectualize. We should not lose sight completely, of certain physical realities.

We should not as artists be intellectually afraid of the potential for object (materially based) "Art in public space" projects.

I personally would like to continue to "build things." There is a time to think and talk, consider, conceptualize (and write), and there is a time to carry on, so to say, to get on with it. Experience making mistakes and learn from them.

In the words of Samuel Beckett:
To—"Try again, fail again, fail better."

An Architect recently asked me, in a strange undertone, of which I took to be some sort of intended provocation, how I would like to try and avoid being in the position, as an artist, of having to decorate (*schmücken*) his building. In the hypothetical case of a "Kunst am Bau" project, for example. I told

him that the best way for me to avoid this hypothetical dilemma would be to design and realize the building myself: Silence is sometimes golden!

If we were to disregard such concrete examples of what "Art in public space" could be and what it cannot be, then another possible approach would be to say, "ok."

"Art in public space" is just a figure of speech. It doesn't really mean anything.

But we know what we mean anyway!

We could in that sense take it or leave it.

In this more general sense we could try to use the term to describe something like "Art culture" involved projects. Projects which are to be placed "outside"—in the weather, so to say. That is, in a somewhat less protected environment to that where "Art culture" projects (exhibitions) more often take place.

We could also use the term to describe in that sense an "Art culture" based internet project—which is more or less the same thing.

The problem with this method, though, is that it would seem to lead to quite a few misunderstandings. There then appears a notion of the term "Art in public space" as some sort of autonomous, politically based cultural phenomenon. That is a concept, which is believed, can be taken and inserted into the "real world" (a world of finance and political violence).

On these terms, this public space phenomenon then becomes a cultural container, in which is to be placed the individual "Art culture projects." This container takes on, in effect, an artificial object character of its own. Which can in turn be placed for a certain duration of time in a larger political framework.

Actually quite similar to the way in which one would place an art (or art intended) object

into its pre-prepared protective environment (exhibition room).

In effect, a whole cultural "public space concept" ready to be dropped, like the proverbial old "dropped sculpture" scenario.

I don't think very much of this approach myself. That is why it has been important for me, thus far in this paper, to try and set a row of *certain* terms under which the proposed notion of "Art in public space" can actually *mean something*.

Again to try and reassert my own stance:

I think it is important to be aware of the existence of the above mentioned attitude and to be conscious of the inherent dangers which it may hold for the *real* spirit of the term. Basically, better to be aware of this, in order to be better able to counteract it.

I cannot deny that Art is on a certain level a sort of mirage. But let's not have to say that a mirage is a public space!

It is the real crossover and interaction of the private, individual creative energy, within the society of which it finds itself a part, which for me constitutes the basic potential importance of "Art in public space."

I would like to compare a few statements of two or three for me important artists of the twentieth century. Artists working in different mediums with perhaps different philosophies and different world views. Who were all of them, to my mind at least, substantially concerned, in their own ways, with the basic gap between the practicing artist and the public—that is the society in which they lived. It would seem appropriate to begin with the architect Walter Gropius—someone who for a large part of his life tried to get to grips with and analyze the foundations of the day-to-day life of his own times.

Later, as an old man, he wrote a book called *Apollo in der Demokratie*, in which he tried to achieve an overview of the newly and speedily developing ground plans of western civilization. He foresaw a lot of future problems (for us contemporary problems) and tried to offer some possible solutions. His basic concerns can be partly summed up in an extract of the book which read:

"A gap has opened between the public and the creative artist, who is misunderstood and essentially underestimated, as if he were a dispensable luxury of society. The unparalleled triumphal march of the practical sciences has driven the magic from our lives. The poet and the prophet have become stepchildren of the super-practical pragmatic human being who, blinded by the success of the mechanized civilization, turns away from them. A pregnant remark of Einstein's sheds light on the outcome of this one-sided course of development: 'Ours is a time of perfect tools but of confused goals.'"

One interesting aspect of this quite comprehensive extract is the way he acknowledges Einstein (the scientist) as a creative individual and simultaneously criticizes the pedantic and limited outlook of his practical science-based colleagues. It is not science that is the problem. It is what is being done with it. Similar to architecture, it is not architecture, but rather what too practically (and money) minded architects are doing to it. They are fulfilling exactly the expectactions of a society which no longer knows anything other than this science-based life-support system.

It is precisely this blind following of science—the trust put in (a lot of the time unconsciously perhaps—but no less fatal for that) the practical sciences which forms the basis of our present western society.

"Bunker"

The dependence on science and the basic outlook which it forms in peoples' minds is also a main source of other culminating factors which in the end plays a huge role in shaping the general public attitude towards art. That is what every artist is dealing with, in one way or another—and having to deal with especially when concerned with the idea of "Art in public space."

There is a very strong tendency throughout society as a whole, of having to put things, including "Art," in their right place. As soon as there appears even a notion of a concept, then it has to be put, as quickly as possible in the right pigeonhole. So quickly most of the time that we never get the chance to find out what the thing is, or could be, in the first place.

Art—Architecture—Sculpture—Public Space—etc.—just to mention some of the things which we are here concerned with directly. As Fernando Pessoa most elequently put it: "Generally speaking, the classifiers of the world, those men of science whose only knowledge consists in their ability to classify, are ignorant of the fact that what is classifiable is infinite and therefore unclassifiable. But what amazes me most is that they know nothing of the existance of certain unknown classifiable categories, things of the soul and the consciousness that live in the interstices of knowledge." And in terms of art, as Marcel Duchamp once put it: "The very idea of trial should disappear"—"for me there is something else in addition to yes, no, or indifferent—and that is, for instance the abscence of investigations of that type."

I believe that artists should never know exactly what they are doing. But what ever they do, they have to do it very precisely. The public should never think (should never be led to think) that they should know what to expect from the artist.

Most scientists most of the time never seem to notice that they never know exactly what it is that they are doing.

And in that sense, in the words of Duchamp again: "Art is the last refuge from science." Scientists seek control. But perhaps the artist is most successful when being like the little magician, who when sometimes getting all mixed up, trying to do magic, somehow, in a manner unknown to himself, gets nature to do his magic for him.

Let's imagine, in relation to the statement of Walter Gropius already considered. A conversation between a few of these other people who I wanted to refer to in that respect a little earlier.

To begin with a comment from Marcel Duchamp: "Instead of forcing the public to approach the work of art, we beg for its approval. What is so boring about art as it is understood today is this necessity of having the public on one's side. Things were better under the kings: the blessing of a single individual or of a small court. Just as idiotic, but numerically smaller.... The public makes everything mediocre. Art has nothing to do with democracy."

And then James Joyce. After having expounded at length on the essential need of art and beauty, in *The Portrait of the Artist as a Young Man*, he lets one of his characters say: "What do you mean, Lynch asked Surily, by prating about beauty and the imagination in this miserable godforsaken island? No wonder the artist retired within or behind his handiwork after having perpetrated this country."

The good thing, I think, about this comment is of course that it is a basic and very healthy acknowledgment of a certain unfortunate reality. Samuel Beckett simply says: "Night now, say it tree! Night night! By the side of the river waters of, this way and that way

"A roof over our heads"

96

waters of. Night! Place! It's turning cold....
But what number of things will make places
into persons?"

It might seem at first sight that Gropius and
the others are arguing in somewhat different
directions. That they might have been opposed
to one anothers philosophy and world view!
But the way I see it, they are *all* saying more
or less the same thing. They all acknowledge
the same problem!

Duchamp, for instance, is talking about how
we should not let the public interfere with
or try to change the inner vision and creative
potential of the individual artist. Gropius is talk-
ing about how we could possibly change for
the better the basic conditions on which public
society is initially concieved and consequen-
tially how the individual is initiated into it.
Duchamp is right when he says that art has
nothing to do with democracy. He also says
that the individual artist/artwork should con-
tain enough power and independence of being
to force the public to step up closer (to the
work/to the creative mind of the artist).

He never denies the importance of the public's
presence for the "art work" in general. He
says that the artist should never be put, or
put himself (or let himself be put) in the
position where it becomes necessary to beg
of the public's attention and recognition.
The amount of artistic independence to be
strived for, and the quantity of begging to be
done, depends to a very large extent on the
quality of the public. It is precisely the quality
of this public which Gropius would like to
inhance.

As artists we necessarily remain healthily pes-
simistic as to such an utopian (short term at
least) outlook. We have to deal (also) with the
present. The society in which we live is without
doubt based on the wishes of those who are
(more or less—as far as they know!) happy
with the way things are. The way they would
also like them more or less to remain. In the
words of Ulrich Beck: "My goal is marvellously
unthinkable—to conceive society anew!"
In that sense I would like to finish with a little
anecdote from Walter Gropius: "When Wright

"Caravan City"

came in, I was talking with my colleagues about teamwork in our profession. He sat down beside me, smiled and asked me to go on. When I had finished, he said, 'But Walter, if you wanted to have a child, you wouldn't ask your neighbor for help, would you?' I thought about that for a moment, and answered, 'If the neighbor happened to be a woman, maybe I would.'"

INDEX

Space Art Public

Space
"If human existence were purely material like that of a piece of wood or stone, it could be protected by a material form that enclosed it tightly, as a precious gem is kept in a padded box. But an animate existence that shows itself in spontaneous movement needs a shelter that leaves over enough space for moving about in. And movement is guided by senses, which also impose certain demands; lastly the intellect must freely direct towards their goal both the movement of the body and the working of the senses.

At each of these levels of our existence we come in contact with the spatial datum of nature. In addition to commanding the space we need for movement, we also form a clear image of it, and realize that a piece of natural space is involved in our existence. We call this our experience-space.

Our experience-space is necessarily in conflict with the space of nature. The space that nature offers us rises above the ground and is oriented entirely toward the earth's surface. The contrast between the mass of the earth below and the space of the air above, which meet at the surface of the earth, is the primary datum of this space. On account of their weight all material beings are drawn into this spatial order, and live as it were against the earth.

Through his intellect and his upright stance man can detach himself from this order and relate to himself the piece of space that he needs for action and movement. He is conscious of a horizontal orientation centered upon himself in the midst of the vertical orien-

tation centered upon the earth—of a space *around him* in the midst of the space *above the earth*.

Architecture is born of this original discrepancy between the two spaces—the horizontally oriented space of our experience and the vertically oriented space of nature; it begins when we add vertical walls to the horizontal surface of the earth.

Through architecture a piece of natural space is as it were set on its side so as to correspond to our experience-space. In this new space we live not so much against the earth as against the walls; our space lies not *upon* the earth but *between* walls.

This space brings a completion to natural space that allows it to be brought into relation with our experience-space; at the same time it allows our specifically human space to be assimilated into the homogeneous order of nature." Dom H. van der Laan

Art
"When someone would ask me what 'Art' is, then in that moment I do not know what it is. But when I am not being asked, then I know what it is." El Lissitzky

"Art is a laboratory of feelings." Robert Musil

"Art is a mirage." Marcel Duchamp

"Art, said Stephen, is the human disposition of sensible or intelligible matter for an aesthetic end.
We are right he said, and the others are wrong. To speak of these things and try slowly and humbly and constantly to express, to press out again, from the gross earth or what it brings forth, from sound and shape and colour which are the prison gates of our soul, an image of the beauty we have come to understand—that is art.
The personality of the artist, at first a cry or a mood and then a fluid and lambent narrative, finally refines itself out of existence,—impersonalises itself, so to speak. The aesthetic image in the dramatic form is life purified in and reprojected from the human imagination. The mystery of aesthetic, like that of material creation, is accomplished. The artist, like the god of creation, remains within or behind or beyond or above his handiwork, invisible, refined out of existence, indifferent, paring his fingernails." James Joyce

"And if the office of Rua dos Douradores embodies life for me, then the second floor where I live in the same Rua dos Douradores embodies art for me. Indeed, art that lives in the same street as life, yet in different place—art like life." Fernando Pessoa

The public
"Nowadays, the world belongs only to the fools, the coarse, and the busy. Today, one acquires the right to live and triumph through practically the same procedure in which one is committed to a lunatic asylum: an inability to think, immorality, and overagitation. Others have extroversively given themselves up to the cult of confusion and noise and believed they have lived—whereas they have only listened to themselves and imagined that they have loved whenever they acted out the superficialities of love. Life hurt us, because we knew that we were alive; death did not frighten us, because we had lost the normal idea of death." Fernando Pessoa

Art—Architecture—City—Politics
A Conversation with Jerôme Sans
DANIEL BUREN

JERÔME SANS (JS): Your special relationship with architecture led you to realize a number of permanent installations in public space beginning in the mid-1980s. What are your views about public space and public commissions?
DANIEL BUREN (DB): It wasn't my relationship with architecture that got me started doing permanent installations in public space in the mid-1980s but the emplacement of a political system that placed a higher value on public commissions. A number of artists were invited to propose such works for public space and then to realize them. The public commission is present even in my earliest works: In 1960, I installed my artistic "weapons" in a hotel complex in the Caribbean. My first significant works were later realized, in 1967, right on the streets, in the city. Human relationships in urban space have always interested me more than architecture proper or the architectural object. How do these relationships unfold? What kind of places attract them, and what places exclude them? How do these places affect the people who use them? When you examine these relationships, you begin to recognize general lines, patterns of behavior, extremely significant deviations—significant for individuals and occasionally significant for a culture in its relationship to another ... The conviviality of Italian squares, for example, be they large or small, is not attributable solely to the fact the Italians love getting together

to discuss things or to exchange the latest day's news. What generally characterizes these squares is that nearly all of them tend to be concave. In other words, they almost literally pull people into their centers. People just want to settle into them. An example of the reverse is the general tendency of French squares to be convex. Accordingly, they push the public toward the periphery, toward the outside. French squares are squares people admire from outside, magnificent objects that expose themselves to view. But they are objects that do not invite and which no one explores. People do not go there to talk. One might carry on a conversation on the periphery. I dealt with the court of honor at the Palais-Royal—a series of polygons that offset the curvature of the court—in such a way that its convex effect was counteracted and reversed. This was necessary in order to provide for rainwater drainage and because of the underground filling. The ceiling of the rehearsal room of the Comédie française is somewhat higher than the sidewalks outside. I reversed this effect, so that the position of the polygons physically stimulated the public to move about in their midst rather than forcing people toward the outside, as objects or sculptures generally tend to do. From the outset, public space represented a place of exchange par excellence, one which really poses problems today. Can art still exist there? Can it create

Daniel Buren, Photo-souvenir *Sens dessus-dessous* (Topsy-Turvy), sculpture in situ and in movement (detail), 1994, Parc des Célestins, Lyon

Daniel Buren, Photo-souvenir *Déplacement-Jaillissement: D'une fontaine aux autres* (Shifting-Shooting: From One Fountain to the Others), work in situ (detail), 1994, Place des Terraux, Lyon, in cooperation with the architect Christian Drevet

itself and develop there? Or is the museum ultimately the only place for it and thus its grave? The only way to find an answer to these questions is to study all the alternatives to the museum. We must put the museum back in its place, and we must certainly emphasize its specific and irreplaceable aspects, aspects which are quite distant from those which, as is still the case today, make works of art un-equivocal. I think that public space, except for that of the museum, which is surely a specific but also public space, is a privileged place for explorations, for actions, and wherever pos-sible today, for realizations.

So public space has always played a part in my field of research. The public commission came as something extra. The public commis-sion gives one an opportunity to create a work that has some chance of being seen for sev-eral years. The public commission exposes a whole series of constraints. It opens up and limits the field of action at the same time. The whole ensemble of these new boundaries, constraints and possibilities opens the way to reflection about art in the city, art in urban space, art presented to a broad public. On the other hand, these questions lead to other questions about art in general and about art in its museum context as well.

JS *Isn't there a great deal of misunder-standing between art and public space?*

DB It is a fact that the majority of works in public space are mediocre, if not actually bad. Yet to deduce from this that the coexistence of the two is the cause of this problem would seem a little hasty. The misunderstanding—if one chooses to call it that—is the belief that art must restrict itself in public space to the so-called one percent, that is, to the typical expression of the "magnificently bad idea." This kind of public art, which has been spread-ing, has made the public mistrustful; and one cannot fault the public for that. The other mis-understanding is rooted in the belief that art in public space serves, through clever "artful camouflage," to enhance the value of what is bad, unattractive, and indestructible at a given location. In fashion for a time was the camou-flage technique involving the use of concealing walls, which no one quite knew what to think about. The practitioners of this kind of art presented their *trompe-l'oeil*, their optical illusions, their gigantic paintings. These kinds of interventions, regardless of their outcome, lead nowhere. They are a prototype of realiza-tion that is unworthy of public space, of non-reflection. Truly taking public space seriously in order to realize a permanent or temporary work there is another matter entirely. It does not involve stopping up holes or filling empty spaces at the request of some client.

JS *After the Palais-Royal, you realized two other public works in France, in Lyon. Could it be that you are becoming a specialist for public commissions?*

DB If I am a specialist after carrying out less than ten public commissions, what might I be called after more than one hundred and fifty solo exhibitions at museums and nearly four hundred and fifty in galleries—not to mention the other five hundred various group exhibi-tions? I am neither a specialist in exhibitions in galleries and museums nor in public com-missions. One should take a closer look at the term "public commission," because it in-volves a variety of possible contradictions. The expression, which was borrowed from ter-minology that was commonly accepted until the nineteenth century,[1] doesn't have the same meaning it once had. A person who commissioned something back then described the object he wanted to have realized in rather

precise detail. In an equestrian statue that was supposed to represent a certain general, one couldn't portray the figure without his horse or only as a bust, and vice-versa. It was impossible for competitors to break the rules of the competition without risking de facto exclusion. Although public commissions of this kind are still awarded, most of them do not specify anything precisely. They indicate a particular location in the city, for example, and announce a competition for the purpose of having it redesigned. Specifications are usually technical and rarely aesthetic. The theme of a work, if there is one, is chosen by the artist. Thus the form of the object created in the process is entirely unknown in advance. For those involved in the decision, the final version, even in a competition, is a total-risk proposition. In most cases, public commissions are awarded by political bodies. In our democratic societies, these are often assemblies comprising dozens of people, which doesn't make the selection process any easier and often renders it impossible to make clear decisions when they need to be made. A person with executive authority (the mayor, the president, the minister …) can refuse to exercise that power for fear of assuming a responsibility that, should things take a turn for the worse, could cost him votes in the next election. The risk is increased by the fact that such responsibility is assumed for something that is never regarded as vital.

Thus artists no longer respond to commissions in the sense of "commands" or "commandments." And this irritates the "purists," who have failed to notice that the word has taken on a different meaning, even today. Let me return to the example of the court of honor at the Palais-Royal. No one from the ministry or anywhere else ever gave me a commission to realize a work that would cover three thousand meters of space in the courtyard. I really think the politicians expected an object, perhaps a fountain, set in the middle of the square. That would have corresponded more closely to tradition and the idea one might have of it today. My proposal was totally different, and to my great surprise, it was accepted. The people who asked artists to do a project for the court of honor at the Palais-Royal never specified at any time that the courtyard should be completely transformed or used either partially or entirely. Thus it was the realization of the prize-winning project that determined the final appearance of this site. It was not the product of a resolution by the authorities who commissioned it. Their role was to select a prize-winner from all of the projects presented and then to give the recipient the opportunity to realize his project. It is evident to me that this approach to the realization of a selected project is the only one that can produce a satisfactory result.

JS Les Deux Plateaux *in the courtyard of the Palais-Royal and* Déplacement-Jaillissement: D'une fontaine aux autres *on the Place des Terreaux in Lyon would appear to share the same underlying intent: to call attention to a place (a historical site or a seat of power) by offering two different views, one during the day, the other at night.*

DB There are certainly some similarities, but I think the differences are even more important. Of course they relate to the specific character of the two locations. The Palais-Royal is a kind of homogeneous, clearly defined "jewelry box," which—although it is a public place—is extremely well protected against the polluting activity of the city, primarily the traffic and the noise. The Place des Terreaux represents practically the exact opposite within the

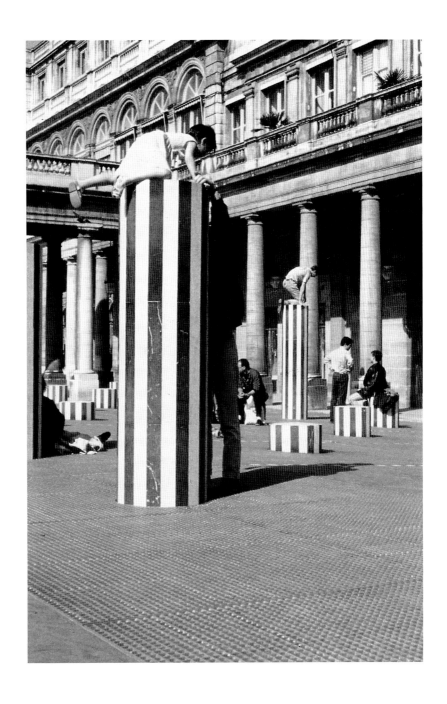

Daniel Buren, Photo-souvenir *Les Deux Plateaux* (Two Levels), sculpture in situ (detail), 1985–86,
Cour d'honneur du Palais-Royal, Paris

city. Although centrally located, it is a completely heterogeneous, open, and uncontrollable place that is fully immersed in the city, with its pollution, its noise, and the ceaseless ballet of bus and automobile traffic. Creating a work from all of these ingredients requires that one move quite far from the museum setting, and it leads us directly to the central theme. And that explains why the architect, Christian Drevet, and I wanted to control the visual impact of the ensemble down to the smallest—a priori banal yet all the more significant—details, such as traffic lights, pedestrian crossings, and other signal elements and aspects of mobility in the city. The entire system of obligatory signals was completely redesigned. One might even say disciplined, as compared to the rest of the construction, which covers an area of several ten thousands of square meters. Immersion into the city is much more apparent at the Place des Terreaux than in the courtyard of the Palais-Royal, and this difference makes things possible on the one side that are impossible on the other, and vice-versa. At a formal level, there are similarities, such as the pattern of the floor—a square grid in each case—or the use of black asphalt, which I have a particular liking for. Other similarities are evident in the intentions. You can see these in the visual appearance of the ensemble during the day, which is transfigured at night through the use of lighting. Before one begins to see clearly, certain aspects of the place that are not visible during the day are emphasized, underscored, and imbued with color by the nighttime illumination.

JS Aren't you afraid that these installations force too far into the realm of the spectacular?
DB If there is a specific fear I do not have, it's that! My work does not consist of positioning an object somewhere but in unveiling a place,

questioning it, repositioning it. If something spectacular emerges, then it was already there before I intervened. It was already a part of the spirit of the place. One may, if necessary, either tone it down it or follow its lead. For the most part, our work at the Place des Terreaux involved cleaning up the site, simplifying it, drawing a few lines, giving "speech" to the place, in the process of which we imposed ourselves as little as possible, to the point of leaving the entire surface area empty. The most difficult task was to convince the technical service providers and other strategic users of the site not to erect posts, employ ledges or projections, or add any signs or other objects of public utility such as shelters, benches, trash bins, lamps, and other "charming ornaments" of the kind that in most cases systematically destroy the most beautiful places (streets, historical sites, splendid monuments) with alacrity, impunity, and a complete lack of shame.

Since the Place des Terreaux is already heavily burdened with history and monuments, the goal of the work was precisely to avoid adding any sign that could possibly give greater emphasis to the self-sufficient spectacularity that is already there. The *Parcauto des Célestins*, an underground garage I realized at the same time in Lyon, one recognizes a certain tendency toward the spectacular which developed from the situation of this underground site, generally one of the shabbiest spots in any city. Considerable effort has been invested in this area in Lyon within the framework of a global policy. The number of parking garages in downtown Lyon has increased, with eight new facilities added in rapid succession. Those involved in this project included architects, designers, and artists. Once the epitome of the kind of unpopular place one goes

to only out of necessity or when it cannot be avoided, these parking garages have now become public attractions!

In order to "give life" to my project, a colossal, immobile underground mass of rough concrete, and, if possible, to make it "vibrate," to realize it, I presented it from different angles and in different positions: from above, from the side, from below, on its right side and left-right-reversed, from inside and even from the outside, under the open sky, with the aid of a periscope developed especially for the purpose.

The spectacular aspect involved here was to have attracted attention to a place that ordinarily repels it and to have transformed it into a seven-story underground sculpture in the midst of the city. So the spectacular doesn't frighten me, even though I am somewhat distrustful of it, since it is neither a tendency nor a goal in my work. When a site requires it, as the case seems to have been here, a certain sense of the "spectacular" may enter the picture. But the spectacular for the sake of spectacle is folly. If I become aware that a work runs the risk of succumbing to that, I immediately begin to question it. In general, I think it is important to reach some kind of an agreement about what we mean by "spectacular." What does it mean to you, and what does it mean to me? Is a successful, beautiful, well-placed work that expresses precisely what it intends to express spectacular, because it is right? Is a unique work—due to of its beauty, its inventiveness, its audacity or any other quality—spectacular because only the person who realizes it was capable of achieving that quality? If so, then both Michelangelo and van de Velde are spec-

Daniel Buren, Photo-souvenir *Les Deux Plateaux* (Two Levels), sculpture in situ (detail), 1985–86, Cour d'honneur du Palais-Royal, Paris

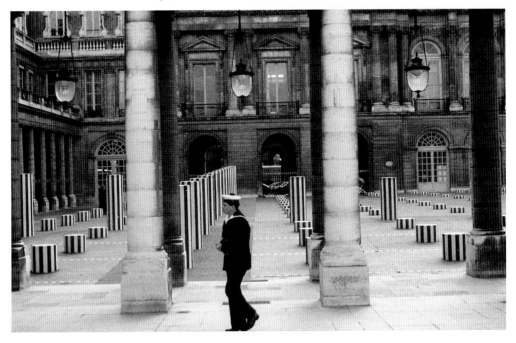

tacular? In this sense, every work of art worthy of being called a work of art is spectacular! Victor Hugo's and Samuel Beckett's ...

JS *What is your relationship to monuments?*

DB There are monuments in architecture and in art that impress me, although building monuments is not one of my concerns. By definition, the purpose of the monument and the monumental is to impose and above all to impress. They naturally approach the notion of the spectacular, reinforcing it to the extent that the spectacular is ephemeral, whereas the monument and the monumental must be lasting. This will to impose, this striving for a tour de force, are not part of the spirit of my work. If I detect a tour de force in my work, I try to eradicate it. If I fail to eliminate it, the work itself cannot be a success. I have always been suspicious of tenacious effort that leaves traces of itself behind. And I know of no art, no great art, that smells of sweat. One of the principal effects of the process of camouflaging the labor invested in the final version of a work is that the sense of the spectacular and the monumental disappears, along with the sense of performance. Generally speaking, a finished work, be it mediocre or wonderful, tells very little about the work process that has engendered it, no matter whether it was inspired, simple and rapid or laborious, ponderous, and hesitant. These adjectives, by the way, give no indication of whether the product is a masterpiece or garbage! A finished work normally does not reveal the sum total of all of the work it took to realize it. The spectacular, however, resides precisely in an exhaustive description of the effort in question. One speaks of the number of hours, weeks, or even years required either to realize the work or in waiting until someone showed an interest in it. And then people go

on to count the number of nails that had to be pounded, the kilometers of fabric that had to be stretched, the astronomical price that had to be paid for everything, the number of assistants, the hundreds of thousands of kilometers that had to be traveled, the thousands of letters that had to be written, the tons of concrete that had to be mixed. We find ourselves in the midst of a large number of imposing artists who take recourse to such devices in order to describe their monumental works. Are they afraid they might not be quite so important? Or perhaps even completely insignificant? At any rate, this method does have a certain advantage, in that it attracts the interest of the media, which can only exist in this way themselves and which have finally found a material they can comprehend in the art of this register.

JS *You have used the word punctuation with reference to your work in public space. Couldn't one apply this title generically to the majority of your works?*

DB Yes, but there are quite a few that could provide the same "service!" When I find a title, it usually happens through a kind of osmosis with the work that has inspired it. I hit upon [the title] *Punctuation* while I was working on a comprehensive survey of all of the public statues in the city of Lyon and their geographic locations in 1979–80. I covered the base of the pedestal of each statue with an adhesive, red-and-white-striped material. Affixed in exactly the same way to each statue, this material described the perimeter of every statue in the city. But it also identified another aspect that is generally given less consideration: the pedestal. In addition, each of these sculptures, statues, fountains, etc., "punctuated" the city in a very clear manner, either through the selection of the respective site or the inter-

pretation or the conclusions one could draw from these "punctuation marks." Above all, this work enabled me to point out that some districts had a great many statues, while others were totally deprived of them. By coincidence, the districts full of statues were the rich ones; the poor areas had not a single statue to show.

Thus *punctuation* was a judicious chose of word that covered as much as possible of what had emerged in the course of this demonstration. The term could have been used as a title for a number of other works as well. But I have never used it since.

1 Translator's note: The artist refers here to the word *commande*, French for "commission." Some of the following remarks are understandable only with reference to the French.

The Patron, or The Fear of Lonely Decisions

KATHARINA HEGEWISCH

The patron has traditionally been the stuff of legend. Numerous spiritual and worldly leaders, popes, ecclesiastical potentates, aristocrats, and entrepreneurs have been guaranteed a place in history for their part in the making of great works of art—a place that they might never have attained by virtue of their other achievements alone, their learning, or even their integrity as people. The patron initiates and facilitates. As the one who issues the commission, the patron is touched with the aura of a co-creator, astutely removing obstacles and determinedly fighting for artistic quality. The fact that the truth often looks rather different is neither here nor there. The history of art is also a history of rejected commissions, pictures not paid for, broken promises. The suffering inflicted on the artist by the party controlling the purse-strings is legendary. Nevertheless, many of the most important works of the past were made as commissions— proof of artists' skill in bending conditions and turning them to advantage in their work.

The renown of the patron depends not on their munificence, but on their courage to put an important task in the hands of a particular creative person. As little as the ethical and moral qualities of the artist can be regarded as meaningful criteria when it comes to judging their work, the character and the motives of the patron are equally irrelevant in any assessment of their achievement. Which popes, which French kings, and which present-day captains of industry ever surrounded or surround themselves with works of art for purely altruistic reasons? The patron's wish to impress others, their desire for reflected glory, or to benefit from what is now known as "image transfer," do not lessen the stature of the work that they have commissioned—always provided that the integrity of the work is not impaired.

Art knows many different patrons. The church, the nobility, and political leaders dominated the field in the past. Today the state and the leading insurance companies, banks and industrial enterprises have stepped into their shoes. Yet the relationship between artists and patrons has barely changed as a result. The two sides are linked by a contract of mutuality. One is given work, financial reward, and an opportunity to spread his/her artistic wings; the other receives a status symbol in return, which is free of negative connotations because it is artistic in its origins. It's a straight quid pro quo—that's the rule in this game. Anyone who accepts a commission also has to accept the rules. Anything else would be naive. The fact that the visual arts have become largely autonomous has changed nothing in this relationship. Of course it has become easier—thanks to worldwide distribution systems—to withdraw entirely from any dealings with patrons. But anyone who enters into such dealings and lets themselves in for the ensuing demands should be aware that s/he is going to be used in some way or other.

"An edifice of ideas is being built here."

According to the strikingly similar wish lists drawn up by the patrons, artists are then expected, amongst other things, to provide beauty, creativity, and visionary expressivity where it is felt to be missing; to introduce tolerance, openness, and an appreciation of innovation into situations which seem to be lacking in these attitudes; they are expected to spark off discussions, to break open encrusted structures, to facilitate interaction, to create a more amiable political ambience, to make a statement about the commissioning institution, and, last but not least, to raise its profile above that of its business rivals.

So far, so simple. Few enterprises make a secret of what they expect from the art in terms of the public's perception and the motivation of its employees. In that sense they are good patrons. Few artists want to admit that they are being used as tools for a particular purpose—in that sense they are bad artists. For—or at least, so one might think—if they had their eyes open when they accepted the commission, then they could make sure that their proposal already had in-built measures to prevent it being used in this manner.

But the situation is more complex than it may at first appear. In order to meet a challenge, one first has to know what it is. In the past the patron was a human being and a partner who could be identified by their social standing, origins, mode of dress, behavior, ambitions, and convictions. By specifying a location and stipulating a theme, by describing the statement the work was to make with which compositional devices or which colors, the patron further revealed him or herself. But most of the parties commissioning contemporary art have lost this recognizability. Now decisions are no longer taken by individuals but by committees—consisting of experts, board members, art advisors, and building sub-committees. With all the members having an equal vote, the committees send out very mixed signals. Why this or that artist is commissioned to make a piece for this or that location is generally shrouded in mystery. Behind closed doors examples of artists' work are assessed, behind closed doors preferences and misgivings are voiced, behind closed doors competition remits are agreed. Amongst private business clients there is scarcely if ever any attempt to talk directly with the artist. Uncertain as to how a dialogue of this kind might be conducted and anxious about its possible consequences, those responsible squander the opportunity to measure their own perception of their company against that of an outsider which might have meant that the art/the artist could in reality initiate new thought processes.

But what the patron expects on paper from the art being commissioned is not that crucial to the artist—see above. For these expectations are so stereotypical as meaningless. Government spokespeople, cultural advisors, and press officers in major firms alike: they all use the same virtually identical clichés in their statements. What is crucial is who the patron actually is. In German-speaking lands the relevant passages in company reports and publicity brochures are always headed with the catchy phrase "Wir über uns"—something like "How We See Ourselves." But these same passages say very little. For even this "We" is a construct made up of a whole number of different views, an articulation of what is frequently an as yet non-existent self-image which is publicized in the hope that it will turn out to be a self-fulfilling prophecy.

The reasons given for the unwillingness on the part of the patron to enter into discussions

are lack of time, questions of authority, and the responsibility of the decision-makers. In truth, however, scarcely anyone in management is prepared to take individual responsibility for a work of art, in other words, to relinquish the security of a collective decision. Like politicians in government, the office-bearers in many firms are only elected for a certain time. As employees within a larger framework and with a duty to maintain the company's "shareholder value," they are extremely reluctant to lay their own opinion on the line—moreover the real criteria for judging contemporary art are not and cannot be objective. No-one is keen to be accused of behaving like a Baroque prince, particularly since contemporary art is such a thorny issue and there is a widespread anxiety that becoming too closely involved could easily lead to an own-goal.

Majority decisions, on the other hand, are above attack because of the legitimacy they enjoy by virtue of being democratic. Company art committees often have as many as ten members with voting rights. And the contract is of course only issued once the heads of finance, public relations, personnel, and buildings and estates are satisfied with the conditions, and the architect and the outside consultants have approved the plans. The considerations that are taken into account in these decisions are rarely made public. It is still regarded as bad form to tell an artist to his/her face that their proposal was accepted because it was the cheapest and would provoke the least controversy. So the patron remains anonymous, replaced by administrators without decision-making powers, who obediently hasten to prevent any closer scrutiny of the parameters once they have been decided. The administrators' overriding aim is that there should be no hitches in the process. They take pride in keeping costs within the agreed budget, they strive to ensure that the artist will take responsibility for any of the risks that could be hidden in a work of art. Instead of standing by as equal partners and working with the artists to find the best way for them to realize their vision of the work without having to sacrifice too much to comply with the user's requirements, planning regulations and security procedures, the administrators are above all concerned to comply with the rules they normally have to observe. Signage for escape routes and showing what floor one is on, fire extinguishers, fire alarms, electric sockets, light switches, security cameras, time-keeping clocks, and user-friendly surfaces all take priority over the work of art. This naturally makes the artist's task immeasurably harder. Test-tube requirements all too often result in test-tube art, which specifically does not do what the patrons supposedly want, namely that it should assist in a reassessment of entrenched modes of perception. In public and semi-public spaces art is registered more casually than in a museum. Any viewers who chance by are generally unprepared, and it is fair to assume a relatively low level of relevant background knowledge, interest or curiosity. As a component in the more or less familiar surroundings of a person's place of employment, the art is simply a backdrop, a setting for everyday tasks. As a rule it has to reckon with viewers who will encounter it day after day for an extended period—in different moods, with different levels of expectation, and at different times of day and year. The intentions behind context-led artworks become apparent less through conscious examination than in one's daily experience of them combined with the function of the site that they occupy. Many forces affect their

perception. So-called "soft factors" like
the tone of the company, work processes,
management style, personnel structures, and
the company's mission all influence people's
judgment of the work as do light conditions
and the proportions of the space. The work of
art and its surroundings—both material and
immaterial—interact with each other. For the
viewer they create a whole whose individual
components may be hard to identify or to
separate but which cannot be denied. If the
artist has to ignore some of these components
simply because s/he is not given the chance
to find out more about them through discus-
sions with the patron, then it is hardly likely
that s/he will manage to integrate the work
into its intended surroundings. In the context
of private business enterprises an artwork
can only ever hope to become more than pure
decoration if it manages to home in on the
interface between the patron's self-image and
a more critical view of that image. This needs
not just brave artists but also brave patrons.
Art needs its advocates. How is people's
delight in engaging with art ever to be kindled
if no one identifies with it? Only on those rare
occasions when individuals openly support
their company's interest in contemporary art,
can this interest bear fruit. Artist and viewer
meet in the artwork. Individuals encounter
each other. Or at least that's how it ought
to be.

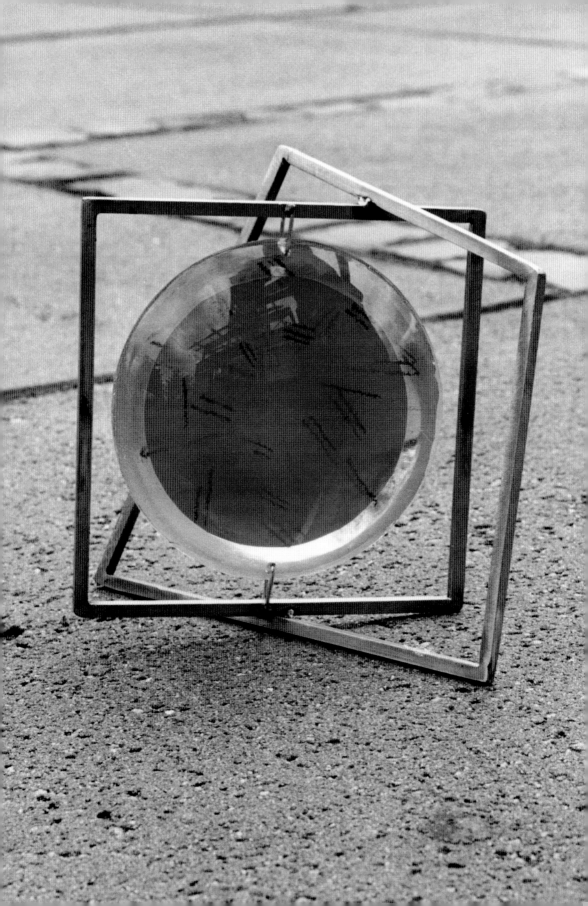

"Let's meet by the artwork in front of the LZB"
A Public Art Project
DOROTHEE GOLZ

From: Dorothee Golz
Sent: January 27, 2001 18:32
To: Siebers, Johan
Subject: Valuable Object

Dear Johan,

The removal of the second half of the lens
from the form went well! Bogumil told me
about the complications after the fact, so I've
slept well the past few nights. More of a mas-
ter wizard practiced in alchemy than chemist,
he probably is the best qualified to take my
impossible idea and make it reality. A form
made of almost one thousand liters of trans-
parent acrylic resin! The stuff has a lot of
inconvenient characteristics, which I fortu-
nately did not know about at the start. All
of the manufacturers of transparent resin think
that it's impossible to cast an object made
of this much resin. However, we wouldn't
allow ourselves to be frightened out of it.
You should check out the intermediary results
of the experimental phase, which has lasted
for months. Interesting, baffling, most of all,
totally useless. In November—a month after
we ought to have been officially finished—
finally, the all clear. Bogumil: "Now I know how
it works." The experimentation was worth it:
the end result is exactly what I'd imagined.
No compromises necessary. Am so relieved.
You absolutely have to keep your fingers
crossed for us when we put the two halves
together. Then it'll be exciting again!
Best regards!
Dorothee

From: Siebers, Johan
Date: January 28, 2001 9:49
To: Dorothee Golz
Subject: Valuable Object

Dear Dorothee,

I just read your email; I am now in my London
hotel, after having been stuck at the airport for
12 hours because of fog. I took off in Houston
over 30 hours ago—man, I need a bath! Any-
way, congratulations on the lens. Two halves
make a whole, but not without some further
interference. I guess that is the point where
the alchemy becomes complete. The acid
test of the idea is its materialization, as al-
ways. But I am sure that will succeed as well.
I've always liked lenses (wearing glasses
since I was a little kid, and of course, all Dutch
philosophers must feel a bond with the image
of the lens—Spinoza made lenses when that
was a high-tech industry. The lens puts into
focus. What's the end product going to look
like?
Do write soon!
Johan

Dorothee Golz, *Wertobjekt* (Valuable Object), model on a scale of 1:10

Interviews

"We asked acrylic resin manufacturers in Germany, the USA, England, and France. Nobody wanted to try it. Nobody had any experience with something like this. And if you don't later build a great number, then the experiments don't pay off. Since everyone begged off, that was the catalyst that got me to try it. I told myself that somehow, there had to be a solution. I was sure of it. After all, the artists don't usually consider if what they have in mind can be realized. But that, in turn, is also the interesting thing. That's the way one discovers new possibilities." *Wilfried Bogumil,* Plastics Expert

"I think the building is great, from the outside. It needs something with an arch, with curves, and so on. I don't really like forms with corners and sharp edges. After all, the glass front is also round. 'Public art' has to fit the building. If it doesn't fit and it wasn't at all necessary, then it's not 'public art' for me."
Ursula Schmitz, Customer Accounts

"Art shouldn't be just for a small circle of the initiated, but also for the masses. Because ultimately, the money for these artworks comes from the masses. Art always needs a forum, and I think that sometimes a public building, such as this bank, is an appropriate place." *Ralf Völkermann,* Computer Department

"The art work should be pleasing. We have space in front of the building. I would say trees alone do not fill up the space. So something like that fits in here. It can also be a meeting place, an artwork like that! Let's meet there and there, not by the streetlight, not by the clock. Let's meet by the artwork in front of the LZB. If my wife asks me then, 'Where should I wait for you, in the parking garage?' 'No, by the artwork...'" *Alfred Wegener,* Currency Department

"The art object should have something to do with the bank. ... But the artwork doesn't necessarily have to have something to do with the bank's function—I just have to be able to walk up to it and say, 'beyuuuutiful!'"
Ursula Palsbröker, Credit Department/
Cashiers' Bureau

"Public art not only ought to be beautiful, but ought to have something to say to me. Not so that I just stand there and say: that is beautiful! ... In any case, I would put the artwork outside, so more people can see it. After all, it's not just for the people who work there, but also for everyone. It would be best if it were the kind of sculpture in which you would see something else after thinking about it for a short while ... Artworks can really shake you up, force you to think."
Bärbel Sanders, Janitorial Service

Dear Johan,

Thanks for your e-mail. Hope you were able to get some sleep. You use the English expression "acid test." Is it true that an idea can dissolve through the process of materializing it—that materialization tests the quality of an idea? It's always hard to turn what one has in one's head into a material, tangible, object for all the world to see. When I'm asked to make an object for a building—that is, for an institution or a company, as is the case for a project for a construction site, then the idea takes precedence over the aesthetic. Only after I've formed the intellectual idea, do I consider the appropriate sculptural form. This is then the intermediary between the idea and the people who go in and out of the building, or the passersby. This is what I use to draw their attention to my idea for a while. For the project for the LZB in Minden, I focus the glance on the lens. My idea is contained in this lens. It becomes visible in the statements of the bank employees, which have been cast as part of the object. As you know, I asked all of the employees to spontaneously write down a sentence using the term "value" and a personal pronoun.

Have a good weekend. Still have to go to a birthday party today.

Talk to you soon!

Regards, Dorothee

Dear Dorothee,

An assignment. A public assignment. To whom do you sign up when you accept the invitation to make an object for a public—more or less public—space? Who, or what, is chosen? And what are the consequences for what you are doing of that depersonalized tendering? There is an anonymity in it, which fits with the times. Art has always been under signs and has always had assignments—tribal, religious, political, mercantile, or even the assignment of everyday life, the genius, or "the beautiful soul." Lastly, the signature of the individual artist, marking yet another assignment, another obligation. And an assignment expects a result and a reward. Even the beautiful soul, even love, has an element of "quid pro quo" in it—it seems. So, in this way, too, the object relates to value and the valuable. Like your words on the relation between the public artwork and the things and events that go on in the building it is a part of. The object itself takes on a role shaping those events; it meddles, it interferes, it becomes an interactive object: the lens expresses this for your planned work; it focuses on value and makes the values of those in the building, those to whom it relates and who relate to it, visible. It is even co-produced by the employees, making it private, in a way, as well as public. It allows for private moments of reflection, on value, on the purpose and meaning of being present in that building. But what is value? The word is often misused, unable to fight back—not in the least in the economic sphere. Value is that which cannot be manipulated or commodified. In the end, value gives meaning, and

Employees of the Landeszentralbank Minden at the interview

"That the artist creates something that creates opposition, that invites the observer to take a position on the work—I don't think that is as important. A message? Well, if a message has to be given, then this one: just look over here—isn't that amazing!" *Palsbröker*

"Public art shouldn't be too abstract, so that it only speaks to a few." *Völkermann*

"The message that public art should convey? Ethics!" *Wegener*

"Art is there for the spirit and the intellect, not to be used." *Völkermann*

"The idea speaks for the artist. The deed speaks for the architect." *Palsbröker*

"Art is always an intermediary, a transporter of opinion. The architect is there to make something that one can use. The kind of artwork that we will have in front of our building

has no function in this sense. Art is there for the spirit and intellect, not to be used. That's why only an artist can make public art. If I could, or had to find someone, I would be careful to make sure of the thoughts that the artist has about the building, about the function of the building—why was this building built, for which institution, for which company—in order to find a statement that is connected to the building—a statement that will make a connection for the observer, in an artistic as well as an intellectual way." *Völkermann*

"Yes, I thought it was good that we, the employees of the bank, were included in the artwork. And I also thought it was good that we were told: everyone can participate, but if you don't want to, you don't have to. That it was the same for everyone ... 'Without trust, every friendship is worthless.' That's what I wrote. At first I thought, 'uh oh, if that's inscribed and people see what you've written ...' But after considering it, I decided it was okay. After all, those are my thoughts." *Sanders*

120

value is non-negotiable, marking the boundaries of what can be negotiated. Values change and develop in interaction, not transaction. But, everything of value is defenseless, unable to resist those who try anyway. Value's acid test for us is whether we can let value be the vulnerability it is, the vulnerability it requires of us. So, ultimately, there is no value in the "quid pro quo" of the transaction, of the payback. What do you think: could one have delivered sufficiently if this is the statement produced under assignment? How to escape the transactional and let your work really be the interactive object that would make it public art?

vriendelijke groet, Johan

From: Dorothee Golz
Sent: February 3, 2001 8:12
To: Siebers, Johan
Subject: Valuable Object

Dear Johan,
When I was asked to submit a proposal for an artwork for the area in front of the LZB, I went about it rather pragmatically. I based my thoughts on the functional, architectural, and intellectual contexts. As an artist, I can deliver something more than just the esthetic form— a plus. This plus consists of the formulation of a statement, a reflexive content. I voluntarily offer this plus, because I believe that this is something the person or institution commissioning the work usually does not expect. Most are satisfied when the artist chiefly or even exclusively concerns him/ herself with esthetic points, making an optically attractive design. The unexpected plus, which the artist voluntarily includes, is, however, thoroughly welcome; the client sees it as a positive aspect. I think that I provide an interactive aspect catering to one of the basic human needs, which is to give expression to the individual and to leave a mark on this place where they work, where they spend so much of their lives. These peoples' statements, many of which are very personal, are presented outdoors in a form with which they feel comfortable. The sentences are protected in hardened acrylic resin. In a certain way, I have carefully packed them as if they were indeed something very valuable. They have their Sunday clothes on, so to speak. And one doesn't get them dirty. When one dresses up, one shows an idea of respect for oneself or also for others. Respect means to value something. All of the sentences are unselected, equal, legible parts of the sculpture. To me, all of the statements are of equal worth. They happen to express what people either thought or felt in the moment when I asked them to spontaneously write down a sentence using the word "value." And speaking of your phrase "value is non-negotiable": You're right, when someone else thinks something is valuable, that's non-negotiable. A value can't be turned into a product. It exists. It creates meaning, I agree with you about that, too. Interaction is the only thing that shifts individual positions, and only through interaction can values be formed. The interactive aspect in my sculpture, however, will certainly not result in a shifting of individual positions. It should only move one to think, causing only a thoughtful interaction between "writers" and "readers." In the context of this commission, this is how I happened to overcome the transactional, and have given the client something that he had not asked for at all. Namely, this "plus," with which he had not reckoned when he made his offer. Here, there is no "quid pro quo." Art— including public art—if it is to remain art, does

"That everyone can see it—that doesn't bother me. Anyone can look at it. My sentence was completely spontaneous: 'every human being is equal.'" *Palsbröker*

"No, my sentence wasn't spontaneous. I really had to think about it. But I think it not only makes sense, but it's important to include the employees. Everyone here has to constantly go in and out, so everyone ought to feel comfortable. And that adds to it." *Wegener*

"When one goes into the bank in the morning, one sees the statement—that creates a connection. I also contributed something, one says to oneself." *Palsbröker*

"I was very surprised when we were asked to contribute a personal statement using the term 'value.' That also made me very happy—that we were, for once, asked about a topic that connected the art with the bank. I'd reckoned with the usual thing: a fountain or a sculpture. I think it's fundamentally good when we're included in the decision-making processes, since everything that is dictated to us from above is felt to be negative." *Völkermann*

"I think we can set standards for others— others can do something like this, too." *Wegener*

"At first, I was shocked, 'you're writing something here that is going to be read by everyone, that will be connected with you.' That made me go through a certain process. At first, I had uncomfortable thoughts—that it would be public; above all, that it would still be there years afterward, perhaps when one is already dead. But then, why not ... It is indeed art, but I've been involved in it, too." *Völkermann*

Thomas Broyer conducted the conversations with the employees of the *Landeszentralbank* in Minden in January 2001

not function according to commercial princi-
ples. Its basis is interaction, not transaction.
Now I've written more than I wanted to. How-
ever, this isn't a spontaneous conversation,
but a written correspondence.
Many regards!
Dorothee

From: Siebers, Johan
Date: February 5, 2001 8:51
To: Dorothee Golz
Subject: Valuable Object

Dear Dorothee,
Unfortunately, I couldn't answer yesterday. The
airplane from London didn't want to start yes-
terday evening. We all had to get out and wait
until another one was ready. I didn't get home
until midnight. Long live the mobile society!
My reaction: Quite. That is about what I meant
to say. I like the reference to the Sunday
dress, wrapping the statements up as a tribute
to their worth. Enough about the content—
although one could go on asking questions,
changing the meaning and the implications in-
definitely—and back to the form: can you tell
me some more about the shape of the thing—
the proportions, the size, the structure that
supports the lens, and why you choose these
the way you did?
Looking forward to your reply.
Cheers, Johan

From: Dorothee Golz
Sent: February 7, 2001 11:32
To: Siebers, Johan
Subject: Valuable Object

Dear Johan,
One should always try to take the airplane
Johan Siebers is not on. You don't seem to
have any luck with airplanes. I hope that the
last couple of days were quieter for you.
About our topic: The center of the object is
a large, transparent lens, about two meters
in circumference. It is mounted in two steel
frames, which are placed inside each other.
Here, the plate and the square are modeled
after the formal plan of the building. It was not
I, but the architect, who had referred to the
building's functional theme: coins and bills.
His action, in turn, offered me a basis for my
thoughts on the formal design. The lens is
biconvex and its center is 60 cm thick. The
writing containing the employee's statements
is distributed over several vertical levels, so
that it looks as if it is swimming in the mass
of acrylic resin. The lens is colored. Seen from
the front, it is like a large, round, red plate,
which becomes yellow and then colorless at
the edges. It is somewhat like a target, and
is made to starkly contrast with the decent
color of the bank building. If one goes to one
side, the light refraction makes the lens color.
The red disappears and the resin seems as
if it were orange or yellow. This makes the
entire object seem to be alive and gives it sur-
prising aspects. The writing is easy to read
when one comes closer. Each statement is
signed. That can be likened to the signatures
that people carve into trees, park benches,
etc., or on the lavatory doors of historic build-
ings. On the latter, people consciously leave
their traces behind, in order to give emphasis
to their presence. Here, I asked the people

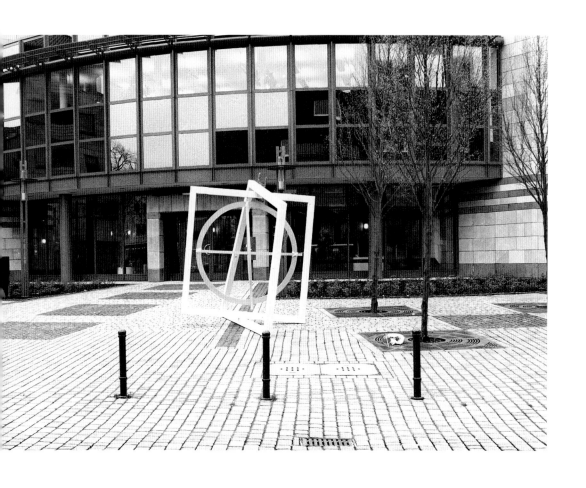

Dorothee Golz, *Wertobjekt* (Valuable Object), model on a scale of 1:1 in front of the Landeszentralbank (LZB) in Minden

who work at the bank to leave their mark. They can't change the "fingerprints" of their perhaps now outdated opinion. This will be transported into the future in this resin, and though defenseless, will nevertheless be presented with self-confidence to the observer. That's it for today. We have to wind down our conversation, because the text has to go to the printers. Answer quickly.
Best regards, Dorothee

From: Siebers, Johan
Date: February 8, 2001 10:18
To: Dorothee Golz
Subject: Valuable Object

Dear Dorothee,
We've talked about form and content of the *Wertobjekt*. I don't want to tell you what I think art is, or what an artist is. I only want to say— these are helpful thoughts, and looks like it's going to be a good piece of work, good for some moments, experiences, encounters, and passings. ("Well done," etc.). But one thing did stick in my mind: you talked about the Sunday dress. If art is, like philosophy, the "Sonntag des Lebens" [Sunday of life] (Hegel's words, not mine), then it is good that a bit of Sunday is brought to the workplace. Better still: no more Sundays, no more workweek. Now that IS a question to end with: what could art, what could thought become in such a world? A new beginning. It would be good if some of the future life of this object of yours would happen to touch upon that question, sometimes, in somebody's head.
Talk to you soon.
vriendelijke groet, Johan

From: Dorothee Golz
Sent: February 9, 2001 18:13
To: Siebers, Johan
Subject: Valuable Object

Dear Johan,
To finish up, I have something good to report: we were able to put together the two halves of the lens! Soon we can build the steel scaffolding in front of the building and add the lens. I suggest: next time, let's meet in front of the *Landeszentralbank*. By the sculpture. Until then!
Best regards, Dorothee

New elements

element copy

projection

ARchilecTuRE model

Art and Architecture at the Crossroads of Bureaucracy and Power
An Insider's Thoughts on the Difficult Task of Realizing Art
for Federal Government Buildings in Berlin
HANS-PETER SCHWANKE

The General Situation

An outside onlooker might well have expected that the resolution of June 20, 1991, to move parliament and government to Berlin and the construction boom it triggered would mark the beginning of a golden age of art in architecture and public art in general in the new German capital. And indeed, during a period in which the museum sector faced massive budget cuts and even closings, art commissions for public and private building projects in Berlin amounted to some five hundred million DM. Even private investors who are not bound to the "Art in Architecture Regulation" were involved on a large scale.

The unconstrained, non-bureaucratic approach of private-sector clients as pioneers in the realization of artistic ideas and their preference for striking works stood in obvious contrast to the activity of public, government building clients. The many works incorporated by private clients into the Daimler complex on Potsdamer Platz and in other business and insurance buildings were executed for the most part by well-paid, world-renowned artists intent upon establishing an unmistakable presence and striking signal effects.

This situation engendered the hope that competition would enliven the scene, raising the level of quality and increasing the prospects of achieving outstanding works of art in the public building sector. Now, with most projects completed, the "competition of systems" presents a sobering picture, especially as regards projects realized for the federal government. For the four constitutional organs that relocated to Berlin—the Office of the Federal President, the Bundesrat (Federal Council), the Bundestag (Federal Parliament), and the Federal Government—among which a certain degree of rivalry was already a given, it was necessary to seek consensus based upon proportion (representation of artists from East and West, a certain number of women artists, young artists, etc.), social obligation, and adherence to the requirement for transparency through competitions. For good reason and with the wisdom of foresight, all four of these constitutional organs officially stepped down as public clients, delegating authority to so-called art advisory councils in order to minimize their responsibility in the face of anticipated public criticism and to bundle and bridge the many divergent interests represented by institutional groups, civil servants, and political circles. No special emphasis was placed on the fact that these councils were advisory bodies only and that final decisions would be made by politicians.

The Advisory Council for the new Office of the Federal President was small, and its tasks were confined to a single building. This was true as well of the Art Advisory council for the Bundesrat, whose membership reflected the

Daniel Buren, Detail drawing for the artistic design of the inner courtyard of the Federal Ministry of Labor in Berlin, 1998

proportional representation of the individual states. The Art Advisory Council for the buildings to be occupied by the German Bundestag, which include the Reichstag building and three adjacent conference and office complexes each the size of a city block, had a great deal more to do. With a funds amounting to twenty-eight million DM, this council had the largest budget to work with. The Art Advisory Council for the offices of the Federal Government faced by far the most difficult task of all. Including the Berlin offices of ministries whose primary headquarters were to remain in Bonn, this council was responsible for selecting art for a total of more than a dozen widely differing architectural structures—from buildings built during the Wilhelminian period to completely new edifices. Given the elected government's greater concern with elections and election dates, it was necessary for this council to respond more directly to the interests of professional associations and to seek consensus in order to avoid negative reactions. Consequently, the membership of this Art Advisory Council reflected a high degree of parity.

The heterogeneous board was composed of one representative each from the German Artists' Association and the German Artists' Union (BBK), one freelance artist as the obligatory female member, and a bare majority contingent of four historians of art and architecture, all museum directors. No other art advisory council included representatives of the very professions that were to be considered for commissions. And nowhere else were they afforded as much influence as in the Art Advisory Council for the Federal Government, for which Klaus Bussmann was appointed official spokesman. The fact that the work of this council was characterized for the most part by mutual understanding and cooperation is a

reflection of their need to unite in the struggle against an awesome bureaucracy and diverse attempts to exert influence on the art program. At roughly twelve million DM, the budget was considerably smaller than that appropriated for the German Bundestag, although the tasks facing this council were much more extensive.

The Concept of the Art Advisory Council for the Buildings of the German Federal Government

Constituted on November 1, 1996, the Art Advisory Council for the Federal Government turned immediately to the complex task of familiarizing itself with existing ministry buildings and new construction plans. On the agenda for the following meetings were visits to buildings and building sites, discussions with future occupants, architects, monument preservation officials, and representatives of the Berlin government administration responsible for art in the city, which has it own "Advisory Council for Art and Design." The first objective was to form as complete a picture as possible of the entire spectrum of art in urban space in the city of Berlin. Constant contact with the Art Advisory Council of the German Bundestag was ensured through the appointment of a liaison representative to each council.

The government's decision to make use of existing buildings to the extent possible and to renovate, restore, and refurnish them in keeping with the new functional requirements generated a uniquely exciting situation calling for response to a broad spectrum of stylistic currents in architecture with the resources of contemporary art in the 1990s. Buildings from the waning imperial era and the 1920s, former ministries of the Third Reich, functional

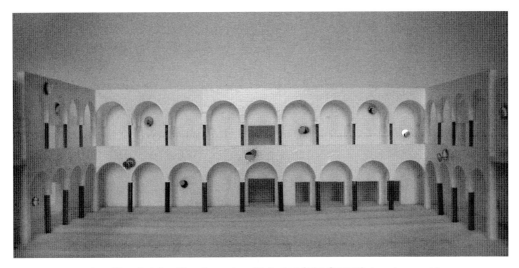

Rebecca Horn, *Verspiegeltes Planetensystem* (Reflected Solar System), formal proposal for the Federal Ministry of Transportation in Berlin, Model, September 1998

structures built during the GDR years, and the few new buildings combined to present such a multifaceted aesthetic, historical, and urban architectural complex that the Art Advisory Council decided not to seek a coherent total concept that would encompass the whole. Consideration of the unique qualities and the future function of each building was to take precedence in deliberations preparatory to the selection of locations, artists, and specific works of art. Artists were not expected to provide finished works but instead to offer intelligent, contemporary answers to existing situations, to come to grips with the specific requirements of the respective building project. Artists were to engage in dialogue with clients, users, and architects as they developed their projects to maturity and realization. The Art Concept contained proposals for eleven direct commissions, seventeen limited competitions, three open, two-stage competitions, and a colloquium. The Art Advisory Council inspected thirty-six locations in the course of its various visits. Eight-four artists were nominated, in-

cluded fifteen from the new states and twenty from abroad. Due to a change of ministers, the roughly 150-page concept document was first presented by the new Federal Minister of Building and Construction to a broad public five months later in ceremonies held at the Hamburger Bahnhof museum in Berlin on March 11, 1998. It contained proposals for eight ministries. The concept was eventually expanded to encompass four other ministries which were to remain in Bonn but would occupy separate "headquarters" in Berlin as well. Because of changes in ministerial jurisdictions under the new government elected in 1998, no further discussions took place with regard to the Federal Chancellor's Office after this time.

Issues Addressed by the Art Advisory Council in Preparing the Art Concept

In view of the once-in-a-lifetime opportunity to present a nation in its architecture and contemporary visual art, artistic design assumed a role that went far beyond the customary context of "art in architecture." The image of the democratic government in the eyes of the world was to be shaped by art that would support and enhance the building structures and their functions, while encouraging the visual experience and contemplation. Fundamental questions concerning the role, functions, and possibilities of art had to be addressed. In the course of extensive deliberations among the experts on the council and in numerous discussions with project architects and others, the key questions for which answers would need to be found within the context of the practical application of the concept began to take shape. What role must art play in government buildings? What kind of art is most appropriate? What artistic resources are most likely to appeal to and enthuse both building occupants and the public? How can we create something that is both earnest and durable? The members of the Art Advisory Council were united in their resolve to show courage in the pursuit of new directions, in articulating diversity, and in linking together artistic, political, and bureaucratic processes. The coexistence of competing, indeed contradictory ideas and ideologies was regarded as an appropriate vehicle of self-representation for a democratic government. All-encompassing, generalized solutions were ruled out, as formal diversity and originality were deemed more fitting for a system of government dedicated to the principles of subsidiarity and heterogeneity.

Political Requirements for Art in Architecture

The opportunity to articulate the expectations of the political community with regard to art was taken by the Federal Minister of Building and Construction at the press conference at which the Advisory Council's Art Concept was presented immediately following its submission to the Federal Cabinet. With respect to the purpose of art in public space, the government's spokesman provided a list of the distinct functions he believed must be served. He emphasized communicative aspects, the need to transcend hierarchical and utilitarian boundaries and to encourage people to engage in dialogue, the importance of responding to specific architectural and historical situations, representative functions, and the aspect of communicating the concerns of artists. Where necessary, he suggested, art should be disruptive, should counteract architecture, define public space and even have the courage to serve as a striking emblem. The Minister planned to achieve all of these objectives with "artworks of the highest order," which he regarded as indispensable for proper representation of the nation. Particular emphasis was placed on the public's demand for unique experiences and the importance of fostering dialogue across generation boundaries. There can be no doubt that the Minister showed courage and a strong sense of responsibility, recognizing the need to promote contemporary critical forms of expression and to provide for a maximum of tolerance. He demonstrated commitment and a willingness to accept risks in supporting works of art that would both polarize and intervene. The Minister's general expression of admiration for art—as an expression of community that joins people together and an essential symbol of the cul-

tural identity of a nation—contributed greatly to the positive public response to these ambitious goals.

Results of Efforts to Realize Art in Architecture on the Basis of the Concept of the Art Advisory Council

During the first six months after presentation of the Art Concept, progress was made only on initial preparations for announcements of competitions and in first contacts with artists. The ongoing election campaign made it impossible to involve the ultimate decision-makers closely in the planning process, and the best to be hoped for was that a basis for decisions could be established. Final decisions still needed to be made about competitions, artists, and locations. The Federal Cabinet had "acknowledged the concept of the Art Advisory Council," but had not yet given its official approval.

Under these circumstances, only reasonable course of action available to the Council was to begin consultations with artists already nominated for direct commissions and, wherever possible, to secure their commitment on a contractual basis. All of these artists were invited to Berlin for detailed briefings and visits to the proposed sites. They were then asked to prepare preliminary conceptual sketches. These sketches were to serve as the basis for agreements on realization among the occupants, the project architects, and the building client. Neither administrative staff members nor political decision makers were especially receptive to most of the rough sketches submitted by the artists, however, having either

Rebecca Horn, *Verspiegeltes Planetensystem* (Reflected Solar System), formal proposal for the Federal Ministry of Transportation in Berlin, Model, September 1998

too little time, too little imagination, or insufficient willingness to immerse themselves in an unfamiliar medium. Practically no one understood that art in public space can indeed ignite exciting, fruitful discourse. But several of the architects also suddenly found the involvement of the co-creative hand of the artist in "their" building disturbing. In the ensuing discussions, the representatives of the Art Advisory Council quite rightly refused to sacrifice publicly visible or accessible sites originally proposed in favor of a retreat into indoor lobbies, hallways, or conference rooms, which would have prevented an effective response to the architectural context (and made a few architects very happy). Endless discussions and substantial friction eventually culminated in failure to place most of the proposed direct commissions.

One of the very first projects actually initiated was Rebecca Horn's *Mirrored Planet System*. The first meeting of the major parties involved, convened for the purpose of ironing out plans, nearly frightened the artist off. A large number of people from the staff of the Federal Ministry of Traffic and Transport appeared as building users—most of them only marginally concerned, if at all, with the realization of the work of art. As if that weren't enough, representatives of the "Internal Services Department" responsible for organization, building security and administration, spokespersons for the works council, and even a delegate sent by the "amateur painters' group" felt obliged to get involved as self-appointed specialists. The building occupant emphatically presented its catalogue of requirements: In keeping with plans for multifunctional use, neither the historical arcade courtyard (the proposed location), nor the glass roof, nor the double arcades, nor the floor, which was also protected by monument preservation regula-

tions, nor the open, above-ground space was to be affected by the proposed work of art. Somewhat depressed, the artist then asked what she would be allowed to use for the installation of her artwork. Yet the tactic employed by these bureaucrats to keep the work out entirely or relegate it to some unassuming spot ultimately failed. Lacking in imagination themselves, they failed to reckon with the artist's own cleverness and inventiveness. During a second round of discussions conducted in the fall of 1998, they all admitted defeat following a convincing presentation of an outstanding set of proposals that took all of their requirements into account. Not a single argument was raised in opposition to this intelligent, ambitious solution.

Installed in 2000, Rebecca Horn's mirror sculpture is comprised of some twenty multipart, motorized mirror elements mounted on the remaining walls of the arcade hall. The mirrors, which tip and turn, reflect the surrounding space into infinity as well as the light that falls through the glass roof. Programmed sequences of movement suggestive of a planetary system simulate the movements of heavenly bodies. Without overshadowing the real activities in the hall, this quiet, meditative, dialogue-oriented movement discreetly calls the visitor's attention to the work of the Ministry as it relates to speed, space travel, and transportation.

Jochen Gerz realized a light installation in the court of honor at the Federal Ministry of Finance under considerably less complicated circumstances, thanks at least in part to his close personal ties with the two men who served as Finance Minister in 1999. Turning the inside out, in a sense, Gerz interviewed members of the ministry staff, each of whom he asked the same question. Recorded on

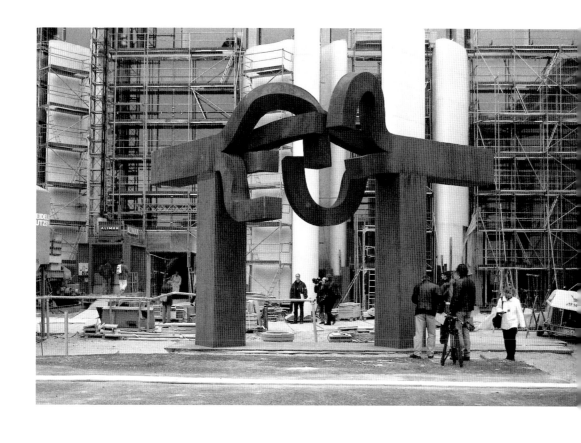

Eduardo Chillida, *Berlin*, court of honor of the Federal Chancellery on the day of the opening

Claes Oldenburg/Coosje van Bruggen, *Question Mark on a Skateboard*,
sketch from July 1999 for the press and information office of the Federal Government in Berlin

video tape, their responses can be played back outdoors on monitors mounted on the posts of the wooden fence around the courtyard at the press of a button. The original question then appears in laser print on the walls and tiles of the courtyard, lending a ghostly aura to the megalomanic architecture of Goering's former Reich Aviation Ministry.

After the new government took office in late 1998, greater emphasis was placed on the social aspects of art in architecture, on the mandate for transparency and competition, and on references to the history of the Third Reich. The impact of political changes was felt in art as well, as the Art Advisory Council had been established by the old government. It became increasingly more difficult to award direct commissions.

The proposals submitted by Daniel Buren and Markus Lüpertz, both of whom were nominated for the Federal Ministry of Labor, were ultimately rejected because the new government host wanted to see "democratic art," i.e., art selected through competition, installed at the site. Daniel Buren's idea for the military-style interior courtyard architecture of what had once been Goebbels's Ministry of Propaganda would have made use of original elements of the building to achieve a unique modification of its intimidating character. The windows and doors on the ground floor were to enter the courtyard in the form of simple metal copies arranged in rank and file and apparently exhibiting the traces of their march. Precisely this back-and-forth, this interplay between architecture and art, this integration of artistic and architectural design into an indivisible whole, would have made it possible to come to terms with the stern rigidity of the walls. The chessboard pattern of colored glass in Buren's copies would also have enlivened the gray of the natural stone while highlighting the mutual complementarity of the originals and the copies. Instead of a reticent pose of concern, one would have encountered a statement full of irony and liberating wit.

While Lüpertz's *Philosophika* fell victim to alleged budget restrictions, Dan Graham voluntarily back away from his plan to create a sculpture for the park complex at the Federal Ministry of Finance, with its monumental bronze statues from the 1930s that had survived the intervening years intact. After taking part in several discussions, he found himself unwilling to get involved with the bureaucracy. At virtually the same time, however, he realized a fully mature work for BEWAG, a major Berlin energy corporation, in a process unburdened by complications.

Ilya Kabakov's plans to erect his work *Two Memories of Fear* on each side of the Spandau shipping canal adjacent to the Federal Ministry of Economics were largely on the basis of the negative vote cast by the works council, which found fault with the fact that the work would block the view of the water from the cafeteria. The once-in-a-lifetime chance to have the work originally erected as a temporary installation at Potsdamer Platz for the exhibition *The Finite Nature of Freedom* in 1990 placed in modified form as a permanent fixture under the care of the neighboring museum Hamburger Bahnhof was carelessly tossed away. One finds this even more difficult to understand in view of the fact that the canal zone—once the border between East and West at this point, would have been an ideal setting for a work devoted to this particular theme.

Claes Oldenburg's and Coosje van Bruggen's *Question Mark on a Skateboard*, proposed for the Government Press and Information Office at a central location on the banks of the Spree

between the Friedrichsstrasse Station and the Reichstag building, barely escaped rejection. The new government press officer and the State Minister of Culture (who had no jurisdiction in the matter but intervened nonetheless, taking a dim view of such projects following the government's refusal to incorporate the art-in-architecture sector within his new ministerial department) found the idea of commissioning an aging artist who made "toys for giants" distasteful. Alleging that the proposed work had little site-specific or historical relevance, they pointedly suggested a work of video art focused on Goebbels's propaganda as an example of the abuse of freedom of information in the Third Reich. With admirable Westphalian tenacity, the chairman of the Art Advisory Council ultimately managed to gain approval for the sculpture in the face of some disparaging commentary. With their accessible, openly readable realization of an artistic idea, Oldenburg and van Bruggen succeeded in uniting politics and the public. In October 2000, Eduardo Chillida's sculpture *Berlin* was erected in the court of honor of the new Federal Chancellor's Office Building. (The selection of art for this building had become the responsibility of the new State Minister of Culture under the new government.) This was possible only because the father of the idea, the original official spokesman of the Art Advisory Council, had assisted Chillida in developing the concept for his work long before the new administration took office. The fact that this circumstance was deliberately left unmentioned during the dedication ceremonies must be counted among the acts of insincerity committed since 1998.

Apart from the exceptions noted above, no other direct commissions were carried out. Of the twelve works proposed for the ministries, only three were actually realized! The final outcome of the limited and open competitions can be regarded as modest at best. Although nearly two-thirds of the sites and artists nominated for the competitions were realized—twice as many as were carried out as direct commissions—the results leave a great deal to be desired in qualitative terms. This is particularly regrettable in view of the fact that only first-rate works of art will endure and represent the ambitious goals embraced by the planners. Quite apart from the irrefutable fact that competitions themselves complicate the entire procedure, increasing preparation time and total work load, generating substantial additional costs, requiring time-consuming processes, and discouraging the participation of outstanding artists, the results of the pronounced influence exerted by building occupants, architects, politicians, the artists' union BBK and the government agency in charge were, at least in part, miserable. Responsibility for the actual conduct of the competitions was not entrusted to a neutral institution without interests of its own to pursue but instead to the bureaucratic subordinate Federal Office of Construction. The often massive interventions undertaken by this office and by other parties in the selection of artist tableaux or jury members led to considerable losses of time, energy, and resources attributable solely to process friction.

The consequence of the undeniable necessity of appointing various users, high-ranking administrative officers, and even works council members to competition juries was that the ready interpretability of art came to be the primary measurable value in jury meetings. The intervening, abstract work of art that could not be interpreted at a glance was not

in demand. Fearful and uncertain in the face of the unfathomable mysteries of contemporary art and lacking the intellectual capacity that would have been needed to explain "difficult, complicated" works to their superiors, bureaucrats tended to turn a deaf ear to unusual, abstract, and daring proposals. Some building occupants sought to solve the "art problem" by channeling funds reserved for art into the restoration of building sculpture (The Federal Press Office) or the restoration of historical portal doors (Federal Ministry of Defense). Fortunately, legal arguments sufficed to nip such proposals in the bud. As things now stand, however, no work of art will be realized at the Federal Ministry of Defense. The absence of a strong Federal Minister of Building and Construction sincerely dedicated to supporting the cause was particularly painful. Yet a few outstanding works were realized nonetheless, among them Wolfgang Nestler's sculpture for the Federal Ministry of Justice, Marcel Odenbach's ceiling frieze for the Federal Ministry of the Economy, and Andreas Schmied's photo installation for the Federal Ministry of Agriculture. It is regrettable, on the other hand, that an incomparably mature, though abstract, proposal by Claus Bury for the inner courtyard of the Federal Ministry of Family Affairs, in which the artist responded to the specific architectural situation, came in only a close second to a banal proposal by the artist Ursula Sax. Her gold-plated bronze sculpture, the figure of a child lying on its back intended to symbolize the birth of humanity, calls to mind the golden "gummi-bears" marketed by a leading candy producer and shows just how close kitsch can come to art.

Art and Bureaucracy

"Realizing art as an adventure of the mind appears to be difficult within the context of bureaucratic guidelines," writes Klaus Bussmann in his foreword to the Art Concept. His remark that "bureaucracy is art's greatest enemy" was received with stony silence by representatives of the administration at the meetings of the Advisory Council. Yet as it turns out, the Advisory Council spokesman was absolutely right.

The three Art Advisory Councils working on behalf of the other constitutional organs faced considerably more favorable situations. The functions of client and building occupant were united in a single entity. The Bundestag enjoyed the added advantage of its recent experience with the artistic furnishing and decoration of the assembly hall in Bonn. Projects were organized and realized on the basis of nongovernmental commissions quickly, efficiently, and without influence from interest groups. The disadvantages of democracy—the lack of continuity and time-consuming decision-making processes—had a much greater impact on the program for government ministries than on those of the other constitutional organs. The author of these remarks, who was responsible for overall supervision, expert evaluation, and coordination of the art program for the government, was forced to cope with a complicated, and for an art historian very unusual, set of administrative procedures at the Federal Ministry of Building and Construction. It became quite obvious that art was looked upon by many as a superfluous luxury. Whenever the issue of cost-cutting arose, there were many who saw art programs as the perfect place to start. Assuming that the concept of living relates to a certain standard of quality in the use of space, then it should be possible,

at least to a certain extent, for people to transpose their knowledge and experience of the furnishing and design of private space to so-called public space as well. The need to grasp urban reality and to respect a given place in the process of planning step-by-step interventions creates challenges which, if met, will allow us to accomplish a gentle change in urban living space. Works of art in public space are neither objects of pure pleasure nor pure utility goods; they are objects which serve a function and at the same time honor the value and significance of specific, non-interchangeable places. Whenever strenuous efforts finally culminate in generally accepted proposals, many people find it necessary to get involved. Their tendency is make clear distinctions between right and wrong, and then wage war on what they see as wrong. Art is creating something that did not exist before, linking of distant things, making the improbably probable, causing surprises that often generate laughter. Art is surely a luxury; it is light and the description and exploration of light. Measured against the primitive, the complicated is always a luxury.

The primary tool not only of the artist but of those tasked with the realization of art is imagination. Creative development cannot take place without a large measure of self-reliance and independence, a wide action radius and the assumption of professional responsibility which, in the field of art, must often take precedence over loyalties as a civil servant. Unless these prerequisites, which are difficult to convey to dry bureaucrats, are met, high-quality works of art will rarely be realized.

But it is precisely these characteristics that make artists and art historians suspect in the eyes of public administrators. To many people, the process of creating something out of nothing in a free and open context is like a circus act, a challenge to break away from customary, bureaucratically organized, predictable routines. The structure of the standard bureaucratic hierarchy, the bearers of laurels at the top, the drivers of innovation and progress, who could make art possible, at the bottom, and in between the voices of objection, the blockers who have the power to turn the job of making art possible into a tortuous ordeal.

Art in Architecture and Politics

Whenever art and politics meet, controversy appears inevitable. Criticism of politicians' lack of understanding of art is nothing new. Paul Wallot, architect of the Reichstag, commissioned the artist Franz von Stuck to do paintings for the foyer of the Reichstag President's office in 1899. Two of the paintings triggered a wave of criticism that threatened to swell into a debate on new art in general, a dubious testament to the competence of legislators in matters pertaining to art.

With respect to the Berlin government buildings, a number of office-holders elected for limited terms saw themselves as guardians of aesthetic principles, a role that was properly assigned to the Art Advisory Council and the competition juries. Should we not regard it as the duty of office-holders in a democracy to consider their successors as well, to place trust in those better qualified to judge, to seek cooperation, and to put their personal intentions on hold?

Ilya Kabakov, *Two Memories of Fear*, project for the Federal Ministry of Economics in Berlin,
September 1998

Art and the Public Space—Art and Architecture

OTTO STEIDLE

Public space is dead ... long live public space! This contradiction (and its social, economic, and artistic requirements) is certainly an object of a controversial discussion among architects and city builders. I'd like to say in advance that my point of view on the question of public space is based on my experiences with art in relation to architecture and the city. If one concedes priority to today's commercial and social realities—the priority that they actually have—then every single private and public building project, regardless of size and importance, independent of regional or global effect, is a solitary thing. However, despite the apparently independent circumstances, I am challenged by the counter question of whether integration is possible. Each private and public building plan is certainly connected to a spatial, functional, and therefore also cultural continuity. Whether big or small, nothing is built that has not been subjected to an exploration of the question of public space. Either because the plan has been rejected, or reduced to its own function and representational factors and therefore isolated, or it deals with a theme of integration (in this context, a sense of continuing the processes of urbanism and democracy).

This balance between progress and continuity, private use and public responsibility for society's space, for the public space, ultimately also influences all of the esthetic decisions for architecture and urban structures, and therefore also for art.

The discussion of stone versus glass, as it is now being passionately carried on in Berlin, is not chiefly about glass representing a progressive direction or stone representing a retrograde one, but rather, it is an exploration of progress itself. The discussion either follows the infinite road created by technological developments in architecture, making a plea for isolation from public space, or it poses a critical dialog between individual vision and the entire situation. The decisions made are of fundamental importance for the future of the public space, for art and architecture, and the relationship between art and architecture. Because if the work of architecture and the work of art are only supposed to represent their own individual existences, they cannot make the contribution necessary for integrative, social development and therefore also for an integrated spatial-social structure—something that can be expected of art and architecture. When art is combined with architecture, as in the German practice of "Kunst am Bau" (literally, "art on the building"), this exploration is often confused by conflicting demands and goals, which at first fly wide of the artistic and architectonic intention. These questions are, for example, about durability and care, or about the budget, or the work's effectiveness as an "event."

Erich Wiesner, *Façade Studies*, 2001, Atelier Moritzplatz, Berlin

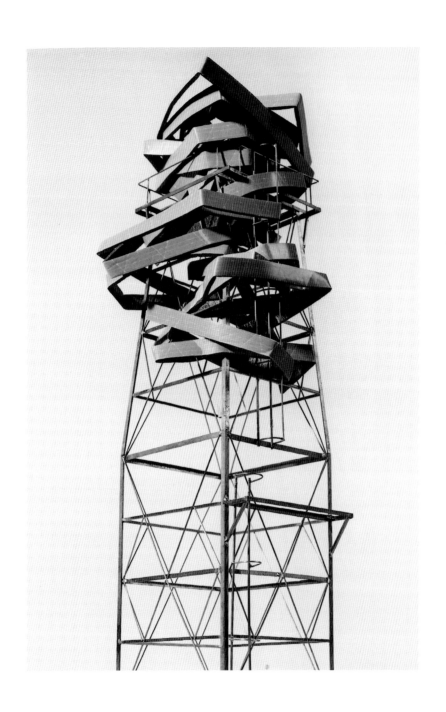

Olaf Metzel, *Cooling Tower*, 1999, University of Applied Sciences Wildau

Architects and artists are certainly able to realize practical principles as well as aspects conflicting with them. However, in the usual discussions with clients and those responsible for the "Kunst am Bau," one often has to deal with subjective, excessive demands, or with those who are only prepared to be responsible up to a certain point, or with those who are unable to make decisions. This mixture of power games and limited competence is usually counterproductive for the creative process that might possibly exist between architecture and art.

Architects are used to dealing with business figures exercising their power and those with limited competence, but artists are not as used to it. Among all of the questions regarding content and hard necessity, how can both artist and architect find a common strategy to realize "art in the public space" and "Kunst am Bau"? My experience shows that there are two different approaches that manage to retain both symbiosis and autonomy. When the building is simply a reason for a commissioned work of art, then autonomy on both sides is a given. It is also assumed when there is no speculation about the architect's desire to increase his prestige through the art, and when the architect does not restrict the artist, either by making him dependent upon the architect, or by binding him to special impulses. In other words, when the building is simply another environmental element for the artist—when it's just a part of the new reality of the building. Often, the artist questions the building, or even attacks it. In my experience, it is best to first begin the artistic work toward the end of the construction work, in order to make such reactions possible.

Regarding the topic of free "Kunst am Bau": we chose this form of cooperation for works at the University of Ulm (see examples from Nikolaus Lang to Lili Fischer). For the Polytechnic in Berlin Wildau, we also partially followed a competition-like strategy that was completely detached from the architecture. A metal sculpture by Olaf Metzel has nothing to do with the building, but instead uses an architectural relict, a cooling tower, for an individual large sculpture made of crumpled scrap metal. This initiated a chain of thought, starting with the industrial prehistory of metal working and moving on to today's educational institution for processing and packaging technology— in front of which the sculpture stands. Whenever we have followed the approach allowing for autonomy on both sides, it was always successful for the art, and never damaging to the architecture, even when it was challenged. In one single case we—an artist and I, the architect—suffered a shipwreck. There was a competition for a library with atriums for the University of Ulm. Regional artistic representatives demanded the competition, which was carried out with the usual mix-up: artistic freedom was proclaimed—yet the artist was required to connect the work with the architecture. The difference was not underscored in this case, and thus the freedom for both architecture and art described above was not to be had. The artist who won the competition did an intervention using a trend from the storehouse of contemporary architecture. She built a transparent façade etched with signs, and placed it where my façade—which consciously emphasized the windows—ought to have been. "My window" was irreconcilable with this media-wall-like illustration. Here, confronting each other, were not two cantankerous people split between architecture and art, but two different interpretations and principles of progress and "continuity."

When it is agreed upon to approach "Kunst am Bau" by understanding it symbiotically, as an integrated part of each work and a common contribution, then architect and artist must have similar goals, languages, means, and role models. In order to clarify this approach, I'd like to talk about my many years of cooperation with my friend from Berlin, Erich Wiesner. When shaping the concept, we work together with flowing, but not blurred borders. From the seclusion of his studio in Kreuzberg, he has a certain freedom but also a greater intensity in relation to the single element—to the color, the texture, the light. While I come from the great network of the city and the building, Wiesner is occupied with phenomena from the sensual, objective, and mental levels. While I intermediate between our designs and officials and investors on all levels, and have to protect them from great losses, he builds chains of associations from the sectors of contemporary or global or regional art. Even during the creative phase, his work often provides impulses, often also the security, to project his vision of a reality behind the world through explorations of dimensions, scale, material, and color (see illustrations and texts from E. Wiesner's workshop). His work, which, at the beginning, referred more strongly to the color and the surface of the building (examples: the Universities of Ulm, Mainz, and Dresden), increasingly and fundamentally penetrates the spatial and structural areas. Interior and exterior references are, however, not abolished or erased, but instead elucidated on many levels (examples: Project DT-Mobil, Bonn, Wacker, Munich, etc.). In all of our more recent collaborations, e.g., in Hamburg, in Bremerhaven with a brick façade, or in Munich with a ceramic façade, it is not about designing a façade, but instead, about the special design of the building in question. Erich Wiesner does not limit his contributions to "Kunst am Bau." He also does "research" in the areas of contemporary and historical architecture, so that, increasingly, the vocabulary of both disciplines enriches the dialog. Finally, I come to the "substantial" questions—such as, for instance, how can something be done, or what are the rewards (because for this kind of cooperative work, there is neither a recognized process nor a recognized form of payment).

It is much more often the case that, at least in public contracts that include obligatory "Kunst am Bau," that the artists' union is especially upset when an architect brings in his own artist for precisely this part of the work. We have often failed at the beginning of a project because of this.

In contrast, the contest, in which Erich Wiesner, too, might be allowed to participate, hinders the closeness necessary for this kind of collaboration. In order to work together despite these limitations, I've been going both ways at the same time: the way of the symbiotic, total artwork, continually working on the theme of art and architecture in projects with Erich Wiesner—and the independent, other way of the autonomous artist's contribution. That's not a compromise, but a compliment to both sides: on one side, art and architecture unite, and on the other, stand in contrast to each other.

Erich Wiesner/Steidle + Partner, *DeTeMobil Office Building,* Bonn

Evolving Collaboration
Herzog & de Meuron and Rémy Zaugg
EVA SCHMIDT

"Art is no longer an architectural afterthought, or an object to attach to a building after it is finished, but rather a total engagement with the building process from the ground up and from the sky down,"[1] wrote Robert Smithson in 1969, apparently seeking to establish as standard practice something which—then as now—remains more of an ideal vision. Architects still tend to feel that artists should keep out of their territory and refrain from intervening in the process of architectural design.

One noteworthy exception confirms the rule. For more than ten years, the architects Herzog & de Meuron and the artist Rémy Zaugg have maintained a continuous working relationship that has spawned a number of projects. Each of these projects has a different look, and each has its own particular history. The nature of their collaboration and the roles played by architects and the artist are redefined in each new venture.

Zaugg is a painter who is also involved in perceptual research. His investigations into painting since the sixties have focused on the viewer's relationship to the work of art in the spatial framework of exhibition architecture and within the broader contexts of the city and the world at large. As a fundamentalist, he sees painting as an instrument with which to acquire knowledge that can be applied to other fields as well. Disappointed in the program of art studies at the Kunstgewerbeschule in Basel in the mid-sixties, he was on the verge

of transferring to the ETH Zürich to study architecture.[2] Instead, however, he resolved to redefine the practice of art on his own terms. He acquired practical experience in architecture in the course of his collaboration with the architects' office Atelier 5 on the extension of the Kunstmuseum Bern in 1982–83. After completing this project, he wrote a number of texts[3] containing his reflections on architecture, and particularly exhibition architecture, from the artist's point of view.

The Herzog & de Meuron architects' office has gained a reputation for its virtually unrivaled abandonment of style, recognizable features, and uniform authorship. In their place, Herzog & de Meuron have developed an open, heterogeneous architectural significance which derives its form from both concrete situations and a multiplicity of visual and material qualities. Zaugg flirted at one point in his life with the idea of a career as an architect, and the architects went through a similar phase marked by a strong interest in art. "Our installations in art galleries are a part of our development, of the direction we have pursued. They played a decisive role in the process that got us where we are today. Now, we no longer see the need to express ourselves outside of architecture. We realized at some point that we would have to focus our energies. And we also learned that it is impossible to practice art and architecture at the same time."[4]

Rémy Zaugg with Herzog & de Meuron, *Antipodes I*, Dijon, 1990

Collaboration with artists is of fundamental importance for both of these architects. In 1977, they joined Joseph Beuys in organizing a Mardi Gras parade in Basel. For their contribution to the 1991 Venice Biennale, they had their buildings photographed by three artists: Margerita Spiluttini, Hannah Villiger, and Thomas Ruff. The list of artists could go on: Adrian Schiess, Helmut Federle, Balthasar Burkhard, Matthew Barney, Hiroshi Sugimoto. They are currently working with Jorge Pardo and Gabriel Orozco, whose collaboration the architects requested on a major urban architecture project in Santa Cruz de Tenerife. On the basis of their own experience as a duo, they developed "different forms of collaboration. The roles and functions of the people involved now change continually as we progress through the various project phases. As work-intensive and difficult these joint projects have always been, we have learned a lot from them,

and we have no regrets about even a single one of the projects we have developed in cooperation with artists. In a certain sense, our interest in collaboration with artists has a selfish side as well, for we are well aware that their contribution inevitably influences our views of architecture to a considerable degree, and that this contribution is part of a different world, quite independent of what we do."[5] Zaugg also views collaboration with others as an important component of his work. His partners in cooperation have included, to mention only a few, the ethnologist Jacques Hainard, the Atelier 5 architects' office mentioned above, the exhibition-maker Johannes Gachnang, and the photographer Balthasar Burkhard. Like Herzog & de Meuron, he takes a critical view of authorship, unity, and the object character of a work of art.

The first collaboration with Zaugg, as the two architects recall, was a more or less "platonic"

Herzog & de Meuron with Rémy Zaugg, Studio for Rémy Zaugg, interior view, Mulhouse, 1996

Herzog & de Meuron with Rémy Zaugg, Studio for Rémy Zaugg, Mulhouse, 1996

one. "Our reading of your important book *Die List der Unschuld*, which came out in 1982 in conjunction with the documenta in Kassel, might be understood as an anticipated collaboration. Our copy is full of comments and notes that practically amount to a dialogue with you."[6] The first concrete collaboration took place in Dijon in 1990. Zaugg had been invited by the Université de Bourgogne to participate in the planning of an institute of art history with its own exhibition hall. In the course of lengthy discussions with the prospective clients, Zaugg learned that not only this institute but a number of other new buildings were to be erected on the campus. In response, Zaugg rewrote the specifications for the com-

mission that was to be offered him. He chose to begin by drafting a master plan for the entire campus in order to avoid uncoordinated construction of buildings here and there on the grounds. He sought the advice of Herzog & de Meuron for this project. Together, they developed proposals for campus restructuring and consolidation, and the university accepted them. The *Antipodes I* student dormitories were then built in keeping with the master plan.[7]

"We had no architectural *a priori*, no preconceived notions about materials, forms, or details. Our talks were very open. We found a common ground rather quickly, and it would be impossible for anyone to say now who first

Rémy Zaugg, Mural for the research building of Hoffmann-La Roche, Basel, 2000

came up with this idea or that thought. The concept of the 'ingenious' idea has almost completely disappeared from our projects."[8] In the case of the Dijon project, the artist invited the architects to participate. A year later, it was the architects who approached the artist. The architects had been asked to present proposals for architectural consolidation in Basel. Working closely with Zaugg, they expanded the narrowly defined commission and generated a comprehensive urban-architectural study of the city of Basel as a tri-national agglomeration entitled *Basel: An Evolving City?* for the Chamber of Commerce in Basel. An important characteristic of the collaboration between Herzog & de Meuron and Zaugg is their tendency to question and redefine objectives in the earliest phase of work on a project.

In 1995, Herzog & de Meuron were invited to exhibit their work at the Musée national d'art moderne in the Centre Georges Pompidou in Paris. They asked Zaugg to develop an exhibition concept and set up the show. They chose him because they knew him to be a specialist in exhibition presentation, not only of his own work but that of others as well. The architects had seen the Giacometti show conceived by Zaugg at the Musée d'art moderne de la Ville de Paris in 1991, for example. He accepted the offer—not because he felt properly recognized as a proven exhibition specialist but for the simple reason that he had never done an architecture show before and hoped to gain new insights from the experience. Publication of the book *Herzog & de Meuron—une exposition,* conceived and authored by Zaugg, followed the exhibition. This work is a reflection on the collaboration between the architects and the artist and on the medium of the architecture exhibition.

The artist approached the architects once again in 1995, this time as a client. He asked them to design a studio building for him on a piece of property near Mulhouse. All distinctions ordinarily implied by the roles of client and commissioned artist/architect are dissolved away. For the artist, the studio is not merely the place in which the work of art is created; it is also a setting for exhibiting and reflecting on the work before it goes out into the world. The product of this particular collaboration is a building which is integrated into the existing situation, a structure that gives form to the transition from interior space to the outside world.

Herzog & de Meuron have been at work on the project entitled *Fünf Höfe* (Five courtyards) for the HypoVereinsbank in Munich since 1996. The commission called for the complete restructuring of a city block in downtown Munich. While the façades facing the surrounding streets were to be preserved, the interior of the block was to be converted into public indoor space with arcades and open spaces for shops, cafés, and restaurants, and the like. Zaugg was asked—at a relatively late point in time, namely in 1999—to propose a work of art for the project. His proposal comprises a color concept for the office entryways, orientation guides and word-pictures at the entrances to the complex, on pavements, and on the exterior building façades. The work gives equal weight to art and commercial graphics; it is everywhere and nowhere, providing both direct and indirect orientation.

Soon after being awarded a commission for a new laboratory and training building for Fritz Hoffmann-La Roche AG Basel in 1996, Herzog & de Meuron invited Zaugg to make a painterly contribution. A classical distribution of tasks? The artist set himself the goal of realizing a

Rémy Zaugg, *Herzog & de Meuron—une exposition*,
Musée national d'art moderne, Centre Georges Pompidou, Paris 1995

work that would respond to the architecture in a relationship of perfect symbiosis. A monumental wall exposed by the glass façade became an image-bearing medium for several word-pictures on a blue background. This decision in turn prompted a number of changes in the original architectural plans.

Worthy of mention in the interest of completeness is the collaboration on the recently dedicated *St. Jakob-Stadion* in Basel, a structure designed by Herzog & de Meuron with a color concept provided by Zaugg. Of the other projects conceived jointly by the artist and the architects, some have developed slowly, while others have come to a halt, as in the case of the design of a public square in Basel—*Der Rüdenplatz: Ort einer Landschaft* (1995), a new exhibition building proposed for a location adjacent to the old museum in Sémur-en-Auxois (1992), and the extension for the Argauer Museum in Aarau (1997).

The encounter between artist and architects in these diverse collaborative projects involves the mutual recognition and exploitation of the limitations and advantages of the respective other métier. This also enables each to critically examine and redefine his own profession. They are under no obligation to work together on a regular basis, and they are intent upon ensuring that nothing is repeated, that each project is unique and exemplary. Though collaboration involving specialists from different disciplines is now more important than ever before, it can neither be improvised nor institutionalized. And thus the cooperation between Herzog & de Meuron and Zaugg is entirely unique and unsuitable as a basis for generalization.

The work of the architects and that of the artist is done at different times and at different speeds. By the time the La Roche building was dedicated in December 2000, the project was history for the architects. They had long since moved on to new projects. The artist is presently working on the concept for a book and is analyzing the results of this cooperative project in a text for which he will take all the time he needs.

1 Robert Smithson, "Aerial Art," in Jack Flam (ed.), *The Collected Writings* (Berkely–Los Angeles–London: University of California Press), 116.

2 Rémy Zaugg in an interview with Bernard Fibicher, in Fibicher, Zaugg, *Reflexionen von und über Rémy Zaugg* (Nürnberg: Verlag für moderne Kunst, 2000), 154.

3 See, for example, *Das Kunstmuseum, das ich mir erträume oder Der Ort des Werkes und des Menschen* (1986), (Nürnberg: Verlag für moderne Kunst, 1998).

4 Rémy Zaugg, *Herzog & de Meuron——Eine Ausstellung* (Ostfildern: Verlag Hatje Cantz, 1996), 31.

5 Ibid., 25.

6 Ibid., 38 f.

7 All of the projects discussed here are documented in Gerhard Mack (ed.), *Herzog & de Meuron, Das Gesamtwerk*, vols. 2 and 3 (Basel–Boston–Berlin: Birkhäuser Verlag, 1996 and 2000.

8 Zaugg 1996 (see note 4), 28.

Four Projects, 1999–2001
WOLFGANG WINTER/BERTHOLD HÖRBELT

Kastenhaus 356.11 Lighthouse, 2000, Skärhamn

The place: Akvarellmuseet, Skärhamn, Tjörn island, Skagerrak, Sweden.

The material/the form/the construction: 356 mint green bottle cartons from the Deutscher Brunnen AG are the building blocks for the three ring modules of varying thickness that form the *Lighthouse* (height ca. 5 meters, width ca. 3.5 meters). There is a light source inside, triggered by a timer, which lights the building in the darkness. Theoretically, one could enter the sculpture, but it can only be reached via an improvised ferry or by swimming. According to the time of day, either the water's surface touches the underside of the walls, or the cliffs and the entire building jut out of the water. The permanent installation is built to withstand weather and therefore takes into account the special wind situation on the Northern waters.

Note: The *Lighthouse* serves as an orientation point for passing ships. In the building's interior, there are seating arrangements whose shape is dictated by the form of the *Lighthouse*. The interior of the carton house can be clearly seen from the Akvarellmuseet, a new museum for Scandinavian water painting located on the coast—that is, on the beach.

Hanoi City Teahouse, 1999, Vietnam

The place: University of Fine Arts Hanoi, Vietnam

The material/the form/the construction: 420 red plastic trays made in Vietnam, handsawed wooden slats, wavy PVC. Contrary to the usual Vietnamese practice of using bamboo as a construction material, roof slats are used as supports. They are sawed by hand out of a large wooden board.

The function: There was no place on the property of the University of Fine Arts Hanoi that could serve as a meeting place for students as well as the so-called "young teachers." Using completely primitive methods, tea was brewed under torn plastic sheets, which offered hardly any shelter from the continuous rain. About twice a week, a "professional" tea-maker was chased off by police street patrols. Toilets and other spaces available for the general public do not exist, or are in miserable condition.

Hanoi City Teahouse's theme is the "need for communication, socializing, informal exchange, unorganized friendship, in short: a lively culture ... The question of ownership, the question of responsibility and the obligation, for better or worse, to clean the things one is responsible for. The question of cleaning also understood as a political act, we stood together on the first day of their stay, shaking our heads in the sculpture classroom: a room full of dirt, broken sculptures, shit, and junk. A perfect installation ..." (Veronika Radulovic, *Die öffent-*

lichen, privaten und ganz privaten Räume im öffentlichen Raum—über die künstlerische Arbeit von Winter/Hörbelt in Hanoi, 2001).
Note: *Hanoi City Teahouse* was built in cooperation with students from the University of Fine Arts.

Feng Shui Basket—Toll Station, 2000, Kunsthalle Hamburg

The place: Kunsthalle Hamburg, for the exhibition *ein-räumen*.

The material/the form: The sides of the *Feng Shui Basket* were made of zinc-covered bars (the kind usually found outdoors). They act as massive blocks that nevertheless allow air to circulate. In a special process, the bars were individually bent and put together to make an amorphous sculptural form.

Note: "… had decided upon a material that is so trivial and ordinary, that at first glance it would not appear to be useful for making art. Metal bars, the kind that are used to make bootscrapers, were formed using a process developed by them. A pavilion-like sculpture was constructed, which is not only an autonomous sculpture, but at the same time, a piece of temporary architecture that is used for practical aims. For this project, it functions as a cashier's booth. Taking its basic form from a wastepaper basket, it protects the cashiers against objects thrown at them and from the uninvited gazes of curiosity seekers. *Feng Shui Basket* alludes to East Asian ideas of harmonizing polar opposite flows of power to create an effect that brings success to intentions and processes." (Frank Barth, *ein-räumen*, exhibition catalog, Kunsthalle Hamburg, 2000)

Chapel of the Peaceable Nature Project, 1925/26 and 2001, Billerbeck

The occasion: Rededication of the *Kriegergedächtniskapelle Billerbeck zu Ehren der im 1. Weltkrieg Gefallenen* (War memorial chapel of Billerbeck honoring those who fell in the First World War) in Billerbeck *to Mahnmal für die Opfer von Krieg und Gewaltherrschaft* (Memorial for the victims of war and tyranny).

The place: In the center of the city of Billerbeck, across from the main portal of the Billerbeck cathedral, there is a Neo-Baroque chapel, erected in 1925–26 according to the plans by sculptor and architect Bernd Meyer. The model for this piece of architecture was the Baroque Ludgeri Burial Chapel by Peter Pictorius the Younger, built in 1732, which was replaced in 1890 by the new Billerbeck cathedral. In the interior of the building, which is built of colored sandstone from the Baumberger Mountains, there is a stone cross on a pedestal. On the walls are written the names of the citizens of Billerbeck who fell in the First World War, as well as of others who died later from war injuries. Since the fifties, some round glass blocks of various colors have filled in the area where the original, round, open roof was.

The intervention:
1. The chapel's building materials should be carefully restored.
2. The name "War memorial chapel" will be replaced with the name *Chapel of the Peaceable Nature*.
3. In order to show off the building to advantage, Meyer laid out a raised square, which gave it a Baroque effect. From street level, one climbs five steps to a rest area, and from there, another five steps to the chapel's forecourt. A red plastic disc will now be set into the rest area at the foot of the chapel—as

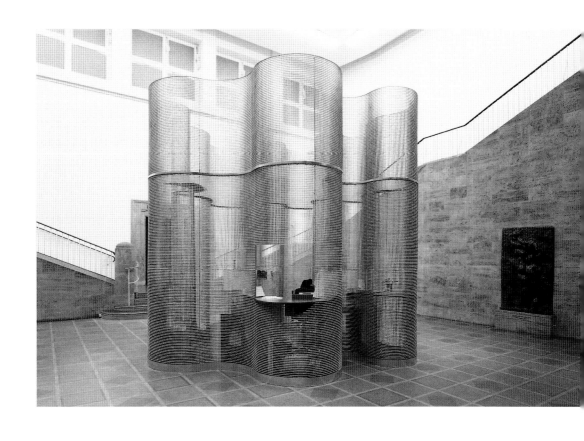

Wolfgang Winter/Berthold Hörbelt, *Feng Shui Basket—Mautstation* (Toll Station), 2000,
on the occasion of the exhibition *ein-räumen*, Kunsthalle Hamburg

a minimalist sculptural element and "stage" for the ritual described in the following:

4. Every Sunday, for the period of thirteen years, at the same time and in every kind of weather and every season of the year, a musical soloist or a small ensemble will present an approximately five-minute-long piece of music on the red plateau in front of the chapel. The limit of thirteen years is set by the budget foreseen. The artists will commission the composer Friedrich Jaecker to write the compositions. The quality and continuity of the performance of the piece by qualified musicians will be assured by giving the musicians an expense allowance in the form of an honorarium. The situation in January 2001: In 2000, the piece "wenn nicht du" will be composed by the Cologne composer Friedrich Jaecker, after the old Gregorian antiphon "Da pacem Domine." On a red, plastic stone floor platform at the foot of the meanwhile restored *Chapel of the Peaceful Nature*, qualified soloists will perform the piece every Sunday, rain or shine, starting in April of 2001. After the citizens of Billerbeck and the initiators of the project conducted extensive exploration and discussion of the sense of the memorial, we were able to agree that the above-described long-term experiment will be carried out in Billerbeck. At the same time, a historian will begin necessary work on the history of Billerbeck in the last century and especially during the time of National Socialism; the documentation will be published in book form.

Wolfgang Winter/Berthold Hörbelt, *Hanoi City Tea House*, 1999, University of Fine Arts Hanoi (Vietnam)

Wolfgang Winter/Berthold Hörbelt,
Chapel of the Peaceful Nature Project, 1925/26 and 2001,
performance of the piece of music and competitive model

What Is It about Public Sculpture and the Past?

ALLEN RUPPERSBERG

From Everlasting to Everlasting
And Song and Dance and Eyes and Heart
And Horizon Line _____

Le Mot Juste and The Circus is Coming
And East of Eden and/or Amor and
Always Spring and Every Fruit and
The Race goes on and on.

A. Ruppersberg, *The Sky above the Mud below*, 1988

"To Remember is to be a Poet." William Wordsworth

"There is no such thing really as was,
because the past is." William Faulkner

"Nothing is more difficult to discover than
a simple fact." Norman Mailer

Public Domain

... a form of individual attachment to the
present.
... a connection of things that appear separate.
... a person to a place.
... biographical associations that crowd the
space in a museum.
... precarious social conditions cannot be
overlooked by the installation of a work of art.
... public facts and private readings switch
places.

Past/Public/History/Image

... a contemporary image with a historic script.
... images collect over time.
... site specificity that begins with a vocabulary
of history.
... the viewer returns to see what was over-
looked.
... a central landmark around which all the
others revolve.

Not Next to McDonalds

... a visual metaphor and contemporary
artifact.
... history constantly being rearranged and
reinvented by the present.
... current context as content.

Vanished

... a memorial tells the public something.
... where is the famous image that everyone
carries home?

It's Not Possible without History

... historical space and aesthetic space open
each other,
... a kind of public narration.

Postcard *The Ark*
On the Mall at "The Landing," a shopping center in downtown Kansas City at Meyer Boulevard and The Paseo.
Another famous development by the J.C. Nichols Company.

... what words are left? What images are left? Who was their author? Art and ourselves.

... the relationship of things seen and things invisible and the overcoming of the second by the first.

Can You Make a Memory?

... newsreels have been called the art form of the twentieth century.

... you are always looking for yourself.

... a search for one lasting image and to rescue it for eternity.

Big and Small! Inside and Out! Neither Box nor Pedestal

... compose and recompose.

... the juxaposition of stories amid images.

... between the natural and the artificial, fact and imagination.

... a common event in the recent history of small towns and villages has been the removal of historical statues and monuments from their traditional locations, where they have functioned for decades as touchstones of local history.

Indifferent to the Past?

... it dissolves the distinction between the living and the lifeless.

... history in free association.

... a site already familiar but an image not yet seen.

Postcard *Old Matt's Cabin*
Made famous in Harold Bell Wright's *Shepherd of the Hills*.

THE END OF THE TRAIL

Postcard *The End of the Trail*
This is probably the most widely reproduced sculpture in America. The "hit" of the San Francisco Pan-Pacific
Exposition in 1915, it was created by James Earle Fraser, who also designed the Buffalo nickel, first minted
in 1913.

Postcard *Footprints of the Stars*
Forecourt of Grauman's Chinese Theatre, where concrete slabs have captured the footprints, handprints,
and signatures of the movie stars of yesterday and today.

Postcard *Bingham Copper Mine, Utah*
Located only a few miles from Salt Lake City, high in the Oquirrh range is Bingham Canyon, site of the world's largest open-pit copper mine. Presenting a colorful view of the green, gray, and red mountains this everchanging stadium affords a spectacular view of the huge mining operation as the electric shovels move fifteen tons of ore at a time.

One Belongs to the Other

… it is essential that people know the place they live in, that their place is important, and that one place is connected to another.

… the security which comes from the knowledge found in local relationships is now lost forever.

… a new image can begin a process of integration.

… the private imagination combined with public and political history.

… artistic, poetic, and utopian goals, their concrete realizations and the boundaries of the public.

Meanwhile … the Buildings Have Changed

… a memory is not just another replaceable image.

… stories and history are replaced by a new culture which doesn't recognize them as either art or history.

… the assembly and juxaposition of images with no seeming connection, natural or moral, but which are yoked together by means of coincidence.

… beliefs which are locked together into relational patterns with architecture and landscape.

… a relationship between the concrete and the imaginary connects a person to a place.

Everybody and Nobody

… the poetry of names, dates, birth, marriage, and death.

… ordinary people are made unique by the lives they are forced to lead.

… a common experience for all people today is the erosion of a sense of place. The local disappeared.

… a possibility of integration through the connections of things that appear separate.

A Reality in Itself

… art and culture from the urban center entering into and influencing the local culture.

… one could hardly tell now what this place had ever been connected to.

… the viewer becomes like an editor, fast-forwarding through history.

From a book review of the *New York Times*:
The Same Ax, Twice
Restoration and Renewal in a Throwaway Age.
By Howard Mansfield.
288 pp. Hanover, N.H.:
University Press of New England. $26.

By Robert Campbell
"What does the title mean? It means this: If you own an old ax, worn to a lovely patina, beautiful but no longer used, and you preserve that ax as a treasured memento, then you do not truly have the same ax. If, on the other hand, you're a working farmer, and you replace the ax handle three times and the head twice, then you do have the same ax, even though not a molecule of the original remains. You have preserved the use of the ax, and its use is an essential part of its being. It's still an ax, not a memento. You have the same ax twice."

The Best of All Possible Worlds
A. Ruppersberg

Art, the Public Space, Pleasure, and Criticism

OLAF NICOLAI

1

In discussions about art in the public space, the artwork and the public space are usually understood to occupy opposing positions that have a "relation" to each other. This relation is interpreted and accentuated in various ways, as a question of form and/or function. This is indicated by a phrase, such as the "fourth dimension of the public space" (Walter Grasskamp), whereby this dimension is unsatisfactorily described with "use." The idea of engagement is connected with form and function. The function of aesthetics is critically examined and the thesis presented is that art in the public space changes the politics of space into culture, that the space is even de-politicized. In connection with this, art in the public space is accused of ultimately being a "glittery show" meant for pleasure instead of leading to a criticism of the structures that constitute the public space. This argument leaves the impression that it is the artwork that first brings aesthetics into the space, that the space itself is not already aesthetically structured. Two constraints on the idea of aesthetics are the basis for this perspective. For one, the aesthetic of an artistic work is primarily considered to be its sensual presence, whose main characteristic is to serve pleasure rather than critical reflection. For another, people are not aware that the public space is always present (and not simply in the work of art)—and also that works of art in the public space are already preconfigured. However, not the solid, finished works of art, but the techniques used to organize this space are preconfigured. The public space that we encounter today has already been formed. If one considers aesthetics to be a phenomenon not limited to artistic production, then today's spaces must be considered to be esthetically configured. When artworks are realized, "enter" the space, then they realize certain tendencies, change these possible ways of interpretation. That refers not only to elements such as color, material, and architectural considerations. It also refers to the above-mentioned fourth dimension. Shaping this dimension formats spaces as conglomerates of scenarios; their hallmarks are their performative qualities.

2

This characterization of the public space—meaning primarily the urban space—is not new. At the beginning of the industrial modern era in the eighteenth century, the organization of city space was thought of as staging. In order to do this, two institutions were important models: the factory and the theater. Significant examples might be the early designs of the ideal factory by Claude-Nicolas Ledoux (1736–1806), or the fantasies of the utopian Socialist, Charles Fourier (1772–1837). Both staged the city as an expression of economic processes. The forms, the urban structures of these cities, and their architecture can be differentiated by how the roles of the actors in this process are defined. In Ledoux's work, the worker is thought of as

someone needing discipline; someone who, as a creature of passions, must be bound to and educated in the economic process. His city forms a circle in whose middle is a factory. The first ring consists of living quarters, the second ring is a garden for leisure. In Fourier's visions, work is a sensual, pleasurable act; the ideal city, the "phalanstere," consists of glass buildings combined together like modules, idyllically placed in an almost bucolic countryside.

The urban space that we inhabit is even more strongly influenced by economic processes. Not just the distribution of roles and the formation of the space itself are already set. The setting is not a simple translation of economic calculation. It is characterized by the specificity of the economic process, which is an increasingly fast, capitalist-oriented production of goods. This form affects not only the fabricated product, but also constitutes social relations, perceptions, and experiences.

This altered sensory-motor perception can be studied through the example of the panoramas at the beginning of the nineteenth century. In these, cities were staged as if they were goods, less according to the criteria of a faithful reproduction than to the criteria of interests. In a study on the panorama, Albrecht Koschorke remarked that visitors to the panorama did not only go into a kind of "aesthetic trance," due to the images surrounding them, but also felt unusually cold. A chill that can be explained by the combination of the dominance of visual perception and the retreat of direct physical experience. The change of perception and the accompanying change in physical experience are connected to changes in the cognitive process. Koschorke calls this the "intellectualization of the sensory apparatus." If one would describe the altered sensory-motor activity as alienation, one must use an ambivalent, alienating term—a term in which alienation is understood as being the prerequisite for the development of intellectual capacity. At the same time, with the techniques of discipline, the prerequisites for the creation of a self-aware, observing subject are formed.

This ambivalence also marks the discussions about the structures of that institution known as *the* symbolic medium, wherein the citizen experiences and forms himself as a mature, political creature, the citizen of the bourgeois theater. Denis Diderot and Gotthold Ephraim Lessing intensively and repeatedly discuss the question of how sensuality and pleasure—entertaining experience, that is—can be reconciled with critical reflection. To Lessing especially, sensuality appeared to have the tendency to dull critical perception. Critical perception must be regular—it must touch without seducing.

A simple comparison of pleasure and critical knowledge is, however, not possible. Pleasure and reflection are rather ambivalent categories. Examining the development of the modern observer in the nineteenth century, Jonathan Crary emphasized the permanent crossover between discipline and autonomy: "Discourse and practice demand a more adaptable, autonomous, and productive observer." These ambivalences are also inscribed in the settings, including those of the public space.

3
Now, what goes into today's staging of goods, spaces, and the public? The Dutch architectural theorist Hans Ebeling describes the endeavor to emotionally bind the user as characteristic of contemporary architects.

"The impression made by this architecture is created not at the level of messages that need to be articulated, but by the atmosphere at the emotional level."

In the nineties, the term "atmosphere" advanced to become a central aesthetic category. However, in connection with that, there has been no turn to a new sensuality, whose hedonism might be understood to be a criticism of a user-oriented consumer economy.

The term describes a new configuration of the nationalization of emotion and desire. The user is supposed to build an emotional connection to the product and product brands, whereby "the private world of experience belonging to the technology user will be carried over into a new, non-technical setting." (Herbert Lachmayer). These settings create effects and bind them into particular constellations. A dominant product task is to create certain atmospheres, thereby prefiguring the emotional relations connected to the product. Acquiring a product does not create a particular atmosphere.

The product is already so bound to its atmosphere that acquiring it is necessary to maintain or acquire the atmosphere. This is the performative quality of products. An altered understanding of the role of the user accompanies it. In the classic constellation of consumption, a product is acquired to satisfy a need, and therefore the active role of choosing and the way the product is used is limited. Nowadays, the impression created is that by acquiring the product, the consumer can acquire an ensemble of atmospheres that correspond to his narcissistic need. In this type of consumption, the consumer experiences himself as the active producer of himself. The performance of the economy creates a new economy of performance.

The term atmosphere includes not only emotional structures as elements in the product, but points out the way that emotions resemble products.

In an advertising slogan for new computer games, the manufacturer, Sega, talks about how the new game is capable of "simulated relationships." Forms of relations, ways of acting, and modes of communication are also categories to which the new kind of artistic production in the nineties can belong—"the realm of human relations is the setting for the work" (Nicolas Bourriaud).

If, faced with this setting, one discusses in detail the artistic interventions that are possible in the above-mentioned comparison of criticism and pleasure, artistic productions would appear to be like amusement parks constructed for the "happy few." The clearly critical and explanatory function of art would also disappear, for which the image of the child in Hans Christian Andersen's fairy tale "The Emperor's New Clothes" paradigmatically stands; the child who points out that the emperor is naked.

4

"The statement made with disarming innocence by the child in Andersen's fairy tale— that the emperor is naked—is usually taken to be an exemplary one. It saves us from bourgeois hypocrisy and forces us to look at things as they really are. However, what one still prefers to silently overlook are the catastrophic consequences of such a liberating gesture for its surroundings, for the intersubjective network in which it takes place. By openly saying that the emperor has no clothes, one's intention is to simply rid oneself of unnecessary hypocrisy and pretence. Afterward, when

it is too late, one suddenly realizes that one has gotten more than one expected—namely, that the community of which one was a member has been dissolved. For this reason, it is perhaps time to give up praising the child's gesture. Instead, we should view it as the prototype for the innocent chatterbox, who, by rashly talking about things that are better left unspoken (in order to maintain a consistent, intersubjective network), unwittingly and unintentionally sets the catastrophe in motion." Slavoj Žižek begins his book *Enjoyment as a Political Factor* with this revision. His argument is aimed not only at the misunderstanding that pleasure and criticism neutralize each other. It also opens up another view into silent and seemingly uncritical pleasure. This pleasure also creates a distance to the naive concept of the critical function of forms of symbolic expression. For the critical position, there is nothing "outside" of the setting, unless it is another utopian setting. The way the staging in which we participate is carried out is crucial for shaping our social roles and with them, the forms of our sensuality.

In his treatise, *The Presentation of the Self in Everyday Life*, Erving Goffman has elaborated on that, quoting a statement by Simone de Beauvoir as an example. A woman dressing and making herself up means that "she does not reveal herself for observation; she is like an image or a statue or an actress on the stage, an agent who is represented by someone else who is not there. The character that she represents is not present. This identification with something unreal is what gives her satisfaction; she strives to identify with this figure, and this identification stabilizes and justifies her in her glamor and splendor."

The staging of the sensual, the forms of pleasure, disclose discursive qualities that are not so much in competition with a reflexive, understandable level than they are the basis for it. The "deception" connected to pleasure and aesthetics has a constructive character for the imagination and constitution of the self. It is inseparably connected with them.

5

This kind of use also formulates artistic positions that have less to do with the utopian attempt to create a fundamental opposing position to the dominant practice of evaluation. Instead, they wish to create within themselves room for action in the system, in accordance with their own ideas. To do this, one refers to the same technologies and constructions that also characterize the given practice. That means that questions about form, mood, attitudes, and style are not a luxurious game with surfaces. They are questions about ways of organizing actions.

Here, it is not about simply repeating or affirmatively doubling mechanisms. Even when the artistic production cannot be located outside of the given esthetic practice, it formulates a specific internal behavior. This internal behavior is not granted to artistic production, but in the craving for a critical attitude, it is almost demanded.

The semiotics theorist Juri Lotman has suggested that this specific in the non-homogeneity of the artistic text be considered in the company of other contexts. Meaning, it is about every aspect that an artistic formulation "loses" as soon as it is "translated" into another context. However, isn't the repetition of given techniques and strategies exactly that—the identity of artistic text and context? Žižek emphasises that repetition in the symbolic field is never a simple doubling. It always

occurs with a re-marking of whatever has been repeated. The techniques used are indeed predetermined, but by repeating them, their modalities are also marked. Repetition introduces, exposes, shifts: "L'écart est une opération" (Marcel Duchamp).

In this context, there is an understandable paradox. The genre known as autonomous sculpture and the institution of the museum can also be productive for artistic works not oriented toward a hierarchy of cultural expressions and techniques. Lotman calls the work of art the only model that organizes the behavior it presents. The work that uses certain techniques builds a space for reflection upon the technical. Autonomy would be then, among other things, a strategy that marks this function.

The question sketched at the beginning, how the interaction of pleasure and criticism is configured through the work of art, is not a question that is first asked about art works in the public space. It is central for the function of every artistic work. In this respect, the current discussions cannot be about the alternatives of pleasure *or* criticism. The question is, how can pleasure and criticism be bound together, considering the circumstances that new articulations will also be the forms for the continuing "capitalization of the subconscious" (Fredric Jameson).

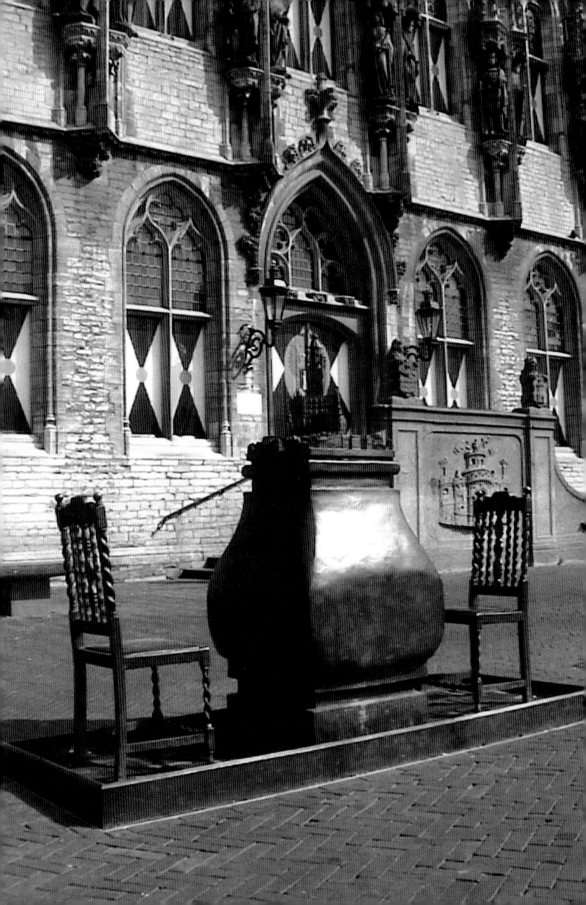

Public Project, or The Spirit of a Place

ILYA KABAKOV

The title of our new book is *Public Project, or The Spirit of a Place*. I will give here an introduction on the theme captured in the title, that is about public projects.

First of all, I would like to say a few words about the biographical circumstances, about how I began to produce a rather extensive group of public projects. For approximately ten years I had been occupied with the total installation, and we constructed total installations in various art institutions and exhibition halls. The genre of these installations was called "total," since they represented enclosed spaces that were juxtaposed to the space of the museum where they were exhibited, and of course, to the surrounding local environment. These all represented a world within another world, and the viewer, upon entering such a space, finds himself in an entirely different place, in a different country, and on an entirely different planet. The contrast between the place where the installation was built and the installation itself inspired the overall conception of these installations; their crux was the juxtaposition they created to viewer's state prior to winding up inside the installation. In producing these installations, this world would be built into the other world, and obviously, this world was the world of Russia, of course, Soviet Russia, and it was inserted into the Western world, that is, into the world of Western democracy, of a Western cultural context. It would seem that the devel-opment of this artistic product—the total installation—would potentially be unlimited, since at that time the themes depicting various aspects of Soviet life seemed inexhaustible to me. It appeared that the reserves of enthusiasm and some sort of masochistic pain that were evoked by the recollections of life in Soviet Russia would never end. Everything appeared in such a way that it seemed I would be involved with this kind of artistic product to the end of my life. But, as they say, you can assume but fate decides, and around 1997 I began to feel that the energy and interest were gradually waning, and the themes, even if they were not ending, ceased to evoke in me that burning and persistent demand to bring them to fruition.

Around three years ago I began to receive proposals from various art institutions to participate in public projects, that is, to produce some works that would be placed in open spaces in various cities and countries and that would be oriented not only toward memories of my past, but also toward the memory of Soviet Russia, insofar as it was necessary to insert them into the normal conditions of the place where the public project was to be constructed.

And once again, also with enthusiasm, I threw myself into the work and again felt enormous interest and a sort of spontaneous energy while creating these projects. We would go visit the places where these projects were to

Ilya Kabakov, *Fountain*, 1999, Middelburg

be erected. A few ideas would emerge at the moment I would find myself in that place intended for erecting the project. A few ideas would come into my head beforehand, and I could only guess whether these ideas would be appropriate for that particular spot. In short, over the course of the last three years, it has turned out, either coincidentally or very naturally, that these public projects were literally produced one after another. Furthermore, we have participated in a relatively large number of competitions, also for producing public projects that were intended not as temporary, but rather permanent ones. It is difficult for me to say now our success rate in these competitions, but approximately three or four times our project was selected for realization. As a result, a certain experience has accumulated and a certain theory has even developed concerning the creation of such public projects. I would like to share these with you now.

Of course, I do not intend to define the meaning of public project broadly and exhaustively, and honestly speaking, I don't really know myself what that definition might be, since in all that I have read about it there are widely differing definitions. Therefore, I can only speak about my own extremely subjective impressions, or perhaps it is better to say, fantasies regarding this subject, as well as to share with you my practical observations that have emerged over the course of the past three years, and discuss the experience I have accumulated while creating a certain number of diverse public projects.

When I peer into the past, a public project to a great degree appears to be something practical that has a concrete, utilitarian meaning. In my imagination, what arises is a great quantity of monuments that were erected in order to reinforce the memory of some very important events in history connected with the places where these monuments are built. In particular, these are usually in memory of some victory or plague, some sort of important historical events or some sort of curious circumstances that are in one way or another connected with the location of these monuments. Furthermore, public projects, without a doubt, have served as ornaments, a unique kind of aesthetic center, aesthetic junctures of an urban ensemble, for example, ornaments in squares or streets, especially classical squares or Baroque structures.

Regarding public projects outside, then without a doubt, these are complexes of park sculptures that have their own mythological proto-images, where all kinds of nymphs, satyrs, and other "pagan beings" peer out from behind the bushes and trees—what emerges in my memory are the marble ensembles of Versailles, the Summer Garden in St. Petersburg and many other places. In modern times, these have become traditional and therefore anonymous public objects have begun to be complemented with new "author's" works. Especially in recent times, we have found ourselves, it seems to me, caught up in a wave of great interest and productivity in terms of public projects literally in all countries.

I will not speak about the reasons for this now, perhaps I will touch on it a bit later, but in any case, the creation of such public projects is unbelievably stimulated today. All of them are based on the notion that the artist constructs his own personal work in the open space made available to him.

The next part of my introduction will have, in part, a critical perspective. According to my observations, these artists' works use the proposed places exclusively in the capacity

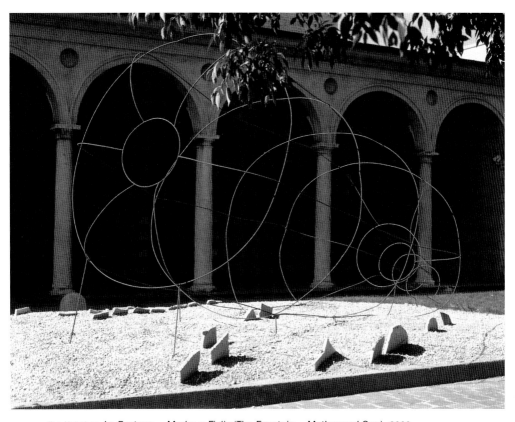

Ilya Kabakov, *La Fontana—Madre e Figlio* (The Fountain—Mother and Son), 2000, Fondazione Antonio Ratti, Como

as exhibition space for their own creations. What does this mean? The author begins from the notion that the place, no matter what it is, even though it is unbelievably important, unbelievably authoritative, and historically significant, is still just the background and the "simple" area for the erection and construction of his own artistic creation. As a rule, the artistic work in this case either ignores what is around it, that is, it considers it to be insignificant or, more often, the author is certain that with his creation he should repress, surmount, and in any way possible, vanquish all that is around it. That is, the artistic project of the artist himself is many times more important and more serious than what is surrounding it. In general, the spirit of victory of an artistic work over the environment is the sought-after goal, the desired result of erecting such a project, where the inter-relationship between the artist's work and the environment looks like the relationship between the victor and the vanquished. This is especially true of many works by American artists, where the ignoring and suppression of the surrounding space seem to be axiomatic and are posited as goals from the outset. Furthermore, this tradition of the victory of the artist's work over the surrounding medium is, of course, a consequence of modernism. The traditions of

modernism that extend even to today are the traditions of an artist who understands himself exclusively in his capacity as a genius and prophet, a unique kind of ruler, all the rest is only that heeds and submissively perceives those brilliant, extraordinary communications that are emitted by this artist. Hence, the inter-relationship between the teacher and pupil, genius and lack of talent, the prophet and the inert masses, the connoisseur and the igno-rant—this opposition for many artists until today is still considered entirely natural and self-evident. Originating from this starting point, any place turns out to be absolutely empty for the modernist, a blank page on which he can write his immortal lines.

The concept of the public project to which we shall turn our attention in the near future, represents a complete juxtaposition to what has been described. In the first place, the atti-tude toward the public project is not the same as toward a temporary exhibit, but rather it is an attitude toward something permanent that in principle should exist forever in a given loca-tion. It should be as though the public project has existed for a long time already among these other objects surrounding it. That is, it should not represent a juxtaposition, but rather a natural and absolutely normal part of that space where it is located. The attitude toward the viewer is also entirely different; it is not an attitude that marginalizes the viewer and is condescending, but on the con-trary, sees the viewer as an active and per-haps even the main character here. The viewer was and will be the master of the situation, because he will perceive this work in the con-text of that space where he finds himself and that existed before this and that he knows well, and not as a naive schoolboy who sees something for the first time and therefore looks only at it. In our conception, the naive belief of the modernist is entirely dismissed. The viewer, even before his encounter with this work, is quite familiar with everything here, he has lived in this place for a long time, he has seen an enormous quantity of things in addition to this completely unusual work that is being thrust at him by the author, and of course, he is capable of comparing all that he sees with what he has seen previously. The concept of the public project in our discus-sion presupposes a rather complex, and one might say, "multi-tiered" viewer. In the most general terms, I will reduce him to three types. The first, especially important type, is as the "master of this place." He is the inhabitant of this city, these streets, this country where the artist has been invited to build his work. He is very familiar with everything beforehand, he has grown accustomed to this place, he lives in it. Everything new that will be placed here, he will perceive as the owner into whose apart-ment something has settled, and he either has to accept it, accommodate it into his normal life, or he has to discard this extraneous, repulsive, and completely useless thing— a reaction that is entirely natural and antici-pated. Hence, the inter-relationship between the public project and the viewer, by virtue of the viewer's living in this place where the artist is a guest, turns out to be fundamental.

The second type of viewer turns out to be the tourist. Tourists are a large tribe now racing all over the globe and they are interested in something a bit different than the owner when viewing a public project. A tourist is interested in the unique characteristics of a place he has visited, the unique accenting of it, and for him the public project he sees there should be somehow characteristic, even perhaps peculiar. The tourist should see the public

project in its capacity as reflecting some sort of unique trait of this place he is visiting, he should see the public project as an important spot in this locale, this city, this street, this space; something that he should remember among all his other tourist impressions. It is the kind of place to which he is brought by bus or finds in his own wanderings around the city because of the impression it creates as a curious, strange and special object. Therefore, this project must be very contrastive, but not in the sense of modernist contrastiveness, but rather in its capacity as a characteristically unique feature of precisely this place, connected with a specific cultural field, the cultural circumstances of this place.

And finally, the third viewer for whom the public project must be considered is the passerby (we shall call him a flaneur), the solitary passerby at the moment of his scattered-meditative stroll, like when we are not really involved in our constant everyday cares, but rather are contemplating various distracting subjects, problems in life, culture, our own memories, sentimental or romantic; I repeat, when we find ourselves in a scattered, solitary journey through life. In this case the public project should be entirely oriented toward this state and toward this kind of viewer who is escaping and is submerging into some other kinds of imagined spaces, such as the past, for example, where certain associations, memories arise. This is that same romantic wanderer, namely the kind of romantic personage and not just a tourist who was described well in the nineteenth century, that same one who visited Italy, who visited other countries and, wandering around his own city sometimes estranged and in a certain state of half-sleep, half-awake, pauses before something that suddenly seems interesting to him.

Another question then emerges: who is this artist who relates to his task in an entirely different way, not like a modernist, to create his work? If we were to label the position of the modernist artist as the position of the master, demiurge and prophet (in fact, such is his behavior and the program of creating his work in a public place), then the artist of a different type, kind of artist we have begun speaking about here, can be understood as his complete opposite. The term we could apply here would be "medium"—the artist has the position of a medium who not so much dominates and terrorizes the place in which he finds himself, but rather listens to it attentively, or, it is better to say, is attuned to the full perception of that voice, that sound, that music, which is supposed to resound in this place. This music, this sound, these voices are especially clearly heard in those places where the cultural layers are very dense, where deep levels of a cultural past exist. The artist tunes his internal hearing to those voices that constantly—and if you listen to them with strained attention then they are very loud—resound in each place where a public project is proposed. Hence, the demands of these circumstances, these signals resounding in the atmosphere that the medium is supposed to perceive, emerge as primary. And these signals are rather precise, and the medium hears them out, and naturally, fulfills those demands, those requests and those expectations that might exist in this particular place, as in any other. In other words, each public project understood in this way is the result of the activization and realization of these voices, the voices of culture, the voices of the place itself that concentrates and literally produces what they anticipate. The artist only compresses and embodies those ephemeral atmospheric

expectations, those programs which would inevitably emerge in this place. The artistic project turns out to be not something delivered and cut into, inserted into an alien environment, but just the opposite: this environment somehow engenders and forms the very image which is already rushing about in the air, that is already presupposed here, that is anticipated. The artist-medium only hears this sound, this expectation and brings it to fruition. What emerges as primary is the decisive significance of context and environment, the circumstances present in this place where the cultural project, the public project is to be built. This includes not only the studying of the historical circumstances, events that occurred here, the streams which pass through here. We are talking more about the reverence for culture, not so much for the very facts no matter how important they might be historically, but more so for the aura of the place that has been shaped here by the past centuries.

When we are speaking about the aura of a place, we are speaking, of course, not only about specific objects, specific buildings, or historical circumstances connected with it all requiring the study of the history and of the specific life of this particular place. We are speaking about the numerous cultural "layers" that concentrate the very place itself. We are talking about the "illumination" of the historical depths, about the well which is always resounding and where one image is layered on another when we find ourselves in this place; we are talking about that very activization of the memory which is what creates the multilayered and multi-voiced resonance. Not only should the memory be put to work, but so should the imagination which restores all those layers that are mixed up and intersect

with one another. This means that besides the material, besides that which is etched in stone or steel, in something hard and sturdy, there exists another, unique "airy medium," something spiritual, an atmospheric network that is concentrated in this place and includes the sky above our heads and the ground beneath our feet and the grass nearby. It encompasses not only what we see, but also what we do not see, primarily the intervals, the voids, the spaces between objects: after all, the meaning of the intervals, the voids is no less important than the significance of the objects between which the emptiness is located. These voids say and mean no less than the objects themselves.

A public project should be completely naturally connected with all these circumstances, and it should participate with all its parts in the already existing ensemble. But we are talking about how it should insert itself and become a natural part, not only visually with the aid of all kinds of active, constructive "tricks" and devices that are well known in art. If around it there is a horizontal environment, then it might wind up being vertical, and if the environment is chaotic, then it might be geometrically precise, but it should function so as to be noticeable not only as an irritant to our eye, not only as a "visual attack," but it should also possess the qualities of a silent dialogue, a more profound and intricate contact with the place where it is located. Yes, of course, it has to be visible. But this visibility should not turn into an attack of modern art, where only I am visible against the backdrop of all the others. In the case of the public project as we see it, the other does not function as a background for it, moreover a background that is dead or incapacitated by the object's activity, but rather it turns out to be a partner in the con-

Ilya Kabakov, *The Weakening Voice*, 1998, on the occasion of the exhibition *Arte all'Arte,* Colle di Val d'Elsa

Ilya Kabakov, *The Illuminated Window*, 1998, on the occasion of the exhibition *Arte all'Arte,* Colle di Val d'Elsa

versation, a normal interlocutor and a respect-ed colleague that it—the public project—should be in relation to the rest of the sur-rounding space. Its participation in this already existing ensemble, the dominant role of the ensemble as a whole and not merely of some leading voice in it, connects the public project to the *Total Installation*.

From what has been said it is clear that our attitude toward the public project is primarily that of an installation.

This is not a sculpture. Much is said about how a public project is a sculpture. But for us it is not a sculpture at all, but rather is the kind of installation object that we had been creating during the entire previous period. The public project belongs in the same series as the *Total Installation*. Only in contrast to the *Total Installation* where the totality was a total-ity of a new world, a totality of an imported world, a world from Russia, Soviet Russia, with the public project the total installation is now constructed inside the layout of an already existing cultural environment which existed long before this began to be built into this cul-tural medium. The public project functions as one element of an *already existing installation*, it transforms any, even an everyday spatial environment, into the space of culture; it often transforms even the most banal environment into one that is activated in its capacity as a cultural environment. This is a paradox that is difficult to explain logically: in what way is an installation structure inserted into an everyday or natural environment? And it has pretensions that now it will not simply participate in an anonymous, banal space, but rather it will re-work that space into a cultural whole. Hence, what occurs is a transition from a banal envi-ronment that surrounded the installation into a public project that reworks this environment

and imparts to it another level of existence. This is a very interesting issue, and in each separate case we will show how this is realized technically. Of course, this is a very difficult process, since when you build an installation in an art institution, its "culturedness," its artisticity is guaranteed by the artisticity and culturedness of the very cultural place itself—a museum, an exhibit hall, etc. To rework the banal space of an ordinary city or even of nature in order to bring out its cultural image and in general to make it into an artistic image is a rather interesting task and turns out to be the decisive one for a public project. Will it succeed or not? Or will the surrounding banal space devour it because of its weak-ness, its misguided consideration of the place or the weakness of the concept; or will the artistic resolution of the public project trans-form this space so that it will stop being banal, while remaining banal in essence. Over the course of our work we have formulated the conception of the public project as functioning as a unique "installation." Installation meth-ods allow for the differentiation in a public proj-ect of its transparency or its lack of trans-parency. Although a project often turns out to be made of very hard materials—bronze, mar-ble, and the like—the overall orientation requires that these projects be created in such a way that they can be maximally transparent so that communication and contact with the environment clearly develops around them.

A public project should always and in the most active way communicate with what is included in it, what stands behind it. The degree of transparency must be maximal.

A no less important requirement is the con-sideration of the significance of the spatial ensemble, and not its sculptural qualities. Although many components of our installation

have been sculptural, what is important is that these sculptures do not affix ones' attention, but rather appeal to the environment, proposing that we see ourselves together with that environment. They invite us to consider ourselves part of the environment and not merely its main characters against the background of this surrounding space. This is a difficult task—to ensure that we see the object together with the environment. This will become clear if we use the example of Giacometti sculptures. They are supposedly made from bronze and possess a finished form, but they experience the influence of the air, the wind. The wind blows, the air squeezes itself into these sculptures, they appear to be material impressions of some sort of forces that we do not see. And at the same time, we see them quite clearly. Any one of these sculptures is the result of the affect of these forces, they suffer from the pressure of the invisible that compress the sculptures from all sides, pressing into them some sorts of figures. The presence of what surrounds us, similar to spirits, must obligatorily be present in such projects that we are calling installations. The installation includes the direct participation of the absolutely entire surrounding world in what you are exhibiting.

Since the word *spirit* has slipped in, it is impossible not to discuss its fundamental influence, its almost magical interference in what we don't see. Moreover, the spirit of a place produces similar projects that we will be speaking about, but this spirit is the main hero. Behind all the images that constitute an installation, behind the artistic world that it creates, stands something that governs it,

Ilya Kabakov, *We Are Free!*, 1998, on the occasion of the exhibition *Arte all'Arte,* Colle di Val d'Elsa

coordinates and gives shape to this entire world. As a result, the viewer should have the sensation that something entirely non-material stands behind all of this, something strange, of an entirely euphoric, irrational origin. It is extremely important that this background, a background that is very active and that governs everything is present in both the artistic conception and in the finished result.

All of these installations are constructed in such a way that they create the image of standing on the edge, on the side and along the contour of figures that under no circumstances occupy or form the center. The problem of the center and the periphery, the center and what surrounds the center is in and of itself an interesting one. The public project and any monument, especially a public one, in essence occupies a very central position and represents an axial image. What I have said in part contradicts the very fact of existence of a public project because such a project must always be located in some sort of center, and everything around it—the environment, the buildings, trees in the park, etc.—surround it. You wind up struggling with what is obvious and self-evident. We shall see later that many of these public installations are built precisely not on the idea of the environment, the idea of the non-centrality of the object on which our sight concentrates, but on the contrary, it's as though the center is fleeing, you are all the time looking at something that is slipping away, moving away from the center, it is centrifugal and not centripetal. This trick that upsets the concentration of your attention appears rather unusual. The question immediately arises: Where is the center of the project that is summoned to be in the middle and to attract our attention? This center undoubtedly becomes nominal, a center that the viewer

himself forms by concentrating his own personal fantasies; the viewer's own attention and his own personal reaction forms the intellectual center, but it is not at all a physical center. The installation more than likely represents a surrounding system of mirrors or antennae that project their energy and their associations on the subjective perception of the viewer, and strange as it may seem, the viewer and not the object that he is looking at turns out to be the center. This paradox is resolved in the installation rather successfully, since it is obvious that no one of the participants is the main one, but each is just a part of the ensemble. As in a symphonic work—the soloist is only distinguished briefly from the common sound, and then again merges with it, drowning in the overall flow of the music. In this sense, it is easy and interesting to compare the principle of constructing such installations with ancient traditions, traditions of ancient Greek theater. The role of the leader of the chorus is to stand out from the common group only for a moment, then his action is supported by the entire chorus and he again disappears into it. That is, he stands merely two steps ahead, only to dissolve into the mass again. The main characters of the festivities come out of the circle of dancers only for a moment, only to enter back into the common dance again. The same is true for the ancient gods, who step out from behind the trees or bushes for a moment only to hide again or run into the woodsy thicket. This presence of the common mass, nature, the chorus is necessary for the soloist, the main character or anyone else who then dissolve back into it; this principle explains the role of the background of any public project. Herein rests the harmony between the environment and the object that steps out of this environment.

Other associations also surface with the word harmony—tranquility, equilibrium, other therapeutic calm meanings. All public projects that we have done are aimed not toward confrontation, not toward provoking paradoxes, not toward agressivity or attack, not toward destruction, but rather they are built on, one might say, their calming qualities. All of them have a principally positive meaning and represent the continuation of the romantic tradition with its melancholy, its tranquility, its reflection, and its memory. This aspect of positivity, if we think about it, is connected to the fact that the main guiding principle here is our attitude toward culture, that is to the fundament which supports and inspires all these public projects. Namely, faith in the fact that culture "supports" and will "support" henceforth any work of art that exists or will exist near it and will "feed" on it—this is the ethical "platform" that was clear to us during the entire time we were realizing these projects. Analyzing all of this, one might say that here we are talking in part about the tradition of the Russian nineteenth century, that looked at European culture with enormous reverence and respect, considering itself to be an important part of that culture which was always considered to be the cradle, the foundation of all reflection present in the younger Russian culture. Such an attitude toward European culture, at least for me, was deepened by the fact that Soviet culture was subjectively perceived as the interrupted and even destruction of that European tradition. Therefore, European culture for children born into the Soviet era was perceived through the prism of that romantic, nostalgic crystal that shines to us from the depths of the past and represents a wonderful landscape that we, living in the Soviet Union, were ultimately and completely deprived of.

Whether this is so or not in reality is another matter, but such a lofty, ecstatic attitude toward European culture, toward the meaning of this culture for today and for those living today, saerved for me as the basis of all kinds of possible improvisations, ideas and images that emerged when we were presented with the opportunities to make something like a public project.

We shall end this foreword as we began it, trying to describe the biographical elements of our engagement with public projects. We began with the biographical, subjective reasons and shall end with the same kind of subjective story, a story about the meaning of a culture in the imagination of a Soviet artist who has been presented with the opportunity to make something on the territory of that very culture. This is a form of gratitude, or a form of internal applause, at the encounter with those origins to which we personally do not belong anymore, and do not possess, but which turn out to be a distant, almost unconscious memory of ours. This memory, this beautiful dream was the energy reserve, the stimulus and the reason for the enthusiasm that prompted the emergence of all kinds of images and ideas for building public projects.

As soon as we would arrive at a certain place by invitation, my hearing would immediately tune into the sound, the voice of that place, to the cultural aura, and the spirit that lived and hovered in that place, the spirit of the place. "Geist des Ortes" (spirit of the place) would quickly dictate in your ear, it was the very same demon that would cast these images, and these images would burst forth quickly, clearly and abruptly. This spirit would dictate: if I were a poet it would have dictated some sort of verses, but in this case it dictated some sorts of images, figures that this

Ilya Kabakov, *Looking Up. Reading the Words...*, 1997, Münster

spirit would demand to be built and realized here. Everything surfaced from the subconscious, surfaced from the inner hearing, and remained only to be realized materially and built. I think that there is nothing new or mysterious in this story. Something similar, I think, was experienced by the exalted German artists who visited Italy in the sixteenth and seventeenth and especially eighteenth centuries, those romantically attuned poets from the countries of Northern Europe and Germany who visited this country and who would mutter to themselves the verses that would emerge, because behind every turn they would discover those sights that until then they had worshiped ...

I. MATTER IN GENERAL
374. UNIVERSE
375. MATERIALITY
376. IMMATERIALITY
377. MATERIALS
378. CHEMICALS
379. OILS, LUBRICANTS
380. RESINS

Public Text

JOSEPH KOSUTH

After nearly thirty years of a kind of informal division in my work between temporary outdoor projects and works and installations in museums and galleries of a more permanent nature, I have found a particular pleasure in doing permanent public works. Working directly with a public space—framed with other meanings than those associated with the specialized institutional ones within art—presents a new challenge of a particular kind. The special task in doing such work is to make certain that it is appropriate to the context. How we define "appropriate" describes the interface between the viewer/reader and the artist as a producer of meaning. This is in terms of both the focus of the work, as a project with a subject area, as well as the social and cultural context of the community which receives it and must live with it. An important consideration, and that which has made it a special challenge, is that such work must be accessible to a non-specialized audience, while, at the same time, providing an enriching cultural contribution *as* it makes a serious addition to the body of my work. The assignment is a different one from working in a museum, for example, which can presume a certain knowing audience. There is a kind of social contract to working in a space shared by many, and the artist has some responsibility to provide a level of attainable meaning. The task is to do that and not compromise one's problematic as an artist.

However, long before I began doing public works with this objective, I found the public site an important one to locate my work. *The Second Investigation* (1968/69) was partially my own critical response to earlier work of mine utilizing photographs in both *The Proto-investigations* from 1965, with works such as *One and Three Chairs*, and *The First Investigation,* begun in 1966, which was made of photographs (negative enlargements of texts such as dictionary definitions and etymological entries) which were, as a form of presentation, intended to be made and remade as a device to eradicate the aura and reliquary of painting so other questions could be raised about the nature of art and language. As a result, photography eventually emerged within what later was perceived as a kind of "avant-garde" practice and led me to abandon its use in 1968 for the next several years, and to begin *The Second Investigation* and its use of anonymous public media. While a kind of "fine art of photography" had existed for some time parallel to the activity of painting, it had all of the problems of painting. It was both old conservative (with the popular appeal of "realism") and new conservative (media-defined along with the best of modernism.)

In 1968 the arrival of work of colleagues of mine eventually to be associated with conceptual art, as well as the need of "earthwork" artists to have a gallery presence, meant that photography was increasingly being seen as a

Joseph Kosuth, *The Second Investigation (Art as Idea as Idea)*, 1969, Portales, New Mexico

part of an avant-garde practice in ways which it had not since Man Ray and other Dadaists earlier in the century. Thus, while this was a time when others were then beginning to use photography in their work, I came to the conclusion that photography was beginning to share many of the limitations of painting: defined formally and technically—be they the perception of either limits *or* innovation—and *a priori* establishing its meaning as art through the *authority* of such form. It seemed to me that *all* media-defined art activities were beginning to share this characteristic. For me, the nature of art had become the *questioning* of the nature of art. Yet forms of authority clearly stop this questioning process. And, in keeping with how Clement Greenberg defined modernism at the time, the modernist institutional view of art was that it was comprised of a Kantian quest to find the limits of the medium. For me, however, the question was a larger one: how does art produce meaning, first about itself, and then as "itself" in the world? To find this out I felt I had to ask: how does art generate meaning as art *outside* of such a formally authoritative context? It was as "a work in the world" that we can not only understand how art produces its own meaning, but also how culture itself is produced. I turned to the use of public media as a presentation device for several reasons. It severed the event of the work from the kind of physical form of art which one associated with the high style of modernism. Since one didn't expect to find "art" in a space reserved for advertising (such as billboards or newspaper ads) it wasn't defined as art *a priori,* as painting, sculpture, or photography is. It made completely clear that a formalist approach to the work would be absurd. In this way, it could not appeal to certain inherited forms for its

validation as art. Yet, in spite of this, it still *was* art. What this could then tell us was that there was more to the activity of art than, say, the manipulation of forms and colors. It enabled me to separate the activity of art from this conventional understanding of what art could be. In this way the work was able to ask questions within the practice itself which a more traditional form of art could not. There was a political content to this process as well. My generation had real questions to ask of institutionalized forms of authority of *any* kind in 1968. Painting seem insular and elitist. Using the organs of mass culture without the pandering to the masses (à la Walt Disney or product advertising) had a distinct appeal to me, and it reflected the particular interests of my political activism at the time.

The Second Investigation was my response to this situation. While I felt such work as *One and Three Chairs* had initiated such a questioning process, it was increasingly limited by this new reading being given to work using photography. *The Second Investigation* work used as its "form of presentation" anonymous advertisements in public media such as newspapers, magazines, billboards, handbills, and, as well, television advertising. This is understood to be the first known use of such a context for the production of artworks, and it should be seen as something specific and quite different from the billboard art which followed in the next decade, where this presentational stategy was often used as an end in itself. The content of the advertisements I utilized in 1968 were based on a "taxonomy of the world" developed by Roget as The Synopsis of Categories for use in his thesaurus. Each ad was an entry from this synopsis, which, in effect, put into the world the frag-

Joseph Kosuth, *The Second Investigation (Art as Idea as Idea)*, on the occasion of the exhibition *When Attitudes Become Form*, Kunsthalle Bern 1969

ments of its own description. What this initiated, of course, was a questioning of the ontology of artworks: the role of context, of language, of institutional framing, of reception. For me, the concerns of this work focused clearly on what was to remain a central concern of my art.

It was apparent to me by the mid-sixties that the issue for new work was not around the materialization or de-materialization of a work, in fact, it was not even *concerned* with materials. The issue which defined my work, as well as that activity which became known as conceptual art, was the issue of signification. What are the questions pertaining to the function of meaning in the production and reception of works of art? What is the application and what is the limit of language as a model, in both the theory and the production of actual works? Then, following from that, what is the role of context, be it architectural, psychological or institutional, on the social, cultural, and political reading of work? It was these issues which separated conceptual art from the modernist agenda which preceded it, and it is this *non*-prescriptive practice which has remained flexible enough to endure and, quite obviously, continues to provide a basis for conceptual art's relevance to recent art practice. Indeed, what is interesting is that when I started my activity it had to have a special name, "conceptual art," but the work of younger artists now, fortunately, can just be called art.

Joseph Kosuth, *Text/Context*, 1979, Galerie Paul Maenz, Cologne

At present, my approach to public art aspires to integrate several aspects that are important to the location. They attempt to provide a "monumental" view to the experience of members of a particular community to their own historical presence, and manage to do so without the normal sentimental and institutionalized aspect of city monuments. As a work of art its context becomes the content: again, it's the architectural, the social, the psychological, and the cultural—as well as the historical terrain which binds them. With this objective in mind, such work utilizes both the historical and cultural aspect of its location and its role in contemporary life. In such projects as mine, the experience of the work becomes one and the same as the architectural environment in which the work is seen, humanizing what is often experienced by individuals as de-personalized public buildings. It is for this reason that such an art project must be seen as integrated, both in conception and in fabrication, as part of the whole urban experience and not be treated as a separate additional object which was added afterwards, as more traditional public art work often is. The buildings of any community are the repository of the life which has taken place there, and its accumulated meanings. This is, finally what history consists of.

The final selection of specific aspects of any given work, as well as the quantity of elements in a work, is established by the material gathered by the research for that site along with the physical configuration of the architecture—with that in itself having social and cultural implications, not simply formal ones. The limits each of these aspects imposed on the other lead up to the final selection, thus consitituting itself as a kind of internal organization of the work. The locations are chosen to provide both a quantity of contexts to anchor the work, as well as to provide an "overall" presence and effect: this permits the work to be experienced as it provides a unifying aspect to the architectural diversity of any particular site. Often the project of a work is to utilize a variety of elements which are meaningful in their specificity, while, at the same time, to construct a larger comprehensive meaning as a group. In short, such projects can be viewed as both a series of works as well as one large work in parts, and, indeed, they are often both. The types of historical and cultural material I consider when I do research for a work is really unlimited. This must be the presumption of any creative process which employs historical material for a project such as mine. My approach to the use of such material, similar to the decision-making process in selecting the material to begin with, is what, to a great extent, ultimately comprises the work. The play between this part of the process and its manifestation in relation to specific sites in the community, forms the complete work. To begin with, as its "root," even before how each text becomes an element of a work of mine, each text also represents a concrete moment in the history of the intellectual life of that community, and each is a telling fragment of one actual individual's personal contribution to the history of ideas. My use of their words, their thoughts, is to honor them as I also build something of my own.

But, you ask, what are these works which I have built, and why? In fact, how is it even *your* work, since the words are the words of others. I would answer like this: as artists we all begin to construct with what is given. We appropriate fragments of meaning from the detritus of culture and construct other meanings, which are our own. In the same sense, all writers

write with words invented by others. One uses words with prior meanings to make paragraphs which have a meaning of one's own. It was clear by the mid-sixties that the existing institutionalized form of art, the paradigm of painting and sculpture, could no longer itself constitute being "a paragraph of one's own." It had, for artists, become the sign and signage of the *ideospace* of modernism: an overenriched context of historicized meaning signifying itself and collapsing new meanings under its own weight. By reducing *any* ingredient of cultural prior meaning to being a *smaller* constructive element (a "word" element) I could then construct other meanings at another level, producing "a paragraph of my own" and still remain within the context of art sufficiently, I felt, to alter it. This has been a basic

aspect of my practice and has, for over thirty years, necessitated some form of appropriation, and it is evidenced throughout my work beginning with examples such as *One and Three Chairs* (1965) through to *The Play of the Unmentionable* at the Brooklyn Museum (1991) and, as well, now with *Was war also das Leben*, my project for the German Parliament in Berlin.

Others have asked: is work such as yours "visual" and are you concerned whether it is "beautiful"? And, I confess, I cannot distinguish between "visual" and "conceptual" when the knowledge of a work's elements and its internal play is acquired visually. A concept must be communicated to be known. (In fact, eliminate the legacy of formalism, and the question becomes nonsense.) The reading of

Joseph Kosuth, *The Material of Ornament*, 1997, Fondazione Querini Stampalia, Venice

Joseph Kosuth, *Ex Libris, J.-F. Champollion (Figeac)*, Figeac 1991

Joseph Kosuth, *Freedom and Belief (Their Own Affair)*, 1998, Parliament Building, Stockholm

the texts and understanding the play between them and between them and the architecture is all visual. In any case, I certainly accept as a potential given all of the meanings and experiences which the work generates, including both "beautiful" or "ugly." However, I think to understand the work, in terms of its having a history and a context, is to comprehend the very limited role traditional aesthetic reception has to this work's deeper meaning(s). In other words, the extent of the role of traditional aesthetics in the play of the work is provided by the viewer/reader, and providing that by them probably risks blocking their appreciation of the work. Still, aesthetic responses to one's experiences, whatever they are, are hard to control or deny. One can, however, more easily control the desire to theorize about those responses. I think of the comment of Roland Barthes, "A text is not a line of words releasing a single 'theological' meaning ... but a multidimensional space in which a variety of writings, none of them original, blend and clash. The text is a tissue of quotations drawn from the innumerable centers of culture."

To make a work which plays with history is, of course, to acknowledge that such a work is a play on the postponement of meaning, it is a play of delay. All you can see of my contribution is a view of the artistic process itself, for when meaning is the material of one's work it remains a gap, something between the lines. It is, however, through, that gap that art sees the world, and then begins to change it.

Contribution to the *D&S Ausstellung*,
A Group Exhibition of 56 Artists Which Took Place at the
Kunstverein in Hamburg, 1989

MICHAEL ASHER

The project consisted of eight postcards. Each postcard has a photograph of a truck printed on the front and descriptive information printed on the back. The trucks photographed were at the same border crossing on their way from Hamburg to what was then East Germany. Each truck was hauling different types of waste products to be dumped into landfills and other disposal sites in the Eastern bloc. Many of these landfill sites had resulted from the extraction of natural resources which had then been exported to more powerful industrialized nations. For each load accepted, the East German government was then paid an amount based on weight and toxicity.

The information block on the back of the postcards included the manufacturer of the truck, model, manufacturer of the container, contents, point of origin of the truck, its destination, and the date and the location of the photo. Some drivers felt they could not answer all of these questions and this was also recorded in the information block. It also became apparent from some drivers that documentation of the trucks might compromise them unless their license plates were cropped out of the representation on the card.

Once printed, the postcards were made available for purchase from a carousel at the front desk of the Kunstverein.

I first became aware of the *D&S Ausstellung* in March of 1989 when I received an invitation to participate along with a copy of the exhibition concept. The invitation was in English and read as follows:

"Dear Michael Asher—The reason for my letter is that I would like to introduce you to a project called *D&S Ausstellung* which is organized by the Kunstverein in Hamburg and planned for fall 1989.

Its aim is to present current artistic contrasts by contemporary artists who cope with the theme of 'real-art, reality's art' (Realkunst—Realitätskünste) in their works and to show art's everyday-nature, fictionalization and internationalization.

D&S Ausstellung works beside a central space with various places and different ways of representation. The exhibition will put in direct confrontation the European versus the American practice within this framework."

Initially I was puzzled by the passage in this letter which expressed the theme of "real-art, reality's art" (Realkunst—Realitätskünste) in juxtaposition to art's everyday fictionalization and internationalization.

The exhibition concept attempted to clarify the theme in this way:

"July 21, 1969. Neil Armstrong is the first man to step onto the surface of the moon. Fully conscious of the mass media, he nevertheless declaims in an apparently spontaneous way, 'A small step for man and a large step for mankind.'[1]

McLuhan's idea of an electronic network as the nervous system of a global village had

Michael Asher, *Postcard Project for the D&S Ausstellung*, Kunstverein Hamburg, 1989

become reality of the first time—a reality that was shown on millions of televisions and monitors through the means of an electronic beam. Yet immediately the subversive question arose: did the moon landing really take place, or was it a staged media event? Became reality a surrogate of itself?

We appear to experience reality only via the television or movie screen. There, in the media, it acquires the kind of presence that it has lost in everyday life. The omnipresence of electronic images lets reality in its entirely appear as a picture; the media images pushes itself in front of reality and begins to substitute for it. This has repercussions on art, which always found itself in an imitative or represantative relationship to reality, especially when it tried to undermine any such thing. The early avant garde movements illustrate this …"

Reality implies art. Art has become a repertoire of public consciousness. Its strategies make growing use of the quotation and the copy, as for example, reflections about the work of the new fauves in the ongoing discussion about post-modernism show. All historical developments which art has run through—are now available for their expressive potential. The medium is the message. The same goes for the reality separated from art, if such a thing can still be found.

In terms of "reality," was the exhibition concept implying that the media image wasn't reliable in delivering to a viewer the experience of the original event? On the other hand, how could the image be expected to stand in for an actual moment when the two-dimensional space it will eventually occupy is necessarily illusionistic, therefore telling the viewer that the image has been abstracted from another context? Furthermore, the moon-landing paragraph as well as the following two seemed to

suggest that the media image existed as a ground for infinite readings untouched by any external corroborating information and thereby furnishing such images with an unattainable meaning and an authority they might not otherwise have.

As for myself, I do not experience media-generated representations as having the "omnipresence" suggested in the exhibition concept, nor do I believe that the media is the primary clearinghouse of images. Moreover, the failure of the exhibition premise to distinguish among different types of media, which infers that they operate in similar ways, seemed to describe conditions which were not apparent in actual practice.

But for a moment let's agree that the television media has a major influence on how we understand images and that the ideas and representations taken from television can be used in art production. Then I would like to know from my perspective in the United States why I don't see many artists who utilize this media by selecting as their source such programs as "Handy Hints," which in the early 1950s showed the viewer how to reuse tomato cans, paper towel cores, and used Kleenex boxes for pencil holders, candle molds, or hardware organizers. I find it odd that codes from this period governing fashion and design, from furniture to studio sets, are quoted regularly in contemporary art practice while 50s models for avoiding waste are ignored.

While visiting Hamburg in the summer of 1989, I finally formulated the idea for the postcards of trucks used for the shipment of waste materials. My project was a response to the corollary I saw between the exhibition concept's reference to limitless meaning and the potential I saw for limitless waste, both being agents for the colonization of space, whether

Hersteller/Fabrikat:	Volvo
Fahrzeugtyp:	F 12 Intercooler
Hersteller Aufbau:	Roland Container Bau
Art der Ladung:	(Auskunft verweigert)
von:	(Auskunft verweigert)
nach:	Mülldeponie Schönberg/DDR
Datum:	15. 09. 1989
Ort:	Zollgrenzübergang Schlutup/Lübeck

© Michael Asher · Projekt für D & S Ausstellung

D&S

AUSSTELLUNG

Foto: André Lützen · Hrsg. Kunst im öffentlichen Raum

Michael Asher, *Postcard Project for the D&S Ausstellung*, Kunstverein Hamburg, 1989

Hersteller/Fabrikat:	Iveco-Magirus
Fahrzeugtyp:	26 030 Turbo
Hersteller Aufbau:	Atlas-Weyhausen
Art der Ladung:	(Auskunft verweigert)
von:	(Auskunft verweigert)
nach:	Mülldeponie Schönberg/DDR
Datum:	15. 09. 1989
Ort:	Zollgrenzübergang Schlutup/Lübeck

© Michael Asher · Projekt für D & S Ausstellung

AUSSTELLUNG

Foto: André Lützen · Hrsg. Kunst im öffentlichen Raum

Michael Asher, *Postcard Project for the D&S Ausstellung*, Kunstverein Hamburg, 1989

it be in the mind or in a debt-ridden country. The postcards were also chosen as objects that could conceivably circulate as waste and perhaps even be hauled by one of the vehicles depicted on the front. Should this happen, it would suggest that different groups of objects, some highly sought after and others in great need of disposal, share some of the same conditions whereby the objects or materials accrue value spontaneously. Only in retrospect does it seem like the choice of a postcard, an object which is easily discarded, was perhaps an attempt to resist an expansion of value for art while noting the expansion of value for waste.

Regardless, I couldn't help but wonder if one outcome in creating a separation between the producer of waste and the recipient of waste wasn't a way of guaranteeing that a disparity in wealth would be maintained through this type of truck transport.

No one that I was communicating with at the time seemed to anticipate that on November 9, 1989—during the exhibition—conditions would change radically: the Iron Curtain would fall, travel would no longer be restricted between East and West Germany, and unification would begin.

1 In 1989, while preparing my proposal for the Kunstverein in Hamburg, I didn't think Neil Armstrong's words were necessarily spontaneous, yet I didn't know when or how they came to be realized. While writing this paper, I found the following information regarding the lunar landing:
In *The First Lunar Landing: Twentieth Anniversary* by NASA Public Affairs, a reporter asks Neil Armstrong when he began to think about what he would say as he stepped onto the moon's surface. Armstrong replied: "Yes, I did think about it. It was not extemporaneous, neither was it planned. It evolved during the conduct of the flight and I decided what the words would be while we were on the lunar surface just prior to leaving the LM."
The sources I consulted indicated that Neil Armstrong's statement deviated from the quote in the exhibition concept. According to *Apollo—A Retrospective Analysis* by Roger D. Launius (published by NASA in the series "Monographs in Aerospace History," number 3, July 1994): "After checkout, Armstrong set foot on the surface, telling millions who saw and heard him on Earth that it was 'one small step for man—one giant leap for mankind.'"

★ Vermietung
★ Verkauf
★ Wartung
★ Behinderten-Spezial-Um-bauten mit Automatic !

CENTER Engnoth-Pöltl

80 95

aha RD 80 MX, schwarz-met., Neuaufbau 94, optisch wie neu, Kurbelwelle defekt, plus atzteilspender, 1.500,-. ☎(03391)39 70 41

aha TZR 80, weiß, 7 (17 PS), TÜV neu. 03362)755 62

aha Special SE, umgebaut auf 1er, 1.700,-. 030)615 86 42

aha DT 80 LC, EZ 8/90, rot-schwarz, ca. 29 n, TÜV 6/97, opt./techn. 2, VB 2.250,-. 030)975 74 34

dapp KS 80, wassergekühlt, TÜV 6/96, 00. ☎(030)795 38 08

●● ■■■ SUCHE

r Motorrad, ab Bj. 85, mögl. günstig. 030)604 85 50

rbreit, zuverlässig, alles anbieten. 0331)97 27 71

852 **Roller**

GELBE SCHWALBE

Das Projekt. Sie sind herzlich eingeladen zu einem Treffen von Gelben Schwalben! **Am 03. Oktober 1995 um 16:00 h an der Neuen Nationalgalerie,** Potsdamer Str. 50 in Tiergarten, um ein Gruppenphoto mit Gelben Schwalben als Skulptur zu machen. Es handelt sich hierbei um ein Kunstprojekt. Bitte kommen Sie und nehmen sie teil! Gabriel Orozco - DAAD. Infos unter ☎(030)324 69 52

Aprilia Amlco, 50, FS Kl III, grünmetallic, Scheibe, Koffer, neuer Helm, Scheckheft, Bj. 92, Versicherung bis 2/96, 6.100km, VB 2.400,-. ☎(030)601 04 13 od. ☎(030)664 13 16

Aprilia Red Rose, (sieht wie Yamaha Virago aus) 50 ccm, dunkelblaumet., EZ 7/92, FSK III, Extras im Wert v. 1.000,-, Diebstahlvers., NP 6.000,-, VB 4.350,-. ☎(030)495 51 90

Aprilia SR 50, Notverkauf, EZ 8/95, Versicherung, Schloß, Abdeckplane, 1 Jahr Garantie, absolut neuwertig, NP 4650,-, 3.800,-. ☎(030)396 56 31

Berlin, nicht fahrbereit, Vb 450,-. ☎(030)676 31 82

Derbi VAmos, Bj. 5/93, VB 2.500,-. ☎(030)855 26 74

Derby Vamos, 50 ccm, Bj. 7/93, 3,9 Tkm, unfallfrei, s.h.gepfl., sehr sauber, anthrazitmet., opt. sehr gut, 2.500,- VB. ☎(030)686 67 31

Derby Vamous Mokickroller, 49 ccm, Bj. 93, 3,5 Tkm, quarz-dkl.blau, abnehmb. Topcase, Windschutzscheibe, VB 2.700,-. ☎(030)401 49 98

Evolis, Bj. 4/95, Autom., 50 ccm, grünmet., m. Koffer, Zustand neuwertig, Versicherung bezahlt, fahrfertig, NP 4.500,-, 3.500,-. ☎(030)445 88 11

Helix Roller, Bj. 91, TÜV 4/97, rot, Topcase, Garage, 14 Tkm, 4.700,-. ☎(030)362 74 05

Hilfe, ich komme nicht klar, verkaufe daher Piaggio, 80 ccm, hohe Scheibe, Vollplane, nur wenige km, VB 3.650,-. ☎(05857)13 81/030-6878329

Honda Vision Roller, EZ 2/92, 50 ccm, 12 Tkm, Autom., E- u. Kickstart, Helmfach unterm Sitz, schwarz, Bremsen neu, Reparaturhandbuch, VB 2.300,-. ☎(030)614 97 47

Honda Ball 50, Automatik, Scheibenbremse etc., 3 km, NP 4.300,-, Vb 3.780,-. ☎(030)392 25 96

Honda DAX, rot, 900 km, wie neu, Bj. 92, versichert, fahrbereit, m. Topcase, VB 2.800,-. ☎(030)854 76 71

Honda Elite, 80 ccm, TÜV neu, 2. Hand, Bj. 91, VB 2.500,- auch Tausch mögl. ☎(030)883 18 16 o. 3235256.

Honda Elite 150, 10PS, 153ccm, BJ 92, 5.7Tmls, rot, 3.600,-. ☎(030)322 85 58

Honda Elite 80, blaumet., Bj. 10/90, TÜV 5/96, steuerfrei, 15 T-Mls., FP 1.300,-. ☎(030)607 85 34

Honda Lead, 80 ccm, wie neu, garagengepfl., 8 Tkm, Bj. 84, TÜV 4/97, 1.350,-. ☎(030)465 84 19

Honda Lead, blaumet., Scheibe, Front-Korb

Peug 400 3.1 Peu Fuß 3.8 Peug Kra ☎(Plag 4/9 Stu ☎(Plag Rei ☎(Piag gep Ein usw Piag Koff Plag Vers ☎(Piag 93, ☎(PK v VB Roll ☎(Roll Kra ☎(Rum zerl 12. Schw ☎(Schw ☎(Schw 690 Schw km, Schw ☎(Sch Ersa Sims ☎(Sims FP 5 Sims ☎(Sims Gep Inte Sims Lack 900 Sims oder

Until You Find Another Yellow Schwalbe
A Photo Series by Gabriel Orozco
FRIEDRICH MESCHEDE

When the Tate Modern was opened in London in summer 2000, the inaugural exhibition included a forty-part series of photographs by Gabriel Orozco. It was entitled *Until You Find Another Yellow Schwalbe*. Made in 1994/95 in Berlin it consists of forty different photographs (measuring 31.5 x 47.5 cm) showing two yellow mopeds next to each other. This series exists in an edition of three, and the one on show in the Tate was on loan from a private collection. In fact, by virtue of the way it was made, this series is more than just a photography portfolio: it is one of the most interesting public art projects to come out of the 1990s.

Born in Veracruz, Mexico, in 1962 and now living in Mexico City and New York, Gabriel Orozco came to Berlin for the year 1994/95 on the invitation of the Berlin Artists' Program of the German Academic Exchange Service. The first weeks and months of his stay passed relatively quiet in the company of his partner Maria Gutierrez. From time to time I met him at exhibition events in various galleries and institutions. Then in summer 1995 Gabriel Orozco approached me in order to present a proposal for his exhibition in the daadgalerie, namely a selection of forty photographs that he had quite unostentatiously been making over the past months. These had all been made in the streets of Berlin and all showed a yellow moped (with the trade name Schwalbe, meaning "swallow" in German) with an "iden-

tical twin", in other words, each photograph shows two mopeds of the same kind parked next to each other on pavements or at the edge of the road.

The exhibition itself, which then took place between October 27, 1995, and November 26, 1995, was to be preceded by the culmination of the project on October 3, 1995, in the shape of a public gathering of Schwalbe enthusiasts in front of the Neue Nationalgalerie (New National Gallery) on Potsdamer Strasse in Berlin.

So What Had Happened?

On his arrival in Berlin, which was completely new to him, Gabriel Orozco had fitted himself out with some "wheels" so that he could get to know the city in his own way. To this end he bought a used Schwalbe moped. As mopeds go, this is a fairly simple one, made in Suhl in the East German state of Thuringia, and a much sought-after brand in the days of the GDR. After unification it quickly became a cult object among those suffering from "ostalgia" (nostalgia for the former "Ostdeutschland") and is still feted in various Schwalbe Fan Clubs. The moped itself was available in three colors—green, blue, or yellow. Gabriel Orozco chose a yellow Schwalbe moped from the VEB-SIMON-Werke Suhl. The title of the work, of course, alludes to the ornithological brand name. Benjamin H. D. Buchloh has rightly

Gabriel Orozco, Advertisement for *Until You Find Another Yellow Schwalbe*, 1995

pointed out that in view of its design, origins, and significance in Socialist East Germany this moped now has the aura of a souvenir about it.

During his early exploratory excursions Gabriel Orozco started to see the situation more clearly. He found himself encountering other Schwalbe owners, more often in the former East of the city than in the West. Unlike the more imposing motorcyclists with their much more powerful machines and outfits to match, the Schwalbe riders were mostly just ordinary people, casually dressed, often young women, teenagers, the occasional freak, but all notable for the fact that they were friendlier and ready to exchange some form of greeting. The fact that a person was out and about on this particular brand and type of moped was a sure sign that this was a kindred spirit. It seemed to Gabriel Orozco that the Schwalbe riders he encountered were a particularly welcoming group on the streets of Berlin.

Then at some point, whenever Gabriel Orozco saw another yellow Schwalbe parked at the side of the road, he started to park his own next to it and to photograph the two together. The "souvenir" (B.H.D. Buchloh) from the East became the motif in what almost looks like a tourist's snapshot of an anonymous encounter. Little by little, therefore, Orozco's trips through the various districts of Berlin led to a series of photographs, each showing two mopeds parked next to each other. Gabriel Orozco always kept on riding around until he came upon a yellow moped: *Until You Find Another Yellow Schwalbe.*

Gabriel Orozco, Invitation card to other Schwalbe drivers *Until You Find Another Yellow Schwalbe,* 1995

Das Projekt - Gelbe Schwalbe

Sie sind herzlich eingeladen zu einem Treffen von Gelben Schwalben !
am **3. Oktober 1995 um 16.00 Uhr an der Neuen Nationalgalerie.** Potsdamer Straße 50, Berlin-Tiergarten, um ein Gruppenphoto mit Gelben Schwalben als Skulptur auf dem Vorplatz der Neuen Nationalgalerie zu machen. Es handelt sich hierbei um ein Kunst-Projekt von Gabriel Orozco, Gast des Berliner Künstlerprogramms des DAAD.
Bitte kommen Sie und nehmen Sie teil.
Je mehr Gelbe Schwalben kommen, umso größer wird die Skulptur.
Ich hoffe, Sie begrüßen zu können.

Gabriel Orozco

National Holiday—National Souvenir—National Gallery

As the project was drawing to an end, Gabriel Orozco came up with the idea of organizing a moped meet. He started by leaving flyers on the parked mopeds inviting the owner to a gathering on October 3, 1995. In addition he placed a small ad in a second-hand magazine in order to reach other special friends of this vehicle. The day, the purpose, and the place were carefully chosen. The day was the Day of German Unity, a newly created national annual holiday held on October 3 each year, the day on which the Treaty of Unification was signed in 1990. The gathering was to celebrate a cult object from the former GDR in front of the Neue Nationalgalerie designed by Mies van der Rohe, because of the name, of course, and as a conceptual framework for the artistic intention. The idea of a public sculpture, which had so far been presented as two objects in symmetry, was now to become as huge as possible, an accumulation, a combination dependent on the chance make-up of the participants. An improvised reception was put on to welcome the expected guests with drinks and nibbles. And so it was that on the Day of German Unity, 1995, Gabriel Orozco and his friends were joined by one Schwalbe fan from the town of Brandenburg who had made the long journey in response to the advertisement, and a mother and child from the Prenzlauer Berg district in East Berlin—rather astonished and clearly somewhat unnerved to find themselves at this gathering and helping to create a sculpture with all of three mopeds.

Photography as Sculpture

Gabriel Orozco made a name for himself both for his sculptures and for his photographs, in which he clearly expresses the three-dimensional, spatial quality of his thinking. Often his sculptural vision is sparked off by found motifs. In addition, his methods frequently involve mise-en-scènes with objects, arranged as a formal structure or to demonstrate a spatial dimension, as for example in the photograph entitled *Turista Maluco*, made in 1991, when Gabriel Orozco neatly placed single oranges on empty wooden stalls at the end of market day in a town in Brazil. Through the evenly spaced, colored points—with the oranges establishing some kind of order in the picture—spatiality is made visible. In this work we see on one hand an intervention by the artist, a time-limited action on his part; on the other hand we also see his desire to temporarily use a deserted, found situation for a particular purpose, namely to turn a public place momentarily into a privately poetic realm. Because the photograph is taken in a market setting, the viewer still senses the bustle of a scene filled with people. Orozco's treatment of this situation after the event contains the certain knowledge of the character of this public place as a narrative moment, which in turn acts as a foil for the other dimension of this place—the spatial dimension—accentuated by the placing of spatial markers in what seems like a deserted still life. Gabriel Orozco's photographs show clearly that they have been preceded by an action; they contain their own pictorial commentary, so that the arranged forms and objects will combine visually in a manner otherwise alien to them, whereby the goal is always to dissolve the existing meaning or sense, so that a new sensuality may emerge. Gabriel Orozco stages

a scene, always reckoning with the absent participant, who now becomes purely an observer.

This is a significant aspect of the project *Yellow Schwalbe*. By placing his own moped next to another at the edge of the road, taking a photograph, and then continuing on his way, Gabriel Orozco prevents any possible witness of this action from participating in it. It is only when the photograph is printed that the missed opportunity is evident. It tells of the absence of possible eye-witnesses. In this circumstance, we see a particular, conceptual notion of photography which treats photography not just as a document but, more importantly, as sculpture; in addition the public urban space is viewed as a setting for actions with a spatial dimension, where the public is always present—as a pre-condition—yet always excluded at the moment when the photograph is taken. Orozco's motifs are all just out there, the whole city is his space. In the case of the yellow Schwalbe it is clearly the juxtaposition of yours and mine—a basic social principle—which is being negated. The parameters of property and ownership are blurred in the moment when the shutter is released and the actual distribution of the items is obscured. It is no longer clear who owns which moped. Both are just as public, because they are entirely without identifying features. Gabriel Orozco plays the flaneur, who first made his appearance in the early twentieth century, and captures the pictures that arise in the streets he is strolling through. The parked moped is both a Readymade—a static object as defined by Marcel Duchamp—and an *objet trouvé* in the sense of a narrative prop from the early days of Surrealism. The motif is all the more incisive for being doubled, and, through its presentation as a series,

has a certain amount in common with artistic production in the 1960s.

Anonymous Sculptures

It was first and foremost Bernd and Hilla Becher who took Albert Renger-Patzsch's "sober" pictorial aims forward to create the notion of "anonymous sculpture" in the photographic image. A standardized perspective on motifs, additive accumulation of comparable objects, and the serial presentation of groups of works combine to subordinate the motif itself to a sculptural concept of that same motif, which moreover far exceeds documentary photography in the usual sense. The true importance of this is only seen today with the benefit of hindsight. In the afterword to their first, hugely influential publication in 1970, Bernd and Hilla Becher note with some restraint: "In this book we are showing objects which predominantly have some practical purpose; their forms are calculated and one can readily see in them the evolution of the structure. They are in the main buildings where anonymity is recognizable as a style principle. Their characteristic features have arisen not despite but because of the lack of conscious design." (Bernd und Hilla Becher, *Anonyme Skulpturen*, Düsseldorf 1970) With their references to purpose, anonymity, and the fact that certain aspects are readily visible, they created three criteria which have led to a new concept of photograph and sculpture and public places.

The photographs in *Anonyme Skulpturen* were taken between 1961 and 1970, and are thereby concurrent with the work of another artist who was using photography in a similar manner as a means to express sculptural phenomena. Between 1963 and 1972, Ed Ruscha

Gabriel Orozco, *Until You Find Another Yellow Schwalbe*, meeting in front of the Neue Nationalgalerie in Berlin, October 3, 1995 (Photo Friedrich Meschede)

published seventeen books, starting with *26 Gas Stations* in 1963. In all his books he takes a typological view of everyday architectural constructions. Both in his first book, which shows all the gas stations on Route 66 from Los Angeles to Ruscha's native Oklahoma City, and in the famous fold-out *Every Building on the Sunset Strip* (1966), the images from the route the viewer can imagine having driven down convey a sense of spatial distance—with an even greater rigor than in Bernd and Hilla Becher's typologies of industrial monuments. The work *Every Building on the Sunset Strip* consists of a fold-out strip 760 centimeters in length, so that in exhibitions viewers have to pace out the length of Sunset Boulevard in miniature. In the pictorial thinking of the Bechers and of Ruscha the anonymity of the buildings is of significance: a means to bring out the sculptural quality of the motifs. The archi-

tects are seldom named, the fruits of their labors are secondary to the original functional commission, which always has a practical purpose.

These approaches being explored in the 1960s by Bernd and Hilla Becher on one hand and Ed Ruscha on the other exemplify two fundamentals that are re interpreted in Gabriel Orozco's work. Unlike the typological order of the Bechers' pictures and in complete contrast to the linear structures of Ruscha's, Gabriel Orozco sets out to explore the disparate, net-like distribution of urban spaces. In the context of current theories of urbanism, Gabriel Orozco's work shows a city without a center and events taking place on the margins of where things are supposedly happening, and he only once located his own activities at the center of the city's art world—at the Nationalgalerie. The work *Until You Find Another Yellow*

Schwalbe is the first significant use of a series in Orozco's photographic output. Before that there had been individual photo pieces where interventions and sequences of events were clear or implied. But *Yellow Schwalbe* is the first work where the principle of a series as an additive sequence of pictures plays a constitutive role. In order that this principle should be evident throughout, certain images are even printed in reverse (which is obvious from any writing in them): no doubt so that all the mopeds would be "pointing" in the same direction, and so as not to destroy the sequence within the series.

Gabriel Orozco's use of the moped as a motif is in keeping with the iconography that he has consistently pursued in his own work. In 1993, he created the sculpture *La DS*, in which he used a Citroën car. By cutting a section out of the middle of this classic car, he made a "one-seater": a hybrid between a car and a complicated motorcycle with four wheels. And in 1994, in *Four Bicycles (There Is Always One Direction)*, he made four bicycles into one sculpture. With this multiple bicycle motif, Orozco was alluding clearly yet subtly to Duchamp's 1917 seminal work of Concept Art in which the motion of a mode of transport was brought to a sculptural halt. Such overtones of interpretation are present throughout his work. Vehicles, which are also always the products of industrial design process, mutate into sculptures. *La DS*, the two-part/one-part Citroën, looks like a mutation of itself, the bicycles multiply into a graphic composition of rotating motifs—again close to Duchamp— the mopeds, parked next to each other, seem in the photos like pairs of anonymous pieces of apparatus.

Until You Find Another Yellow Schwalbe is thus Gabriel Orozco's only series to date. It man-

ages to achieve a form of silent communication with the viewer, which gives the work its narrative appeal and its humor over and above its qualities as an example of sculptural-spatial juxtaposition. At the same time it is an artistic sociological study of the city which is captured on camera in the surroundings of the parked mopeds. The atmospheric serendipity of the pictures opens up associative narratives and creates a scenario for the anonymous sculptures like props for an open-ended story. None of the actors are in evidence, any action is taking place elsewhere, even the location is away from the center, and yet the salient features are all present at this moment in this place as it is shown in the picture. The individual pictures and the sum of the moments in the series thus become a metaphor of the circumstances and events that characterize the cultural environs of the urban space, which by virtue of its limitlessness conveys the widest possible definition of "public" and which demonstrates so vividly the chance encounters that arise in any metropolis.

With the series *Until You Find Another Yellow Schwalbe*, Gabriel Orozco has created a monument to a cult-object in the reunified Berlin of the 1990s, for like the famous Trabant car, known as the "Trabi," these mopeds are becoming ever rarer in the city streets; in that sense his action can be viewed as a metaphor. In an age when public art is proliferating and constantly clamoring for attention, Orozco succeeds in directing our attention in such a way that the object is more than a plastic artifact and urban jetsam (public art). By only momentarily "discarding" his work, parking, going on, documenting what he has seen, and constantly seeking out new locations for his encounters, he presents a pictorial manifesto of an approach which is implicitly critical of

other forms handed down from the past. His action initiated a stream of silent communication, which is only continued with the viewer once the work is shown within a public museum space. Gabriel Orozco has succeeded in creating a work in the tradition of conceptual photography in which the notion of sculpture occupies center stage, expressed as a form in the picture, and by definition creating a certain distance to the viewer, or, as Werner Büttner once put it: "The viewer is always just too late."

Kultur-Sponsoring

Sponsoring wird im Rahmen der Image- und Sympathiewertung gezielt eingesetzt.
Hans J. Baumgart, Daimler-Benz

Man kommt damit an Zielgruppen heran, die der klassischen Werbung eher zurückhaltend gegenüber stehen.
Hagen Gmelin, Deutsche Telekom

Wir sind kein Mäzen. Wir wollen etwas von dem Geld haben, das wir ausgeben. Und das schaffen wir auch.
Peter Littmann, Hugo Boss

Diese Programme bringen uns soviel Bedeutung, daß wir bei wichtigen Fragen gehört werden können.
Raymond O'Argenio, Mobil Oil

Für spezifische Marketingziele bieten sie oft kreative und kosteneffektive Lösungen, besonders wenn es um internationale Beziehungen und das Verhältnis zur Regierung und zu Verbrauchern geht.
Metropolitan Museum, New York

Es ist ein Instrument zur Verführung der öffentlichen Meinung.
Alain-Dominique Perrin, Cartier

Wer das Geld gibt, kontrolliert.
Hilmar Kopper, Deutsche Bank

Public Sights

HANS HAACKE

When people talk about art in the "public space," I like to put quotation marks around the word "space." Traditionally, one uses the term "public space" when something is installed out of doors—in the streets, squares, or parks—that is, in places belonging to the city, the state, or the federal government. Public space is not the same as being in "public." Events taking place indoors do not necessarily exclude the public. As long as they are not put on exclusively for a private circle, they fulfill the criteria for being public. From this perspective, events in commercial galleries, museums, and other generally accessible indoor areas belong to the public. In recent times, the public can be found also in cyberspace, which can be seen as a type of "public space." What happens in all these places can potentially affect public opinion. Because everyone in the public space has physical access to artworks, others and I, years ago, wrongly thought that these works were therefore not just for the initiated, but accessible to all, also in the communicative sense. Since the number of people seeing artists' works in areas tended to by the city's parks and sanitation departments is much larger than the number of museum and gallery visitors, we were also under the illusion that there we were reaching "the masses." That, too, was a well-meant, yet false conclusion.

It has to do with a naïve understanding of reception, reduced simply to the optical. In interior spaces provided for such presentation, the readiness to engage with art works is normally greater than "on the street." In the "sacred halls," they are met with greater attentiveness and a certain degree of respect. Only in rare cases does rejection lead to vandalism. Understanding reception as context-dependent is the daily bread of advertisers and public relations people. The usually considerable differences between the attitude toward works meant to be viewed inside or outside are narrower at events staged outdoors by art institutions, such as the *Sculpture. Projects* in Münster. The art public "takes to the streets." And because the national and international media comment extensively on the event, also people not interested in art pay attention to works installed on the streets and squares and in the city's parks. That does not protect them from deliberate destruction. The opposite can even be the case since the media interest increases the fetishistic aspect of the works, and thus destroying a work promises an even greater resonance. In my own practice, I have had experiences with many different presentation sites. None of them are free of restrictions. Apart from reasonable architectural and financial limitations, political forces often came into play and these were then, at times, inextricably linked with

Hans Haacke, *Standortkultur* (Corporate Culture), 1997, poster, on the occasion of *documenta X*, Kassel and 11 other German cities

213

financial conditions. On numerous occasions, the completion of a project depended on the courage, resourcefulness, and room to maneuver of those responsible for the exhibition.

I have been invited twice to the *Sculpture Projects in Münster*. My proposal for the first invitation in 1987 was not realized. The plan was to have a Münster city bus temporarily painted with camouflage patterns. Along the right side of the bus a question would have been added in white Helvetica (typeface) reading: "What do HIPPOS and this bus have in common?" The answer would have been found on the left side: "They drive through residential areas with Mercedes engines." Most passersby would not have been satisfied with that because they wouldn't have known what a HIPPO is. The explanation would have been found on the rear of the bus: "HIPPO = South African armored vehicle. Used by police against black inhabitants."

In 1987, South Africa was still dominated by the racist apartheid regime which was despised by the entire world. Although the UN had declared an embargo on all goods for military use, Daimler Benz delivered more than six thousand cross-country Unimog vehicles to the South African government. With the company's knowledge, they were converted to armored troop transporters (Hippos) and rocket launchers—or they had been shipped ready for military use. In addition, Daimler-Benz, in a joint venture with a South African state company, manufactured heavy and extra-heavy engines, and it built in South Africa the only automobile production plant outside of Germany. It now dominates the market. When he took over as CEO of Mercedes Benz of South Africa Ltd., Jürgen E. Schrempp explained in 1985: "I see great possibilities in this country, and that is not simply lip service. We are here and we want to stay here." He led the South African Mercedes affiliate during a bitter strike of their black employees. He has since moved on to become the CEO of DaimlerChrysler.

The Stadtwerke Münster (municipal services of Münstwer), whose advertising spaces are operated by the Deutsche Städte-Reklame (a nationwide municipal advertising company), refused to cooperate with my project. Advertising with political content is not allowed on city vehicles, they said. Furthermore, camouflage paint interferes with general traffic safety.

Ten years later, the Deutsche Städte-Reklame sponsored a large poster (350 x 175 cm/ 138 x 69 inches) that I designed for *documenta X* in Kassel. In 1997, four thousand of these posters were displayed on advertising kiosks in twelve large cities. On the poster, in front of the photograph of a slice of ham, one could read how companies assess their strategies as sponsors of culture. One of the people quoted was a spokesman of Daimler-Benz: "Sponsoring is used purposefully as part of image and good-will promotion." A splendid Renaissance chest served as the background for the culturally hygienic conclusion (set in gold letters) of the former chief of the Deutsche Bank, Hilmar Kopper: "Whoever pays controls."

Although the poster covered the entire surface of the kiosks, it was probably noticed only in Kassel, where it could be seen in three places of the *documenta parcours*. But even there, visitors to *documenta* paid attention to it only in passing. A widespread allergy to continual visual bombardment in the urban landscape leads us to block out many of the appeals for attention. A complex poster with relatively small elements therefore disappears easily

in this visual noise. There was little resonance in the media. The debate on public policy I had hoped for did not occur. This example demonstrates that mass distribution in "public space" (which is dominated by advertising) does not guarantee participation in public discourse.

In the same year as *documenta X*, another of my projects, *Standort Merry-Go-Round* (German Merry-Go-Round), was carried out in the *Sculpture. Projects in Münster 1997*. Although focussing on a monument on the city promenade (compared to four thousand posters plastered in twelve cities it was geographically extremely limited) the project attracted a great deal of attention, not just in Münster and Germany, but internationally.

At this location, in 1909, a pompous nationalist celebration had been held to celebrate the dedication of a cylindrical war monument made of huge stone blocks. The monument commemorates the Prussian victories of 1864 in the German-Danish War, of 1866 in the Austro-Prussian War, and of 1870 In the Franco-Prussian War. Particular emphasis was given to the "Re-establishment of the Empire" in 1871, on the occasion of Wilhelm I's coronation in Versailles as the German emperor. To local Münsteraners the war memorial is known as the "Mäsentempel" (asses temple). The inspiration for this neo-logism is a row of figures of naked warriors winding around the monument.

Hans Haacke, *Hippokratie* (Hippocracy), 1987, on the occasion of the exhibition *Sculpture-Projects in Münster*, not realized

HIPPOKRATIE

Entwurf für Bus-Ganzlackierung. Text steht weiss auf Tarnfarbengrund.

Was haben **HIPPOS** und dieser Bus gemeinsam?

HIPPO = südafrikanisches Militärfahrzeug, gepanzert. Im Polizeieinsatz gegen schwarze Einwohner.

Sie fahren mit **MERCEDES-Motoren** durch Wohngegenden.

Hans Haacke, *Germania*, 1993, German Pavilion,
XLV. Biennale d'Arte, Venice

Next to this heroic readymade I placed a cylindrical enclosure made of construction planks. Looking through the gaps between the planks, one could see a children's carousel in motion. The carousel organ played the German anthem at an extremely fast tempo, and therefore at a very high pitch. The music aroused the curiosity of passersby, leading them to look through the cracks. For the children, that was enough. Their parents and grandparents noticed relationships between the two round structures. The response from the media and personal conversations lead me to believe that the juxtaposition of the two structures made people think.

German history had been one of the themes of my works before, indoors and outdoors. And it continued being so later. My obsession with this history has resulted, among other things, in censorship, a temporary injunction, an arson attack, and a full-house debate in the German Parliament.

Klaus Bussmann—with Kasper König the founder of the *Sculpture. Projects in Münster*—played a role in my "Images of Germany," not only in his hometown of Münster, but also as Commissioner of the German Pavilion at the Venice Biennial. In 1991, the stubborn Westphalian invited Nam June Paik and me to represent Germany in the Giardini Pubblici. After thinking about it for a while, I accepted the invitation, because Bussmann, despite political pressures on him to play the "Greater German" card (after the reunification of Germany), had invited an artist who was neither German nor of "occidental" heritage, and

Hans Haacke, *Germania*, 1993, German Pavilion, *XLV. Biennale d'Arte,* Venice

Hans Haacke, *Standort Merry-Go-Round* (Location Merry-Go-Round), 1997,
on the occasion of the exhibition *Sculpture. Projects in Münster*

furthermore, pairing that artist with someone who was suspect of denigrating his own country. And this on an international stage. I understood "representing Germany" in two different ways: in the sense of the usual national flag-waving typical for such occasions, and in the sense of "rendering" and "portraying," that one associates with the visual arts. At a dinner in New York, I explained to Bussmann during the main course how I'd thought about my representation of Germany. For the rest of the evening, I waited in vain for some comment from him. The answer came the next morning: "Okay, we'll do it." And so, in the interior of an art-world space, the marble floor Hitler had laid there in 1937 was destroyed. And, in 1993, over the entryway to the German Pavilion, where the eagle and the swastika had once hung, a giant Deutsche Mark with a mint date of 1990 was fastened. Thanks to the presence of the international media, a huge public saw this photogenic rubble.

Like the "elite" spaces of the art world, traditional public spaces—like so many others—are subject to the pressures of today's entertainment-driven society, where ratings are all important. In addition, art works offer developmental aid for real estate interests, marketing, and tourism. But that's not all they do. They also take part in the public discourse, though it differs from case to case—sometimes more, sometimes less, and sometimes not at all. They are under its influence. But, in turn, they can also affect how we understand and come to terms with the world; how we behave in personal relations and as a society; what kind of future we hope for; and what we are ready to do to bring it about. Whether artists, producers, and their clientele care about that or not has no bearing on the effect of this interconnected chatroom. The public space has ears. It pays to listen and to join in the conversation.

Hans Haacke, *Standort Merry-Go-Round* (Location Merry-Go-Round), 1997, on the occasion of the exhibition *Sculpture. Projects in Münster*

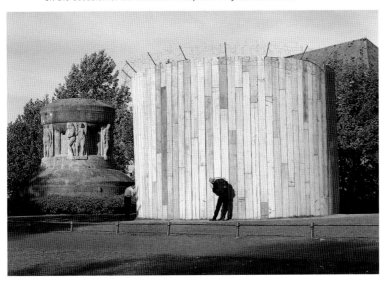

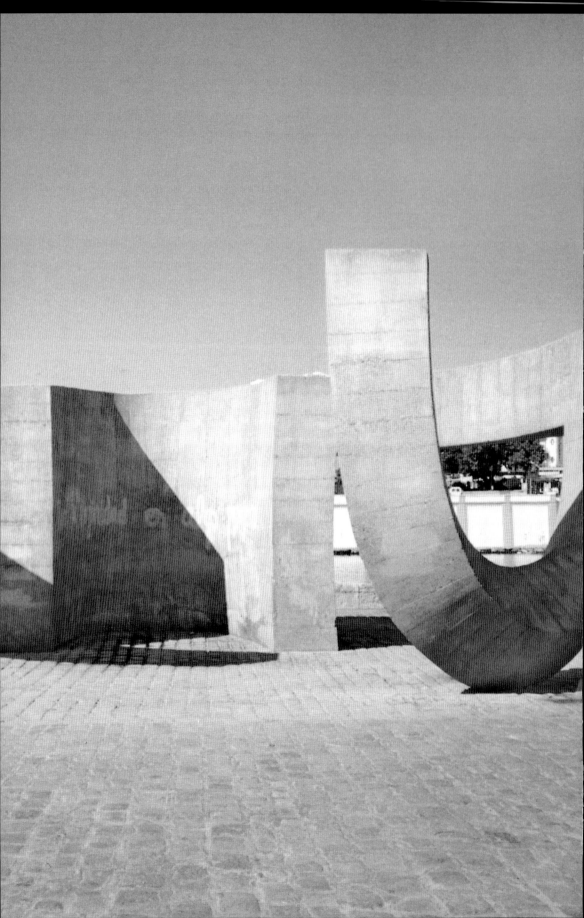

Eduardo Chillida's *Tolerancia* of 1992

Architectural Sculpture as a Monument of Ideas

SABINE MARIA SCHMIDT

In 1492, the *Reconquista* came to an end in Spain, and the Catholic Kings gained a final victory against the Moors in Europe in the siege of Granada. On March 31, 1492, Isabella the Catholic and Ferdinand of Aragon issued the Edict of Granada, paving the way for the total expulsion of the Jews from Spain. The edict required all Jews to convert to the Christian faith. Those who refused were to leave the country without delay. What followed was a mass exodus of Spanish Jews. In order to enforce the edict, a new institution was established in Castille with Papal approval: the Inquisition. Its purpose was to ensure strict adherence on the part of the "newly baptized" Christians to Catholic doctrine. A similar edict applying to the remaining Moors in Spain was issued in 1502.

On May 31, 1992, the five-hundredth anniversary of the banishment of the Jews from Spain, Eduardo Chillida's memorial *Tolerancia* (Tolerance) was dedicated in Seville. The artist had waited ten long years to see his work realized. Like his monument to Guernica, the memorial in Seville was to commemorate a specific historical event, one that played a very significant role in the historical consciousness of all Spaniards. And as in the *Zuhaitz* in Grenoble, a memorial in protest of racism, and *The House of Our Fathers* in Guernica, Chillida worked with the genuine function of the memorial as a "source of identity," creating in Seville a monumental symbol conceived not as an abbreviated representation of a historical event but as a human gesture. In this memorial as well, Chillida avoided deliberate or partisan commentary on history, designing it instead as a sign of encouragement to action.

In the summer of 1980, the artist was approached by Luis Uruñuela, then mayor of Seville, and his deputy about the possibility of designing a memorial for the city of Seville. Originally, the monument was to commemorate Seville's first *auto-da-fé*, at which five Jews had been burned at the stake five hundred years before. The memorial was to embody an "antithesis" to the intolerance of the Inquisition and to honor its victims.[1]

Chillida responded to this inquiry and visited Seville in July 1981.[2] He selected a site that struck him as particularly appropriate for a memorial: a spot on the old Muelle de la Sal (Salt Mole) at the Triana Bridge immediately adjacent to the Guadalquivir, which divides the city of Seville. This location was to retain its original plain, "industrial" appearance. Thus Chillida requested that a simple, unembellished plot of ground without vegetation be set aside for the sculpture in the course of landscaping work in preparation for Expo '92. The sculpture was to serve the function of a plinth. As was discovered later, this spot is situated near the former seat of the Inquisition, which made it possible to emphasize the essential conceptual reference topographically.[3]

Eduardo Chillida, *Tolerancia* (Tolerance), 1992, Seville, Muelle de la Sal

221

Even then, in 1981, Chillida considered creating a monumental concrete sculpture that could be produced in situ in order to reduce the costs of the project.[4] It was not until six years later that he would actually realize a sculpture on site, however, and not in Seville but in Barcelona. Evidently—according to contemporary press reports—specific plans for the sculpture had not been developed at this point. Chillida was initially commissioned to develop a proposal and submit a maquette to the municipal government.[5]

It is quite possible that the newspaper articles represent only the official version of the story and that Chillida had already developed specific plans for the site. The accounts presented in these articles conflict with statements made by the artist later on, including the following remarks recorded in an interview:

"As for this location ... The city wanted this work, and the work was already done, but there was no site for it. So in Seville I didn't select the site first before doing the work. The thing in Seville was that I was interested in the tolerance project, and I had already figured out the relationship between the human dimensions and the scale of the sculpture. And so I had to look for the right location, a place at which everything would fit together ... And there were coincidences in this case as well. I saw the work's position as soon as I saw the place. The sculpture was to be erected with its back to the square on which we were standing ... as if to embrace the whole world ... I see a connection between *Tolerancia* and what it means to practice tolerance. The work is an expression of this idea. And then suddenly this man said to me, 'Do you know that right here, where we're standing, just a few meters farther to the left, is the place where the last inquisitions were conducted in

Seville?' Thus I had the sculpture turn its back to the Inquisition, without even knowing that it had been there."[6]

Chillida stated in other interviews done in 1991 that he had obviously had a precise concept for the work in mind and had been looking for a suitable site:

"That was the ideal site for the idea embodied by this work. I saw how perfect the work would fit in there. I could already see it standing there, on that spot that was like a plinth."[7]

An important aspect of the relationship between the sculpture and the site is Chillida's idea of erecting the sculpture with its back to the river,[8] a decision he claims to have made intuitively, without any particular reason. This example clearly illustrates the significance the artist attaches to an intuitive feeling for places, to the sense that does justice to the "historical character of a place," to its historical dimensions. Later on, another historical link to this site was discovered. The Jews of the city had operated the city's salt market at the Muelle de la Sal. The story of the Seville sculpture offers a striking example of how explicitly Chillida emphasizes such historical aspects.

The site was selected in 1981 (the same year in which Chillida was made aware of the location of the Inquisition). The maquette entitled *Proyecto para Monumento a Sevilla* was completed in 1982, and, despite the many years of negotiations that followed, was never modified.

Completed after the *Poets' Houses*, the model for Chillida's *Tolerancia* exhibits a relatively clear, simple structure, the layout of which calls to mind a triple-conch complex. Two solid C-shaped segments are attached to the central niche structure. These sections sweep out on a horizontal plane level with the top of the

apsidial central element, their concave sides facing one another. Viewed from above, these two curved elements form an ellipse which penetrates the apsidial structure. A segment of this ellipse is missing, so that the form does not close. The missing segment appears on the left side of the sculpture, joined to one of the horizontal, floating arms as an additional curved element. Resting upright on the ground, it opens upward, toward the sky. Viewed from certain perspectives, this bowed segment appears to support the floating elements, although it plays no part in the structural statics of this architectural construction.

The three arc-shaped forms are reminiscent of the three *Wind Combs* in San Sebastián. They are grouped together here in a single work. Compared to the middle element, the horizontal bows seem extremely large, thus reinforcing the association with a human gesture of embrace. Chillida achieves this anthropomorphic quality with a clearly structured, organic, yet asymmetrical form, which is enlivened by the shifting patterns it presents from different views. The non-representational form thus assumes a specific habitus that allows it to "speak." It develops a formal configuration that is also capable of performing symbolic functions, and it refers to historical sources in art.

The form calls to mind the "monumental arms" of Bernini's Piazza Obliqua, which, according to Bernini himself, "symbolizes the maternal arms of the churches that embrace all Christians."[9]

On the occasion of a symposium on the formal language of the Basque sculptor, Thomas Messer wrote:

"Chillida's sculpture is abstract in the sense that it does not present things. Yet it is not aloof from the normal perception of the world, and it is grounded in a sculptural language that has the capacity to point out parallels in the factors that shape life, humankind, and nature. Chillida's sculpture is always close to something ..."[10]

Chillida's sculpture remains abstract and demands a great deal of the viewer in formal terms. All of his sculptures share a complex system of references. Despite their formal clarity—or perhaps because of it—his sculptures are full of tensions and ambiguities. The *Tolerancia* memorial finds these between the two poles of the motifs of the hand and the house. Thomas Kellein has spoken in this context of the "latent anthropomorphism" of Chillida's abstract sculptures.[11] This ambivalence of anthropomorphic and architectural or geometrical structure is particularly striking in the monumental concrete sculptures.[12]

The choice of this Basque artist, whose work was still unknown in Seville (and in the rest of Spain) in the early 1980s, triggered heated controversy from the very beginning, although the artist's concept was not the bone of contention. Critics complained that no competition had been held and focused upon the sculptor's regional origin. Chillida is a Basque, they pointed out, whose mentality and intellect does not accord with Andalusian sensibilities. Many of these critics contended that an Andalusian artist should have been given preference in Seville.[13]

Because Chillida's was to be the first modern, abstract sculpture in the city of Seville,[14] the project also generated the first discussions ever focused on the question of public art in Seville. Critics also lamented the fact that such a controversial and unwelcome memorial was to be erected at a central point in the city, near prominent buildings and such sym-

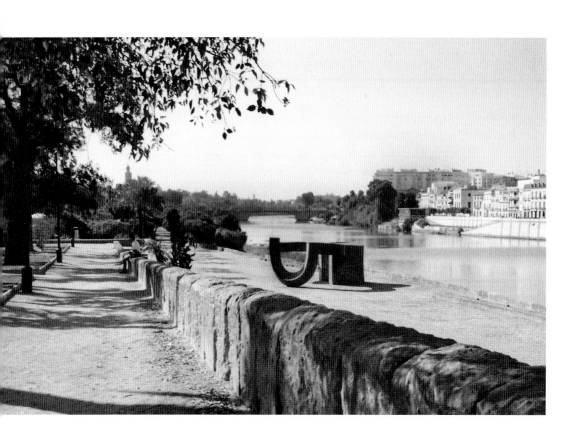

Eduardo Chillida, *Tolerancia* (Tolerance), 1992, Seville, Muelle de la Sal

bols of the city as the Torre de Oro, the Plaza de la Real Maestranza (Seville's bullfighting arena) and the Triana Bridge. Increasing criticism, a lack of funding concepts, and the election of a new city government combined to postpone the project for the time being. It was not until January 1987 that negotiations with the artist were resumed during the administration of Mayor Manuel de Valle and against the background of preparations for *Expo '92* in Seville and the five-hundredth anniversary of the discovery of America. Chillida had exhibited a large steel version of his maquette *Tolerancia I* (1985) at the *Sculpture-Projects 1987* show in Münster. The city government expressed wholehearted interest in the sculpture and considered purchasing the work for a monument to the Peace of Westphalia. Chillida refused to sell the sculpture, however, stating that it had been conceived for Seville and that he still considered its realization there a possibility.[15] Funding schemes developed within the context of planning for Expo '92 also paved the way for realization of the project, at an estimate cost of about one hundred million pesetas.[16] The project received substantial funding from the Jewish society of the "Amigos de Sefarad." The renovation of the Muelle de la Sal by the city was also incorporated into the plans. Five meters high, twelve meters wide, and weighing 480 tons, the sculpture was constructed in 1991[17] and dedicated in a grand official ceremony attended by King Juan Carlos, his wife, and Haim Herzog, then President of Israel. Asked to comment on the significance of the memorial, Chillida answered: "The work embodies a vague idea that cannot be interpreted in any concrete manner. But in essence it emphasizes that one should be tolerant and accept the ideas of other, even

when they are different. One must be capable of accepting them, rather than opposing them." [18]

Chillida's memorial is not meant primarily is a reminder of the past. Chillida chose a form in Seville that would offer a broad spectrum of possibilities for interpretation. Thus, for example, the tripartite structure of the sculpture can be seen as a reference to the three major religious movements of Judaism, Christianity, and Islam, which still coexisted in peace in the early medieval period. It does not recall or commemorate the Inquisition but instead calls attention to the phase of mutual tolerance.[19] Chillida avoids expressing concrete positions with respect to history in his memorial sculptures. His sculpture does not judge or take sides, nor does it seek to assign guilt or identify victims.[20] Chillida uses abstract forms which cannot express historical themes within any degree of sophistication but which do offer complex approaches to recognition, identification and interpretation.

His sculpture symbolizes a steadfast belief in the power of human gesture. It offers a vision of peaceful coexistence. It does not mourn the past but point to the future: "I would be very pleased if my work contributed in even the smallest possible way to reconciliation among the Jewish, Arab, and Christian peoples. I know that this is still a utopian vision, but it is interesting to concern oneself with utopia."[21]

Chillida's memorial seeks to point the way. It is a memorial to faith in the power of utopia.

1 Antonio de la Torre, *Ortiz Nuevo: Chillida es el Picasso del arte español contemporaneo*, in: *ABC* (9 July 1980).
2 Immediately before his visit, Chillida had been awarded the *Medalla de oro al Mérito en Bellas Artes* by King Juan Carlos I. On this see Francisco Correal, *El monumento a la tolerancia se podría instalar junto al puente de Triana*, in: *El Correo de Andaluz* (3 July 1981).
3 "Para Chillida, el lugar está cargado de sugerencias: el rio como brazo de unión de las dos Sevilla, la proximidad del sitio en que estuvo enclavado el Castillo o Cárcel de la Inquisición, y otros poderosos motivos de inspiración." Fausto Botello, *Chillida, dispuesto a hacer su monumento a la Inquisición*, unidentified publication (4 July 1981), Chillida Archives.
4 See also Angel Perez Guerra, *Chillida quiere que el monumento a la tolerancia se situe junto al puente de Triana*, in: *ABC* (4 July 1981).
5 José Aguilar, *Oposición en Sevilla a un monumento de Chillida dedicado a la tolerancia,* in: *El País* (7 April 1982).
6 Quoted from Nina Koidl, *Aspekte der Skulpturen im öffentlichen Raum von Eduardo Chillida,* unpublished M.A. thesis, Frankfurt, 1993, pp. 142 f.
7 Pepe Iglesias, *Chillida ultimó ayer en Sevilla su escultura a la tolerancia,* in: *El Correo de Andalucia* (2 July 1991).
8 See also Mercedes Olmedo: "El artista tuvo también la clara visión, según cuenta, de que la escultura debería levantarse de espaldas al río, y se sorprendió enormemente, por la casualidad que se daba, cuando el mismo día de tomar su decisión alguién le comentó, que el muelle de la Sal se enfrenta justo con el castillo de San Jorge, sede de la Inquisición, con los cual ‹La Tolerancia› le dará la espalda a la intolerancia." in: *Chillida: Mi escultura expresa el deseo de que judíos, cristianos y árabes vuelvan a darse la mano,* *ABC* (1 April 1992).
9 Quoted from Wolfgang Hartmann, *Platz und Skulptur,* in: *Plätze und Platzzeichen,* exh. cat., p. 23.
10 "La escultura de Chillida es abstracta en el sentido de que se abstiene de comunicar hechos específicos. Pero lejos de estar desligada del mundo de la experiencia visual normal, se basa en un lenguaje plástico que tiene el poder de evocar significados paralelos a los que imperan en la vida, en el hombre y la naturaleza. La escultura de Chillida trata, por lo tanto, claramente acerca de algo." Thomas Messer, *Las formas de Chillida*, in *Symposium Chillida* (Bilbao: Universidad del País Vasco, 1990), p. 100. In another publication we read: "His works are abstract to the extent that they avoid direct reference to objects or figures, yet they relate closely to the visual experience of the foundations of our existence." Thomas Messer, *Der baskische Bildhauer Eduardo Chillida*, in exh. cat. (Frankfurt, 1993), p. 12.
11 Thomas Kellein, *Eduardo Chillida——Skulpturen zwischen Hand und Haus,* in Eduardo Chillida, exh. cat. (Kunsthalle Basel, 1991).
12 The sculpture *Gure aitaren etxea* in Guernica exhibits both the iconography of the ship that has run aground and a masklike similarity. The monument in Gijón employs a helmet- and head-shaped structure.
13 On this see José Aguilar, *Oposición en Sevilla a un monumento de Chillida dedicado a la tolerancia,* in: *El País* (7 April 1982); Manuel Biescas, *Chillida colocará en Sevilla su monumento a la Tolerancia,* in: *La Gaceta del Norte* (26 June 1982).
14 José Maria de Mena, *Sevilla, estatuas y jardines* (Seville, 1993). This book, which is more a city guide than an contribution to art history, provides a list of the best-known statues and monuments in Seville, most of which were erected during the late nineteenth century and the 1920s. All of the sculptures from the post-war period are figurative and reflect the expressive repertoire of the nineteenth century. The author of the book is a member of the Madrid Academia de Bellas Artes des San Fernando and chairman of the Monuments Commission. It is interesting to note that the author emphasizes the criticism of the sculpture in his discussion of Chillida's sculptural work.
15 In Münster, Chillida later realized the two-part sculptural ensemble entitled *Tolerance through Dialogue* in the interior courtyard of the City Hall.
16 The sculpture was financed by the Municipal Commission (Comisaria de la ciudad de Sevilla para la EXPO 1992) and the Fundación Sefarad. It cost approximately 98,597,918 pesetas. Chillida received an artist's fee of fifteen million pesetas.
17 Following completion of the concrete foundation in April 1991, the wooden forms were constructed in May and June. Concrete was poured in early July 1991. The wooden forms were removed late the same month. The sculpture was braced by an iron framework until it was unveiled.
18 Pepe Iglesias, *Chillida ultimó ayer en Sevilla su escultura a la tolerancia*, in: *El Correo de Andalucia* (2 July 1991).
19 A plaque bearing an inscribed dedication appears next to the memorial in Seville. The insription explains the intent behind the memorial: "Este monumento a *La Tolerancia*, obra del escultor Eduardo Chillida, se erigió a iniciativa del ayuntamiento de la ciudad, con la colaboración de la consejería de obras públicas y transportes de la junta de Andalucia y el Patrocinio de la Fundación 'Amigos de Sefarad' que lo ofrece a la ciudad de Sevilla en homenaje a la memoria de sus antepasados y al mensaje universal de tolerancia y concordie que ellos nos brindaron. Sevilla, Muelle del Sal, 1 de Abril de MCMXCII."

20 The memorial was sternly criticized by the Jewish organ-
izations Asociación de Comunidades Judía de España and
Bené Berit in Israel. They contended that the memorial
made no reference whatsoever to the edict of the Catholic
Kings and that, instead, the Spanish had created a monu-
ment to their own tolerance—a complete reversal of the
true facts. Moreover, the memorial, which was to serve as
a reminder of the Inquisition, should have been financed by
the Spanish, and not by Jewish organizations. On this see
(author unknown), *Grupos judíos oponen al "Monumento
a la Tolerancia,"* in: *ABC* (31 March 1992).

21 José Bejarano, *"La tolerancia" de Chillida llama a la con-
cordia entre judíos, cristianos y árabes,* in: *La Vanguardia*
(1 April 1992).

THE DOOR IS THE MOST VUNERABLE AREA IN TERMS OF
VANDALISM AND MUST BE TREATED WITH REPELLENT SO THAT
GRAFFITI CAN BE REMOVED.

DOOR AND
SURROUND SAME COLOUR
* FOCAL POINT, MUST BE RIC

HANDLE
SPACE.

CONCRETE

BOOK FIXING CENTRALLY PLACED SO THAT
THEY CAN BE TURNED UPSIDE DOWN
∴ 20 MOULD POSITIVES, BECOMES 40.

"A book must be the axe for the frozen sea within us"[1]
Rachel Whiteread's *Holocaust Memorial*
ANDREA SCHLIEKER

On January 24, 1996, the young British artist Rachel Whiteread officially received the prestigious commission from Vienna to create the city's first Holocaust Memorial, dedicated to the sixty-five thousand Jews killed during the Nazi regime in Austria. The memorial, intended for Vienna's Judenplatz, the heart of the old Jewish ghetto, was to be inaugurated on November 9 of the same year, the fifty-eighth anniversary of the *Reichskristallnacht* (Night of the Broken Glass). What ensued over the next four years, however, was a story of highly charged debates full of often emotional and explosive arguments that cut right across Austria's political and religious landscape. These led to ever-increasing delays, frustrations, animosities, and a deeply divided community, until, after much careful deliberation and patient negotiating, a solomonic solution was finally achieved which allowed for an unencumbered and fully supported realization of Whiteread's extraordinary work.

The *Holocaust Memorial* in the Context of Rachel Whiteread's Work
Prelude In December 1994 Simon Wiesenthal, the eminent campaigner for justice and retribution, had pointed out to Michael Häupl, mayor of Vienna, that the city had failed to offer a dignified place to mourn the sixty-five thousand Austrian Jews who fell victim to the Nazi regime. Wiesenthal had made no secret of his dislike of Alfred Hrdlicka's *Monument against Fascism* (inaugurated on Albertinaplatz in 1988), whose representation of a street-washing Jew was seen by many to perpetuate humiliation. Häupl acted swiftly: by autumn 1995 a distinguished international jury, chaired by the well-known Austrian architect Hans Hollein,[2] had been appointed and a thorough competition dossier compiled and released to nine invited artists and architects from Austria, Israel, Britain, and the United States.[3]

The artists were required to make their proposals within the framework of a number of fixed stipulations: the site (Judenplatz); a commemorative inscription as well as a list of all the concentration camps where Austrian Jews had perished; and "... in view of the difficulty inherent in representing the unspeakable horrors,"[4] a non-figurative idiom for the memorial.[5]

Prior to the competition, Hollein had instigated excavations on Judenplatz, and important remains of the synagogue destroyed during the pogrom of 1421, including the platform of the bimah, had been uncovered. According to the competition documents, the artists were at liberty to decide whether to incorporate the archaeological findings into their designs.

As the youngest of the invited artists, with no personal experience of the Holocaust, Whiteread was at first uncertain whether she was able to engage with a subject matter of such daunting and harrowing magnitude. Her recent

Rachel Whiteread, Drawing for the project *Holocaust Memorial*, 1995, Vienna, Judenplatz

experience of living in Berlin,[6] however, had equipped her with a direct knowledge of the "topography of terror." While in Berlin, Whiteread became interested in how World War II had left its traces on the city, both in terms of the fascist architecture of the time and of the battle-wounds still scarring so many buildings. She further extended her research by visiting the sites of atrocities, including Sachsenhausen, and also by reading many of the survivors' reports.[7]

Judenplatz[8] Whiteread's first encounter with the city of Vienna was in November 1995, for a briefing session and a first visit to the site. The small and intimate scale of Judenplatz seemed to offer a perfect foil for Whiteread's artistic approach. Unlike other squares in the city, many of them major tourist attractions displaying the grandiose and heroic of much metropolitan city planning, the Judenplatz, although central, appears hidden away and almost domestic. These were important characteristics for Whiteread, whose work tends to the familiar, quiet and everyday, the private and personal.

Much of Whiteread's sculpture is an exploration of the interior, in a double sense. Stalking her own memory of childhood, Whiteread makes casts of the inner spaces of things, of domestic objects such as a wardrobe (*Closet*, 1988), chair, bed (*Untitled*, 1991), or table. She gives substance to the intangible, the air-filled spaces underneath or inside familiar objects that are essential or commonplace in our lives. "I'm interested to invert people's perception of the world and to reveal the unexpected," she says.[9] She thus creates form that is both a negative mirror-image and an abstract of the cast object, form which is often related to the cube. In spite of her deliberate recourse to the language of minimalism, Whiteread's austerity is simultaneously imbued with emotion and sensuality. Whether made in plaster or translucent resin, whether in magisterial white or glowing with intense color, her works oscillate between a haunting, spectral appearance and a seductive luminosity and evanescence. Her sculptural forms refer to basic human experience—eating, sleeping, death ... They probe our sense of being in the world. Yet the theme of death is perhaps most inexorably pursued. A cast of an ordinary bath takes on the solemn appearance of an Egyptian sarcophagus (*Untitled [Black Bath]*, 1996); that of a table and chair recalls the architectural form of a mausoleum (*Table and Chair [Clear]*, 1994). Conversely, mortuary slabs create casts of abstract or strangely physical looking sculptures (*Untitled [Amber Slab]*, 1991). Indeed, the notion of the *memento mori* is a constant presence in her work, not least maybe because of our association of the cast with the death mask. A memory of things now irredeemably lost resonates through all Whiteread's work. In some way, perhaps, her sculptures encapsulate the quintessence of what we mean by memorial. For an artist who quarries notions of interiority with such determination and poetic clarity, it was crucial for her conceptual development of the memorial that Whiteread perceived the square, so tightly packed with houses on all sides, as a kind of interior or room, the streets leading into it as doorways.[10] The strong geometrical order of the surrounding façades, with their rusticated ground floors and horizontal cornice lines, became a vital visual marker to underpin the grid-structure of Whiteread's emerging plan.

Rachel Whiteread, Model for *Holocaust Memorial*, 1995, Vienna, Judenplatz

At the same time, the artist was struck by the predominantly residential nature of the square. Unlike London, Vienna has managed to keep a center that is not completely taken over by shops and offices, but also offers its citizens integrated living space. The rich stucco of the façades is mirrored inside the houses, where period ornament abounds in lofty rooms. Taking hcr cue, as always, from the given context, Whiteread's "library" displays details such as ceiling rose, cornices, and panelled double doors, that are ubiquitous features of these nineteenth-century bourgeois interiors. Thus the typical room-size of a Juden-platz apartment,[11] as well as the nature and size of the square itself, not only galvanized the conceptual process for Whiteread's work, but became the benchmark for its human scale.[12]

The Library and the Book Whiteread was familiar with the distinguishing appellation of Jewish people as "people of the book." According to Jewish belief, the book epitomizes heritage and constancy in the face of displacement and diaspora; it is seen as a symbol of sanctuary for Jewish learning and for the continuance of Jewish tradition. The word rather than the image was the central messenger for the story of Jewish suffering. As James E. Young pointed out: "We also find that in keeping with the bookish, iconoclastic side of Jewish tradition, the first memorials to the Holocaust period came not in stone, glass, or steel, but in narrative. The *Yizkor Bikher*, "memorial books," recalled both the lives and the destruction of European Jewish communities according to the most ancient of Jewish memorial media: the book"[13]

In Whiteread's *Holocaust Memorial* the book is a symbol both powerful and evocative, yet it is firmly fixed within a domestic iconography. The memorial's shelves are filled with seem-

ingly endless copies of the same book, a reference to the vast number of victims and their life stories, a book now forever closed. It is an inverted and hermetic library, the books do not reveal their content, their spines remain invisible. "Reading" the memorial becomes a claustrophobic experience, as the viewer metamorphoses into the sensed wall against which the books are pressing. At the same time, the books of Whiteread's library make tacit reference to the excavated bimah beneath the square—the stage on which the holy book, the Torah, was once read.[14]

The double doors, offering the possibility of entering or leaving, are hermetically sealed. The void encloses an eloquent reminder of the sixty-five thousand lives forever lost: it is the core of the work, signalling, as Robert Storr put it, "... a gap in a nation's identity, a hollow at a city's heart."[15] James Young added, "... Ms. Whiteread is preoccupied less with the Holocaust's images of destruction than with the terrible void this destruction has left behind."[16]

Both familiar and uncanny, the library appears to be exhaled from the surrounding houses. A private place for contemplation and learning, stranded in a public square, its emotional force, like that of Whiteread's other work, is restrained, dignified, and elegiac. With its seemingly endless rows of books, of histories lived, of things said and written, and yet to be said and written, her library presages the infinite process of mourning this memorial announces.

Whiteread's *Holocaust Memorial* represents a logical development as well as an extension of her formal vocabulary. Her earlier cast of the interior of an English Victorian living room, *Ghost* (1990), solidifying and actualizing emptiness, heralded Whiteread's breakthrough to

her international reputation. Her first public sculpture, the now legendary *House*[17] of 1994, the cast of the interior of a whole house in London's East End, was another important formal and conceptual stepping stone towards the evolution of her *Holocaust Memorial*. Whiteread herself comments on the relationship between the two works: "The difference between *House* ... and the Judenplatz monument is that House was in effect a private sculpture being made public 'by default' (as a result of its scale and visibility). The Judenplatz monument is from inception bound up in history and politics."[18]

Water Tower, her second public sculpture, was commissioned by the Public Art Fund in New York in 1998.[19] Both *House* and *Water Tower*, as well as her fourth public art project in competition for the empty plinth in London's Trafalgar Square, to be installed in September 2000, were conceived as temporary projects. The *Holocaust Memorial*, however, carries the challenge and the burden of permanence. And, in contrast to any previous work, the *Holocaust Memorial* is not cast from a "found" object, existing room or situation, but is constructed entirely of elements coming from the artist's imagination and thought.

With her library Whiteread has conceived a sculpture that is an antidote to the heroizing monument.[20] It commemorates and encapsulates loss; it is a reminder of "... the major wound of Western civilization whose tissues have not healed and can never heal."[21]

Rachel Whiteread's *Holocaust Memorial* speaks of the unfathomable in language both modest and poetic. Evoking in minimalist terms an impenetrable archive of public and private memory, of pages laden with secrets they can never disclose, this work, through an association of humble tomb, grand mau-

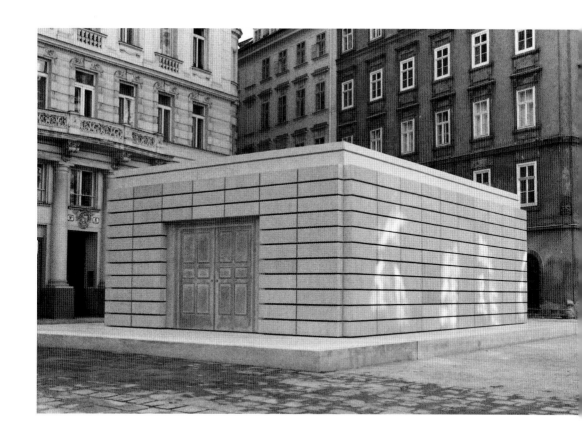

Rachel Whiteread, *Holocaust Memorial*, *1999*, Vienna, Judenplatz

soleum, and empty cenotaph, has the power to contribute enduringly to healing.

Competition and After: A Diary of Events

The four years that passed until Rachel Whiteread's memorial could finally be completed were dominated by political and social argument rather than aesthetic debate. The complex maneuvers and tugs of war which ensued and thwarted its progress were played out mainly between five different interests—those of local residents and shopkeepers, a small group of Austrian artists, local politicians, a lobby of archaeologists, and sections of the Jewish community. Throughout this, the artist tried to remain aloof from the maelstrom of dispute and simply protect the integrity of her work in terms of the mandate she had received from the City of Vienna. For the history of the memorial's genesis it seems important, however, to trace not only the phases of its artistic development, but also to record chronologically, some of the significant events along the arduous and often apparently irremediably blocked path that led from the first public announcement of the memorial to its final acceptance and inauguration.

January 1996: Austrian and British press alike welcome the competition result. Rachel Whiteread starts work immediately, making moulds of the "book" elements in her London studio and fine-tuning her design.[22]

February 1996: At this early stage, progress seems remarkably swift and uncomplicated. Whiteread visits Vienna for a formal presentation at the Rathaus and to discuss technical details. She has built up a team for the fabrication and installation of the memorial, lead by the Viennese architects Christian Jabornegg and Andras Palffy, who were to remain loyal supporters of the memorial throughout the history of its making.

Viewing first samples, it was of paramount importance to Whiteread that the concrete, a material whose urban grittiness she much prefers to the grandeur of marble, had the right coloring and surface texture. "If used properly," Whiteread believes, "it can be absolutely beautiful."[23]

It was to be an unusual experience for an artist so accustomed to making her own sculptures—even something as monumental and physically challenging as *House*—to delegate part of the fabrication to others.

March 1996: A large exhibition, entitled *Judenplatz Wien 1996*, of all competition models and drawings is presented at the Kunsthalle in Vienna. The accompanying catalogue, with prefaces by the mayor of Vienna and the president of the Israeli Cultural Community (IKG), together with essays by several prominent jury members, unanimously applauds the winning design. A subsequent tour of the exhibition to Jerusalem, London, Berlin, and Washington publicizes Whiteread's proposal nationally and internationally.

The first and by then relatively minor voices of dissent are heard. Some local residents fear that the memorial is a security risk and too massive for the site: the Freedom Party represents their concerns.[24]

April 1996: Rachel Whiteread is awarded the Prix Eliette von Karajan.[25] For this occasion, an exhibition of her work is staged in Salzburg, and subsequently travels to Vienna. In his opening address during a grand opening, the Austrian President, Thomas Klestil, fully endorses Whiteread's winning proposal for the Judenplatz memorial. Approved at such high

political level, the memorial seems secure. *May 1996*: The Labor (SPÖ) and the Green Party agree the budget for the memorial and a showroom for the excavations. The Conservatives (ÖVP) vote against, and the Freedom Party leaves the meeting in protest. Local protest flares up after a crude full-scale scaffold model appears on the site. A local shopkeeper collects 600 signatures against the memorial.[26]

June 1996: Controversy engulfs the project from another side. The Austrian painter Arik Brauer calls Whiteread's memorial a "monster tomb" (*Monstergrabstein*), without artistic value (*kunstlos und hässlich*), that would ruin (*verschandeln*) the square for centuries and itself invoke anti-semitism.[27]

At the same time, the archaeological lobby campaigns to extend the time for the excavation: articles about the "sensational findings" appear daily in all local papers. Leon Zelman, President of the Jewish Welcome Service in Vienna, joins the debate to "rescue" the Judenplatz, arguing that the excavations themselves were the better memorial.[28] Simon Wiesenthal responds in *Die Presse*, defending both site and proposed memorial.[29]

Rachel Whiteread travels to the small upper Austrian village of Kollerschlag, to work with a local craftsman[30] on the details of the memorial. A first sample of the book elements is ready for inspection. Here she makes the mould for the ceiling rose, tests its proportions, and designs the double doors.

July 1996: The Kulturausschuss (SPÖ and Green Party) decides to double the size of the subterranean showroom from 110 to 220 square metres to accommodate the new findings. Far from calming things, this seems only to fan the flames. Leon Zelman calls the memorial an alien structure (*Fremdkörper*)[31] that

destroys the square, and the Freedom Party continues to press its view that the memorial is not acceptable to the public. The vociferous arguments thus create a strange and uncomfortable alliance of ultra-right political forces and sections of the Jewish community.

At the end of the month the excavations are halted. Some local politicians and residents strenuously demand a relocation of the memorial to other sites, such as Morzinplatz.[32]

August 1996 was to have seen the beginning of the building of the memorial on site. Instead, the debate becomes further inflamed. During a television debate on August 1, Alfred Hrdlicka calls the memorial a "parody," and a few days later expresses his view that the memorial constitutes an attack upon him and his memorial on Albertinaplatz.[33] The local press mentions rumors of a possible delay for Whiteread's memorial.[34]

Yielding to the mounting pressure, the city administration convenes a new expert committee, including representatives of Jewish and political life, to explore the ideal fusion of memorial and excavations.[35] The committee recommends the creation of an entrance to the subterranean showroom via the Misrachi House at Judenplatz 8, and the transformation of this, the oldest building in the square, into a Documentation Center on the history of Jews in Austria, from the middle ages to the Shoa. This puts an end to a disagreement which had included suggestions to open the memorial as an entrance to the showroom or to create a public staircase in the square.[36]

September 1996: The memorial becomes a major issue in the Viennese elections. The city government decides to wait until after the local elections on October 13 to find a solution. Pressure increases from some prominent members of the Jewish community[37] (Chief-

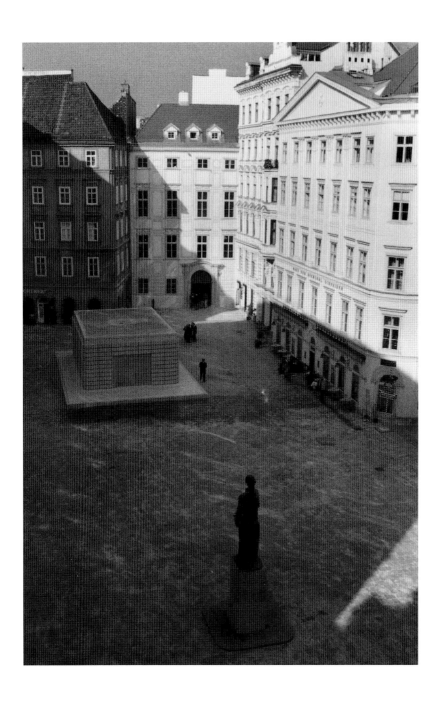

Rachel Whiteread, *Holocaust Memorial*, 1999, Vienna, Judenplatz

Rabbi Chaim Eisenberg and Ariel Muzicant, President of the B'nai B'rith) to alter the appearance of the memorial. The use of glass instead of concrete, to allow a view through to the excavations, is repeatedly suggested. While the situation in Vienna is becoming ever more fragile, Rachel Whiteread's retrospective exhibition at the Tate Gallery in Liverpool opens to wide acclaim.[38] A model of the *Holocaust Memorial* is included in the show, prompting one critic to comment wistfully: "I only hope that the current Viennese political infighting does not prevent Whiteread's gravely contemplative work from reaching fruition. The *Holocaust Memorial* promises to be as haunting as *House*, simultaneously celebrating endurance and commemorating loss."[39]

October 1996: On October 9, one month before the originally planned opening of the memorial, the *Kurier* announces: "November date does not hold." The reason is a decision to extend the excavations and to double the size of the showroom once again, this time from two hundred to four hundred square meters. The artist is not officially informed by the city about any of these developments, and only after probings by her associates does she receive a letter from the mayor (October 11, 1996), stating "… we are not at present in a position to exclude delays in the existing schedule." The letter also reiterates the mayor's commitment to the memorial: "Let me therefore assure you right away that I regard the *Holocaust Memorial* and its erection on Judenplatz as an unshakable fact." This confident assertion was to remain the only official comfort or hope for the artist during the next several years.

Two days after the letter, the mayor's position is seriously weakened at the election, the ruling Labor Party (SPÖ) suffering considerable losses. The main champions of the memorial bow out (Ursula Pasterk and Hannes Swoboda), and coalition negotiations with the Conservatives (ÖVP) begin. The Freedom Party makes unprecedented gains on the Vienna City Council.

By the end of the month, newspapers announce the memorial's inauguration for June 1997, and that of the museum and showroom for November 1997.[40]

November 1996: The debate about the memorial's relocation reaches its peak. Members of the Jewish community and of the Conservative Party, as well as the former and still popular mayor of Vienna, Helmut Zilk, join the chorus for a relocation, and demand to maintain the excavations on Judenplatz as the "best" memorial.

The *Judenplatz* exhibition arrives at London's Architectural Association. Critics celebrate Whiteread's proposal as a "fitting elegy."[42] During a conference with distinguished international speakers, organized by the AA, Whiteread's proposal is regretfully discussed as a "phantom memorial," its final realization more doubtful than ever.[43]

The press, triggered by the date of the originally promised inauguration, speaks of a "political minefield" in Vienna, emphasizing a perceived latent anti-semitism in Austria as the true reason for the continuing procrastinations.[44] Robert Storr, jury member and New York curator, believes more sinister forces are at the heart of the problem: "The current impasse is not primarily the result of squabbles within the Jewish community, nor of public art politics as usual. Rather, the stalemate centers on a fight for control over the past as well its influence on the future."[45]

December 1996: Whiteread visits Vienna to inspect the now completed casts of book

elements, the double doors, which she had designed while in Kollerschlag six months previously, and the first sample of one of the (finally to be four) plinths. But the rows and rows of books, meticulously cast in their light gray concrete, are to remain in storage for the next three years.

Her visit attracts huge media interest, and in a plethora of press and TV interviews Whiteread, hitherto reluctant to speak out, declares categorically that she refuses to consider alternative locations or materials "... it is impossible to tear the memorial out of its context"[46] and makes it clear she is "... not prepared to have the piece changed by public opinion."[47] The new SPÖ/ÖVP coalition decides to pass the decision about location to the Jewish community (IKG). Its president, Paul Grosz, a steadfast supporter of the memorial, is clearly unhappy about this shift of responsibility, handing it resolutely back to the city.[48] In an interview with *Der Standard* he states: "The excavations are used very efficiently as a lever against the memorial. Let us not forget that the excavations only happened because of the memorial."[49]

This continuation of unproductive exchanges between city and Jewish community, however, throws a number of pertinent moral and philosophical issues into sharp relief. For example, the question for *whom* is the memorial intended? For Jews as a focus for grief, or for Austrians as a reminder of a terrible period in their history? A remembrance of victims or admission of collective guilt? Furthermore, prompted by isolated but powerful calls within the Jewish community that the excavations be used as sole "memorial," the question was asked "whether the Nazi Holocaust was unique and should be singly commemorated or whether it was the climax to centuries of

pogroms and persecution and should be marked by emphasising historical continuity."[50] Confronted with a new level of crisis and a string of lacerating arguments, the new cultural councillor, designated by the mayor to find a solution to the protracted debate, orders a "Denkpause," a time for reflection.

January 1997: This reflective period is begun by a symposium organized by the Jewish Museum in Vienna, "Stein des Anstosses. Denkmäler—Mahnmale—Schoa Erinnerung." The contributors, also weary of the complex and so far fruitless debates surrounding the planned Holocaust Memorial in Berlin, are unequivocal in their view that Shoa memorials must not be allowed to degenerate into easy substitutes for atonement or emollients to memory (Isolde Charim, Vienna). Memorials should not become the tidy rounding off (*Schlusssteine*) of history, not places for merely an empty formality of wreath-laying (*Kranzabwurfstelle*, Julius H. Schoeps, Vienna), but active sites of contemplation.[51]

The clamor with which the press have hitherto treated Whiteread's memorial noticeably quietens. Arguments still are still flashing between the pro and contra camps, but they and the players are familiar and the general pattern of ever-renewed delay continues. A promise, made at the beginning of the year, for an opening in June 1997 turns into one for November of that year, until that too, dissolves from view.

February 1997: For Whiteread 1997 is a hugely busy and successful year. The Palacio Velázquez in Madrid honors her with a large exhibition.[52] Here she shows *Untitled (Five Shelves)* of 1996, a large white plaster piece which is later to grow into a room of ghostly shelves with *Untitled (Paperbacks)*, 1997,[53]

and finally, into a forbidding, wall-like configuration of library shelves[54]. Although formally different from the Viennese books, these are clearly related. For Vienna she had based her books on hardback folios, which had been carved in wood before being cast. Regular, though not identical, they displayed slight alterations in the shape and curve of their exposed pages. For these works, Whiteread made casts from paperbacks, with a deliberate broken, rhythmic pattern, including residues of original coloring. In an interview she admits: "All of these things (book pieces) have come out through the frustration of the *Holocaust Memorial* and I think that when that is made I will stop making book pieces. It's a frustration working in the studio miles away from Vienna while all these bureaucrats argue about it. It's my exorcism, being in the studio."[55] The artist feels exasperated at having "absolutely no control" over what is happening in Vienna.[56]

June 1997: While Rachel Whiteread is being internationally celebrated for her prize-winning pavilion at the Venice Biennale in the summer of 1997, the press focuses again on her stalled Viennese memorial. "Having commissioned the project, the Austrians have been prevaricating over it for two years, and nobody any longer believes it will happen,"[57] opines *The Sunday Times*. Serendipitous meetings with the Viennese cultural councillor and even the Austrian Chancellor[58] take place during the press days in the Giardini Gardens, but only further disclose the depth of obfuscation and inertia that have meanwhile entangled the project. The lack of movement and direction bedevilling the memorial debate intensifies, the project appears irrevocably stuck.

October 1997: The *Wiener Journal* dedicates a whole issue to the discussion surrounding the memorial, inviting a large number of known supporters and opponents for written responses.[59]

By now supporters and opponents alike seem eager for the "Denkpause" to end and demand a quick decision from the politicians. The cultural councillor promises a resolution by February 1998.

The BBC, whose team had been following the artist for eighteen months, broadcast a fourty-minute documentary about the *Holocaust Memorial* and its surrounding tribulations.[60]

November 1997: The memorial receives another blow, this time from an unexpected quarter: the Viennese Archbishop Christoph Schönborn publicly declares his opposition to Whiteread's monument in favour of the synagogue excavations. In catholic Vienna such a statement clearly has a powerful sway for public opinion.[61]

The mayor receives a crucial letter from Paul Grosz, on whose interpretation the eventual conclusion of the long-smoldering conflict was to rest. He states: "We welcome any decision taken by the City of Vienna regarding the site for the memorial, as long as it respects the excavations, i.e., as long as the memorial will not be sited immediately (*unmittelbar*) above the Or-Sarua synagogue."[62]

January 1998: The atmosphere begins to change perceptibly towards greater willingness to find a solution *on* Judenplatz. Within the press debate the memorial is shifted, like a stage set, now to the center of the square, then turned sideways, then exchanged with the Lessing monument.

February 1998: The breakthrough finally comes in a meeting on February 18 at the IKG's headquarters in Vienna. It is a first

face-to-face meeting between the artist and the disputing factions within the IKG. Chaired by the cultural councillor, Peter Marboe, the meeting has to be steered across explosive terrain, to find a generally acceptable answer for the question how far the memorial can, should, or must be moved in order to avoid conflict with the integrity of the excavations. Paul Grosz declares that the memorial should not stand above the "sacred heart" of the excavated synagogue, i.e., the bimah, while others want to exchange the memorial with the Lessing statue.[63] Marboe realizes that the encounter is "not so much a question of centimeters and meters, but of willingness for mutual acceptance."[64] The Lessing memorial's complicated and symbolic history soon rules out relocation.[65]

March 1998: The announcement that everyone had been awaiting for so long is made jointly by the mayor and Marboe: the memorial, to be slightly shifted sideways, will be built on Judenplatz.[66] The news is generally approved, and received with relief, even by those who had until recently argued for relocation. Only the Freedom Party continues its protest.[67]

April 1998: The exact degree of repositioning, accepted now by all involved parties, is declared: one meter.[68] As the memorial's position would now be too close to the street, a decision is taken to pedestrianize the square. The architects Jabornegg and Palffy, who apart from their work on the memorial had also devised the concept for the subterranean museum, are commissioned to design surface for the square that would integrate all its elements.

Speculation about inauguration oscillates between the end of 1998, March 1999, and November 1999.[69]

September 1998: The concept of a new *Gesamtkunstwerk* for the square gets a further boost at an official press conference to present the finalized concept for Judenplatz and a ceremony of foundation stone laying[70] to mark symbolically the beginning of the building program. Unable to accept the carefully brokered reconciliation, the Freedom Party calls the memorial "a meaningless concrete cube in the shape of a garage."[71]

November 1998: Rachel Whiteread approves the new design for the square while in Vienna to view the four white concrete plinths that are to surround the memorial. The steel lettering bearing the names of the sites of genocide is still not as flush with the concrete as her precision in these matters demands, and measures are discussed to put this right. She is also invited to create the concept for a permanent exhibition room in the planned Holocaust Museum with objects and drawings relating to the genesis of her *Holocaust Memorial*.

January 1999: Work on the ceiling above the excavations and on the Misrachi House begins.

April 1999: The foundations for the memorial are completed as well as the erection of the central cube on which the books are to be mounted.

May 1999: Whiteread returns to Vienna. It is a moving and surprising moment of shock for her to walk onto Judenplatz. She no longer encounters the gaping hole of the building site of the past three years, but sees her memorial taking shape, definitely and irreversibly, with several rows of books already in place. Looking remarkably like the image she had produced in numerous drawings and models, it is now no longer a "phantom," a "project," or a "proposal," but tangible, and literally concrete, reality.

Rachel Whiteread, *Untitled (House)*, 1993, London, Artangel

Rachel Whiteread, *Water Tower*, 1998, New York, W. Broadway & Grand Street

September 1999: Whiteread visits the concrete factory in Amstetten where the large, by now partially remade, plinths of the memorial are stored, to give her final quality approval. She supervizes their installation on Judenplatz the following day. Apart from a few minor "cosmetic" improvements, the *Holocaust Memorial* is now complete. A large wooden fence is constructed around it to shield it from view. Cocooned like this, the memorial awaits its final unveiling, to coincide with the completion of the Holocaust Museum and the entire re-designed square, on October 25, 2000. Vienna has now created a unique place of pilgrimage and contemplation. The story of Jewish sufferings from the Middle Ages to the Shoa is recounted here, thoughtfully and sensitively, through an astute combination of historical fact and contemporary symbol. From eloquent archaeological findings, to a comprehensive documentation center, and, finally, to a profound and poetic statement in the language of art, there will exist here vital and powerfully persuasive prompting for memory, admonishment, and reconciliation.

1 Franz Kafka in a letter to Oskar Pollak, January 27, 1904: "Ein Buch muss die Axt sein für das gefrorene Meer in uns." Quoted from Andreas Huyssen, "Monument and Memory in a Postmodern Age," in James E. Young (ed.), *The Art of Memory: Holocaust Memorials in History*, Munich, 1994.
2 Jury members were: Amnon Barzel, Director of the Jewish Museum in Berlin; Phyllis Lamber, Director of the Centre Canadien d'Architecture, Montreal; Sylvie Liska, representative of the Israeli Culture Community, Vienna; Robert Storr, Curator, Department of Painting and Sculpture, Museum of Modern Art, New York; Harald Szeemann, independent curator, Zurich; Lord Weidenfeld, publisher, London; Simon Wiesenthal as well as the mayor of Vienna and two city councellors.
3 Clegg & Guttmann (US), Peter Eisenman (US), Valie Export (A), Zvi Hecker (I), Ilya Kabakov (USSR), Karl Prantl (A), Zbynek Sekal (A), Rachel Whiteread (GB), Heimo Zobering (A). It is interesting to note that Clegg & Guttmann also

employed the library as a symbol in their proposal. Here the building is reminiscent of a watchtower.
4 Hans Hollein, *Judenplatz Wien 1996*, Vienna and Bolzano, 1996, p. 97
5 See in this context not only Hrdlicka's memorial, but also of George Segal's earlier, highliy figurative *Holocaust Memorial*, installed in San Francisco in 1984.
6 Rachel Whiteread was a guest of the prestigous DAAD scholarship program in Berlin from May 1992 to November 1993.
"Wherever you turned in Berlin there were stark and raw mementos of the past. I could not help becoming preoccupied with the Holcaust then." From Rachel Whiteread's press statement, Karsten Schubert Gallery, London, 25 January 1996.
7 Soon after her time in Berlin she went to see the concrete bunkers and defences on the French Atlantic coast, as well as Maya Ying Lin's *Vietnam Memorial* in Washington. All this was to provide important influences for her work.
8 See R. Pohanka's essay in this publication for a detailed historical outline of Judenplatz and the exavations of the medieval synagogue. Here it is explored solely in relation to Whiteread's work.
9 Rachel Whiteread, interviewed by Dorothee Frank, "Diagonal," ORF Radio, 5 October 1996.
10 See Rachel Whiteread interviewed by David Silvester, "Carving Space," *Tate* magazine, issue no. 17, spring 1999, p. 47.
11 The memorial is 3.8 m high, 7 m wide, and 10 m long.
12 "... I don't think I have made anything that hasn't been related to my own physicality, my own scale." Ibid, p. 46.
13 Young, op. cit, p. 22
14 Rachel Whiteread's was the only once of all nine proposals that did not incorporate the ruins of the fifteenth-century synagoge in any direct way.
15 See *Judenplatz Wien*, op. cit. p. 109.
16 James E. Young: "Vienna's Change of Heart," in *The Forward*, 13 March 1998.
17 See Rachel Whiteread, *House*, London, 1995.
18 Rachel Whiteread, "Statement on the Project," in *Judenplatz Wien*, op. cit., p. 84.
19 See *Looking Up: Rachel Whiteread's Water Tower*, Zurich, 1999.
20 No doubt informed by Adorno's dictum about the impossibility of aesthetisizing terror after Auschwitz, the so-called the anti- or counter-monuments were developed by artists such as Hans Haacke or Jochen and Esther Gerz in the 1980s. For further information about these works see Stephan Schmidt-Wulffen: "The Monument Vanishes, A Converstion with Esther and Jochen Gerz," in Young, op. cit, p. 69; Hans Haacke: "Und ihr habt doch gesiegt,"

ibid, p. 77; Andrew Causey, *Sculpture since 1945*, p. 217, and Christoph Heinrich, *Strategien des Erinnerns: Der veränderte Denkmalbegriff in der Kunst der 80er Jahre*, Munich, 1993.
Particularly interesting in this context is also Micha Ullman's *Bibliothek* (1994) on Bebelplatz in Berlin. Sunk into the ground, Ullman's library of white empty shelves makes solemn reference to the book-burnings that took place in that square in 1933. Standing on a square glass plate, the viewer looks down into a void that would have been archive for the 20,000 books that were burnt by the Nazis. For a detailed discussion see Friedrich Meschede (ed.), *Bibliothek Micha Ullmann*, Dresden, 1999. See also Horst Hoheisel's inverted fountain, sunk into the ground in his *Monument to the Aschrott-Brunnen*, Kassel, 1987, in Young, op. cit., pp. 36, 37.

21 Hussen in Young, op. cit, p. 10.

22 I should state here that from January 1996 to its final inauguration in October 2000, I have been working with the artist on her *Holocaust Memorial* as project coordinator and negotiator between the artist and all other relevant parties.

23 Rachel Whiteread in *"The Monument,"* BBC documentary, 18 October 1997.

24 See "Gestaltung Judenplatz: Bürgerversamlung einberufen," in: *Wiener Freie Zeitung*, March 1996, issue 3j/96.

25 See *Rachel Whiteread. Skulpturen 1988–1996. Prix Eliette von Karajan 1996*, Salzburg, 1996.

26 "Streit um das Mahnmal," *Kurier*, 4 May 1996.

27 Arik Brauer, "Kunstlos, hässlich, kontrapunktiv," *Der Standard*, 13 June 1996.

28 "Leon Zelman gegen Judenplatz Mahnmal," *Die Presse*, 17 June 1996; see also Ute Woltron, "Dieses Denkmal findet statt," *Profil* 32, 5 August 1996, p. 76, which includes interviews with both Wiesenthal and Zelman.

29 "Mahnmal: Wo denn sonst?," *Die Presse*, 26 June 1996.

30 Siegfried Fenkhuber für Werkstatt Kollerschlag.

31 "Schauraum neu, Kritik bleibt. Leon Zelman: Mahnmal ist ein Fremdkörper am Judenplatz," *Der Standard*, 30 July 1996.

32 See Ernst Josef Lamberg, "Falsches Denkmal, falscher Ort," *Der Standard*, 26 July 1996.

33 "Streit um ein Wiener Denkmal, Teil Zwei: Vom Albertina- zum Judenplatz," *News*, 8 August 1996; see also Joachim Riedl "Synagoge oder Monument" in *Süddeutsche Zeitung*, 2 August 1996, who remarks on the animosity between Hrdlicka and Wiesenthal.

34 *Kronenzeitung*, 8 August 1996; *Die Presse*, 10 August 1996.

35 The committee includes amongst others: Hans Hollein; Paul Grosz, president of the Israeli Cultural Community (IKG); Richard Schmitz, governor of the 1st district; Ortolf Harl, city archaeologist and city councilliors Ursula Pasterk and Hannes Swoboda.

36 Ingrid Luttenberger, "Nachdenken bis nächsten Mittwoch," *Die Presse*, 16 August 1996.

37 Ingrid Luttenberger, "Judenplatz: Vorrang hat die Ausgrabung," *Die Presse*, 13 September 1996.

38 See *Rachel Whiteread, Shedding Life*, Tate Gallery Liverpool, 1996.

39 Richard Cork, "The sculptures that broke the mould," *The Times*, 17 September 1996; see also Roger Bevan, "The safe art of exhibitions and the unsafe art of memorials," *Art Newspaper*, September 1996.

40 *Kurier*, 31 October 1996 and Eva Linsinger, "Die Enthüllung des Holocaust-Memorials verzögert sich bis Mitte Juni," *Der Standard*, 11 November 1996.

41 "Holocaust-Mahnmal: VP für anderen Standort," *Der Standard*, 16 November 1996; Eva Linsinger, "Grosz: Kein Antrag auf Mahnmal-Übersiedlung," *Der Standard*, 19 November 1996.

42 Sarah Kent, Judenplatz, *Time Out*, November 1996.

43 See Rebecca Comay, *Memory Block, Rachel Whiteread's proposal for a Holocaust Memorial in Vienna*, unpublished manuscript. This illuminating essay focuses especially on the relationship between the Holocaust Memorial and the Lessing statue.

44 See Lynn MacRitchie, "The war over Rachel," *The Guardian*, 5 November 1996; Ian Traynor, "Vienna unearths its Jewish guilt," *The Observer*, 6 October 1996; Peter Popham, "An artist cast into controversy," *The Independent*, 2 November 1996; Michael Kimmelman, "How public art turns political," *The New York Times*, 28 October 1996; see also Tom Hagler, "Nightmare in Old Vienna," *The Sunday Telegraph*, 2 January 1997.

45 Robert Storr, "Es steht viel auf dem Spiel," *Der Standard*, 5 December 1996; reprinted in *Art News*, "The Struggle between Forgetting and Remembering," March 1997.

46 "Komplett absurd," Rachel Whiteread interviewed by Horst Christoph, *Profil*, 9 December 1996, p. 95.

47 Rachel Whiteread, in *The Observer*, 6 October 1996.

48 See press release of IKG, 4 December 1996.

49 See *Der Standard*, 19 November 1996.

50 Ian Traynor, *The Observer*, 6 October 1996.

51 See Paul Kruntorad, "Stein des Anstosses," *Frankfurter Rundschau*, 27 November 1997, and Georg Hoffmann-Ostenhof, "Versteinerte Erinnerung," *Profil* 5, 27 January 1997, p. 79.

52 This was a slightly different version of her Liverpool retrospective.

53 This piece was made especially for the British Pavilion in Venice. Rachel Whiteread represented Britain at the

47th Venice Biennale, 15 June–9 November 1997.
See catalogue published by the British Council, 1997.

54 *Untitled (Book Corridors)*, 1997–98, shown at the
Anthony d'Offay Gallery, London 1998.

55 "Carving Space," interview with David Sylvester,
Tate magazine, Spring 1999, p. 46.

56 Rachel Whiteread in "*The Monument*," BBC2 documen-
tary, 18 October 1997.

57 Waldemar Januszczak, *The Sunday Times*, 21 June 1997.

58 I was introduced to Viktor Klima and took the opportunity
to discuss the Holocaust Memorial with him.

59 *Wiener Journal Speziell*: Judenplatz 1997, no. 205,
October 1997.

60 Entitled *The Monument*, it was produced and directed
by Nicola Bruce. The film was also shown by the ORF on
Austrian TV in January 1998.

61 Eva Linsinger, "Sönborn gegen das Judenplatz-
Mahnmal," *Der Standard*, 21 November.

62 Letter sent by Paul Grosz to Michael Häuptl,
20 November 1997; transl. by the author.

63 Based on the author's meeting notes.

64 "Judenplatz bleibt," Peter Marboe interviewed by
Markus Wailand, *Falter*, 4 March 1998.

65 Vice-mayor Bernhard Görk announces: "Lessing will not
be moved," *Kurier*, 24 February 1998.

66 See Rathauskorrespondenz Wien, 4 March 1998. There
is widespread international echo: see for example, Jane
Perlez, "Vienna to go ahead with controversial Holocaust
Memorial," *The New York Times*, 4 March 1998; "Holocaust
Memorial row ends," *The Times*, 4 March 1998; "Wien baut
Mahnmal," *TAZ*, 4 March 1998; "Wiens Holocaust-Denkmal
auf den Judenplatz," *Neue Zürcher Zeitung*, 6 March 1998.

67 See *Kurier*, 4 March 1998, p. 11.

68 "Symbolträchtiger Meter," *Der Standard*, 24 April 1998.

69 *Kurier*, 30 July 1998.

70 This was jointly undertaken on 28 September by
Simon Wiesenthal, Ariel Muzicant, new president of the IKG,
Peter Marboe and the mayor, Michael Häuptl.

71 *Die Presse*, 29 September 1998.

Four Statements, February 2000

THOMAS HIRSCHHORN

Statement: *Altars*

An altar is a personal, artistic commitment. I want to fix my heroes. The altars want to give memory of someone who is dead and who was loved by somebody else. It is important to testify ones' love, ones' attachment. The heroes can't change, but the altars' location can change. The altars could have been made in other cities, countries. The altars could be in different locations: on a street, on a side way, in a corner. These very local sites of memory become very universal sites of memory, by virtue of their location. That is what interests me. I choose locations that are not in a center or strategical point of a city, just any place, in the same way as people can die anywhere. Most people don't die in the middle of a square or in a beautiful boulevard; their death rarely happens in a strategic location, even famous people don't die in "the center." There is no hierarchy of location between anonymous and famous people. There are unexpected locations. The location is important not in the relationship to the layout of the city, but in relation to the people who died. This gives me the plan to locate the altars. These altars are questioning the status of a monument today by their form, by their location and their duration. Thus, the choice of location is determinating for my statement on work in public space and my critic of monuments. The form of these four altars comes from spontaneous altars, that one can see here or there, made by people who wish to give a precarious homage to someone deceased on the spot, by accident, suicide, murder, or heart attack (Gianni Versace, J. F. Kennedy Jr., Olaf Palme). The forms of these homages are alike, whether made for celebrities or made for the unknown: candles, flowers, often wrapped in transparent paper, teddybears and stuffed animals, written messages on scraps of paper with hearts and other love symbols. With this wild mixture of forms, the messages of love and attachment to the deceased person is expressed without any aesthetic preocupation; it is this personal commitment that interests me. It comes from the heart. It is pure energy. One is not preoccupied with the form quality of the elements, but only with the message that is to be conveyed. The reason why I have chosen artists that love for their work and for their lives is: no cynic, only commitment. The forms of these altars, that are profane and not religious, convey a visual form based on weakness. The forms and locations of the altars show the precarious aspect of the work. It is because of necessity and urgency that they are there. The cruelty and the non-spectacularity of these monuments makes them untouchable by people walking by, proprietors, street-cleaners, dog-walkers, policemen. Everyone could be concerned. Everyone is concerned. These altars will disappear sooner or later. The average duration of this altar is of two weeks. The disapearance of the altar is

Thomas Hirschhorn, *Meret Oppenheim Kiosk* (detail), 2000, Zurich University

as important as its presence. The memory of what is important doesn't need a monument. I have made four altars for four artists and writers: Piet Mondrian, Otto Freundlich, Ingeborg Bachmann, and Raymond Carver. The *Piet Mondrian Altar* was shown in Geneva in 1997, the *Otto Freundlich Altar* was shown in 1998 in Basel and Berlin, the *Ingeborg Bachmann Altar* was shown in 1998 in Zurich and in 1999 in Hall in Tyrol, and the *Raymond Carver Altar* was shown in 1998 in Fribourg, in March 2000 in Philadelphia (curator: The Galleries at Moore), in November 2000 in Glasgow ("Vivre sa vie," group show).

Statement: *Kiosks*

This "Kunst am Bau Projekt" was intended for the new building for the brain research and molecular-biology research department of the University of Zurich. The work is a "work in progress" made for the entrance hall of this department. This hall is a public space, even if it is mostly frequented by students, professors, and laboratory technicians. The project is to build eight kiosks in four years, every half year another kiosk. Each time, a kiosk is set up in a different location within the entrance hall, which is designed in a specifically neutral and functional architecture, as the whole building itself. The kiosk is installed in this interior hall like a compact cell, independent, an implant in the existing space, like an airport kiosk, train station kiosk, or hospital

Thomas Hirschhorn, *Spinoza Monument* (detail), 1999, on the occasion of the exhibition *Midnight Walkers & City Sleepers*, W 139, Amsterdam

kiosk, selling newspapers, cigarettes, and candy. I want to show its integrated presence in a building. Whether used or not, it just stands there, present. Thus, this kiosk is important as a mobile object that stands out from the existing surroundings by its handmade, quickly made form. It is in contrast with the top quality architecture, with the top technicity and functionality. With this voluntary contrast, I wanted to propose an outlook towards a different reality. This reality can liberate new or unknown energies. I want to confront the reality of this institution; biologists, technicians, researchers, with the reality of other researchers in other fields, artists, writers. They too are committed in their research. They too do research. The small size of the kiosk is made to receive one spectator so that he can isolate himself and concentrate on the information given within the kiosk, for one minute, for one hour, or for a whole day. The kiosk is built with a wooden structure covered by cardboard and lit with neon lights. On the top, outside, there is a sign with the name of the artist or the writer. Inside, all the available books by and on the artist or writer and also videotapes are displayed to be consulted by the public. The inner walls are covered with photocopies of texts on his or her life, images, writings, and other documentary elements. Everything about the kiosk is made so that the person is plunged into a totally different world. The world of Robert Walser, for example. I want the visitor to discover or complete his knowledge of the artists' work. I want to cut a window towards another existence.

Thomas Hirschhorn, *Sculpture Direct*, 1999, Galerie Chantal Crousel, Paris

The presence of a work of art within this scientific work-world wants to question the fact of beeing committed and engaged with a human activity and with the precarity of this activity. This work-in-progress project, through its rhythm of rotations, and by its time-limited form, is a statement about art commitment in public space. The fact that the project lasts four years makes it long enough to give awareness and memory, and it is not long enough to create habit and lassitude. Too often "Kunst am Bau Projekte" and work in public space create habit and lassitude. I want people to continue without kiosks to be interested in artists and writers. This work is video-documented with interventions of the spectators and users of the kiosks over a period of four years. This documentation will become an important element of the project.

The kiosk project is a comissioned project, resulting from a competition organized by the University of Zurich. It will run from 1999 to 2002. The kiosks are made for: Robert Walser, Otto Freundlich, Ingeborg Bachmann, Emmanuel Bove, Meret Oppenheim, Fernand Léger, Emil Nolde, and Liubov Popova.

Statement: *Sculptures Directes* (*Direct Sculptures*)

Direct Sculptures are models of monuments. *Direct sculpture* is a critique of the monument. My critique of the "monument" comes from the fact that the idea of the monument is imposed from above. A monument is determined, produced, and situated by decisions from above, by the power. And its forms correspond to the will to lead people to admire the monument and along with it the dominant ideology—whether it is the monument to Abraham Lincoln or Christopher Colombus,

the monument to the memory of the first step on the Moon or the memorial wall in Washington D.C. of those who lost their lives in Vietnam. Something demagogic always remains in a monument. I want to fight against hierarchy, demagogy, this source of power. *Direct Sculptures*, in contrast to *Altars, Kiosks,* and *Monuments*, are located in interiors, exhibition spaces. *Direct Sculptures* are in interiors because they are models. The *Direct Sculpture* is a physical result of a confrontation of two wills: the will that comes from below, the heart, and the will that comes from above, the power. One is the support, the other is the message. The two wills are condemned to exist together. They ensue confusion. Confusion is the meaning of the *Direct Sculpture*. *Direct Sculpture* has no signature, a *Direct Sculpture* is signed by the community; colored spray graffiti shows this. It is not a ready-made. It gives a shape to a new type of sculpture: I mean a three-dimensional form coming from a two-dimensional thinking that lends itself to receiving messages that have nothing to do with the purpose of the actual support. The message takes possession of the sculpture. The message appropriates the sculpture. The *Direct Sculpture* that I showed first was inspired by what happened in Paris at the spot of the car accident that killed Princess Diana: on this location exists a monument that represents the flame of liberty. Because of the princess' death, this monument, which had been standing unnoticed for years, took on a new message. People started using this monument for their love messages to Princess Diana, thus transforming it. This transformation interests me. Lady Diana is of no interest to me. What counts for me is that this sculpture is appropriated by its environment, signed, marked, changed, and no longer imposed by

Thomas Hirschhorn, *Raymond Carver Altar*, 1999, on the occasion of the exhibition *Vivre sa vie*, Glasgow 2000

a force from above, but integrated, welcomed or not welcomed, confronted, by the heart, from below. Other monuments inspired *Direct Sculpture*: in the old east section of Berlin, there is a very large sculpture in honor of Ernst Thälmann, co-founder of the German Communist Party. This monument is about twelve meters high, and the bottom part is totally covered by graffiti, inscriptions, and signs added by the youngsters living in the buildings nearby. The sculpture belongs to them because of their painted interventions. Due to their graffiti, it belongs to them; they appropriated it because it stands in their territory, they gave it a meaning. The sculpture now has a meaning, it became a monument that is just. I want to make monuments that are just. *Direct Sculptures* are models for just monuments. I made five *Direct Sculptures* in 1999, the first one at the gallery Chantal Crousel in Paris,

and *Sculpture Direct II, III, IV, V* at the gallery Erna Hécéy in Luxemburg.

Statement: *Monuments*

I try to make a new kind of monument. A precarious monument. A monument for a limited time. I make monuments for philosophers because they have something to say today. Philosophers can give the courage to think, the pleasure to reflect. I like the strong sense in philosophical writings, the questions about human existence and how humans can think. I like full-time thinking. I like philosophy, even when I don't understand a third of the reflections. I'm interested in non-moralist, logical, political thinking. I'm interested in ethical questions. That's why I chose philosophers to make *Monuments*. But the monuments for these philosophers are conceived as commu-

nity commitments in contrast to the altars, which are personal commitments. Something beautiful that humans beings are capable of is thinking, reflection, the ability to make brains work. Spinoza, Deleuze, Gramsci, and Bataille are examples of thinkers who instill confidence in the reflective capacities. They give forces to think. They give forces to get active. I think that reading their books continues to make sense, to give questions, to reflect, to keep beauty vital. The monuments have two parts or even more. The "classical part," a form, they reproduce the thinker with his features, head, or body. This part of the monument is a statue. Then, there is another part of the monument: books, videotapes, statements, biographical documents are there to be consulted. This is a new part of that monument. It is the "information part." The "information part" with its materials respond to "why." The "classical" statue part responds to "who." The information part of the monument is a physical place to isolate oneself, to sit down, in a little construction (like in the kiosk project), and to study and get informed about the philosophers working twenty-four hours a day, seven days a week. This construction with the documentation on the philosophers is a proposition to bring public acces to everyone: for those who have never been in contact with philosophy, but also for those who are "professionals," specialists, philosophers, or amateurs. I want to give equal access to both. I want to give people the possibility to first be in contact with the information, to read about the work, the philosophy, and then afterwards to see the statue. I want to provide a different access to the monument. Thus, the monument is not just standing there, but wants to offer the possibility to be informed about its meaning and furthermore about the thinking of those philosophers. There is an active and a passive part. The plastic aspect of the monument is precarious: cardboard, wood, tape, garbage-bag covering, neons. It means: the monument will not stay here for eternity. This monument does not come from above. It will not intimidate. It is made through admiration, it comes from below. In this way, it shows its precariousness and its limitation in time. It is inforcing the precarious aspect of the monument. It conveys the idea that the monument will disappear, but what shall remain are the thoughts and reflections. What will stay is the activity of reflection.

The four monuments are for Spinoza, Deleuze, Gramsci, and Bataille. I made the *Spinoza Monument* in a street in the Red Light District in Amsterdam in 1999 and the *Deleuze Monument* was built in a public housing space, Cité Champfleury, in Avignon in the spring of 2000.

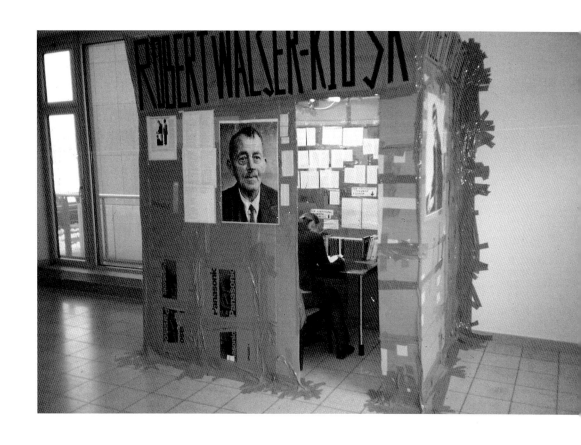

Thomas Hirschhorn, *Robert Walser Kiosk*, 1999, Zurich University

AS THE ARTIST IS PART OF THE PUBLIC
PUBLIC ART IS ART FOR YOURSELF

HISTORY AS WE KNOW IT HISTORY AS IT WAS

HISTORY ITSELF

AFTER ANY GIVEN TIME

Con Edison Modified Manhole Cover Q-8-S
Public Art Fund Design
A Lawrence Weiner original design.

41-2001

GIVEN THE LIGHT
URBAN PEOPLE DO NOT IN FACT HAVE ANY MEANS OF DETERMINING
WHERE THEY ARE FROM LOOKING TO THE STARS
THE MATERIAL REALITY OF THE WORK ITSELF ALLOWS EACH
MANHOLE COVER TO OFFER A CERTITUDE
AT THAT MOMENT WITHIN THE SPHERE WHEN DETERMINING
WHERE YOU ARE IS OF SOME USE IN UNDERSTANDING
THE RELATIONSHIP OF HUMAN BEINGS TO OBJECTS IN RELATION
TO HUMAN BEINGS -- LW

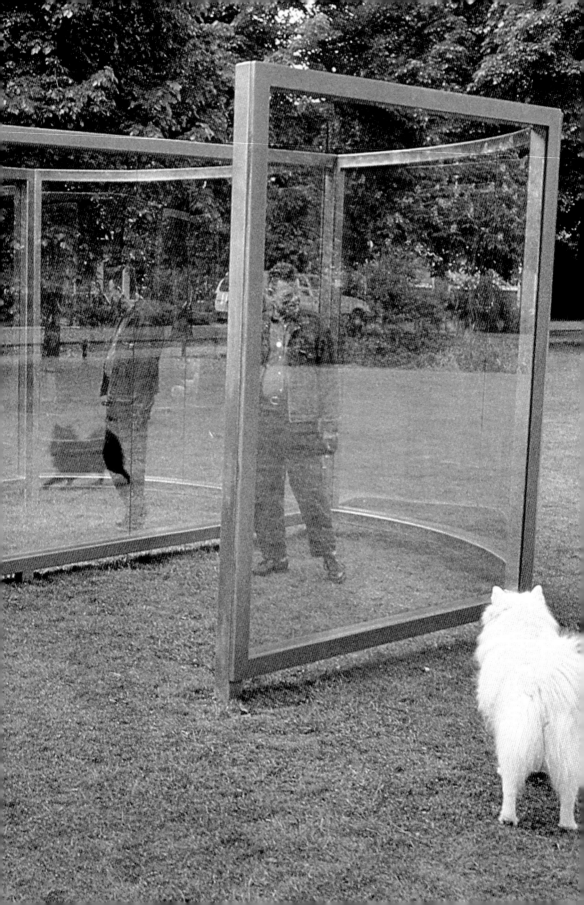

Modern Life and Quasi-Religion

DAN GRAHAM

My truncated two-way mirror pyramidal pavilion for the Museum at Santiago de Compostela, Spain, on the roof terrace, is a parody of the architect Siza's very 1980s stone pyramid, which culminates his work. Unlike the Siza, my pyramid can be entered by the public who experience a 60s-like, cutaway top. This is also a reference to Bruno Taut's original glass utopias. In the late 60s, we hippie artists were interested in building cardboard pyramidal forms where you could receive "pyramid power" from the "eye of God" as we sat under the point within the pyramid. The glass pyramid on the roof of corporate buildings of the 80s was part of that period's return to neo-1930s, neo-Fascist/neo-Enlightenment forms. In Italian Fascism, the state was represented by monumental forms which simultaneously alluded to both Roman and Egyptian stereotypes of absolute power. The two-way mirror office building, often with a glass pyramid on its roof, is emblematic of the 80s and 90s metropolis.

In Western culture the pavilion placed in a park setting began with the Baroque garden where it was often used for special effects. In the nineteenth century it grew in size into "The Crystal Palaces" of the "World's Expositions." It now encompasses the quasi-utilitarian modern "non-place" bus shelter and telephone booth.

Two Adjacent Pavilions, first shown as a model in 1978, was realized at *Documenta 7* in 1982;

it was my first outdoor two-way-mirror pavilion. Each of the square, enterable forms allows for four to six people standing and to lie prone inside. Each is the same size as the other. The four sides of each structure are made from two-way-mirror glass of the same percentage reflectivity. The difference is that one pavilion has a transparent glass ceiling, while the other's ceiling is covered with a dark, non-light-transmitting material.

The properties of the mirror-reflective glass used in the pavilions cause one side to be either more reflective or more transparent than the other side at any given moment depending on which side receives more light.

In *Two Adjacent Pavilions* the spectators' gaze and body inside are superimposed on the spectators' gazes and bodies outside as well as onto the shifting landscape. They are, like all my work from the early 70s, about the spectators inside the pavilion/or artwork's own and the other spectator's perception process. The changing of overhead clouds/light affects the always shifting relation of the superimpositions of indoor and outdoor bodies, reflectiveness as against transparency in continual flux. *Two Adjacent Pavilions* was first realized at *Documenta 7* in 1981. It related to the large eighteenth-century palace.

My sculpture/pavilions use the materials of the modern corporate city, including the use of surveillance power. They are emblematic of the surrounding "corporate" city, but create a

Dan Graham, *Fun House* (detail), 1997, on the occasion of the *Sculpture. Projects in Münster*

heterotopia in place of alienating effects of this corporate architecture.

Two-way mirrors as used in office buildings are always totally reflective on the exterior, reflecting the sunlight, and totally transparent for workers inside. In *Two Adjacent Pavilions* and other pavilions the inside and outside views are both quasi-reflective and quasi-transparent and superimpose intersubjective images of inside and outside viewers' bodies and gazes along with the landscape, which contradicts the one-way-mirror situation of the corporate office façade where people inside can see transparently outside, while the public only sees a mirror of themselves and the environment.

Typologically the work belongs to the park/garden's pleasure pavilion which has been an antidote to the alienating qualities of the city as well as an utopian metaphor for a more pleasurable city in the future. These pavilions are used for people as restful play-a-fun-house for children and a romantic retreat for adults. They are both emblematic of the power of the corporate city and help to dissolve the city's alienation effects. They also relate to the eighteenth-century motion of the Arcadian "rustic hut." This type begins after the Enlightenment with the notion of the "elemental rustic hut," first proposed by Marc-Antoine Laugier. Laugier was a mid-eighteenth-century French urban planner and theorist. Like Jean-Jacques Rousseau, Laugier set up his model of the elemental "rustic hut" to uncontaminated nature. The "rustic hut" was supposed to be a reduction of man's and architecture's original nature to its "own self-sufficiency," when there was no oppression of man by man, architecture and man were closest to "nature."

In the seventeenth century, royal Baroque palace garden pavilions were part of the symbolism of royal power in relation to nature. One example is Munich's Amalienburg Pavilion, located in a wooded sector of the Munich Nymphenburg Palace's formal garden. Designed by François de Cuvilliés, it contained a ten-sided *Spiegelsaal* or hall of mirrors, with open corridors at two ends. The formal aesthetic of this *Spiegelsaal* connected the king to the mythology of artificial nature upon which the plan of Nymphenburg's formal garden, as well as the alchemical principle of the pavilion, was based. The mirror room related the exterior to the interior, sunlight to the material qualities of mirrors and windows, and daylight to the artificial light of night-time. Each of the four windows was oriented to a cardinal direction. Pedestrian pathways radiated from each window, continuing into the woods toward north, south, east, and west nodes. The sun rose and shown directly through the eastern window. Wreaths of artificial foliage, which were mirrored in forms embossed in silver above the mirrors of the *Spiegelsaal*, formed a tunnel through which the rising sun passed each morning. The sun set along the path to the west, directly aligned to the window facing in that direction.

The sun's light turned the silvered mirrors, and hence the entire room (including its intricate silverwork of artificial nature imitating the arranged "real foliage" of the exterior park), into gold.

The king in essence symbolized the sun. The alchemy of changing silver to gold was the alchemy upon which his rule derived its potency. Cuvilliés's pavilion was designed so that a spectator standing in any one cardinal direction and looking through a window would see reflected forms from the mirrors to the left

Dan Graham, *Yin/Yang*, 1996

and right side of the window, then the reverse from two of the other windows. This would be the view of the king, the invisible centerpiece of all directions and perspectives.

Seventeenth-century Japan had a similar symbology of the ruler as sun, whose principle transformed sunlight as gold from moonlight (identified also with water). The Ginkakuji Garden in Kyoto contains a Silver Pavilion which was visually and symbolically aligned to the Kinkahuji Garden's Golden Pavilion, which represented the sun. The Silver Pavilion was devoted to lunar images. In front of the Silver Pavilion, alongside an artificial pond, is a permanently raked and maintained cone of white sand about two meters high. Its top is flattened. It represents both Mount Fuji and, by extension, the island of Japan. Its title is "Moon Facing Height." The surface of sand surrounding this cone is raked areas to suggest to the lunar principle as manifested in the waves of the sea. This metaphor is aesthetically emblematized during the night of the full moon, when the moon's light hits the sand "sea" which becomes silver-reflective from the silicon particles in sand. Within the Silver Pavilion, from a second-floor viewing point called the "moon viewing crack," a "moon" stone can be seen (through the garden's symbolic arrangement of nature reflected upon the surface of the artificial pond. Illusionistically, this "moon" is situated in the precise mirror reflection above the reflected hillside, aprearing to float in the reflected heavens (stars of the night-time sky).

In the twentieth century, corporate power has replaced the power of the state. In the 1970s glass façades of corporate office buildings changed from transparent glass to two-way-mirror gold (reflecting the new interest in a return to the monetary gold standard) and then to silver two-way mirror. The silver reflection identified the buildings' façade with the sky. The corporation's arrogance toward the environment was now under attack by the public and the use of a sky-reflecting façade provided

a visual alibi identifying the building (and corporate power) with the sky, linking it to the surrounding environment.

Two-way mirror also was a solar reflective, insulating material which cut the costs of air conditioning and saved the dwindling pretroleum supplies.

The initial use of spy glass or two-way mirror glass was in customs areas and in psychology laboratories where patients were observed by unseen students. The returning traveler and patient behind what they took to be mirrors were secretly placed under surveillance by unseen authorities on the other side.

There was a shift from the transparent glass office showcase of the 50s and 60s to the two-way-mirror tower of the 70s to present-time.

The power of the corporation was initially symbolized by the golden color of the first two-way-mirror glass buildings. They provided a reflective image for people outside and transparent surveillance for those inside. At this moment silver coating has replaced the gold. It is to the seventeenth-century royal palace grounds we should look for a precedent of ultimate power being symbolized by the sovereign's identification with gold and silver.

The most modern aspect of my pavilions is their relation to what the French anthologist Marc Angé calls the "non-places" of "supermodernity," "which turn back on the self, a ... distancing ... (and) a particular form of solitude ... (which) comes at the end of a movement that empties the landscapes, and the gaze ... of all content and ... all precisely as the gaze dissolves into the landscape."

Dan Graham, *Two Adjacent Pavilions*, 1978–81, Rijksmuseum Kröller-Müller, Otterlo

Examples are bus waiting shelters, airports, and the experience of long-distance car driving. The phenomology of these "non-places" involve the spectators looking with distracted gazes "which produces a self-consciousness" where the act of looking (and people looking at the looking) becomes a spectacle in itself. The rooftop park for the DIA Foundation from 1989 is both optical pavilion and a re-design of a previously unused roof to give the DIA exhibition complex a variety of new functions. In the center of the roof is a raised boardwalk— like a wooden platform containing a two-way mirrorized cylinder with a door allowing spectators to enter its interior. The cylinder is enclosed within a two-way mirror cube, with space between the two. The cylinder is centered on and has the same dimensions as the overhead New York City wooden water tower. The cylinder gives, on the interior two-way-mirror concave lens, an anamorphically enlarged image of the viewer's body. On its exterior surface, an outside spectator sees, superimposed on an image of the interior spectator, concave-lens-contracted images of themselves and their body. They see themselves gazing superimposed on the image of an exterior spectator observing. On the curved surfaces, bodies are also superimposed on the skyscape.

The cylinder's curved surface relates to the 360-degree surface of the body and to the exterior 360-degree skyscape. As the skyscape changes relative to the cloud cover and time of day, the two-way-mirror interior alters continually in relative reflectiveness as against transparency.

The enclosing two-way interior cube relates to the ninety-degree street grid of Mid-Manhattan. Its surfaces reflect the spectators between the cube and the cylinder and the sky and cityscape as on a flat mirror/window surface.

The DIA cylinder inside the cube has become a symbol of the DIA Art Foundation.

The platform is raised to give an unobstructed view over the skylights and fence around the main area of the roof. The roof previously had a tool shed, which I turned into a combination coffee bar and videoteque.

I decided not to cover the airconditioner unit, giving the roof the quality of a raw downtown "slum building" roof, as well as combining this with the elegance of an uptown penthouse rooftop.

The cylinder is the centered on and has the same dimension as the roof's cylinderical water tower, hanging above.

The boardwalk planking relates the work to a "Coney Island" like seaside amusement walkway and the work to Battery Park City (visible from the rooftop) which I surmised would eventually extend up the Hudson River to the region of the DIA Foundation.

The large expanse of the rooftop not on the raised platform is covered by a child-friendly rubber matting derived from New York City playgrounds (the area around the swings) and can handle children falling and all people lying on it to read or be romantic sky-gazers.

The work is a symbol of DIA.

The central pavilion is designed for performances and the bulwark wall is for film screenings.

The DIA spaces had previously been used as interior meditative "ideal" showing spaces for "great" art/works/installations meant to be viewed by isolated spectators under prime showing conditions. My work necessitates a large public audience aware of each other's, as well as their own gazes, at the art work under continually altering outdoor solar/sky conditions.

I organized a program at the DIA to purchase, screen, and archive videos selected by guest curators in the areas of architecture, cartoons, music, and performance. This was to break the emphasis in the 80s on work exclusively painting and sculpture and relate the space to the nearby surviving alternative performance space, "The Kitchen," I wanted to archive in my space some of the best of the lost 70s work in video and performances.

I wanted the DIA to become an outdoor "ICA," allowing multi-media use, as well as providing a public meeting place/coffee lounge.

For the catalogue I produced a video with a booklet. The video relates the DIA roof to New York's shift from the 70s to the late 80s from public parks and spaces to corporate private public space. The booklet extends the video essay and provides a map to locate the sites on the video.

The Children's Pavilion is a 1988 collaborative project with Jeff Wall and now will be realized in Blois, France, in two years. From the outside it resembles an enlarged playground landscaped hill from which children climb to become "king of the mountain." It also ressembles a "World's Fair" pavilion perhaps by Benetton.

Children and others can enter the side of the "mountain" and inside can observe nine back-illuminated Jeff Wall circular photos each of which is of small children from different "immigrant" nationalities against uniquely different skies suggesting individual horizons or lives. In the center of the floor of the cylindrical core-like drum is a small, circular water basin. The apex of the ceiling is an oculus—a large convex two-way-mirror coated lens showing an image of the changing real sky and images of the space inside, including reflections on the water basin, people inside gazing up toward the nine photo-images with symbolic skies.

Children reaching the top of the pavilion, looking down see on a concave two-way-mirror coated lens, images of the sky, themselves gazing downward as anamorphically distorted "giants," superimposed on the tiny upward gazes and bodies of the adults and children below, and the fictional children and idealized skies in the photos. People inside and people outside's perceptual processes/gazes are superimposed on each other. Due to the qualities of two-way mirror as the real sky continually alters, so does the relation of relative reflectiveness of the sky and children's faces above as against the transparent image of the interior people's bodies and gazes.

While the optical qualities of the work as "observatory" and as "magnifying glass" as well as the urge to become "king of the mountain" are related to boyhood mastery of the environment, the interior of the work as well as its mound-like quality relate it to female "Mother Earth." I had in mind a history of Roman and French monuments starting from Lascaux's cave art, through the Mediterranean grotto, and then allude to the Roman Pantheon. In the Pantheon's open oculus, the sun at different times of the day shines on different Roman gods whose statues were represented in the niches at the sides of the dome. Of course, the gods in *The Children's Pavilion* are *modern children.*

I also wanted to relate to Bouleé and Ledoux's Neoclassical projects for observatories and the all-seeing eye of Reason.

My original site was in the area that later became Paris's Parc la Villette, adjacent to the mirror-coated dome of the science museum's Omnimax cinema. Parc la Villette, in the Socialist's original program, might be seen

Dan Graham, *Two-Way Mirror Cylinder*, 1989, DIA Art Foundation, New York

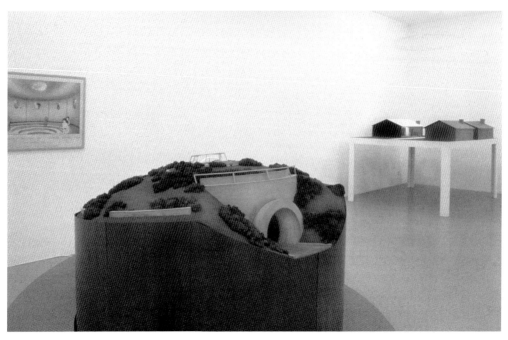

Jeff Wall and Dan Graham, Model for *Children's Pavilion*, 1988, Villa Gilet Collection

as anti-Europe-Disney—an educational scientific playground and theme park for families of upper-lower class and lower-middle class on the edges of Paris.

In Blois, it will be part of this small city's tourist and children's "theme-park" which now includes a Houdini Museum and, in an old chocolate factory, the movie props from the film *Charlie and the Chocolate Factory*. The work could be important to the 90s Socialist French vision, as it is a monument to Immigration. This is an idea from the USA, just as the *Statue of Liberty* is from France. When I first conceived the work in the late 80s I was interested in partly landscaped, underground public architecture like that of Emilo Ambasz in his San Antonio Conservatory. I wished to support the idea of ecological architecture opposing to the 80s corporate mega-penis. There is also an echo of the landscaped playgrounds of the

Japanese-born American sculptor/architect Noguchi.

Having done a group of works in the mid-70s of time-delayed video installations which were contextualized to windows related to transparent windows and mirrors, or as the title of my book puts it, "Video-Television-Architecture," I became interested in designing a museum, "living-room-like" space to show six different single-channel videos by various video or film artists, including my own works. In my 1986 original *Design for Space Showing Videos*, consisting of a labyrinth of six enclosures whose walls were variously two-way mirror and transparent glass, spectators could relax and sit or lie down on cushions on the floor to experience the tapes. Images of various spectators observing the videos were superimposed on images from different video screens. The perceptual processes of acting/being a video

watcher as well as the relaxed social process of the act were observed in this quasi-functional interior "pavilion."

As the light continuously shifted from different scenes in the various videos, so did the types of superimpositions change.

For a second design of the piece for my mini-retrospective in 1996 at the Generali Foundation in Vienna, I designed a pavilion whose booths were triangles and substituted perforated aluminum screens for the transparent glass panels. The images of the TV screen pixels were the focus on the perforated aluminum. Where two-way mirror glass changes from relative reflectiveness to relative transparency dependent on the light source, perforated aluminum is almost opaque from a distance, but a peep-hole experience observed up-close. The labyrinth design for this work was also used for the outdoor *2-Way Mirror Hedge Labyrinth* for the 1989 Stuttgart IGY. The hedge references to Baroque and English garden hedge labyrinths, while the two-way mirror emblemizes the modern city's office buildings. The labyrinth form is also symbolic of the "labyrinth" of streets of modern recti-linear city plan.

This proposed water pavilion from 1996 is in the form of the "Yin/Yang" symbol. The yin area is a water basin/pond. The yang area, which consists of small white pebbles, alludes to the classic Japanese garden. Dividing the yin water area from the yang side is a curved two-way-mirror barrier in a sinuous S-shape. Dividing most of the yang, pebbled area from the park's grassy exterior is an almost full two-way semi-circle. The semi-circle isn't complete, allowing a gap from the entrance to the yang area. Optically, the change in overhead light conditions causes a play of concave and convex reflections. There is a superimposition of people's bodies and gazes on each other inside and outside the form. These images are all superimposed on the changing sky-scape and the reflective surface of the water. As the sun's light changes, there is a contin-uous alteration of the relative reflections and against transparency on the two surfaces of the two-way mirror glass.

H 200 cm

P 68 cm

L 74 cm

Beckmann's *Bathing Cubicle*

OLAF METZEL

Max Beckmann, *Badekabine (grün)*
(Bathing Cubicle [Green]), 1928,
Pinakothek der Moderne, Munich

Sundays are free. Admission to the museum. That makes it a little more public. Sunday is the people's day, open to the public, you would like to think. On workdays, however, it's empty and quiet, because then it costs money. You once again realize that art can be a luxury. Even more luxurious is when a collector is allowed to show his collection in a museum. Private pay-per-view or private view-per-pay? But who really wants to be everlastingly confronted with the personal viewpoint of a collector? Even the soap operas—storing things or clearing them out—don't help; just get rid of it all. Whatever. We're not talking about a very large public. The biggest luxury, however, is architecture. Is exhibiting in the museum still the artist's task? Maybe the checkered, new art museum in Hamburg, whose ceilings in the exhibition rooms are about as high as those in a public project apartment building.

Mail order catalogue, France 1998

Or the new painting gallery in Berlin. Here, you can see immediately how much room there is left over. Even when the big foyer with the Walter de Maria fountain reminds you more of a shopping mall, they would never be as generous with space in a bank. The gilded brass door knobs. An opportunity just thrown-away. Lack of space is the mother of invention. Even in museums. And it leads to dialogue. For some time now, at the Alte Pinakothek in Munich, the French painting of the seventeenth century, the vedutas of Venice, and the Spanish paintings of Velázquez and El Greco are placed next to paintings by Max Beckmann. He himself described the old masters as "a very nice set of friends," who provided him with ideas and challenges while on the path through the "fantasy palaces of art." *View of the Tiergarten with White Balls.* A painting like a sculpture. Why still place his—Beck-

mann's—sculptures alongside? The same thing happened to him that happens to every painter trying to make it in this branch—with the exception of Matisse.

Scheveningen, Five O'clock in the Morning. This title is a promise, pretending to be everything that the image contains, and vice-versa. With a title like that, do you really need a painting? Beckmann is actually a profound German painter. His "looks" represent a path on which you would gladly lose your way.

Bathing cubicle. Here, too, the view is of the sea. In the foreground, a few objects and a book. *Titan* by Jean Paul! Then an abstract, green sculpture. That has to be it, the bathing cubicle. Next to it, bathers. Maybe the view is from a bathing cubicle. *Haut gout des voyeurs?* Protected spaces, closed in. Rented in order to change clothes, to keep your clothes in. An area not open to the public, lined up, facing the sea. If possible, fenced in. There are public changing rooms or bathing cubicles, but the restrooms are right next to them.

Cubicles in general. Voting cubicles—are they public space? Is that democratic transparency? I ordered voting cubicles from a mail-order catalog for the *Basisarbeit*. Put them together within a few minutes, including desk and curtain. Everything out of cardboard, except for the plastic curtain. Knocking it all down also goes fast, that's the way it is with cardboard boxes. Is that why there are so many non-voters? At any rate, there is something cardboard about democracy.

If the gaze wanders away from Max Beckmann's paintings, it falls upon El Greco. Despite all of the high regard for this painter, the portrait of the *Young Spaniard* by Velázquez dominates, even though it's not hung in a central position. The gaze of the person in the portrait does not penetrate you through and through; it simply and clearly displays that the observer isn't there. You feel yourself to be superfluous. Now we have to talk about the confessional booth, but afterward, we'll just hear the blah-blah-blah from the opinion factories. Or the telephone booth. There isn't much difference. At any rate, Le Corbusier's studio in Roquebrune was not more than three times as big. A cubicle, too, with a view of the sea and Monaco. How much room do you actually need to work? Admittedly, there are worlds between Beckmann and Velázquez, bathing cubicle and confessional, telephone booth and studio. It's exactly the same situation between gated communities and shopping malls, and public space. Privatization and economic interests will reduce it even further. And it continues to lose meaning as a forum for art. But what actually happens in the locker room? For instance, in the locker rooms during half time at a soccer game? What's the state "in the locker room" (Rainer Bonhof)? If it's bad, the opponent would be "hard to be played on," as you might have once read in a particular stadium program. Recently, Arsene Wenger said that during the second half, the players didn't dare to come out any more. They'd leave the changing room, of course, but never left their own half of the field. Anyway, the locker room is supposedly the last taboo zone, as another soccer coach, Otmar Hitzfeld, said—don't leave it to the mercy of the private TV stations. He probably knows what he's talking about.

Because if the cubicles were a bit bigger, you'd talk about Big Brother, rather than containers. Everything is once again public. Transparent. But not for free. And not really outside.

Phone booth, photograph 1990

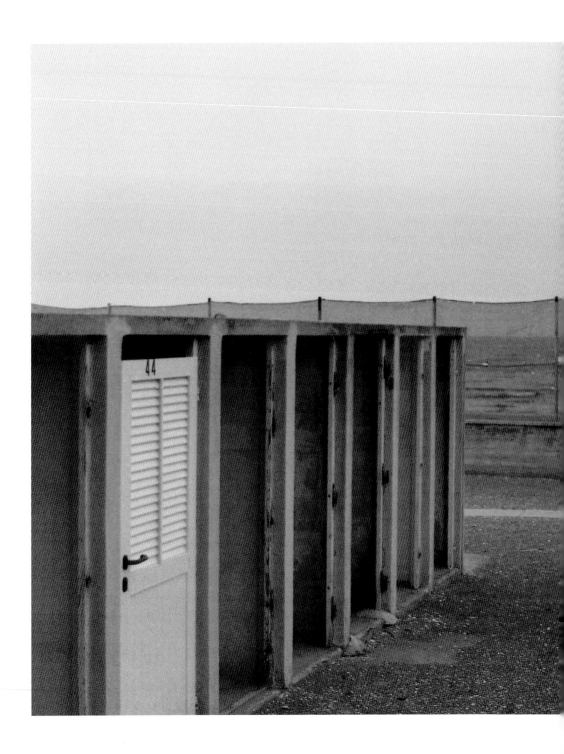

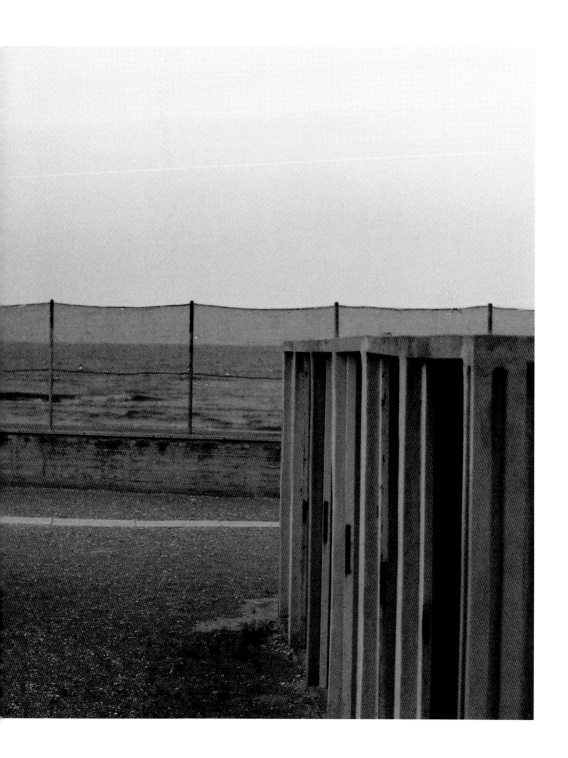

Torette, photograph 2000

Olaf Metzel, *Besiktas Jimnastik Kulübü*, 1995, in collaboration with Christoph Daum, on the occasion of the exhibition *Orient/ation. 4th International Istanbul Biennial*

Le Corbusier, Roquebrune, photograph 1999

Horse Sense and Cucumber Salad

BOGOMIR ECKER

Legends are good. For instance, let's take the apparatus we call the telephone. If one believes the legend, the sentence "The horse does not eat cucumber salad" was the first informational news—the first sentence ever spoken into a telephone.

In 1861, participants in an experiment in the small town of Friedrichsdorf, near Frankfurt, supposedly spoke this sentence into an apparatus invented by the physics teacher Philipp Reis. It was the first functioning telephone in the history of the world. The line ran a few meters, from a school building to a shed behind. They could have just yelled over. And I still really like this first sentence ever spoken into a telephone.

Up until recently, telephones were usually immobile and belonged to the private sphere. For a few years now, we have been experiencing a phenomenon in daily life: this apparatus is becoming ever more a means of transporting the public space. Never before has the private been spread so widely throughout the public space, although continuing to act as if it were still purely private.

When walking through the city, on the train platform, at the airport, or shopping in the supermarket, one notices that the shreds of speech balloons from private conversations overhead in public make as much sense as the first sentence of 160 years ago—the beginning of telecommunications. A great speech balloon avalanche has been launched.

It is really not a statement of central importance. A horse also doesn't eat ballpoint pens, paper clips, or ten-millimeter screws. One could take this type of statement, add many more to it and still only come to conclusions about what a horse doesn't eat (that is, what a horse isn't). It is not an important sentence. "The horse does not eat cucumber salad" was probably also simply the speaker's nervous attempt to imagine his conversation partner, in order to start a dialog. The other is unknown; he is speculative. This is similar to what is happening with the dialogs about art in the public space. The few meters to one's conversation partner is still a great distance. Ultimately, however, art survives through its will to assert itself, from its inefficiency, its unwieldiness, and incompatibility with a functional, opposing system. Isn't the artist the first critical observer of his own work, and is it not so, that he is thus forced to invent his imaginary opposite, his public? The mobile phone should function, naturally. "The horse does not eat cucumber salad"—really?

The artist's space is, at first, private, even when this space is on the street. The private and the public are constantly bumping into each other. But through the act of publication, however, this space appears to be more absolute, as opposed to the relative spaces of city planning or the wild growth of urbanization. The artist's absolute space, and the relative spaces of politics. One can't have any political negotiations about this kind of art, can't hold any neighborhood group therapy sessions. Instead, it is at first a more fundamental, even lonely process.

One individual focuses on another individual. Uses his hand to pick up the telephone receiver and say: your party is unknown.

This process exists, despite institutional protection in the museum's public space, just as it does in the anonymity of the public urban space—though, there, it is completely unprotected. It doesn't matter how large the spectacle, the premise, is. One individual focusing upon another is of greatest importance, and is, at its core, an emancipatory process; because showing the artistic product (or better, the circumstances required for showing) is included in the artistic act. Thus, the work is first finished when I can anchor this dialog about the public in a work of some form.

Although in the past twenty years the possibilities for this essential showing, this publication, have rapidly increased, it paradoxically appears to me that it is becoming increasingly more difficult, too, because perception itself has changed.

After all, it is known that art has a twin, called mass culture. Historically viewed, the image of the artist has changed enormously, since we artists alone are no longer responsible for the design of public images for the public space, as was the situation perhaps one or two centuries ago. We have a great deal of competition, and need to take the offensive and not complain about it. I've always had great difficulties with this big brother—he is so greedy. He gets fatter and fatter, takes up more and more room, and therefore, in many parts of society, acts like an air bag: he is always blown up and constantly, frantically trying to have an erection that lasts forever. Simultaneously, I have an extremely ambivalent relationship to this brother, a kind of bond, which binds even when I'm always trying to dissolve it. For me, mass culture is

a real problem, because it always obstructs everything.

"The answer to this problem, whatever it may sound like, must be connected with the present shift of the term 'public.' Though doubtless the street lamp is certainly a public phenomenon, there is currently doubt if it can correctly be called a political one. Namely, it belongs to that phenomenon making up the so-called mass culture, and this culture is differentiated from all others through its tendency to depoliticize its participants. That can be understood like this: all other cultures are publications of something that used to be private. Mass culture, however, is the opposite: it is the private occupying the public space. While all other cultures give space to the political by opening up the private, mass culture obstructs the political space by putting the private on display ... The political creates an atmosphere of responsible decision. In the political space, the other approaches me— namely because he steps out of himself— and demands that I converse with him, answer him. I take on this responsibility when I take up a position toward the other. The resulting dialog can lead to decisions that affect his and my future. Mass culture creates an atmosphere of irresponsible consumption ... (Vilém Flusser)[1]

For a long time, the public space has no longer been defined and taken as a geographical location within an urban culture. It has been broadened and accelerated, become new communication spaces, such as the Internet. Playing these various parts of the public space against each other, or the hysterical "discovery" of one of these parts of the public space as the only possible working model is ridiculously ideological. So, too, is the act of playing slower images, or slower image systems

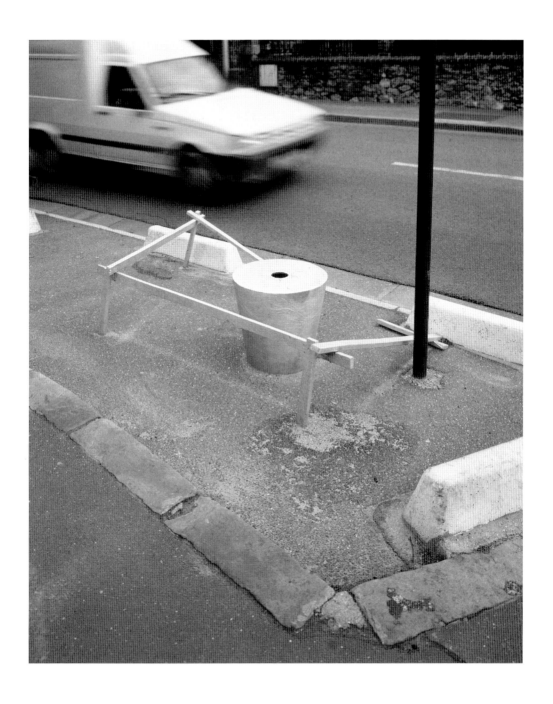

Bogomir Ecker, *Territory B*, 1998, Enghien-les-Bains, Avenue de Ceinture

against accelerated media or image systems. At its core, all of this oscillates between academic bean counting and technological fetishism. The operative possibilities of art have increased altogether. Never before have artists had so many helpful machines to perfectly design and realize their artistic works. Never before have so many concepts of the artistic existed side by side. The artist as "social worker," the artist as "service provider." It's like acting school (the artist as ...): each one looks for his own path through the machine park and the social group for which he is responsible. It will not be possible to solve the social and esthetic problems created by urbanization with sculptural, painterly interventions and designs, or with image projections. We are not a fire brigade, and when something like that is expected of us, we need to be asked well in advance. The artistic works in the public space, no matter what size, are more like miniatures or mosaic stones in relation to the monumentality of a city. One has to look for them. We are all familiar with the "Easter egg hunt," and it is always wonderful when someone finds the "egg." But woe if one doesn't find it, or is distracted from the search. Then it's annoying. The impregnation generally taking place through the influence of images from the entertainment industry and mass culture leaves very deep marks. It is thus simply a question of how (in this mixture of permanence, simultaneity, and opacity of functions and images) the expectations of art in an urban milieu will cause possible confusion. Cause by formulating another, possibly divergent and therefore critical idea, something different from the space of reality.

It is, rather, that one can no longer really believe in linearity, as we are familiar with from the sciences or complex operating processes.

It is the difference that is interesting, not the ideals of precision and exactitude. It is diversity, the incongruous, which makes a contrasting statement possible. In my opinion, one learns more about reality precisely through incongruity.

At first, the yawning, giant maw of the public space swallows almost everything. It cannot be stopped and naturally has the tendency to equalize everything. Though it indeed promises sensations, it removes the edge from its own statements.

Public space has become a battlefield for attention. One has to adjust to this fact.

The little fountain by Mataré—usually overlooked by most people—at the foot of the overwhelming mountain known as the Cologne Cathedral, in the shadow of the train station and various streets, is, to me, still a convincing artistic work, an artistic strategy enabling the work to survive in the public space. Fittingly, this exemplary work is the last illustration on page 534 of the catalog of the *Sculpture. Projects 1997 in Münster*. Appearing after the book's final credits, it seemed to me as if the work were ringing out the old century and ringing in the new.

I don't really know exactly what public space means to me. It means a great deal, when it succeeds in posing, for only a moment, a provisional, temporary question. In view of this, even temporary answers are interesting, because in this moment, in this second, it's possible to have colossal thoughts.

1 Vilém Flusser, *Dinge und Undinge*, Munich, 1993, from the essay "Strassenlampen."

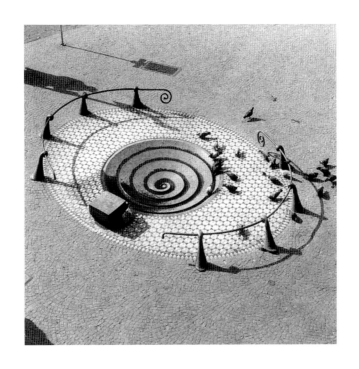

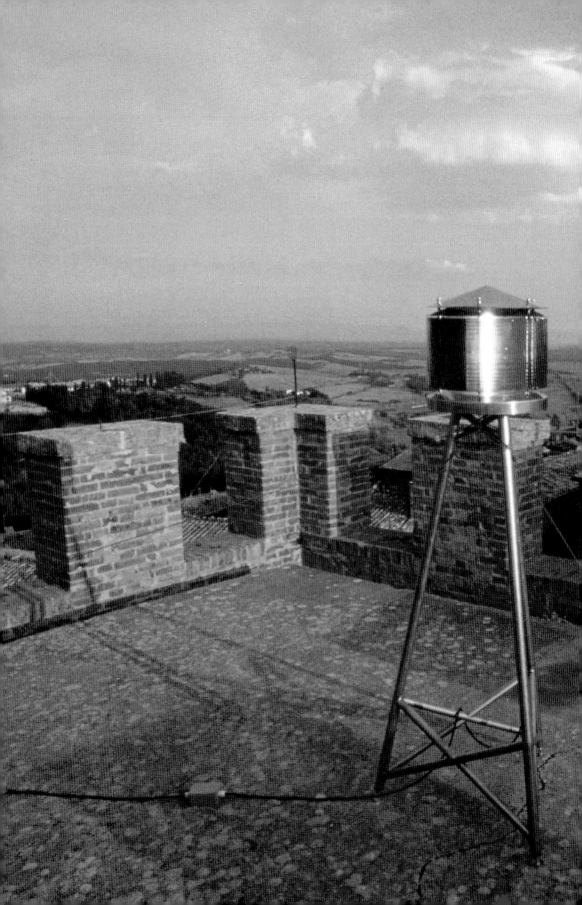

The Only Thing We Have in Common Is That We Are Different

OLAFUR ELIASSON

The two following situations are totally relative and sliding between them at all times seems to be more suitable layout for the dynamics of our memory and expectations. I wanted to say something about the complexity of what we spoke about before. When I work I often play with an idea about representation or perhaps I should call it "a picture" which is the opposite of the so-called real. Surely we then can discuss what is "real" and so on, but nevertheless let's just assume for a moment that there is a real "real"—and a representation as well. Here I should say that when talking about the real slash representation, I mean the "experience of" these states.

If a person works developing photos for years and years, he doesn't take the photos outside, but sits in his shop and develops the photos of, let's say, landscapes and so on for his entire life.

Then there is the other person who actually takes the photos by going out into the landscape. This person day after day goes around with the camera capturing chosen vistas. Those two people obviously over time develop two different ways of seeing landscape. One by looking at the photos, through the process of developing them, and the other through walking around outside in the actual landscape shooting the pictures.

For the developer, the real landscape is the image on the photo, the picture. The imaginable outside is the representation of these pictures. The developer knows the landscapes very well from the photos, and the day he finally joins the photographer outside he recognizes the scenery from the photos. So for the developer the outside is a representation of what he already knows from the pictures.

For the photographer it's the same issue, but reversed. The pictures that the developer has made in the developing shop are representations of the landscape outside where the photographer takes the pictures. When the photographer sees the developed pictures he recognizes them as representations of the outside landscapes.

Is the one person better equipped than the other? I think that one of the two is not necessarily worse equipped to function in our society than the other. The notion of being outside in the physical landscape or so-called nature as opposed to only seeing the picture of the same nature does not indicate or prove that the person outside is better or more qualified than the other. And the idea that what we would normally call real—in this case the outside landscape—should be a more valuable experience than seeing a representation is a romantic hierarchy left over and used to define freedom for the few.

So to get back to the photographer and the developer; a case that of course is not that simple. An unfortunate but common scenario could be if the developer states that for him real images, the photos, have tactile qualities

Olafur Eliasson, *Five Lamps for Tuscany*, 1999, Casole d'Elsa, on the occasion of the exhibition *Arte all'Arte*

such as blowing wind or smells from the plants. The developer starts to project the sensual knowledge he has from the outside onto the images, and due to this believes that experiential conditions arise from the photos—then there is a problem. Or in other words, if the developer, by looking at the pictures, loses the formal setup for his frame of reference and assumes that he is in fact outside and not looking at a picture, then our developer misreads his own reality by displacing his body from the mind. He is split in time and has lost his presence in "now." The developer might live a life with the assumption that the pictures are in fact not only images but real spaces and until he one day acknowledges and experiences clashes and bumps his head into the photo. Like when Truman rows into the stage-set wall in *The Truman Show* and realizes reality is unexpectly somewhere else than lived. Or on the other hand—to defend our developer—he might as well be aware that the images are indeed nothing but pictures but still nevertheless his reality since they form his frame of reference, memory, and orientation. He, for instance, was able to orient himself in the outside landscape with the vision-related knowlegde he had only from seeing the pictures. He was aware that the smell was new and even had an impact on his way of seeing, but his presence in time is verified through his synaesthetic recollection of the smell from developing chemicals when recognizing a particular well-known landscape from the pictures.

Similar stories can be told about the photographer as well. I assume that the search for the picture eventually will have an influence on seeing. Thinking "is this a possible picture" when traveling through and looking at the landscape creates a certain camera eye—the viewfinder of the camera is locked onto the mind and seeing has gotten a bit more representational since it goes through the compositional ordering of a picture frame. As with the developer, the question is also to what extent the photographer is aware of the new layer of representation. Has the photographer lost his presence here, by devision of the mind and body, the knowledge and experience?

So the complexity lies not in the judgement of where you are or what you do, but rather in to what extent you know where you are and are aware of what you're doing.

Afterword

In the south of Denmark there is an amusement park called LEGOLAND that includes a miniature version of Skagen, where the picturesque idyllic northeast point of Denmark is located, perfectly copied in LEGObricks. Here obviously—to everybody—we have a copy and therefore we reason that the real Skagen is safely situated in its northern location by the ocean. But where in fact is reality here? Unlike the Skagen at the ocean, the LEGOminiskagen does not pretend to be something else then it already is. It's a copy and shows this unmistakenly. Nobody is being fooled. The so-called real Skagen on the other hand has less honesty in its claim of identity—with its decorated old-style harbor atmosphere Skagen looks like a romantic turn-of-the-century fishing village and is kept so for the annual tourism. Any sense of real is blurred since the intention has little to do with promoting presence. The commercial setting comes closer to amusement parks, and is disguised in layers of representaion.

Do not misunderstand me—I am not trying to justify LEGOland as a better place than Skagen. In fact I myself would much prefere to vacate

in Skagen compared to LEGOland—but the issue here is again not the site and whether one is better than the other. What is at stake here is our liberty to take advantage of our ability to see ourselves in these various places and how we reflect up on being there. For the sake of complexity—let's say the photographer lives and works in Skagen and the developer in LEGOland.

The fable might be a little blunt in its point and as I said I'm not trying to reach out for a generalizing model of how the world is to be percieved correctly. I myself am trying to understand how relating and experiencing can be dissected. And how the ideas coming out of this are useable for my projects.

I believe that a fine-tuning of the above-mentioned example with the two complentary issues—the picture and "the real"—is necessary to illustrate and understand how the complexity has only just begun.

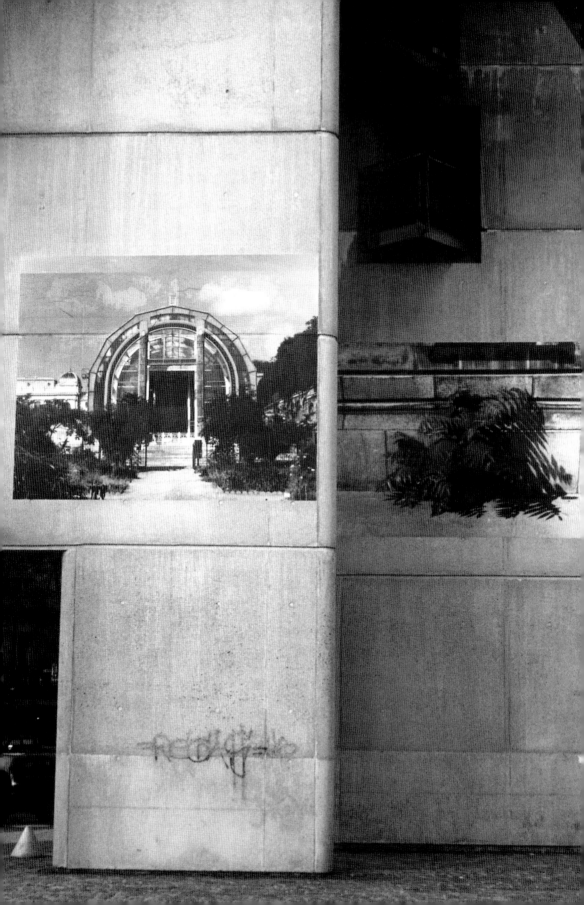

Notes on Art and the Public

PAUL-ARMAND GETTE

The ideal place for the encounter between art and the public is surely not the museum, which always selects its visitors, but outdoor space. It is rather naive to think that the museum is open to everyone and that art is the focus of general interest. One must make a choice: either art is elitist—and why not—and seeks refuge in galleries and museums, or it shows its face in the streets and parks, which still doesn't make it popular. I like this somewhat uncomfortable position of art vis-à-vis society, which has created the organisms of culture only to soothe its conscience and to maintain control of an unpredictable phenomenon. My decision to practice art was a response to my desire to shake up the way we have of seeing things, though I am well aware that no one likes to be disturbed in his habits. Society is actively employed, by virtue of the constraints it imposes, in restricting the development of the imaginary, which has always been a source of liberty, to a minimum. All "democratic" nations speak of respect for the individual and freedom of opinion, yet they all maintain police forces and promulgate laws that secretly embody the opposite of what they purport to defend. Art is undoubtedly the only activity that defies these constraints or devotes itself to ignoring them. It preserves for itself the possibility of saying what no one wants to hear. Thanks to art, and thanks to all those who practice it, music, poetry, and visual art defy this obscurantism, and humanily—insofar as it so desires—is not totally reduced to the status of a herd by clerics, politicians, or travel agencies. Mass tourism is not an instrument of rapprochement and learning; it is a highly efficient means of promoting ignorance.

Expansion into outdoor space often gives the artist access to three-dimensionality. Personally, I have never felt the allure of "nature." I have always thought that sculpture can benefit from its link to architecture or from the structure of a garden. Should I prefer to remain within the realm of the two-dimensional, urban space offers me a degree of monumentality that would seem ridiculously gigantic in a museum setting. The advertising specialists who shamelessly steal artists' ideas have grasped the importance of this problem precisely. Although they lack quality, their productions are seldom inappropriate to the locations in which they appear. Artists have too often succumbed to the desire to accomplish something "grand," something that simply reflects the ambition to occupy a maximum amount of space. These oversized paintings, which are destined only for museums, are a lamentable example of the fact that contemporary artists have lost sight of the need to adapt their art to the place for which it is intended.

Without public commissions, art remains a mere showpiece. I do not wish to deny the role it can play in this form, but it keeps it

Paul-Armand Gette, *Two Posters*, each 300 x 400 cm, Paris, Parc de la Villette, Esplanade de La Rotonde, 2000–01

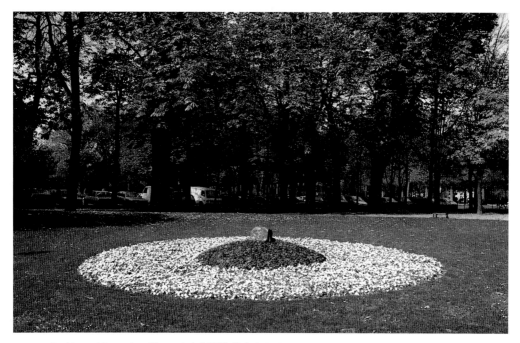

Paul-Armand Gette, *Le gâteau de lait* (Milk Cake), Paris, Jardin des Champs-Elysées, 2000

from the public, reserving it exclusively for connoisseurs. It makes no difference to me if the production of art is reserved to a small circle. I am not a socially committed artist. Recent experiences of this kind are still quite vivid in our memories. They support the establishment of the most totalitarian ideas and generally earn public approbation. These reflections reveal the difficulties encountered by the artist in practicing is chosen métier. They emphasize the discipline he must have in a society that dreams only of subjugating him to its prevailing intentions. Even more than politicians, the artist is the guardian of freedoms in a society that is dedicated, although it does not openly confess it, to restricting them. If the goal of advertising is to sell something and thus to condition and impoverish the individual, art must offer an opening to which we are not accustomed. We should stop pursuing the goal of making people ignorant. Let us not forget that Umberto Eco, long after Marcel Duchamp, sees the benefit of art in its capacity to a give the viewer the opportunity to experience a situation that the museum automatically restricts by injecting an additional feeling of sacralization. We have already spoken about the public commission and the advantages it offers the artist. Now we must examine the disadvantages that are introduced by the masters of art who, under the fallacious pretext of guaranteeing quality, subject it in most cases to the rites of competition. I understand that discussions lead to the selection of an artist, but then one should also be willing to give him complete freedom of realization within the framework of budgetary requirements. If politicians are paid to make decisions, then they should make them completely, at least in this area. A more simple solution, accept-

288

able to artists, would be to refuse to participate in competitions. A little courage, my dear colleagues!

Another point that I would like to address here is the alleged perennial character of art. Rather than permanence, which is always relative in relation to time, I much prefer the ephemeral. It does not create a lasting burden and makes it possible to vary the aspect of the ornament in space (urban space, for example). It may come as a surprise when I use the word "ornament" with reference to art, but I have always stressed the greatest simplicity with respect to the primary aspect of my proposals. I say "primary," which is not to say that you cannot continue on, if you prefer. Without being meaningless, the ornament, which is unjustly regarded as devoid of utility but not without beauty, stands in contrast to the general monotony. By virtue of this quality, which must be added to its apparent lack of utility, it retreats from the everyday world. The transience of proposals avoids the habits that, because the eye no longer recognizes things, lead to boredom. Entertainment is becoming less and less collective—that is, public—and more an individual pleasure. Television and, in its wake, video games confront the individual with virtual images that estrange him from his feeling for the world and cause him to lose the use of certain senses, such as touch. The danger that the image of a sublimated body poses, for example, is that it replaces the real body and establishes stereotypes that unfortunately become an object of desire without offering the possibility of satisfaction. Advertising, which uses these images and distributes them everywhere, creates a sense of something lacking. Without turning realistic, art would do well to propose other things than these models of women or men who play the role of lures, trying to seduce us into buying things. The cultures of antiquity invented gods and goddesses; advertising invented the mannequin. I don't see where the progress is!

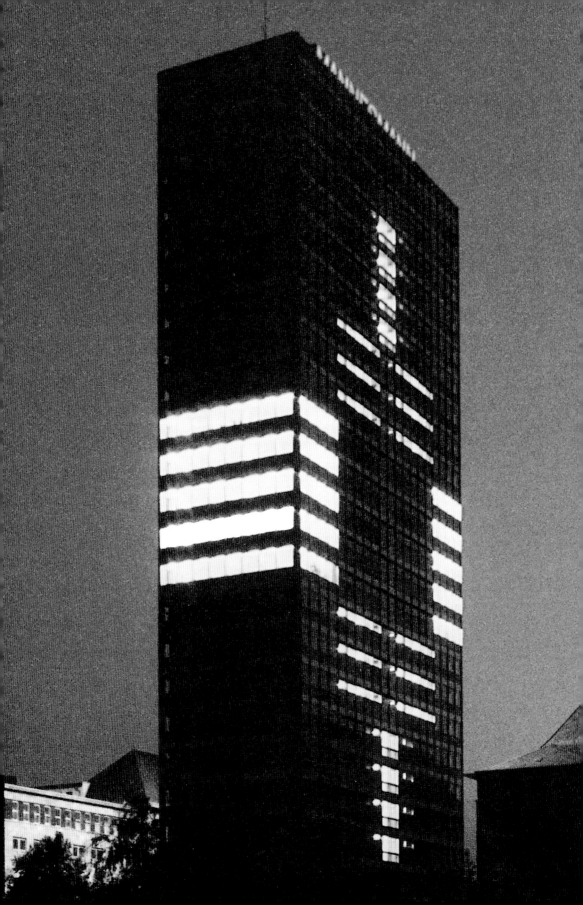

"And, it's a pleasure…"/The Laboratory of Public Space

MISCHA KUBALL

Everything that moves in the city is "public"
Everyone who moves in the city is "public"

Every Gesture Made in the City is Political!

Our responses to the dynamic construct we know as "public space" are characterized by intervention, change, and acts of appearing and disappearing. Artists have responded to the changing character of public space, and the public has developed a new attitude towards the art it encounters in public places. Thus it would seem only fitting that we replace the private with "individually motivated yet public action." The ingredients of interventions in public space have changed as well:
"The artistic integrity of a work must be preserved. It should be embedded in each work and obey the logic inherent in that work. The work should engage in dialogue with the viewer, who must be able to recognize what the artist is referring to and, ideally, to feel an emotional response to the work. Art may indeed seem out of place or represent a disturbing factor at a given location, but it should not evoke the impression that, by taking possession of a place, it means to dominate the urban situation. Yet at the same time it must be strong enough to assert itself amongst the myriad stimuli of its surroundings." (Georg Elben)
The era of the "drop sculptures" is over. Public art must go beyond the personal gesture of the artist, must transcend pure subjectivity and respond to the urban, social, and political structures that define a given place. The reciprocal relationships that emerge in the process form extracts for the "Laboratory in Public Space."

The City as a Laboratory/Temporary Installations/Interventions

I would like to outline the methodological and artistic aspects of the "city as a laboratory" with reference to six selected, exemplary public-space projects I realized during the period 1990 to 2000 in collaboration with a corporate enterprise, a school of architecture, a synagogue, a university, a museum, and as a contribution to the Bienal de São Paulo. In addition to my comments on these projects, I also include excerpts of statements by authors who were closely concerned with the respective projects. Their thoughts mediate between project concepts and public perceptions and are thus an indispensable part of the public process involved in each intervention.

Megasigns on the Mannesmann Building, Düsseldorf, 1990

The city as resource—proceeding from this fundamental standpoint, this project was devoted to an investigation of the possibilities offered by architectural potentials. A central

Mischa Kuball, *Megasign No. VI*, 1990, Düsseldorf, Mannesmann Building

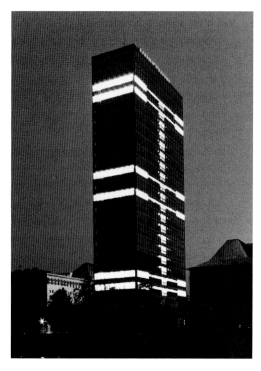

Mischa Kuball, *Megasign No. II*, 1990,
Düsseldorf, Mannesmann Building

focus was the idea of exploring architecture, its utilitarian functions, the people involved in architecture, and its position in the urban context withing the framework of an expanded concept of sculpture.

A total of six different signs encompassing all four sides of the building were projected, each for one week, with available office light from the existing architecture. No changes whatsoever were made in the building structure. "Mischa Kuball's concept for his Düsseldorf Mannesmann project is based upon a few simple fundamentals: A high-rise building, the functional character of which is evident in the simplicity and austerity of its external form, was to serve as bearer of artistic signs for a limited period of time. These signs were designed by the artist in his studio and realized in the real setting with the aid of modern technologies. The artist did not disturb the building in its daily function as workplace; art took possession of the building's exterior only at the end of the work day, when it became an empty shell, the congealed form of working and living processes that can never be expressed in the building's outward appearance." (Quoted and translated from Ulrich Krempel, *Mischa Kuball: Megazeichen*, Düsseldorf, 1990)

Bauhaus Block at the Bauhaus Dessau, 1992

In two years of preparation and discussion with all of the Bauhaus departments, this project focused on the forces at work at the Bauhaus in the form of artistic interventions and thus created the first installation—encompassing

the entire building and its functions—since the institution was closed by the National Socialists in 1933.

"Now that the great goal, the "preservation of the foundations of human life" has been identified and the general frame of reference has been set beyond the scope of digital and electronic technologies upon the process of communitization and, in the sense of a model, upon the city and the region, the tools and the methodology must be qualified. One possible approach can be derived from history, not as mere revitalization or nostalgic copy, which would be an abbreviated interpretation, but—as Heinrich Kloth proposes—as a continuation of the modern era with new concepts and under new conditions."

(Quoted and translated from Lutz Schöbe et al, *Mischa Kuball: Bauhaus-Block*, Ostfildern, 1992)

refraction house, Stommeln Synagogue (near Cologne), 1994

The synagogue was closed for eight weeks, during which it was physically accessible to no one. Light was placed behind the windows and directed upon the neighbors in the immediate vicinity. This project was accompanied by stimulating conversations with people in the neighborhood and a controversial panel discussion (Bussmann/Grasskamp/Haase/Stecker) on the subject of monuments/memorials.

Mischa Kuball, *refraction house*, 1994, Synagogue, Stommeln near Cologne

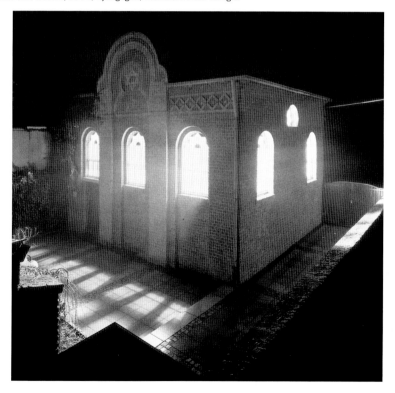

Mischa Kuball, *"Lightbridge" at Bauhaus Dessau*, 1992, Bauhaus Dessau

"Kuball's idea is as simple as it is convincing: The synagogue, so tightly boxed in and well hidden that it is hardly visible from the street, becomes a point of attraction, particularly at dusk and during the night. It awakens our curiosity. When we approach it, however, the glaring spotlights repel us, prohibiting entry and drawing all attention back to themselves and to the center that forms the religious sanctuary. The concentrated energy within makes synagogue walls look dark; its window panes appear to glisten; both are dematerialized in any event. The glazing posts and bars of the five windows break up the beams of light and cast a pattern of dark lines onto the surrounding ground—particularly striking in wet weather. Thus there is a strong contrast between the concentration of the self-outshining monument and the diffusion of a light that projects neither images nor geometric forms but, in a sense, only itself. The contrast is heightened by the abrupt alternation of inside and outside, of the animated and the inanimate, of the spiritual and the profane. And all of this against a background that links the past and the present."
(Quoted and translated from Armin Zweite, *Mischa Kuball, refraction house,* Cologne, 1994)

Private Light/Public Light, São Paulo, 1998
This work was realized as the so-called "German contribution" to the *24th Bienal de São Paulo* in 1998 in response to an invitation by Bienal Commissioner Karin Stempel. The underlying concept of exchanging private light with seventy-two families and thus transforming private light into public by removing it from the private context and placing it in a new public context in the Bienal exhibition building.

This project reflects the very special relationship between the Brazilian people and the city. "Mischa Kuball's concept seems very simple: private and public spheres are intricately linked according to certain rules, overlapping and mutually penetrating one another as projections, switching the conditions under which they operate and, to some extent, becoming dissolved in each other. The element that works as a catalyst in this process is light— as an object, a medium and a metaphor, always uniting all three aspects in a symbiosis. In the same way that light seems to represent the concept in all parts of the project, it is also a mere sign and no more than an appearance—a fleeting trace that brushes against an object in passing, brightly illuminating something that cannot be grasped."
(Quoted from Karin Stempel, *Private Light/ Public Light*, Ostfildern, 1998)

urban context—Underground "Gauleitungsbunker," Lüneburg, 1995–2000
The "Gauleitungsbunker" (an underground bunker built as a refuge for local government officials) in Lüneburg existed for fifty years without attracting public interest. In 1995, students from the University of Lüneburg began to inquire into the problem of a contemporary approach to historically sensitive relics of the Nazi period.
The installation entitled *urban context* represents an attempt to trace the form of the underground complex in public space. It must also be seen as a documentation of a project in which students presented both their own activities and the objects of their historical research to the public.

"Mischa Kuball developed a concept for the underground bunker that defies fixation in a monument. The discourse of memory is thereby focused entirely on local history and presented at an authentic historical site—though neither as living archeology nor as vague empathy. His intervention seeks neither to mourn nor to uplift. Its aim is—literally—enlightenment as a disturbing appeal. He does not intend to 'give the bunker, this historically troubled place, a different face' (*Landeszeitung*), but instead to emphasize the underlying historical relationship.

He approaches the bunker in a demonstratively direct manner, opposed to all traces of repression and 'memorializing.' He avoids all comforting references to art history. Eleven spotlights affixed to a bridge structure above the street, cast a flood of light across the roadway. They follow the outline of the bunker, tracing the tunnel beneath the street, measuring the dimensions. The bunker itself remains closed, concealed: an underworld of absolute darkness in stark contrast to the glaring light. An aggressive provocation of our imagination: 'What was here? ...'"

(Manfred Schneckenburger, quoted and translated from Harmut Dähnhardt and Ruth Schulenburg, ed., *Mischa Kuball, urban context—Projekt: Bunker Lüneburg*, with essays by Hartmut Dähnhardt, Manfred Schneckenburger, Ulrich Krempel, Ruth Schulenburg, Dirk Stegmann, Paul Virilio, 2000)

public stage, Staatliche Galerie Moritzburg, Halle (Saale), 2000

public stage investigated the possibilities for public action on a stage outside the walls of the Moritzburg. For three weeks, a stage, lighting equipment, and technical support were made available to the people of the city twenty-four hours per day. The question of the public acceptance and use of an offer of this kind was directly related to the discussion of the progress of democratization and self-determination among the urban populace in the tradition of the question "To whom does the city belong?" The project also inquired into the degree of demand for *self-publicity* in Halle.

"Nothing unexpected happened, either on stage on via the network. Everything remained within the boundaries of a cultural normalcy based upon a broad consensus. Yet what might have happened if something unheard-of, something radical or scandalous had been presented on the "public stage"? Presumably nothing. For as Speakers' Corner has demonstrated for years, even the most unheard-of, radical, and scandalous statements fall on deaf ears so long as they remain confined to such a taboo zone and stay out of the mass media, make even the most banal things a center of attraction. And those are the essential characteristics of the two opposing models of media publicity and art publicity." (Dieter Daniels, quoted and translated from Cornelia Wieg, ed., Staatliche Galerie Moritzburg, in *Mischa Kuball: public stage*, with texts by Dieter Daniels, Ulrike Kremeier, Katja Schneider and Cornelia Wieg, Cologne, 2001)

Mischa Kuball, *Private Light/Public Light*, 1998, *XXiV Bienal de São Paulo*

Ilda Ferreira Pita, Santo Amaro, São Paulo

Art in Hospitals
ANGELA VETTESE

Foreword

It's wonderful to see that art sometimes succeeds in getting back to where it came from: back to moments of joy and suffering, rituals, the celebration of life in all its emotional manifestations. Moments like birth, death, or meditation while keeping vigil at a sick person's bedside.

Medicine invades our lives more and more and, in the countries we define as civilized, homes and churches no longer provide the backdrop for these universal experiences. Perhaps, now that every utopian credo in history is faced with global crisis and the convergence of different cultures is changing our ways, these moments alone can still rouse a whole community to offer its affectionate and comforting embrace. After all, which values could an artwork in a public space give prominence to nowadays? Very few other than birth, death and the quest for good health. And which public space has been assigned this specific role? Hospitals, clinics, "places apart"—often anonymous and tendentially dismissed from our minds—in which we all in fact live the most important moments of our existence. What's essential for artwork in a hospital is that it offend no faith; ideally it should integrate them all. Neither should its subject matter be focused on any particular religious episode. From this perspective too I regard three works by Italian artists as particularly

important. These three men grew up—inevitably—in an environment profoundly shaped by the Roman Catholic Church. They nonetheless succeeded in discarding their religious upbringing or "revisiting" it in a way that would make it acceptable to people of any other faith. Only in this way can art born of religion take a form that denotes ethical and ethnic respect, the sole foundations of peace.

Three Works of Art

We make death our starting point and take as our example *La Salle des Départs*, a project by Ettore Spalletti (born 1940), in a hospital at Garches, in France.[1] Death has little to do with the individual who is dying: this person may have suffered from a long, painful illness or have been whisked off by sudden failure of a vital organ; they may have lived till the very last with a lucidity sometimes valued but more often cursed; they may be sorry to leave this life or only too pleased to go. But a corpse has no further desires and needs nothing. Death has more to do with the people left behind, shaken by the length of time spent caring for a sick loved-one or by their sudden departure. Cemeteries are made for the living, and so are morgues, where the need to concentrate on essentials is very often an excuse for squalor. These places are temporary

Alberto Garutti, *Ai nati oggi* (To Those Born Today), 2000, on the occasion of the exhibition *Over the Edges*, Ghent, market square

299

repositories for the collective consciousness and science that have admittedly lengthened our existence but have failed to provide the means to make its end tolerable.

It took Spalletti two years to complete his project, in 1997, working with the hospital's architects and doctors. It was the doctors, aware of relatives' psychological and social needs, who first realized that the morgue should be restructured. It has been transformed simply with innovative use of color and materials, while complying with mandatory practical procedures and safety regulations. Its simplicity is moving: the result is "normal," making it as "sublime" as death itself. The walls are painted or rather, delicately finished with coloured plaster, without inappropriate frills of any kind. The waiting room is in pale green which, continuing through two intermediate rooms, turns into a sky blue that takes on a more intense hue in the room where bodies are identified. This room's three pre-existing arches now look like three chapels; in each one stands a milk-white marble base, its edges rounded cushion-style, ready to receive the coffin and the family that gathers around it. In this austere but airy place even a corpse without mourners regains its dignity: the blue is intense but bears no relation to darkness. In the middle of this visual ocean is a truncated cone made of marble, a vase, a kind of urn similar to the ones already seen in the previous rooms, recalling baptismal fonts as well as cinerary urns. In the vase is running water, a reminder that this element is sacred to all religions, even the most ancient, and carries a message of rebirth or purification.

Alberto Garutti (born 1948) has instead celebrated birth with three installations based on one same principle (his project is dated 1998): one in Bergamo, on Piazza Dante (where it remains as a permanent installation); one in Rome, on Via della Conciliazione, during the Year 2000 Jubilee; and one in Ghent, on the town's busiest square, during the exhibition *Over the Edges*.[2]

Making art in public places also means—for the artist—establishing a relationship with the chosen location, involving the local people (or some of them at least), creating a community spirit focused on appreciating and supporting the project. This particular installation was conceived as follows: whenever a baby is born in a certain hospital, the newborn's father or a member of the medical staff presses a special button; this activates a wired mechanism which then, in a designated place several miles away, increases the luminous intensity of the street-lamps for about a minute. The first breath of each new human being, regardless of gender or race, is thus greeted by a metaphorical "luminous breath."

The emotional element of this project is not simply the fact of announcing, abstractly, that a baby has been born, but also and above all saying that "a baby has been born here and now." In this case too there was no architectural intervention. The project is explained to the public with a stone laid in the ground with written on it—extremely concisely—the reason why every now and then the street lamps in that place light up for a moment during the day or shine brighter after dark. Its poetic quality lies in imagining, totally abstractly and with no visual evocation, the effect that this new life will have on the family and on local history. We could go as far as to consider it the last, most extreme and essential act in the Christian iconography of the "Madonna and Child," from which this work borrows only the theological "light = life" parallel.

Michelangelo Pistoletto (born 1933) chose a moment in people's lives that is less extreme but emotionally no less powerful: the time when a person who is ill, or one of their family, feels the need to meditate. Prayer, for those with religious faith; contemplation for those without. The Paoli Calmet Cancer Hospital in Marseille has a Catholic chapel which, given the city's multiethnic population, was no longer used. Medical staff were nonetheless amazed to see how many people, Christians and non-Christians, turned to a nun for spiritual support: a sign that the chapel was out of touch with the times, but not with the need it had been built to fill.

The problem was put to Pistoletto. The solution he came up with was a multi-denominational chapel, completed in 2000:[3] the plan is a flower with five petals, all communicating and with no corners; the elevation is divided into mesh walls, suggesting a possibility of osmosis as well as respect for differences. Each of the areas is identified by a religious symbol relating to the respective faith, like a "found object" there would be no sense in making today. The five areas are intended for Jews, Christians, Muslims, Buddhists, and non-religious users (in this last area books take the place of the symbol). People who face the outer wall when praying direct their thoughts towards the past, with their backs to the flower's center. But on the benches you can sit facing in the opposite direction too.

In the center is an ellipse that does not "belong" to any religion; it provides a neutral crossing place, so no believer has to walk over an area others consider sacred. Placed in the geometric fulcrum of this ellipse is a version of *Metrocubo di infinito*, created with the *Oggetti in Meno* series (1966). This work was chosen because it clearly plays with the thoroughly secular magic of thought: as an icon, it prompts imagining but not fantasizing. Inside it six mirrors reflect the one opposite, potentially ad infinitum, though from the observer's viewpoint it is never possible to catch these continually interchanging images. It is an altar that asks us to participate not in a mystery but in a comprehensible phenomenon. It has a dark side, a flight towards the undefined, reflecting the fact that although human knowledge can never be complete, it is an act of faith in our reasoning power. In this case our need to turn to transcendence and the comfort it offers do not conflict with science or secular knowledge but become their allies.

Experimental Art and Health

The attention paid by experimental artists to places and events related to public life has increased enormously. Nonetheless very few[4] have chosen to work in the area of health. Of course, some have been working, since the eighties, on and around the subject of AIDS.[5] A number of their initiatives have made a strong ethical impact: for instance the introduction and widespread adoption of the red ribbon as a symbol of the illness, *Group Material's* informative activity,[6] or the collection and display of *Quilts* sewn by relatives of AIDS victims.[7] However, these projects have remained outside the hospital environment rather than interplay it in any specific way. The only permanent artwork in the field of AIDS too—besides some murals by Keith Haring, conceived more as happenings than interventions of lasting significance for the surrounding location—was the decoration of the AMAFAIR association's offices in New York by Joseph Kosuth in 2000. A number of truly radical works have offered

a new way of focusing attention on birth and "health maintenance" as a decisive part of civil and hence artistic life. Among the artists women have been particularly prominent: for instance, Mary Kelly with *Post Partum Document* (1973–79), a project inevitably exhibited in spaces typically reserved for art displays, and Mierle Laderman Ukeles's *Manifesto! Maintenance Art* (1969), with its invitation to consider the day-to-day tasks involved in caring for offspring as an artistic performance. Experimental forms of art clearly run risks when they enter the world of hospitals: since officialdom tends to have the last word in these places, scope for artistic intervention may well be limited to decorations acceptable to the Establishment: eloquent examples can be seen in the horrendously bombastic "embellishments" found in homes for the disabled, built and decorated during the Fascist era in Italy.[8] And even when the early twentieth-century avant-garde did consider art's relationship with public places, it nearly always disregarded hospitals.[9] In the innovative articulation pursued by the leading figures of De Stijl, The Bauhaus, and Russian constructivism, public places were thought to offer fairly solid ground. But these artists concentrated on applying new approaches to the "decoration" of schools, government buildings, and the like, and they steered clear of the treacherous terrain of hospitals. Moreover, even in the great pictorial cycles of the past, there is little evidence of work in hospitals by the most illustrious artists: the significant contribution made to the Spedale di Santa Maria della Scala in Siena by Domenico di Bartolo and Vecchietta in the mid-fifteenth century is an exception that proves the rule of lazarettos devoid of ornamentation or decorated with essentially standard devotional iconography.[10] As we already pointed out at the beginning, however, churches too used to provide a place for the celebration of events related to health: in societies profoundly influenced by Catholicism at least, baptisms nd funerals were always held in places of worship, and these were abundantly decorated by artists; people also meditated or prayed for the recovery of health in churches as well as in sanctuaries built for this very purpose.[11] The fact is that, until the beginning of the twentieth century, there was little to celebrate in hospitals besides births and deaths. Hospitals were places that every society tended to keep out of sight. As emphasized by authors like Foucault, Guattari, and Deleuze,[12] this was not only for the same reasons that they preferred to ignore the existence of mental asylums, prisons and other places of collective confinement. Something more devastating and painful than dissidence had to be "covered up," and this something was the therapeutic impotence of medical science. In this respect the only model that can offer today's artists a frame of reference is the tradition of mosaics and decorated architecture that long existed in spas, places where health is "maintained" rather than recovered.

The enormous progress of medicine and surgery over the last fifty years has meant hospitals are no longer simply hospices in which people wait for death or, in the most fortunate cases, spontaneous healing: people are now hospitalized to undergo active treatment, in vitro fertilization, and reconstructive surgery, from coronary bypasses to reduction of myopia. Hospitals are becoming increasingly entrenched in the public mind as centers we go to in order to lengthen our lives, donate (blood, sperm, bone marrow) or receive (transplant organs).

In the late-capitalist societies of today we are encouraged to consider them as places where our health can be monitored so that, later on, some costly-to-treat condition won't make us a burden on the public purse. Mastery of the means to guarantee longevity in general has a symbolic implication that rich societies will hasten to underline. This symbolism is not neutral nor is it only positive since in countries that are poor, at war or penalized by sanctions, hospitals continue to be places of suffering. But the power of this symbolism means the key issues of life, death and social disparity will once again become the concern of art. The most foresighted institutions— and, still more so, the most attentive artists— are starting to take this into consideration, and in all its aspects, challenging and controversial as well as appeasing. Linguistic developments stemming from the expansion of public art, from the eighties to the present day, are helping to overcome the obstacle represented by mere decoration: nowadays artistic language is moving increasingly towards interaction with the public, an approach which, in hospitals, has no precedent in history.

Ettore Spalletti, *La Salle des Départs* (Waiting Room), 1996, Garches, Hospital

Michelangelo Pistoletto, *Lieu de Recueillement* (Place of Contemplation), 2000,
Marseille, Institut Paoli-Calmettes

1 This project was made possible by the Fondation de France, which published a booklet about it. See also the catalogue edited by G. Di Pietrantonio and published by Galleria Massimo Minini, Brescia 1997.

2 cf. the catalogue of the exhibition *Over the Edges*, ed. by J. Hoet and G. Di Pietrantonio, SMAK, Ghent, 2000, pp. 114–117.

3 This work too, like Spalletti's, was possible thanks to a contribution from the Fondation de France, which published a booklet about it.

4 cf. the chapter on *Art in Health Services* in Malcom Miles, *Art Space and the City—Public Art and Urban Futures*, London and New York, 1997, pp. 151–163.

5 For an overview on this subject, see the catalogue of the exhibition *DIRE AIDS* (Turin, Promotrice di Belle Arti, May–June 2000), ed. by G. Cochrane, G. Verzotti and A. Vettese, Milan, 2000.

6 cf. *Frank Moore on the AIDS Ribbon*, in Tom Finkelpearl, *Dialogues in Public Art*, Cambridge, Massachusetts and London, 2000, pp. 419–437.

7 cf. Peter S. Hawkins, *Naming Names*, in *Thinking about Exhibitions*, ed. by Reesa Greenberg, Bruce Ferguson, and Sandy Nairne, London and New York, 1996, pp. 133–156.

8 cf. Franco Ragazzi, *Cronache della pittura murale. Antonio Giuseppe Santagata il "Giotto dei soldati,"* in the catalogue of the exhibition *Muri ai pittori—Pittura murale e decorazione in Italia 1930–1950* (Milan, 1999), ed. by Vittorio Fagone, Tulliola Sparagni, and Giovanna Ginex, Milan, 1999, pp. 83–95.

9 For further insight into this field see Germano Celant, *Ambiente-Arte: dal Futurismo alla Body Art*, published by Biennale di Venezia, Venice, 1977.

10 cf. Maria Cristina Bandera, *Siena*, in *Pittura murale in Italia—Il Quattrocento*, edited by Mina Gregori, Turin, 1996, in particular pp. 41–47.

11 Related to this issue is the joint involvement of Renzo Piano and Robert Rauschenberg in the project for the new sanctuary dedicated to Padre Pio (part of the ongoing enlargement of the hospital he founded). It is nonetheless strange that, with all the events organized to celebrate the Jubilee and the huge sums of money spent on them, no prominent contemporary artist was commissioned to make art inside Catholic hospitals or clinics.

12 cf. Gilles Deleuze, *Postscript on the Societies of Control*, in: *L'Aure journal*, May 1990, no. 1, now also in *OCTOBER The Second Decade, 1986–1996*, Cambridge, Massachusetts and London, 1997, pp. 443–447.

MARIA NORDMAN
SITING / RECITING

from Notes 1968–

The choice of time and place of the work — is already the work.
This work begins in the site and time
where words are not yet formed for its meaning —
in places readied in cities

where people could arrive by chance —

EACH PERSON POTENTIALLY BRINGS MEANING TO A WORK
at the time and place of arrival.

The following notes are written in concert with a work made in greater Los Angeles through an interpersonal use of time, opening this sculpture in the city between 1969–1999. The following text on this page accompanies this work in print since 1975 and thereby its presence questions if a text in print could become a work extention, and if in fact this text does or does not connect directly to experience. It needs to be clarified, that the work referred to, is presently not located in its first city site, being cited now in the more constant process of sculpture, named memory.

WORKROOM constructed 1971 (1016 Pico) conjunct to:
WORKROOM 1969–71 (1014 Pico) *(see opposite page)*
open from time to time for use by any person

the rectangle is in a constant position and I take a constant position with it:
two fixed positions and a frame of constant change

the frame is still with each change that fills it with the attention

the attention is still with the frame that fills it with each change

each change is still with the attention that fills it with the frame[1]

[1] "Workroom," Interfunktionen 12, Cologne 1975, p. 99

Workroom 1971–99 Construction notes:
A room located on the sidewalk of a street for any passerby,
 having a door, a window, a floor a hatch and four steps
 with the given window covered by a two-way transparent mirror
by day giving the passer-by on the sidewalk a reflection of the self with the street
while the person inside sees people passing and hears the street and its sounds
 by night the opposite occurs
 should the person inside turn on electric illumination in a back room —
 the person passing on the street sees directly the whole room and
 the person in the room now sees her- or himself reflected in the mirror —
this found room is altered to have a hatch in the floor
containing food, books blankets telephone and work materials *for the person using
the site as a workroom for 24 hours*
 –removal of linoleum, glue, walls, electric installations.
Workroom 1971–99 **receives a new meaning through each of its uses.**

Although this work was dismantled in 9/9/1999 — the notion that sculpture is
readily destroyed is an illusion: this work exists with the changes of memory
 being its first constantly changing site
— it's related to ***Untitled I 1989*** with the same window scale as *Workroom 1969–*
used for the scale of its sliding doors/windows of wood and glass
 with the individual elements shown as standing sculptures in concert
 with the collection of the Musée d'Art Moderne et Contemporain of
 Geneva and by the Renaissance Society in Chicago and Dia Center for
 the Arts in 1991 with individual elements presented each as a sculpture
and as a constructed unity placed at the entrance to Central Park NY in 1990 —
 which could be used as a living area for two adults *by night*
accompanied by a person having an age of several weeks or months —
with any other persons taking their places *by day* —
Untitled II I989 is its sister work in steel and colored glass.

Certain works also occur in response to invitations to realize a work in concert with a museum:

ALAMEDA 2000–2001 A COOPERATION BETWEEN LOS ANGELES COUNTY
MUSEUM OF ART AND MUSEUM OF CONTEMPORARY ART *(pages 483–84, 488)*
conjunct to ***Untitled 1973–*** occurring first on the street at the Newport Harbor Art
Museum for the person passing by chance in an alley and for museum visitors
— sunlight interacting with an open loading door on February 23, 1973 11:30 A.M.
and with the changes of other times—this work can't be repeated or reconstructed:
 it can be made only in a new context in a new formation with my input
 receiving each time a new title: the site and its date of presence —
with the chosen site so readied that the outside of the work's construction
is found inside the museum, and the surfaced white reflective surface is
outside the museum and found on the street
 where the chance passerby may or may not meet the person
 leaving the museum to see the work *in daytime*
starting with the time of full illumination projected by the sun into the door—
**deflection and reflection is part of the work's coherence with solar infall —
the person arriving on the street
at an unmarked site** **potentially co-creates its conditions.**

Although this work is continuing since 1967 — this text does not wish to infer that every city is already providing a continuous condition for the existence of sculpture in inter-personal circumference, *(as interperformance)* but rather, that the language for this condition could be beginning to be formed between the persons of a city — who continue to work together, as is the case in my working over two decades with people of Münster, to whom I dedicate the work named ***Cheir***
**realized with persons met by chance at the site of an open place at the time
of their arrival — with no preparation other than the presence**
>**of each person the sun the field of grasses
>the decisions as to the use of time of interpresence.**

realized near Ginkgo Biloba trees at the Schlossgarten & later
>>>on the Domplatz Münster 1987.[2]

**A work may be enabled by months of discussion
before it is realized in a site and time
as is the case for the work *Brehminsel 1983* Essen.**

Siting or reciting a meaning is the condition of presence —

**whoever would give a title to a presence —
entitles any next person to name a it in a new way.
And the openness of this process is a question in development.
Naturally the full recording of a response would mean —
noting responses of this person through a lifetime
of creating or not creating meaning.**

[2] in concert with these works realized in Münster:
Domplatz & Landesmuseum Kunstverein room October–December 1983
Untitled II 1989 — atrium Westfälisches Landesmuseum Münster April 27– June 9, 1991
tangent with:
>***Untitled II 1989*** — Planten en Blomen Park, Hamburg June 21–July 5, 1991
>a two-room building on stilts with five steps over the ground is useable

for habitation in one part during one turn of the earth at a time
by day by any persons, and *by night* by any two persons in the company of a neonate
>cabinets holding food, drink — given out during the time of the exhibition —

with places to sit, sleep or eat, cabinets for blankets, a working toilet
a skylight, steel, wood, eight colored glass moveable walls/door — having a conjunct
roo*m open to any person at any time* with a wood slat window to the earth —
>having eight black wooden panels, six galvanized steel exterior panels

De Civitate October 1995 — a park in process since 1989 at Wienburgstrasse corner
Sacre Coeurweg, Münster in first opened by the exhibition of Sculpture in the City
of Münster 1995 by invitation of Klaus Bussmann and Kasper König

MARIA NORDMAN aus Notizen 1968–
ORT ERÖRTERN

Zeit- und Ortswahl sind schon die Skulptur selbst. –
Diese Arbeit fängt dann und dort an
wo für ihre Bedeutung noch keine Wörter da sind –
wo Menschen per Zufall ankommen könnten –
JEDER MENSCH BRINGT DER ARBEIT MÖGLICHERWEISE
IHRE BEDEUTUNG
zur Zeit und am Ort vom ankommen.

Die folgenden Notizen sind geschrieben zur Zeit einer Arbeit realisiert
in Los Angeles – existierend an der Straße durch interpersönliche Benutzung
von 1969 bis 1999. Der folgende Text dieser Seite begleitet diese Arbeit seit 1975
und stellt in Frage – ob Text eine Arbeitserweiterung ermöglicht oder nicht.
Hier ist es klar zu machen, daß diese erwähnte Arbeit nicht mehr in ihrer ersten
städtischen Nachbarschaft zu finden ist – sie befindet sich jetzt in der Konstante
der Skulptur: im Gedächtnis selbst.

ARBEITSRAUM gebaut 1971 (1016 Pico L.A.) konjunktiv mit:
ARBEITSRAUM 1969 (1014 Pico L.A.) S. 307
offen von Zeit zu Zeit für die Vorbeikommenden: Das Viereck hat eine konstante
Position und ich nehme eine konstante Position damit ein; zwei fixierte Positionen
und ein Rahmen in konstanter Veränderung.

in sich
der Rahmen steht still mit jeder Veränderung welche die Aufmerksamkeit / hält

in sich
die Aufmerksamkeit steht still mit dem Rahmen welcher jede Veränderung / hält

in sich
jede Veränderung steht still mit der Aufmerksamkeit welche der Rahmen / hält[1]

[1] "Workroom," Interfunktionen 12, Cologne 1975, p. 99 *(Dieser Text ist nicht als*
Übersetzung gemacht, sondern als Brücke — MN)

Baunotizen: ***ARBEITSRAUM 1971–99***

Ein Raum für die Vorbeikommenden – am Bürgersteig einer Straße
 mit einer Türe, Fenster, Fußboden mit Luke und vier Treppen –
 das vorhandene Fenster hat einen transparenten Doppelspiegel
Entfernungen: elektrische Beleuchtungen & Installationen, Linoleum & Wände
**ARBEITSRAUM 1971–99 erhält durch die Benutzung von jedem Menschen
eine neue Bedeutung.**

Obwohl diese Arbeit am 9.9.99 abgebaut wurde – wird die Skulptur als leicht
entfernbares Objekt hiermit in Frage gestellt: diese Arbeit existiert in ihrem
ersten Ort worin sie sich weiter verändert – in Gedächtnisbewegungen.
Weiter ist diese Arbeit strukturell verwandt mit ***Ohne Titel I 1989–*** ausgeführt mit
den gleichen Fenstergrößen des ***Arbeitsraum:*** hier angewandt für
Gleitwände / Türen (Holz und Glas)
 die einzelnen Elemente dieser Arbeit stehen als Skulpturen im Dialog mit
der Sammlung von MAMCO Musée d'Art Moderne et Contemporain Génève 1996–
2001; auch gezeigt von der Renaissance Society, Chicago1991; vom Dia Center for
the Arts 1990–1991; und für 12 volle Drehungen der Erde Juni 1990 –
eine Konstruktion offen Tag und Nacht am Eingang vom *Central Park New York*
 – *nachts* bewohnbar von zwei Menschen in Begleitung von einem
 Menschen im Alter von einigen Tagen, Wochen oder Monaten
 deren Plätze *tagsüber* auch von anderen Menschen benutzt werden.
Ohne Titel II 1989– (Stahl, Holz, Farbglas) ist mit dieser Arbeit direkt verwandt.

Andere Arbeiten sind mit Einladungen von Museen ausgeführt:
ALAMEDA 200–2001 EINE ZUSAMMENARBEIT VOM LOS ANGELES COUNTY
MUSEUM OF ART (LACMA) & MUSEUM OF CONTEMPORARY ART
(S. 483–84, 488) konjunktiv mit ***Ohne Titel1973–*** zuerst am Newport Harbor Art
Museum ausgeführt an dessen Hinterladetür.
Die Sonne wurde eingeladen die Form durch ihren Einfall um 11:30 am 23.2.1973
in die Türe zu entscheiden – mit einer Konstruktion durch diese Zeit
vorgebaut. Diese Arbeit kann weder erneuert noch wiederholt werden. Sie kann
nur in einer neuen Zeit und an neuem Ort mit mir zusammen realisiert werden.
Sie ist damit ein neues Werk mit neuem Datum und Namen.
Die Arbeit ist so realisiert, daß im Museum die Außenkonstruktion zu sehen ist,
und das reflektierende Werk könnte am Straßenrand gefunden werden, wo der per
Zufall ankommende Mensch tagsüber den vom Museum kommenden Menschen
treffen könnte oder nicht. Die Arbeit ist in die Türe eingebaut ohne Titel oder
Nameetikette für das Werk am Ort. Mit der Projektion vom Licht der Sonne in ihre
eigene Konstruktion, wird Deflektion und Reflektion Teil vom Dialog mit den
ankommenden Menschen auf einer Straße.

Obwohl diese Werke in Städten seit 1967 weiter anfangen, ist es noch nicht gesagt – dass jede Stadt schon Skulptur als interpersönliche Umgebung unterstützt. *(Interperformance)* Die Sprache für diesen Weitergang könnte aufgebaut werden zwischen Menschen von verschiedenen Städten, die über Jahrzehnte hinaus zusammenarbeiten. Dies geschieht bei meiner Arbeitszeit mit Menschen in Münster, an die ich **CHEÍR** widme:

eine Arbeit realisiert mit Menschen, die an einem offenem Ort ankommen könnten – **CHEÍR** findet ohne Vorbereitungen statt; sie entwickelt sich durch die Präsenz von jedem Menschen, von der Sonne, einer Wiese, einem Stadtplatz, und durch verschiedene Entscheidungen.

Realisiert unter Ginkgo Biloba Bäumen im Schloßgarten & später am Domplatz, Münster 1987.[2]

Ein Werk könnte auch durch öffentliche Diskussionen ermöglicht werden – wie die Doppelskulptur in Essen – *BREHMINSEL 1983–*

Ortserschaffung und Erörterung charakterisieren Präsenz – wer eine Präsenz ernennt, nennt dadurch auch den nächsten Menschen als Ernenner anderer Bedeutungen. Die Qualität von Offenheit von diesem Prozess entscheidet dessen Entwicklung. Offensichtlich würde eine volle Bedeutungsphase heißen – daß man verändernde Bezeichnungen von Ernennern durch verschiedene Lebenszeiten aufzeichnet: oder als unbeschriebene Qualitäten anerkennt und respektiert .

[2] zusammen mit diesen Arbeiten sind folgende in Münster realisiert:
Domplatz 1983 & Landesmuseum Kunstvereinsraum Oktober bis Dezember
Ohne Titel II 1989– Atrium Westfälisches Landesmuseum 27.4.–9.6.1991
in Einzelelementen, jedes eine Skulptur – im Weitergang mit:
Ohne Titel II 1989– Planten en Blomen Park, Hamburg 21.6.–5.7.1991
– als zusammengebaute Elemente: ein Gebäude fünf Treppen über der Erde benutzbar während einer Erdumdrehung

Blind/Hide—The Mobile Birding Unit

MARK DION

The Exhibition

Insite 2000, an ambitious exhibition taking place in San Diego and Tijuana, facilitating a wide ranging public's interaction with a diverse and challenging array of artist's projects.

The Site

The location of the project *Blind/Hide—The Mobile Birding Unit* is the Tijuana River Estuary at Imperial Beach, a coastal wetland of remarkable biological diversity. The Estuary encompasses over 2500 acres, dramatically climaxing with the Tijuana River system entering the Pacific ocean. The Estuary landscape is shared by a tense and complex conglomerate of interests, which include the National Parks Service, the U.S. Navy, Border Fields, State Park, and properties of both the city and county of San Diego. This web of bureaucracies becomes further complicated by the area's proximity to the Mexico–United States border, one of world's most controversial and contrasting international crossings. Experiencing the area known as the Tijuana River National Estuarine Research Reserve provides the visitor with an impression of a landscape under siege and requiring an extraordinary amount of protection. National Park Service rangers scour the wildlife refuge in search of rule-violators, while the border police continually patrol and survey the territory. Due to the Research Reserve's location near the U.S. Navy test-landing field, scarcely a moment passes without a low-flying helicopter buzzing overhead. Far from a restful place, one would hardly expect this habitat to be home to numerous fragile plant and animal populations, however due to development sprawl, particularly on the California side of the border, multitudes of wildlife are funneled into the Estuary as the only available coastal habitat left. Where else in Southern California can fish and birds find natural breeding space?

To make matters even worse, the Estuary represents a unique pollution problem: Contamination from its former existence as a landfill and military site, but even more critically, as the endpoint of the 1735-mile-long Tijuana River watershed, which flows one-third through the U.S. and two-thirds in Mexico, the Estuary recieves an etremely heavy load of domestic and industrial toxins. The challenge of the *Blind/Hide—The Mobile Birding Unit* entails creating a situation which condenses and articulates the complex history and social relations of the Estuary site.

Mark Dion, *Blind/Hide—The Mobile Birding Unit*, 2000, view from inside, Tijuana River Estuarine Research Reserve, on the occasion of the exhibition *Insite 2000*, San Diego and Tijuana

The Birds

Of the 491 bird species listed in San Diego county, the Tijuana River Estuary boasts 370 documented bird species. The area functions as an essential nesting and feeding location for both resident birds (fifty-two year-round species) and thousands of migratory birds moving along the Pacific flyway, twice a year. The Estuary hosts a number of significant species which are listed endangered or threatened, like the California least tern and light-footed clapper rail.

The Birdwatchers

The American Bird Conservancy designated the Tijuana River Estuary a "Globally Important Bird Area" and thus the National Wildlife Refuge has been a magnet for thousands of birdwatchers, or birders each year. Worldwide an estimated eighty million people are bird watching enthusiasts, of those 17.7 million embark on birding tourist trips annually. Second only to gardening, as America's favorite leisure activity, birdwatchers spend about one thousand dollars each on equipment, literature, and birding-related travel each year. Birdwatchers are compulsive list keepers—they may have trip lists, season lists, annual tallies, and of course the most critical of all, the life list, a grand enumeration of all the species encountered in a lifetime.

Mark Dion, *Blind/Hide—The Mobile Birding Unit*, 2000, view of the outside, Tijuana River Estuarine Research Reserve, on the occasion of the exhibition *Insite 2000*, San Diego and Tijuana

Mark Dion, *Blind/Hide—The Mobile Birding Unit*, 2000, view from inside, Tijuana River Estuarine
Research Reserve, on the occasion of the exhibition *Insite 2000,* San Diego and Tijuana

The Project

Blind/Hide—The Mobile Birding Unit takes the form of a diminutive (nine feet wide, sixteen feet long, ten feet high) architectural work, overlooking a pond and reed bed at the Tijuana slough National Wildlife Refuge. The location of the structure maximizes bird-watching opportunities, while each physical aspect of the building facilitates its function as an animal observation station, as well as embodies the exacting aesthetic constructs to produce particular meaning.

A blind or hide designates a shelter designed to conceal a viewer from her quarry—an invisible building. The exterior of the Estuary blind, covered with contemporary high-tech carmouflage, while mimicking the surrounding habitat, still maintains an architectural profile. For birds and other animals, the blind becomes part of the ambient environment. The structure's exterior has no designations but rather mixes and mimicks the architectural vernaculars of the various power groups which share the landscape as overlapping spheres of influence and control—the park service, the military, and the border police. Any viewer serendipitously approaching the blind uninformed will likely conclude the building's purpose is a sinsiter one, associated with surveillance, the military, or any other exercise in dominion. The aesthetic is one of total concealment.

Access to the *Mobile Birding Unit* is obtained by securing the key from the Park Service Visitor's center and hiking out the half mile to the facility. This process deters all but the most serious viewers. Once opening the space's door and windows, the blind's interior achieves a stark contrast to the minimal functional exterior by appearing a lush and well-appointed ornithological field station. A cosy camp-style interior complete with an impressive research library and gathering of photographs, charts, maps, and equipment housed in practical furnishings, greets the intrepid visitor. With current birding information, state-of-the-art optics, and references to the lavish visual culture and history of American ornithology, the field station functions as a mecca for wildlife enthusiasts and those sharing a keen interest in landscape and ecological issues. In addition to a pictoral memorial to seminal figures in the history of American avian conservation (Rachel Carson, John Burroughs, Frank Chapman, etc.) a salient component to the blind consists of a color photographic frieze of portraits of some of the Estuary's resident birds. While appearing like exquisite examples of the mythic triumph of nature photography, capturing the essence of the bird in the wild, they are in fact images depicting taxidermy specimens in National History Museum dioramas. The Mobile Birding Unit's many didactic and decorative elements are loaded in such way to encourage multiple and contradictory meaning, to foster visitors to think about birds zoologically, ethically, ecologically, and historically.

Mark Dion, *Blind/Hide—The Mobile Birding Unit*, 2000, view of the outside, Tijuana River Estuarine Research Reserve, on the occasion of the exhibition *Insite 2000*, San Diego and Tijuana

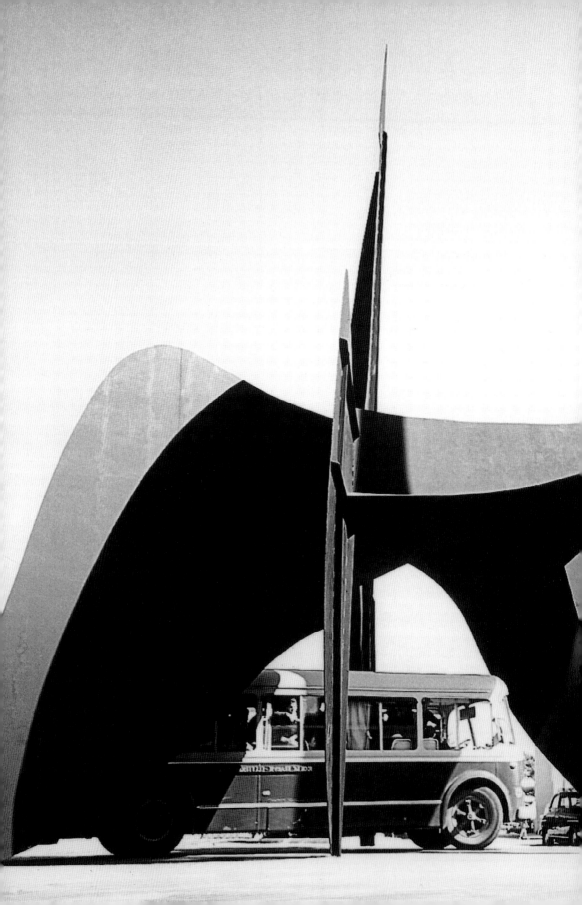

Art in the City
An Italian-German Tale
WALTER GRASSKAMP

Spoleto

In the summer of 1962 a remarkable exhibition took place in the Umbrian city of Spoleto: during the *Festival dei Due Mondi,* around one hundred modern sculptures were scattered throughout the city's outdoor areas. For one month, Spoleto, at the time a city with a population of not quite 40,000, had the largest number of outdoor sculptures per capita that might possibly ever have been attained.

These sculptures were produced by fifty-two artists, chosen by the art critic Giovanni Carandente; they were a splendid cross-section of modern sculptors. Hans Arp, Alexander Calder, Henri Laurens, Jacques Lipschitz, Henry Moore, and Ossip Zadkine exemplified the "Classic Modern." Artists such as Kenneth Armitage, Lynn Chadwick, and Eduardo Paolozzi represented the new generation of British stars; and among the new generation from other countries were Beverly Pepper and David Smith from the U.S.A., Eduardo Chillida from Spain, Robert Jacobsen from Denmark, Etienne Martin and Germaine Richier from France, as well as Rudolf Hoflehner and Fritz Wotruba from Austria. Other artists from Yugoslavia, Holland, Japan, and Israel rounded out the exhibition's international set.

Of course, over a third of the participants came from Italy. From Mirko Basaldella to Pietro Consagra, Lucio Fontana, Nino Fran-china, Quinto Ghermandi, Emile Gilioli, Berto Lardera, Giacomo Manzù, Marino Marini, Umberto Mastroianni, Luciano Minguzzi, Alicia Penalba, Arnaldo Pomodoro, and Alberto Viani, most were artists who were also known beyond the borders of Italy. They were also then represented at the tone-setting world exhibition of contemporary art, the *documenta* in Kassel. Some of them were represented more than once, thanks to the good relations to the art scene in Italy fostered by *documenta* curator Werner Haftmann, who had spent several years there.

The steel company Italsider was a strong supporter of the exhibition in Spoleto; they built the exhibits of ten of the sculptors. Nevertheless, a German visitor commented that it was "a wonder, that such an all-encompassing and expensive undertaking—showing sculpture for an entire summer in Spoleto—could be realized."[1]

Although Otto Herbert Hajek was the only German artist represented in Spoleto, this mysterious imbalance was not able to mar the judgment of the correspondent from the north, who, on the contrary, was willing to praise the exhibition in Spoleto, which was "almost unnoticed by the German public" as "the most dazzling that my eyes have ever seen."

Alexander Calder, *The Gates of Spoleto*, 1962, on the occasion of the *Festival dei Due Mondi*, Spoleto, 1962 (Photo Eduard Trier, Cologne)

A New Kind of Art Show

This correspondent was not simply some gushing festival tourist, but the German art historian and critic Eduard Trier, author of standard works in the field of modern sculpture, as well as the longtime rector of the Düsseldorf Kunstakademie. Moreover, in 1959 he had worked on *documenta II*, where, for the first time, contemporary sculptures were placed in an open exhibition architecture between the ruins of the Orangerie and the parklands of the Karlsaue.

It must have been obvious to him what a strong role model the second *documenta* was for Spoleto. Therefore, he willingly conceded that Spoleto had gone much further with what had been experimented with in Kassel. Trier praised Spoleto above all because the sculptors had not once again made the "great escape into the natural parks," which had been the European fashion after the Second World War, but had placed their works in the middle of the city, searching for and overcoming a new challenge in the urban outdoors. Aware of the "exuberance" of his experience, Trier celebrated the exhibition as a breakthrough with which sculpture had finally found a way out of the "estrangement" that museums, gardens, and parks had led it into. The return to the city and the conscious exploration of this place appeared to him to offer a promising new perspective to sculpture: something that was surprisingly and convincingly initiated in Spoleto.

Incidentally, Trier was not alone in his enthusiasm: the critic Martha Leeb Hadzi in the magazine *Art in America* made it known that she had seen "an absolutely new kind of art show" in Spoleto; the city would not be able to simply return to normality afterwards.[2] Trier saw, by the way, a decisive advantage in the fact that the exhibition was not limited to the historical part of Spoleto, but included the "less attractive new city, with train station, business, and industrial quarters," where prominent works could be seen, such as the almost twenty-meter high *City Gate*, a monumentally dissected stabile, through which Alexander Calder allowed the busses to pass.

Stagnation

Eleven years later, the same author noted that since "the successful international sculpture exhibition in Spoleto in 1962 ... the same sort of undertaking has become a trend in the old cities of Italy." As a basis for this evaluation, he referred to public sculpture exhibitions in the cities of Carrara, Parma, and Rimini which had taken place in 1973, almost exclusively with Italian artists, as well as one in Volterra, which was the subject of his new article.[3]

To Trier the visitor, the exhibition in Volterra appeared not to be as successful as the one in Spoleto eleven years earlier. Also, according to Claudia Büttner, who has recently produced an international overview of exhibition campaigns of this kind, the exhibitions in Carrara, Parma, Rimini, and Volterra, as well as the one in Turin in 1974 were "mostly very conventional, rather museum-like pageants."[4] But unlike Eduard Trier and Martha Leeb Hadzi, she does not even deem the initial exhibition in Spoleto to be so outstandingly meaningful. Instead, she sees its effect "above all, as a new aesthetic view of the historical old city." She finds fault with the fact that the historical centers of the Italian cities served only as "picturesque background" to the modern sculptures and that "formal contrast and delightful confrontation" had not created a

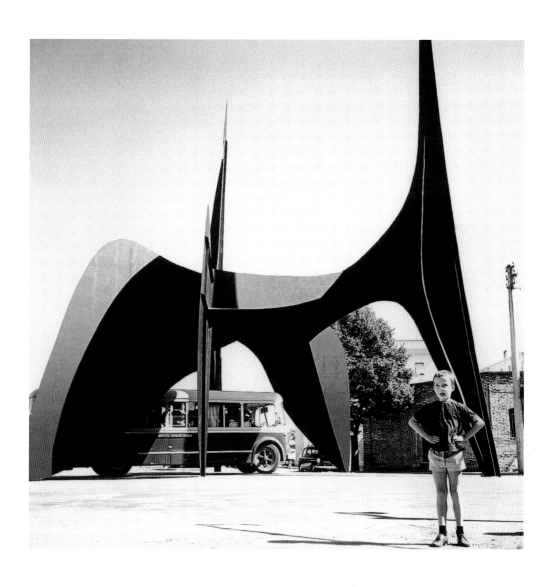

Alexander Calder, *The Gates of Spoleto*, 1962, on the occasion of the
Festival dei Due Mondi, Spoleto, 1962 (Photo Eduard Trier, Cologne)

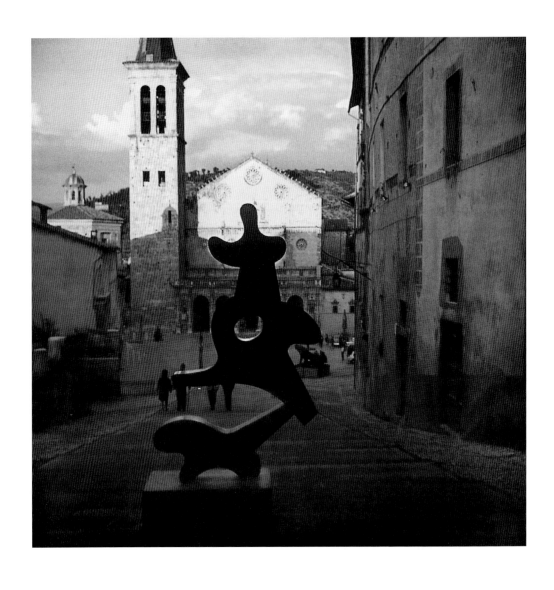

Hans Arp, *Bewegtes Tanzgeschmeide* (Dance Finery in Motion), 1961, on the occasion of the
Festival dei Due Mondi, Spoleto, 1962 (Photo Eduard Trier, Cologne)

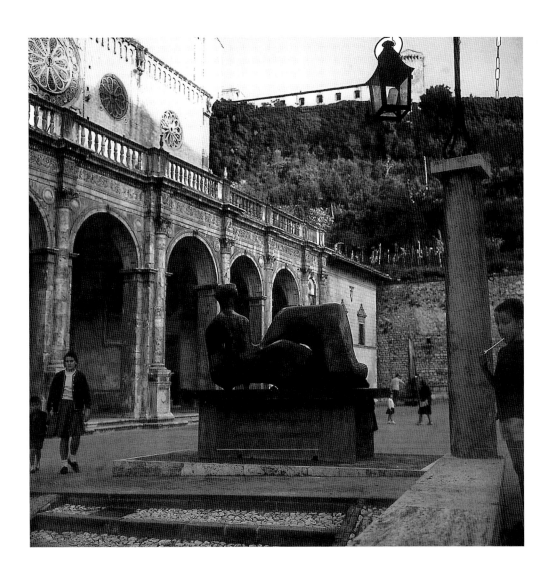

Henry Moore, *Reclining Figure*, 1957, on the occasion of the *Festival dei Due Mondi*, Spoleto, 1962 (Photo Eduard Trier, Cologne)

Berto Lardera, *Ritmo eroico I* (Heroic Rhythm I), 1952–53, on the occasion of the
Festival dei Due Mondi, Spoleto, 1962 (Photo Eduard Trier, Cologne)

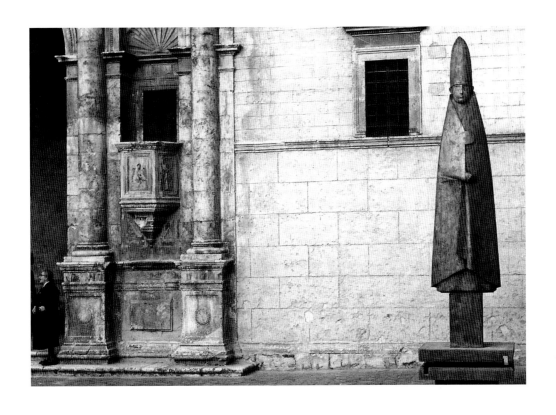

Giacomo Manzù, *Cardinale* (Cardinal), 1959, on the occasion of the *Festival dei Due Mondi*, Spoleto, 1962 (Photo Eduard Trier, Cologne)

true connection between art and its surroundings. The "attractive, picturesque image" that they must have offered seems to Büttner to be suspiciously like the high-class set decoration seen in tour advertising. These opinions, especially as it concerns Spoleto, could not be further apart from each other. Who should be believed—the emotionally intoxicated contemporary just returned home, or the sobered-up art history of today's generation? Has so much happened in between, to let the Spoleto exhibition appear nostalgic and conventional, or have its innovations become standard? These questions can only be answered after considering what has changed since then.

Change

The boom of urban sculpture exhibitions that it caused in Italy came rather ineffectively to an end in the seventies, until *Arte all'Arte* began a new round in a few Tuscan cities in the nineties. As a critical look at the situation between contemporary art and historical cities, *Arte all'Arte* again brings together an international cast.[5] In the meantime, ground-breaking changes in the presentation of sculpture in the public space had occurred outside of Italy. The characteristics and history of these changes have been explored often during the last few years, so that it is only necessary to point out a few of the most important aspects: since the sixties, due to various historical reasons, art in the public space in the U.S.A., Great Britain, the Netherlands, Belgium, and Germany has become a theme of growing aesthetic importance and public attention.

Claudia Büttner identified stops along the way in this post-war career: exhibitions in the U.S.A. (New York, 1967; Saint Paul, 1970; Grand Rapids, 1973); in Holland (Sonsbeek, above all in 1971); and in Germany (Hannover; most importantly Monschau, 1970; Münster, 1977 and 1987; and repeatedly, the *Documenta*).[6]

In the course of time, the showplaces changed from gardens and parks, which were the first places to have granted shelter to outdoor sculpture, to the inner city streets and squares—"from the park to the parking lot," as one of the Münster curators, Kasper König, succinctly formulated it in 1987. In addition, exhibitors ceased to borrow already completed sculptures and then to look for the right, temporary spot to put them in; instead they increasingly began to favor works made for the exhibits, and even began to commission works.

On their side, the artists stopped making outdoor sculpture in their studios for unspecified locations. Instead, they began to design specifically for the actual exhibition location, even if the exhibit would be placed there only temporarily. Through this, the profile of outdoor sculpture became more clear. At the beginning of this development, almost every sculpture made out of indestructible materal had been considered. It was seldom taken into account if the sculptures were meant for the interior of a museum or for the outdoors.

If the work was not a monumental commission or a memorial, the artist usually left both options open. Only with the success of exhibition campaigns for modern art in the city domain did outdoor sculpture gradually isolate itself from the context of sculpture and acquire its own history as a genre.

Relation to Site

This change came to fruition in the quarter of a century that took place between Spoleto in 1962 and the second *Sculpture-Projects in Münster* in 1987. The latter adopted as principle what had been previously considered a privilege: namely, that the artists themselves would choose the locations for their sculptures.

In view of this revolution, even the best examples of modern outdoor sculpture that were still executed in the studio and then fortuitously placed somewhere in the cities fell into disrepute. They were labeled "drop sculpture" or "parachute sculpture," because, in their poorly chosen locations and in their urban accumulation, they looked as if they had been thrown out of cultural supply helicopters and simply left to lie where they landed.

Works of art that had been conceptualized specifically for their outdoor sites should replace these works. The new magic words were "site specific." At the latest, during the Münster sculpture exhibition in 1987, these words became internationally known as a new model for public art.

This return, from the modern "autonomous" sculpture to the almost archaic concept of art in connection to a site was greeted with similar enthusiasm as a breakthrough—a quarter century after Trier's report from Spoleto. Site-specific artwork promised a real integration of sculpture and environment, art and daily life; and by doing so, to overcome the often deprecated arbitrariness of urban arrangements and abstract ambiguity of city ornamentation.

The price for this new situation of the artwork—the loss of its long and vehemently defended modern autonomy—appeared limited in view of the possibility for a "re-rooting" and the hope for new popularity. For this change in priorities, the postmodern delivered the correct transitional formula on time, in order to defuse the once tension-filled relationship between art and the public.

With the transition to site-specific art work, the hostility towards contemporary outdoor sculpture actually began to abate, at least in Münster. These hostilities had been present during the previous exhibition in 1977, which admittedly was dominated by massive examples of minimal art. Now the charm of an urban liveliness was discovered in them; it appeared to stem from the works themselves, even if their relation to their site was not immediately understood.

Art and Architecture

This relief was particularly great in Germany, because art in the public space had long been supported in a way that was as profitible for the artists as it was questionable in its results: since the thirties, a social and political, perfectly sensible law set aside a certain percentage of the entire sum used to build public buildings for art works.

There were contests or commissions for façade mosaics, murals, or sculpture in the structural surroundings. This new sub-genre of outdoor sculpture was known as *Kunst am Bau*, or art and architecture. The great prominence of some foreign artists in the public space can be credited to this long boom in post-war Germany; there was even a certain prosperity for sculpture and architecturally related painting. Admittedly, this art also soon fell into a routine, which allowed some sculptors to plaster hospitals, schools, parks, and gardens from Hamburg to Munich with their trademarks. No matter how the Italian artists might have

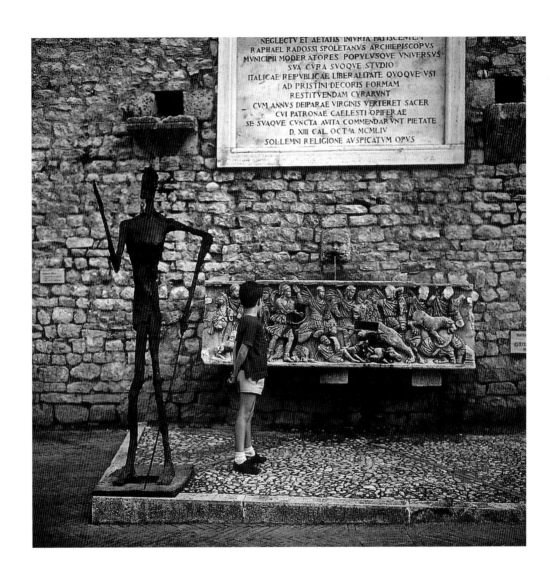

Germaine Richier, *Don Quichotte de la forêt* (Don Quixote of the Forest), 1951, on the occasion of the *Festival dei Due Mondi*, Spoleto, 1962 (Photo Eduard Trier, Cologne)

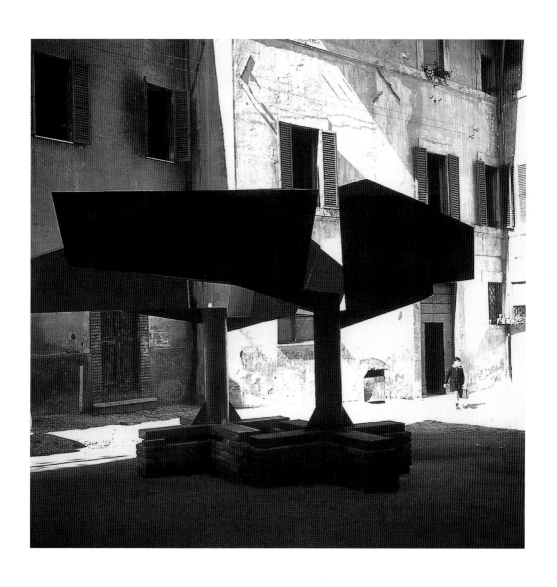

Lynn Chadwick, *Two Winged Figures*, 1962, on the occasion of the *Festival dei Due Mondi*, Spoleto, 1962 (Photo Eduard Trier, Cologne)

Marino Marini, *Cavallo e Cavaliere* (Horse and Rider), 1956–57, on the occasion of the
Festival dei Due Mondi, Spoleto, 1962 (Photo Eduard Trier, Cologne)

Fritz Wotruba, *Liegende Figur* (Reclined Figure), 1960, on the occasion of the *Festival dei Due Mondi*, Spoleto, 1962 (Photo Eduard Trier, Cologne)

envied their German colleagues for this state-funded welfare, the results themselves were not always enviable.

The spreading abstraction placed sculpture in an often purely formal correspondence to buildings and squares, whose aggressive functionality and sober construction sculpture could neither compensate for nor transcend. Abstraction in sculpture and a spare functionality based on economic considerations in architecture often did not form a visual harmony. Instead, they documented an absence of relationship that detrimentally affected the urban situation when it should have actually helped to articulate it.

In view of this background, the excited response to the site-specific, often figurative and narrative sculpture in Münster in 1987 can be understood; but the enthusiasm with which Eduard Trier returned from Spoleto to Cologne in the reconstruction years a quarter of a century earlier is also to be understood. In Italy—otherwise than in Germany—he had been able to see abstract sculpture on a historic, architectural stage: meaning, in a contrast in which both could only gain through the historical and formal polarization.

Spoleto Revisited

Perhaps Claudia Büttner's critical assessment is therefore missing something specific to the 1960s; at the time, it was not only about recruiting tourists. There was something much more special to offer them; namely, an astonishing contrast between historical architecture and contemporary art.

This contrast was something that had not been experienced in either the U.S.A. or the bombed-out cities of Europe; there, modern architecture and outdoor sculpture encoun-tered each other on the same level of time so that they could not make up for the loss of historical depth and aesthetic variety, but instead had to express this loss; naturally, even more so for their opponents.

In Spoleto, however, modern sculpture obviously profited from a suitable backdrop for perception, which allowed modern sculpture to be, historically and spatially, distinctly recognized and therefore also enjoyed; here, voluntary and fleeting alliances apparently made possible a certain happiness in observing art, which Eduard Trier had captured: a happiness not always granted to observers of art by the relevant branches of academia, but which is certainly one of the secrets of its survival—even if it is simply the happiness of the tourist.

If there was a time-travel machine, one would love to revisit Spoleto 1962 in order to see more than the few photographs one can get hold of.

The beauty of modern sculpture seen against the historic form of Italian cities appears, in hindsight at any rate, as the legitimate pleasure of a time in which abstraction was just as breathtaking as site-specificity was for a later generation.

Nevertheless, one must be on one's guard against making the current parameters of art the standard by which the previous is measured, and to reproach it for not having attained the standards of the present. Conversely, it is worth the trouble to survey aged art from today's standpoint and to search for what its contemporaries probably didn't yet see in it; for even, perhaps, what must have remained invisible to them; for a remnant, therefore, which makes the art of that time still appear to later generations to be museum worthy.

In his essay *Die unverbrauchte Moderne (Unused Modernism)*, the German art critic

Laszlo Glozer has found a suitable formulation for this.[7] In it, he speaks of the "expectant life" that is hidden in the art of yesterday, unseen and unused by its contemporaries, recognizable still, or perhaps only for the first time today. Through this, art, whose survival over generations or indeed ages even the normally presumptuous Karl Marx was at a loss to explain, can be seen as a magical storehouse out of which posterity supplies itself differently than contemporaries do. A storehouse used like this will not be emptied so quickly.

Looking back at Spoleto with this in mind, the suspicion grows that perhaps a few typical non-site-specific modern sculptures found the most beautiful places for which they could have been made, if that had been an intention of the time: site-specificity as luck of the draw, in retrospect.

So, if there were such a thing as a time-travel machine, one would certainly want to look at the things in Spoleto once more in peace and quiet—perhaps at Calder's abstract city gate: Was it really just another conventional work made in the studio simply because Calder could not have heard of site-specificity at the time, since the term first became widely known after 1967? Or was it instead something created for the exhibition, one of the first examples of the new site-specific art *avant la lettre*?

Festival

Looking back at the now-obliterated happy event of the exhibiton in Spoleto, one is admittedly sceptic about the aesthetic imperatives of our own times: was site-specific sculpture really such a colossal step forward, or has it already, like the spark in Spoleto, been put into its place by history?

The expiry dates of site-specific slogans, like all artistic slogans of the twentieth century, fell due faster than at first expected. Surprisingly, autonomous sculpture quickly regained a profile against the growing ritualization of site-specificity, which had swiftly reached the art academies. But autonomous sculpture was not the main thing; certainly, it was not the new challenge for site-specific smugness. In 1997, the third *Sculpture. Projects in Münster* showed rather that such exhibition campaigns run the risk of creating their own art; a generation raised with fairs, circuses, fantasy lands, amusement parks, and popular entertainment tried with prodigious service, acoustic bombshells, narrative meanderings, endless birthday parties, colorful urinals, technical clowning, absurd vehicles, enameled antique autos, and popular sleight-of-hand tricks to assure themselves of their prominence at the cost of not being perceived at all as art. This "festivalization" of art suggests not only a milder look back at the beginnings of campaigns like these, especially at their touristic implications, but also at the question of how much the success of the exhibition strategies changes the art itself. Above all, naturally, there is the question of the perspective of art in the urban outdoors, but this question will luckily not be settled by either art historians or critics—it will only be answered by the exhibitions themselves.

Dating

However, another question arises for the art historian: what explains the continuity of these attempts to intersperse contemporary art in historically evolved cities? And why did sculptures leave the parks and gardens which actually offer them an optically comfortable abode?

For the first decades, this thesis, that these attempts were supposed to increase the attractvity of the cities concerned, could alone hardly suffice, because at the time, wide-spread resistence from the population against modern outdoor sculpture still had to be reckoned with. Touristic considerations might, at the beginning, have played a role in Spoleto, as they did last year in Münster, but from the standpoint of art history, they can be seen only as economic circumventional arguments. Reformulating the question: what is the attraction of these undertakings, that they have been carried out at various locations and for varying publics for about forty years, independent of the predominant artistic modes, and in very dissimilar cities?

Should one see in this an attempt by an urban elite to occupy the territory shared with the rest of the cities' population with art, and to therefore claim cultural hegemony for themselves? That would then be the cultural refinement of marking of one's own territory; something known mostly in the realm of animals, but which is also quite common in the realm of the human being. But zoological analogies do not go far when it comes to art.

Opposed to that is the productive idea that perhaps these campaigns can be seen as an attempt to date a territory: that is, to place signals of the present against a historical context. If the exhibition of contemporary art in a historical city space is an attempt to newly date this space, then such undertakings are suddenly not as modern as they appear to be. Dating the environment through architecture and art is something that appears regularly in history; Romanesque and Gothic developed in the Middle Ages as stylistic alternatives which allowed a decision between an antique and a modern kind of design ("opus moder-

num"). Since then, the attempts of all other later epochs to date themselves are known as styles. Taking this into account, marking the present would have been one of the main tasks of art from an early point on.

The modern era has indeed not developed a binding style; but it is obsessed with the idea of dating. It continually deals with questions of contemporaneity as well as fashion, criteria of actuality and antiquariansim. Even its own way of seeing itself has become a victim of its own enslavement to the present; namely, when it wanted to end itself in order to proclaim the postmodern and now, even a "second modern era" (*Zweite Moderne*).

The outdoor sculpture of the modern must be a welcome tool for dating; it allows the burden of the historical to be broken, where it simply could not be demolished; that is, in the context of city architecture. In order to assert itself over the past and to date its own contemporaneity, outdoor sculpture is, at any rate, thoroughly useful. In cities with an overwhelming predominance of history, it helps to date the present through temporary constellations and short-term contrasts.

Perhaps the inquiry after such a self-assertion with relation to history explains the migration of outdoor sculpture out of park and garden: in the artificial context of nature, there is the danger that it can be seen as a vegetative fossilization of modernity, as an exhibit of a natural history of the form and the phrasing of the landscape. In contrast, outdoor sculpture in the urban context is always also effective as a historic index, as a sign of the now.

1 Eduard Trier, *Moderne Plastik in einer alten Stadt*,
Jahresring 63/64 (Stuttgart 1963): 143–147.
2 Martha Leeb Hadzi, "Sculpture at Spoleto. The World
of Art: Report from Rome," *Art in America* 50, no. 4 (1962):
116–118 (quoted in Büttner; see Note 4).
3 Eduard Trier, "Eingriffe in die Stadt: Volterra 72,"
Das Kunstwerk 26, no. 6 (November 1973): 40–41.
4 Claudia Büttner, *Art Goes Public. Von der Gruppenaus-
stellung im Freien zum Projekt im nichtinstitutionellen Raum.*
Ph.D.diss., TU Berlin, 1996. Munich, 1997.
5 *Arte all'Arte*, catalog, San Gimignano 1996 (artists:
Luigi Ontani, Giovanni Anselmo, Getulio Alviani, Michelangelo
Pistoletto; curated by Laura Cherubini). *Arte All'Arte*, catalog,
San Gimignano 1997 (artists: Gilberto Zorio, Sol LeWitt,
Jessica Diamond, Amedeo Martegani, Marco Cingolani,
Salvo, Anish Kapoor; curated by Giacinto Di Pietrantonio and
Jan Hoet).
6 Apart from Claudia Büttner's dissertation, see my book
Unerwünschte Monumente. Moderne Kunst im Stadtraum
(Munich, 3rd ed. 2000), as well as my essay "Art in the
City" in the catalog *Sculpture. Projects in Münster 1997*
(Stuttgart, 1997).
7 Laszlo Glozer, *Westkunst. Zeitgenössische Kunst seit
1939*, catalog for the exhibition *Westkunst*, Cologne, 1981.

Searching the Street

RICHARD DEACON

The exhibition at Sonsbeek in 1993 featured a large number of works, some of which were characterized by being more or less discreet interventions in the urban space of Arnheim, alongside those works that were installed in Sonsbeek Park itself. Accompanying the exhibition was a rather inadequate map showing the locations where works might be found. During the opening groups of people could be seen wandering around, the city map in hand, trying to locate the works. Some were obvious, others were not. What struck me at the time was many things that were not art, or at least not intentionally so came to be seen as possibly meaningful. This could have been because of their strangeness or apparent dislocation or merely because the map seemed to be directing one to this spot. I was interested in this confusion, in the way that objects or situations came to be interrogated. It seemed that, given willingness and an open attitude many haphazard conjunctions appeared in a new light. It was also troubling to me that this very sophisticated audience could have such trouble locating whatever it was they were looking for. If that was the case for an audience trying to find things, what could the citizens of Arnheim make of it? It's a conundrum to which I have no ready answer. On the one hand artists were shying away from overtly strident works and looking for some kind of integration into the fabric of urban life. On the other hand this very aspiration seemed to allow some of the works to disappear. And if they disappeared, what status

did they have—the rather bulky catalogue gave them some context but again I couldn't imagine that this document was readily accessible to the person on the street. The photographs that I sent were taken in New York and London last year. They are of things seen whilst walking and are clearly in some sense intentional—they are made—and also about to disappear, collected for disposal. I suppose my interest was roused by the formal qualities that they display, their situation, construction and assembly. But I also think of them as tender. They are poignant in a way that I find interesting. It is a limbo that is quite close to the position in which art in the public domain finds itself. I think it is important, for many reasons, that artists do not surrender their capacity to work in the public domain, but I do think that it is not obvious what we should do.

Richard Deacon, *A Small Group of Photographs*, New York 2001

Richard Deacon, *A Small Group of Photographs*, New York 2001

Two Projects, 1987 and 1997

PETER FISCHLI/DAVID WEISS

Project Proposal for *The House*,
for *Sculpture-Projects in Münster,* 1987

Our plan for the sculpture exhibition in Münster is to erect a building on a scale of 1:5. It will be an approximately four-story business complex in the modern International Style. In the front will be shops, offices, and the entrance. In the rear, there will be a receiving area and loading dock.

The location: The ideal location would be the property near the train station between the cinema and the fast food joint. The building would fit in, both architecturally and atmospherically, and would not create any contrast, as it would in the inner city, for instance.

Architectural style: The building's usual, modern style should convey a sense of conventional, conformist normality. It should be a small illustration of middle-class power and splendor.

Construction methods: We would like to have a wooden box constructed according to drawings that we will send. We will then need about two weeks to add a façade and all of the other details.

Project Proposal for *Garden*, for *Sculpture. Projects in Münster,* 1997

A garden with flowers, vegetables, and a seating arrangement with table and chairs will be constructed. It will have equipment, tools, and other garden utensils.

We plan to create the garden on the triangular property located between the inwardly facing city wall and the hedges facing a meadow.

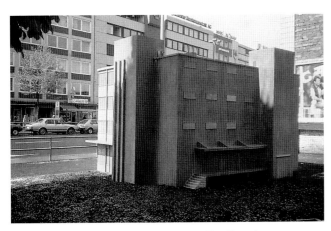

Peter Fischli/David Weiss, *Das Haus* (The House), 1987, on the occasion of the exhibition *Sculpture-Projects in Münster*

Peter Fischli/David Weiss, *Garten* (Garden), 1997, on the occasion of the *Sculpture. Projects in Münster*

There is already a stand of older and newer trees, and in the middle are several beds belonging to a private garden. The garden will be extended by adding on to the existing beds. However, it would not cover the entire surface. We are thinking about approximately ten mixed-crop beds containing berry vines, herbs, and flowers. All should be native plants.

This ideal setting—made accessible by a simple wooden bridge built over the canal—promises a great degree of intimacy and privacy for the imaginary gardener, who will be portrayed through the mass of order and disorder, enthusiasm and contemplativeness, and through the growth of the plants, which will be allowed to flourish as they please. This imaginary gardener works in and benefits from the idyll.

In order to carry out the work and take care of the garden, it would be desirable to have a gardener for the site. He should have a generous understanding of gardening, be knowledgeable about mixed crops, and able to advise and work with us. If possible, we should meet with him at the beginning of autumn, 1996. At that time, we can discuss and determine the initial work necessary to do in October and November. Another couple of aspects: The hedges, that is, the topiary animals, should not be trimmed in either the fall or spring, so that they will only be perceived upon a second or third glance. Since the exhibition will be opened on June 20, the garden should by then display a certain lushness and splendor. The meadows surrounding the beds should be filled with as many flowers as possible.

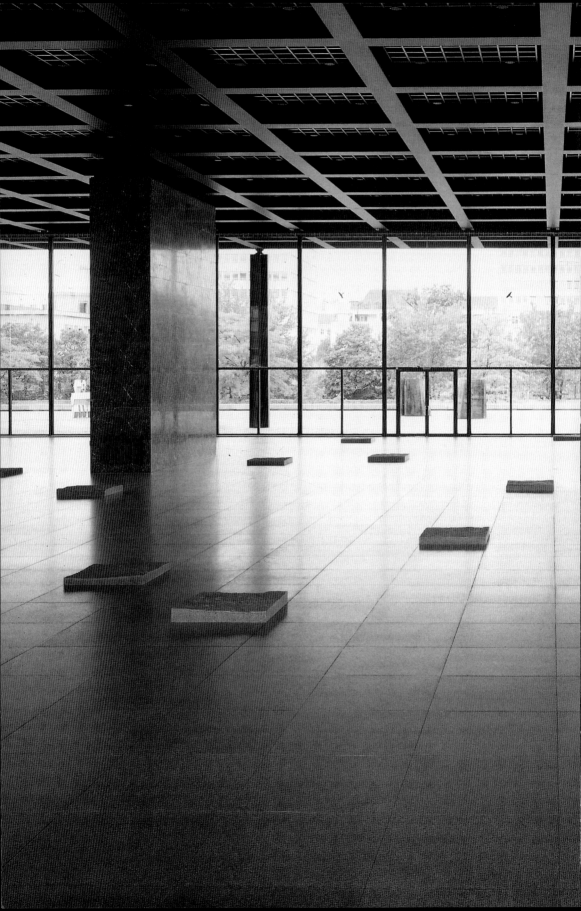

"It's all been said—but not by everyone!"

A Conversation with Florian Matzner in Munich, January 2001

ULRICH RÜCKRIEM

FLORIAN MATZNER (FM): Few debates over the last thirty years have caused such controversy as the question of so-called "public art" as an alternative to the White Cube of the classic art temple. In your view do public (external) spaces and private (internal) museum spaces contradict or complement each other? Do you work differently in these two contexts?

ULRICH RÜCKRIEM (UR): The museum space is a priori connected to the visual arts, or at least ought to be. Sites in external public places have as many different aspects as there are places: when you are taken to a site/space/place questions arise—practical, functional, formal and historical, political and sociological—which you have to take into account to be sure of not putting something utterly disconnected there, just leaving it there: often the best would be to do nothing at all. No-one has taken something away yet instead of putting something there. The ideal situation is when I can also deal with the space around the sculpture, or when that site/space is fine the way it is, which is definitely the best-case scenario.

FM In this connection I am interested in the relationship and hence the inter-dependence between the site-specific (or site-determined) aspect of a work on one hand and the aesthetic and formal autonomy of the work on the other hand, particularly in public spaces?

UR Whether for outdoor spaces or for internal spaces in a museum I always use the same cultural language that I have evolved over the years. The forms I use are stele, block, plaque, floor relief (a plaque lying flat on the floor). In internal spaces there is of course also the wall relief. These forms and shapes are then (according to my instructions) either split horizontally, vertically, or horizontally and vertically: split horizontally then cut vertically, sometimes reduced in volume, the cut surfaces are—depending on the circumstances—either left as they are, ground, or very occasionally polished.

So there are individual sculptures, double sculptures, groups of sculptures produced in the same manner and with the same shapes as well as all the possible variations. The combination of the three methods of production for different shapes or on the same shapes, or the same production methods. In fact there is a whole variety of processes that I can use inside or outside. The situation influences my choice: shape, amount, size, color, methods. So whether it's inside or outside the space itself is an important component in my work. My best examples of works are the *40 Platten* (Forty Stone Slabs) I made that are now in the Nationalgalerie in Berlin. I gave them to the Nationalgalerie on condition that they would show them every five years recreating the original setting from 1998, which I determined down to the last detail, even to the point of having the curtains removed from the windows. And then there is the same theme

Ulrich Rückriem, *40 Platten* (Forty Slabs), 1998, Neue Nationalgalerie Berlin

again, which I was able to realize in ideal conditions outside: *20 Stelen* (Twenty Steles) on a plateau in the foothills of the Pyrenees near the town of Hueska in Spain ... after all I have been doing this for sixty—no, rubbish!—for thirty years ... and recently I have actually set some pieces into the ground. You only see one side of the slab. So there is nothing standing in the way or cutting across other vertical objects in the situation. But it's not that I wish a hole in the ground would swallow me up. It's just one of the four possible variations of the forms in my sculptural language, with one exception, the wedge-shape that you find in a quarry I know in Anröchte.

FM You were one of the first artists to make public art in Germany—which you have been doing since the mid-seventies—and also one of the first (with your own exhibition spaces in Ireland and Germany) to "retreat" back into the hallowed halls of the museum temple.

UR I'm faced with the problem of how to store my works, since all the individual sculptures and groups are monoliths. If these aren't stored in their original shapes, the different sides of the parts (lying apart to save space) will then turn different colors and later, when they're put back together again they will still look like separate parts and not like a monolith. So I have to put them together as they should be, which means that they take up a lot of room. So the obvious next step was to make a good home for the stones, which could be a store and exhibition space in one. That was how Clonegol in Ireland and the two spaces in Essen came about, and now Cologne ... at the same time I became much less dependent on commercial galleries and public exhibition institutions, museums, etc. But of course there are obvious disadvantages, too. In the first place it's very expensive and

wearing to have something built, as are the subsequent costs for the upkeep, security, checks, PR, and on and on. On top of which, I have had fewer offers of exhibitions in public exhibition spaces because a lot of curators thought I'd contentedly withdrawn into my own spaces. It's just that I know that my pieces work are much more powerful in calm, clear, simple spaces.

FM We shouldn't forget that in art museums-the recipients are only interested lay-people and experts, who represent roughly 0.1% of the population. In public spaces, on the other hand, every person who passes by is a potential art recipient: the unemployed, school children, workers, housewives ... Does this mean that the artist has a different kind of responsibility in work for public spaces?

UR As soon as an artist (sculptor) has permission from a museum director to carry an object into the museum, then the work is a priori identifiable as an art object. When the artist then installs the work in an art museum or in a gallery, no-one can come and say—initially—that's not a work of art; whether it's bad, mediocre, or good is not an issue. By now plenty of people know this, not just the so-called art professionals, the experts. So it more or less follows that a workof art placed in a public space (outside, in a town, in a village, in the country, wherever) will not be a priori recognized as art.

FM The proliferation of contemporary art in public spaces over the last ten years—not just as part of temporary exhibition projects but also as so-called art and architecture, as a strategy on the part of banks, insurance companies, governments, and so on to underpin their status—hasn't this induced a rather critical response in you, particularly when it comes to the permanent siting of works?

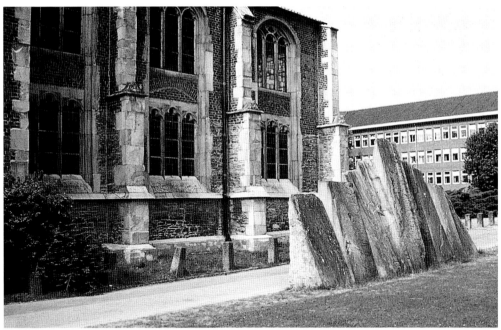

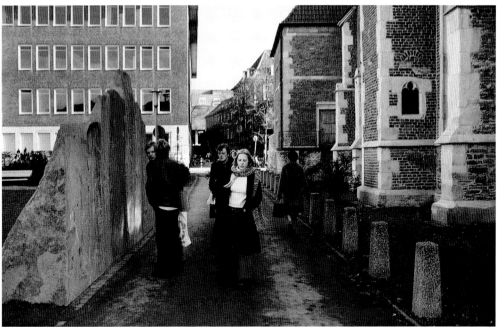

Ulrich Rückriem, *Dolomit zugeschnitten* (Cut Dolomite, nine-part sculpture), 1977,
north side of Petri-Kirche, on the occasion of the exhibition *Skulptur Ausstellung in Münster*

UR Every place has its own formal, functional, historical, and individual circumstances, which can change very quickly. Soon or later it can and will cast doubt on the placing of a particular sculpture. Particularly when you're talking about pieces that have been made for a specific place or space. What initially seemed like the perfect solution will cease to apply when the surroundings change. It's not without reason that sculptures were put on plinths in the past. Besides protecting them, this also elevates them and inspires respect for the subject. It's actually not that surprising that with time these plinth figures lost their own special places, and have been neglected or even destroyed.

For instance when I saw my works for the old Opera House in Essen after a few years, they were in such bad condition that I never want to see them again. Nor most of the others either. What stays with me is the memory of good, happy times when I was planning the pieces, making them and installing them. In Münster for instance with Klaus Bussmann and Kaspar König and their people, you remember; you were there, too.

FM *To come back to one point, why you've "gone inside" recently and have even gone so far as to build your own spaces.*

UR I had been planning works for gardens, parks with sculptures, even squares—none of which had been realized. So what!—perhaps they're better just as plans and dreams, better than if they had ever been made. I know it looks as though I'd retreated into the hallowed halls of the museum. But that's only one side of it. I've simply been pursuing my own interests by building spaces myself, and at the moment I am building another one, definitely the last; in it I'll show all my theme-forms, the different work processes and their variants in eight rooms, which is something I couldn't do in any museum anywhere in the world.

You could say there is no place where art cannot exist, unless that place were invisible. I've made work in all sorts of places. In squares, in streets, at crossings, in front of, beside, behind, in architectural structures, in entrances, in historically significant places, by rivers and lakes, in parks and gardens, in landscapes, in woods, at the edges of woods, meadows, planes, fields, in unimportant places, in non-sites, in one-time industrial sites. And the places themselves were quiet, noisy, exciting, boring, harmonious (and the opposite), aharmonious, brutal, bright, dark, open, closed, cheery, sad, meaningless, laden with meaning …

FM *… You've been in the business for over thirty years—so? …*

UR … and all these rooms in museums, old or newly built, could still be at my disposal but they'll be increasingly disconnected from current trends. Is it one's fear of sinking into obscurity during one's own lifetime and making a virtue out of necessity and saying, "I don't need any of you any more, I can manage perfectly well on my own!" No, it's not that: just like I did thirty years ago, I still need help, appreciation, public acclaim, and the material backing to realize my dreams. I'm still utterly convinced that quiet, contemplative art, at peace with itself, which leaves the everyday life somewhere else, is just as important today as it ever was in any other epoch of modernity. An artist is his own man, if he can manage it!—Actually, now that I come to think about it, all my best works are the ones I never made!

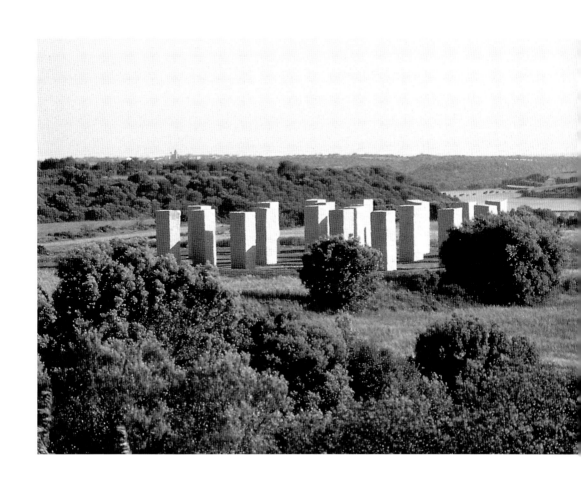

Ulrich Rückriem, *20 Stelen* (Twenty Steles), 1995, Huesca (Pyrenees)

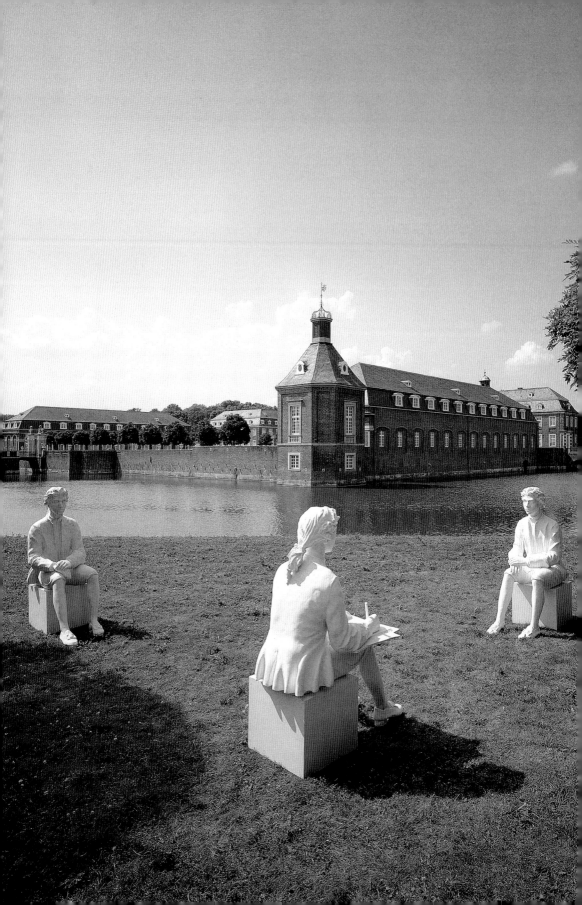

Two Projects, 1999
GIULIO PAOLINI

Proposal for *Tre per Tre—Ognuno è altro o nessuno* (Three by Three—Everyone Is the Other or No One) at Schloss Nordkirchen for the exhibition *Skulptur-Biennale im Münsterland*, 1999

Brief Notice First of all I have to say that until now, December 9, 1998, I haven't made a survey of the locations meant to be the first substantial contact with the project. To say that I *couldn't* make it, though, wouldn't be the real reason that kept me away from it. I'd rather admit that *I had not wanted* to take that step that was the first request. I have deliberately, consciously, avoided "entering" the project, crossing the threshold, committing myself to the circumstances, risking— in so doing—to get away from the theme of the concourse.

The Project The scene is held by three male figures (three synthetic resin statues, life-size, dressed in contemporary clothes). At first, from a certain distance, one has the impression of facing three identical figures. In fact they look very much alike, even if, an instant later, at a closer distance, one realizes that— yes—they are just one same figure, but more exactly, three different roles of "moments" of the same character.

The first, with an absent glance, lost in the void, is the *model*; he is posing for a portrait. The second—similar to the first—is the *author* of the portrait; he is absorbed in the act of drawing.

The third—again a replica of the other two— is the *observer* of the work: thus he could be the observer of the portrait, till now unfinished, or of the work, of that same work that we are here trying to describe and to which he belongs.

The three characters gravitate around the same "gambling-table." The game will neither start nor ever finish, since everyone is a guest, and not the owner of the same scene: the scene of the work, that is to say, the space where the work take place. The author is the guest of the work that, on its side, hosts the observer. To draw, to oberserve. To observe, to draw ... Reversing the order of the elements the image doesn't change, the dilemma remains the *Liber Veritatis* infinitely goes on.

Note To visualize the project I have taken and adapted the central figure of the engraver from *L'Etude du dessin* by J. B. Chardin.

Giulio Paolini, *Tre per Tre—Ognuno è altro o nessuno* (Three by Three—Everyone Is the Other or No One), Schloss Nordkirchen, 1999

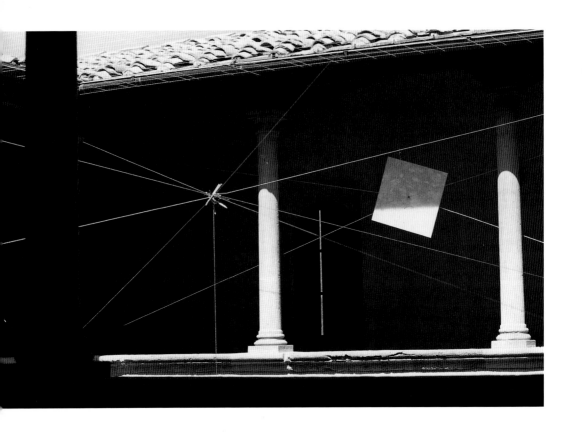

Giulio Paolini, *Quasi* (Almost), inner courtyard of the Pinacoteca in Volterra, 1999

Proposal for the project *Quasi (Almost)* in the inner courtyard of the Pinacoteca in Volterra for the exhibition *Arte all'Arte*, 1999

There, it's about to happen!
Unless …
It should happen right now, or almost …
It should really happen that everything composes (or recomposes) itself.
Up to what point?
To the point of equilibrium, or at least to reach a certain stability.
But when?
This is something we can't know and we can't even think of asking ourselves.
Almost a countdown. How much time do we have?
We can only wait … until everything has happened.
Will we know it is happening?
That is exactly the point: It's up to us, to us alone, to decide about it.
So we'll say that everything had already happened before …
We won't say anything because no one will be there to listen to us.

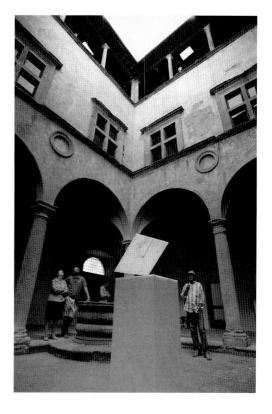

Giulio Paolini, *Quasi* (Almost),
inner courtyard of the Pinacoteca in Volterra,
1999

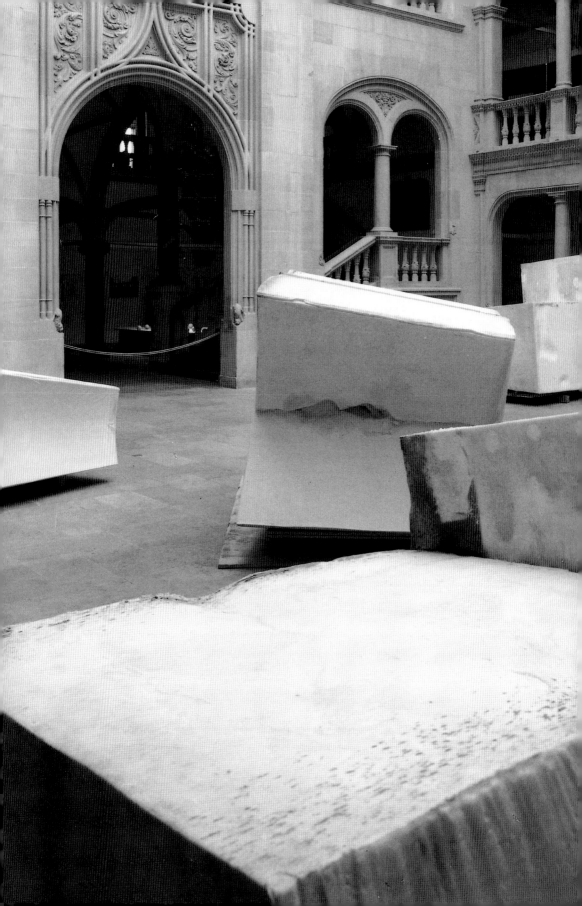

The Age of the Curators

HERMANN PITZ

It has long since been widely accepted that the eighteenth-century notion of genius is a thing of the past, the idea that the artist—an outstanding exception amongst men—is chosen by Nature and for the express purpose of giving form to the (science or) art of his day. This artist has long since disappeared from sight. The outstanding personality was by definition a man, and "despite" the underlying belief in the eternal authority of genius, the notion was still prey to fashion: at times in the eighteenth century even Rembrandt's work was dismissed as no more than dabs and daubs, and Bach's music languished until it was rediscovered in the nineteenth century.[1] In the twentieth century there was a degree of progress in the matter of identifying artistic personalities: film stars and pop stars become enormously famous and exercise a huge cultural influence—and no-one feels the need to justify this with allusions to the notion of genius. Modern pop and contemporary classical music are not so easy to tell apart any more, and women have successfully made their mark in a realm that was once the sole preserve of men and male geniuses. So the cult of genius, where it still existed in the twentieth century, simply seems ludicrous and scarcely credible—in art as much as elsewhere—one need only call to mind the adulation accorded certain political leaders who were hailed as geniuses.

The artists of my generation (who studied in the 1970s) were very well aware of the change as it occurred. In 1972 the continuous innovation of the past came to a halt. Hitherto Pop, Op, Minimal, and Concept Art had followed in a steady progression; but suddenly there was no new direction any more, or, where people claimed to have found one—in New Figuration and the like in the early 1980s—it was false and unconvincing. I still wonder today to what extent the image of empty motorways in the days of the oil crisis in 1973 was the cause of this change, although it certainly hastened it. Progress had become a fiction: one tap on an oil rig was turned off and we were catapulted back into a situation that up until that point had seemed lost and gone forever.

The second half of the 1970s saw the clearest expression of the change. I think the word "post-modernism" first filtered through to me shortly before 1980. As soon as it emerged it was readily comprehensible from my limited perspective: modernism had been a progressive evolution, post-modernism was a dispersed evolution. That was enough to unsettle the art student. Where it had previously seemed to be enough to belong to a "movement," carving out one's place on the contemporary stage under the wing of that movement, now one was suddenly thrown back on one's own resources. It was essential to get out of this situation, but it was already clear that

Joseph Beuys, *Unschlitt* (Tallow), presentation of the "thermal sculpture for a set time" in the courtyard of the Landesmuseum on the occasion of the exhibition *Skulptur Ausstellung in Münster 1977*

diligent application in the studio was of as little help here as adopting the regressive persona of the genius. The idea of being a genius of some kind merely seemed embarrassing. There were two exhibitions at the time, which seemed to me to be connected to the notion of the artist as non-genius. The first of these was the exhibition *Ambiente/participazione* at the Venice Biennale. In it there were reconstructions of all sorts of artists' spaces—from Duchamp to Fontana to Yves Klein. Next to it newly commissioned spatial pieces were on show, work by Maria Nordman for one. It was as though the exhibition was relegating the notion of the original into second place behind the immediate spatial experience of artists' spaces (some no longer extant). The visitor was not concerned (any more) with the aura of a work, but with different models of spatial art, prototypes of artistic praxis. The spatial experience made the pictorial idea seem anti-illusionistic, even in the notion of the "installation" which had something unpretentious about it and was first being used at that time. This was very much in keeping with the uncertainty that I felt about my own studio work in those days.

The other exhibition project was the sculpture exhibition in Münster in 1977: this combined an overview exhibition of twentieth-century sculpture with a "project section," which involved the visitors going outside and touring seven commissions placed in and around the town of Münster. The project in Münster actually went a step further than the one in Venice, since (possibly to the surprise of the organizers) the presence of the seven new works was so powerful that one soon came to see the "historical section" (despite artists like Julio González being extensively represented for the first time in Germany) as the necessary

didactic basis for what people like Bruce Nauman or Joseph Beuys were proposing. Significantly, both these artists' projects were never realized and only ever existed as models.

For me this exhibition opened up a whole new area of research, which I have continued to explore today and return to every so often: the relationship between the model and reality, what happens when a small piece becomes a large one, the possible connections between three-dimensional works and urban spaces, and more in that vein. Of course it would be fair to assume that I might well also have hit upon these topics under other circumstances, yet there is no doubt that these exhibitions had a deeply formative influence on me. Since the late 1960s there had been certain exhibitions which were of similar importance in the art world. Perhaps it would not be wrong to talk of the "Age of the Curators." The line started with Harald Szeemann's *When Attitudes Become Form* (1969) and continued through to *documenta IX* (1992) curated by Jan Hoet, which marked the end of an era. It is a particular feature of the exhibitions in Münster that neither did any particular style emerge from them nor did they ring in a new epoch—although it might have seemed that the opposite was the case in 1987 when Klaus Bussmann and Kasper König had tracked down a whole number of artists who fitted perfectly into the debate on "public art" at the time, and who shone so brightly in Münster. But today it is clear that these artists have grown apart from each other in their work as effectively as they seemed to be coming together in that exhibition of 1987. Since it seems that the exhibition-makers were not in the position to make the art world "modern" again and to establish a generally accepted avant-garde, if all they were able to

do was to administer a number of different work modes, what then was their achievement? How could it possibly be justified to talk of the age of the curators? The fact is, it was their age because the artists were able to function within the framework of their programs and not vice versa; on one hand the artists were delivering the works for the exhibitions the curators were putting on, on the other hand the way the exhibitions were run provided the artists with the lead they needed to continue with their research.

Yet in the 1990s the Age of the Curators came to an end. Now there were no longer any exhibitions where there were any specific discoveries to be made, or whose themes turned the spotlight on specific questions that artists were pursuing, as had been the case at the exhibitions put on by the Curators of the Age. Nowadays the exhibitions programs from the Age of the Curators still exist as formulas for the globalization of the art world, but we don't any longer come back from the various biennials having discovered a new or special artistic position. We find ourselves returning from events where individual artists cannot hold their own against the multicultural event as an entity. Individual artists at these events are interchangeable and are indeed interchanged. Even the exhibition-makers have become interchangeable, "baby curators" as Nam June Paik called them some years ago.

But on the whole this development is to be welcomed. In the 1970s Klaus Bussmann and similarly enterprising figures in the art world pointed us in the direction of a new understanding of the artist. Visual artists now engage in dialogue with institutions; they work together with them, they are sometimes critical of them. Increasingly, artists, as the suppliers, are anonymously active in the development of a highly developed product called "the visual arts." This tendency is no doubt entirely in keeping with a fundamental characteristic of artists: despite working as individuals and being treated as such by the art world—partly still following in the cult of genius from the eighteenth century, partly because there are of course good and not so good artists—artists are actually working collectively to solve the enigma: what should pictures look like today?

1 M. Soeting on Harry Mulisch in: *De Volkskrant*, Amsterdam, February 2, 2001, p. 27.

Art in the Public Space, Art and Architecture, Artists and Architects
A Conversation with Ulrike Groos in Saint Gall, March 2001
ROMAN SIGNER

ULRIKE GROOS (UG): The earliest examples of art in the public space can be found in parks and squares—places that even today are still popular locations for art outdoors. Your outdoor works are seldom realized in squares or artificial green spaces; usually, you work in open nature.

Why is this your preferred exhibition space outside of the museum?

ROMAN SIGNER (RS): I really like to work in nature, where I don't have to consider the architecture. My least favorite sites are houses. I prefer to work outdoors. I also like to work out of bounds—I mean, art doesn't always have to be placed showily in front of a building. The architects always want that, because it's prestigious, it adds to the value of their building.

For example, this work with the kayak (*Installation mit Kajak/Installation with Kayak*, 1993, Trogen). It's in a gymnasium, in the country, and someone raised an objection—that it ought to be somewhere in a city, or in front of a building. The current site is the wrong place. But I don't think that it's the wrong place. Admittedly, it is somewhat isolated, but for me, that's its special charm. That's why I also really like the project with the cabin on the river (*Skulptur am Fluss/Sculpture on the River*, Wettingen an der Limmat, 1997). The work is simply set in the countryside, without being connected to any piece of architecture. Actually, I think that is the ideal form—when art is not an appendage of architecture.

I really don't like to make these sculptures for squares. Where the artist is expected to organize the squares: here's where the flowerbeds will be, and there are the hopscotch games and whatever else. I make sculptures, autonomous objects. I don't like to subject them to a piece of architecture, by making an entryway, for example. Usually, my works oppose architecture.

UG There are differences in your projects in the public space—for instance, between Spazierstock/Walking Stick *for the* Sculpture. Projects in Münster 1997*, in which a central theme is constant movement and change— and works that start with an experience, whose results then become the actual sculpture. An example of that is* Engpass/Bottleneck*, for the* Aussendienst *exhibition (2000, Kehrwiederspitze, Hamburg).—What meanings do these various directions in your projects have for you?—When do you decide upon which form?*

RS I work very closely with the space, and usually have various ideas. You have possibilities in your mind, the various projects, and the space decides whether I think it's good or not. It is actually an art, or luck, to do that right. It's important to be aware of the opportunity, and above all, to make something that really fits there. I think that is very important. Those are all slow decisions for me. I don't

Roman Signer, *Engpass* (Bottleneck), 2000, Kehrwiederspitze, Hamburg

start with the form, but with the situation at hand. Then an idea is created, which slowly ripens, becomes concrete, until a clear form results.

There are also other approaches, such as the transitory sculptures, for instance, the *Aktion vor der Orangerie/Action in Front of the Orangery* of 1987, for *documenta 8*.

UG When you look back at your works for the public space, which projects have you designed for a very specific place? I'm thinking about the Spazierstock/Walking Stick *in Münster, which at least requires some water—a pond, lake, or river.*

RS Exactly. That's the problem with the work in Münster—the work was bought and then put into storage. At some point, it should be re-installed, somewhere in Münster. I would have preferred it if they'd kept it where it originally was, in the park around the old zoo. It would have had to be restructured a bit. Because it's really dependent upon the situation. You can't just easily put it somewhere else. And if it is moved, it's necessary that I be consulted.

A basic question, too, is, does it make sense to take works meant for a particular part of the public space, sell them, and put them somewhere else? Of course, it's financially interesting, but nevertheless, I'm against the idea. Another example is the work that I'm making for the Centre Pompidou in Paris, these boots (*Stiefel/Boots,* 2001). The museum wanted the work *Ich war hier/I was here* (1996). In that one, I climbed a rope, and made some footprints on the ceiling with both boots. The work was first shown in Esslingen, in the Villa Merkel.

Paris wanted to buy the work, but asked that I make the prints on a board, so that the work could be hung. In Marseilles, in Frac, in Lyon,

or wherever. But that is absurd, that's not the idea behind *Ich war hier*. The joke is that I was there, on that ceiling—you can't transport that.

So then I told Paris that I still had these back problems and that climbing was just extremely demanding for my muscles, everything hurts all over afterward. I can't do that any more; I'm too old for that. Not healthy enough; for one, I don't work in a circus, and second, I'm no longer twenty years old. If I did work in a circus and I were twenty years old, I would do it with pleasure.

Then I had the idea that I would shoot the boots up, that would be really good. The action will take place on March 27, 2001, in the Centre Pompidou. And then, naturally, this work can't be simply transported. It's made especially for this location, and when they loan out the work, you just have to invite me there, and then I'll do it again. It's really a site-specific project, isn't it? But naturally, there are works that can be transplanted, such as the works conceived for museum exhibitions.

UG In Hamburg, in February of this year, there was a symposium in conjunction with the exhibition Aussendienst. *The topic was "Where Is Art ... Perspectives on Art in the Public Space." Artists, critics, and curators were invited. If someone were to ask you, an artist, a question about perspectives on art in the public space, what would you answer?*

RS I've never really seen that, art in the public space. I've always thought, art in the public space—those are projects that I would like to do, but for a long time I couldn't afford to do them. In the public space, it's possible to realize many of my ideas. For instance, I'd had the idea for the work *Engpass* for *Aussendienst* in Hamburg for a long time, but I was never able to do it alone.

Roman Signer, *Engpass* (Bottleneck), 2000, Kehrwiederspitze, Hamburg

But I would not like to limit my projects in the public space to structures. My fuse action, for instance, was also art in the public space (*Aktion mit einer Zündschnur/Action with a Fuse*, 1989, Appenzell rail routes, Appenzell-St. Gallen). That was also a thing that took place in public. Or my other actions done in the public space. I consider my temporary projects to be just as important, even if nothing is left over.

Sometimes I even have my doubts about sculptures made for buildings, when they are so integrated into the architecture. I still haven't seen many good examples of that.

I certainly see perspectives for the future. Perhaps another approach would be sensible. For example, that the architects look upon the artists more as colleagues and not always insist upon having the last word.

Maybe another generation of young architects will come along who will be able to work more cooperatively with the artists.

UG When did you start doing your work in the public space? What were your earliest works?
RS I'd always had ideas for the outdoors. If you look at my drawings, then you'll see ideas that should be realized in the public space. But in those days, when the first drawings of my ideas were done, I couldn't realize anything. I drew plans, ideas—they're always my own imaginary ideas—and I'd always hoped that perhaps an architect would come along and say, okay, please build that. I really could have used the financial help, too, but nobody came along. But at any rate, I'd always reckoned with public space. Although I've never really gone in for art as a part of a piece of architecture. But sometimes I've simply had

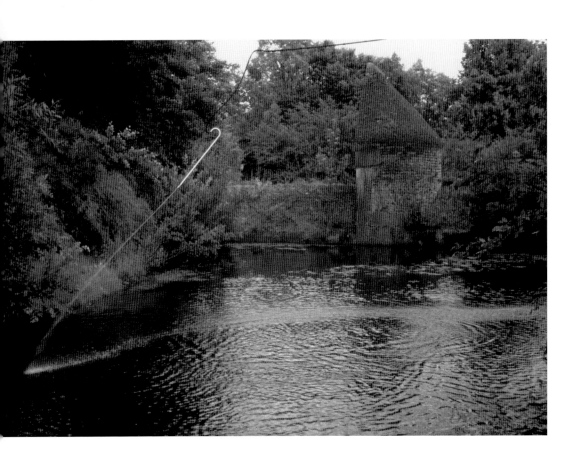

Roman Signer, *Spazierstock* (Walking Stick), 1997, Münster

Roman Signer, *Installation im Wasserturm* (Installation in the Water Tower), 2000,
Sammlung Hauser und Wirth, Saint Gall

Roman Signer, *Installation mit Kajak* (Installation with Kayak), 1993, canton school in Trogen, Appenzell

larger, more complex ideas and fantasies, so why shouldn't the public finance things that otherwise would not be feasible? That's actually the thing that is still interesting.

UG Do you still recall the very first project that you realized?

RS A very important project was, for instance, in Bochum. The work is still there (*Atmende Säule/Breathing Column*, Project Bochum, 1979/80, Karl von Ossietzki Square, Bochum-Langendreher). That was in 1979, and it was actually the first sculpture that I was allowed to make for the public. There was a so-called sculptors' symposium, and I was invited by the Museum Bochum, along with about eight other European sculptors. We had to look at the city squares; everything took a long time for me—I was there several times. Then I literally lived two or three months in Bochum, in order to finish the sculpture. I had an office in there—at Klöckner-Humboldt-Deutz—and I drew some of the plans there in the office, and oversaw all of the work. Finally, we put up the sculpture, and I was still there, in a little hotel. I must say, I wouldn't have time for that these days.

Apart from myself, other artists were invited, who at the time, were already famous, such as Morellet and Spagnolo and those people. They were also there, but they didn't spend three months there. They arrived sometime, talked a bit, and then they went away. They sent their plans to be realized, and then they returned for the opening. At that time, I thought they were arrogant guys. They weren't even there. Today, I would probably do the same thing. There isn't enough time any more to spend three months in Bochum. But okay, then, I had the time. It's all relative.

In Hamburg I did something similar. I drew the plans, flew up, found the site, said "here

and here," left, made some phone calls, did some drawings, and then I returned for the opening. And that worked. I didn't have to be there the entire time.

Yes, you can work like that, too. Nowadays, that's normal for me. That's the way I work.

UG What are your next outdoor projects? At the moment, there are piles of requests from museums. Do you even have time for projects in the public space?

RS I also don't like to do competitions any more, because I've had so many disappointing experiences, and they demand an extreme amount of energy and time.

I also see the danger that an artist might encounter, for instance, when he does nothing but art for architecture or art in the public space. I don't think that's the right way. There should be exceptions. You should create your oeuvre. Your work, and then, out of this work, something can be created. But when an artist specializes in simply architecture, then his work will suffer. That's very problematic, because these artists are stuck with this, and you suddenly stop hearing anything about them. I think that is also somewhat tragic. They survive, they're financially secure, but they can't make a reputation. Their work often becomes boring. It repeats itself. I try to make my projects completely unique.

The project with the car in Hamburg (*Engpass/ Bottleneck*, 2000) is completely different from the water tower project in Saint Gall (*Installation im Wasserturm/Installation in the Water Tower*, 2000, Sammlung Hauser und Wirth, Saint Gall). Although many of the works have things in common, each one is totally different from the other.

I think I'll be allowed to make a few more, if they're good. You realize it yourself, if they're good.

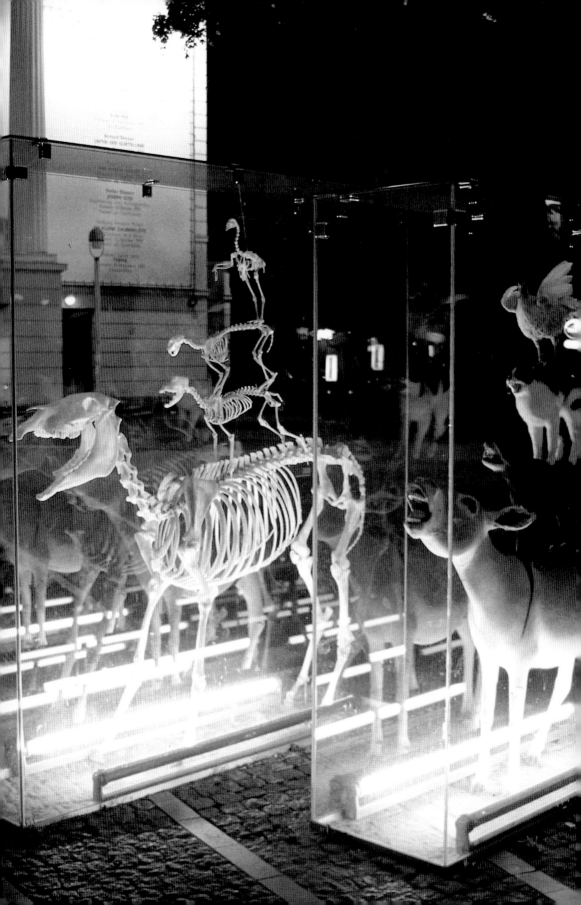

"Why don't we do it in the road
no one will be watching us
why don't we do it in the road?"

HANS-JOACHIM MANSKE

This Beatles track (Lennon/McCartney) that came out on the *White Album* in 1968 is one of the key texts for Conceptual Pop in the 1960s, which John Lennon loved and which was epitomized in Richard Hamilton's sleeve design: pure white with the name THE BEATLES in raised letters, in the spirit of Duchamp's "dematerialization of the art object" (Lucy Lippard).

During the days of Conceptual Art in the late 1960s and 1970s it was perfectly legitimate to adopt the Beatles' maxim "That's my way" as one's own. But in those years dominated by Conceptualism, when the dynamic underlying mood was engaged in something of a historic game of chess with Duchamp's silence, there were less patient souls on the lookout for artistic positions who were prepared to take a serious interest in the external urban spaces that had been emptied by the bourgeois populace.

Paradoxically it was the note found in Robert Musil's estate referring to the "invisibility" of monuments that provided the crucial impulse— whether people were aware of it or not. His often quoted comments which became a veritable mantra against public art assumed a claim to perception that was valid for museums and galleries but which, it was suggested, did not apply to art in public spaces. Therefore there was a need for a new relationship between art and public life, which would entail a radical change in modes of perception handed down from the past.

The new artistic approaches that had been tested out since the 1970s, first and foremost in the *Sculpture. Projects* in Münster, also had an impact on art criticism and art history. Musil's supposition that artworks in public spaces should and ought to be seen, could be questioned in the case of the long phases of official art that have periodically prevailed since Antiquity and even more so in the case of autonomous art in public spaces.

Wolfgang Kemp has pointed to the findings of the Frenchman Paul Veyne[1] who conducted an analysis of public monuments such as Trajan's Column in Rome and concluded with a plea for a "historic aesthetic of non-perception and not-wanting-to-be-perceived." Veyne asks why we have an art form which is conceived in such a way that one cannot see it. Political art like Trajan's Column and other monuments are of course an expression of power *per se*. In Veyne's opinion there is no mistaking their "overwhelming indifference towards being seen for their own sake" which states in no uncertain terms that it is more important to make a statement through the monument than for that monument to be perceived or for one to perceive it oneself. According to Paul Veyne we need "a sociology of art, which no longer works on the assumption that ideology is communicated through

Maurizio Cattelan, *The Bremen Town Musicians I and II ("Love Saves Lives"
and "Love Doesn't Last Forever")*, 1997, Bremen

iconography. It would focus on the art that is only decoration, which one does not look at too closely, which one can barely see, yet which is nevertheless very important."

Let us look more closely at the paradox in our perception of memorials and monuments referred to by Musil. Despite their indifference to their own legibility, memorials and monuments do have a political function. But since the nineteenth century, when art started to be co-opted for "public service" of this kind less and less frequently, it has increasingly lost its claim to exist in public spaces—as Martin Warnke has put it. In Warnke's view this applies particularly to art that "sees itself" as autonomous, which is a contradiction in terms in a public setting.

The "duty to refuse" that Warnke expected of autonomous art does have a certain historical logic to it, but is hardly relevant in terms of art praxis in recent times. The democratic state as the commissioning body and the artists making self-reflective works are primarily interested in an "art of non-scrutiny." Since as a rule neither side wants anything from the other, their common cause, historically—and still today in many cases—had a non-intentional quality to it. As Warnke rightly remarks, particularly in view of the fact that autonomous art has no public function, its indifference—as defined by Paul Veyne—is one of its most important features. Trajan's Column, Gothic cathedrals, and autonomous art in public spaces are elementary components in a political and religious *ordo*, which needs narration and forming above all for its "ontological" function.

Those responsible for the *Sculpture Projects* in Münster did not themselves adopt any particular theoretical positions, a fact that was crucial to the overwhelming success of the undertaking. All they did was to create a frameworks that was as stunningly simple as it was historically "loaded": they handed responsibility for their ancient bishopric over to the artists. And in doing so they were breaking all the rules that had applied for hundreds of years to the relationship between public patron and artist, that is to say, no artists had ever been given such freedom. However, this unusual lack of constraint was simultaneously a rope for the participants to hang themselves with. The curators for their part did not indulge in their own in-born flights of fancy; they readily accepted the natural vanities of the relevant administrators, the politicians' egos, and the visual expectations of the town's inhabitants, and were never tempted to parade these as proof that no-one was actually interested in contemporary art—above all in public spaces that were already quantitatively and emotionally overloaded.

The artists, for their part, were more than equal to the challenge, because (aside from one or two exceptions) they did not transpose their own doubts, prejudices, and fears into unrealizable visions. Münster is a perfectly normal town, with nothing very extreme about it, and massive "attacks" have more of an effect here than perhaps in Rottweil and Marzahn or in the Gropiusstadt housing development in Berlin. Münster actually seems to lack nothing—but probably the artists felt good about what they were doing because precisely those things that only they could provide did turn out to be lacking after all.

Klaus Bussmann opened an important chapterin public art: drawing on his great expertise and sensitivity he recognized that the 1960s notion of the artist breaking out of his/her studio was seen by the contemporary "avant-garde" neither as a new vision of art and life

nor as a return to *l'art pour l'art*; and thus it was that Münster—not Cologne, New York, or Los Angeles—became the symbol of a re-definition of public art.

Bremen, January 2001

As twilight descends the Senate's right-hand man for public art is sitting in Theatro, an artsy café in Bremen. He is not talking to artists nor is he debating with others as to how the town might overtake Münster, and not just catch it up—although from where he is at his usual table he has a good view of the little square in front of the theater, which is occupied by Maurizio Cattelan's *Bremen Town Musicians I* and *II*. A direct import from Münster that was not paid for by the Senate but by two citizens of Bremen who, it is to be hoped, will one day be rewarded for their services and will be able to enjoy the finest wines like the poet Hauff in the Ratskeller and the stone figure of Roland.

Beside the espresso there is a paper on the subject of improving cultural efficiency by means of the new fiscal insight into the advantages of "construction via destruction." The paper is dealing specifically with the "product group" public art and the strategic relevance of such activities. The text opens with an explanation of the notion "problem." This is to be understood as embracing: cause, circumstances, extent, those affected; only on the basis of verifiable facts, without discursive justifications. Then there is a series of questions: What is our interest in public art? What is the problem? Where and how is this problem manifested? Who is affected by this problem? What are the causes or relevant circumstances regarding this problem? What is the extent of the problem?

Meanwhile, at precisely the moment when the street lights went on, lights also went on in the two glass showcases with *Town Musicians I*—the traditional pyramid made from life-sized stuffed animals—and *Town Musicians II*—the same formation but with the animals now reduced to skeletons. "Die Liebe rettet das Leben" (Love saves our lives) is written under the positive version; "Die Liebe dauert nicht ewig" (Love doesn't last forever) is written under the negative version.

The assistance sought by the Senate and its consultants in their wish to reach an informed decision, which is to be entirely "understandable and transparent," is already available in intellectual and aesthetic terms in the shape of these two artworks, which ought in fact to obviate the questions regarding increased efficiency. They already speak the language of hard facts and passionate positivism which is what is wanted today. An outstanding "landmark factor," a fine example of urban decor and of ersatz decor in one, they make a notable contribution to the *comédie humaine* on a Balzacian scale: a vivid embodiment of Hamlet's question "To be or not to be," both in the tragic version by Shakespeare and in the satirical version by Ernst Lubitsch in his film of the same name.

Although all the elected political representatives of the town of Bremen know Cattelan's *Town Musicians*, strangely enough no-one ever talks about them. This of course means that they are far from a convincing argument for the "product group" public art, which is only to their credit.

Instead a different "work of art" is hypostasized all the more frequently—a work that no-one knows particularly well and which only a few have seen or can see, because it is not placed on one of the "main arteries." This

work is Jochen Gerz's *Bremer Befragung* (Bremen Poll) which consists of a short documentation and a plaque fixed to the second large bridge over the river Weser (directly by the Neues Museum Weserburg). Its position is marked optically by a triangular protuberance on the balustrade.

The *Bremer Befragung* was one of Jochen Gerz's less spectacular projects, yet as a process it maintained a high intensity over a period of several years. On one hand the artist proceeded primarily along the lines of the dialogues with the public that were conducted in the 1970s under the auspices of the town's program of public art; on the other hand the action was planned and carried out in the effort to change the paradigms that govern the relation of art and public life. With his customary radicalism—which made Jean-Christophe Ammann's criticism of "drop sculptures" and Martin Warnke's pleas for a "duty of refusal" for autonomous art in the 1980s look like academic chit-chat—Gerz demonstrated his concept of "invisible monuments": "We only devise empty spaces in order to pack them full …" Gerz spoke with semi-public groups, such as prisoners or employees in a large Bremen company; he then published a sequence of interim reports in both the Bremen daily papers.

Gerz's charisma, his polished rhetoric, and above all his skills in dialectic gradually created an "artwork of words": "The artist's head is a public space. His propositions become components in the heads of those who exchange places with him. The work of art consists of commentaries on the work of art … The *Bremer Befragung* is a sculpture that grew from the pictures of those who imagine it. All those who do this are its authors." (Gerz)

In the mid to late 1970s the program of public art in Bremen involved discussions that could hardly have been more intense. The fact that projects were realized in all parts of the town, including the most distant, meant that these discussion made their mark throughout the town—with the result that for the first time living artists were perceived as having a significant minority part to play in the history of the town. But the real long-term effect of the program was not the impact of the works of art—for however avidly they had been fought for, they very quickly fell victim to the patterns of perception identified by Robert Musil—instead the real effect was the (at times extended) presence of the artists while their works were being made and their part in carefully targeted participative strategies.

If one were to look at the bottom line of this form of "permeating the town with art"—one of the aims laid down by the Culture Committee at the Conference of German Towns in 1971—then the battle for the "unwanted monuments" (Grasskamp) and the active involvement of artists in the day-to-day running of public spaces as well as in various educational, social and leisure institutions, in hospitals and prisons, and even inparliament and in the town hall, one would have to conclude that the consequences were general rather than specific. In the 1980s, when traffic-calming measures were at their peak, and white markings were "narrowing" spaces, dissenting voices in the media would almost always begin with "Anyone who thought it was public art is sorely mistaken: this white line means that the people living in areas A, B, and C will never be able to turn left again on their way home etc. …"

This enduring collective memory of the work of artists who had by then in the main returned to their studios proved to be the deciding fac-

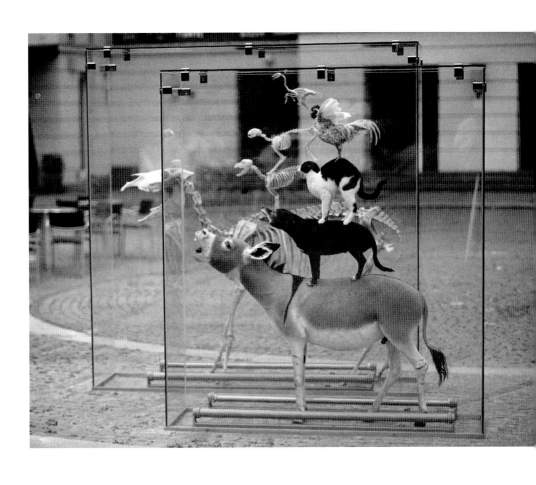

Maurizio Cattelan, *The Bremen Town Musicians I and II ("Love Saves Lives"
and "Love Doesn't Last Forever")*, 1997, Bremen

tor for the powers-that-be in artistic and cultural politics to approve the first Museum for Contemporary Art (showing exhibits from private collections) being opened in Bremen in 1991.

The major public impact that Jochen Gerz achieved in Bremen also owes much to the Neues Museum Weserburg which backed him with its professional moral authority. Thus the circle was completed, for Gerz was in his own way continuing with the "permeation of the town with art," even if this art only existed in the imaginations of its citizens. The *Bremer Befragung* had an extremely warmly welcomed cathartic effect on this town with its distinctly Calvinist leanings. The mayor and the Senate took the artist's demand that memorials and monuments should disappear from public view as the leitmotif of their politics—construction via destruction.

At the outset of a new century "public strategies" by artists in Bremen are following two distinct lines. On the one hand existing artworks are used as artistic material. In the same sense that Remy Zaugg in Münster in 1987 redeployed two artworks from 1912 in the place where they had originally stood and for which they had been made, declaring that what he was doing was an act of "spiritual hygiene," Jochen Gerz would now like to banish all existing artworks in order to reinstate the "emptiness" that preceded them.

In 1987 the citizens of Münster put the "reinstatement" of the *Knecht mit Pferd* (Boy with Horse) and the *Magd mit Stier* (Girl with Bull) right at the top of their hit list of a total of fifty-three projects for public spaces. In Bremen most of the responsible politicians and cultural office-holders—and the media too—were of the opinion that Gerz's suggestion should be approved and a start should be made clearing away the existing artworks. However, as is so often the case, a contract along these lines could not be issued because of the costs involved. In any case it is clear that the result would have entailed considerable public interest, since Gerz was not only interested in clearing works away but in the imagined emptiness which could only have been achieved through lengthy dialogue.

While the *Town Musicians* by Maurizio Cattelan stand for the classic dialogue between work and viewer, they are also beholden to conceptuality—but unlike Jochen Gerz (twenty years Cattelan's senior), whose point of departure is a fundamental critique of the truth-content of media images, Cattelan starts with the manipulative results of these same images and confronts them with surprising and unsettling physical and haptic forms. Cattelan seeks the sensuality of matter, Gerz seeks its de-sensualization. The *Town Musicians* are not only placed to best effect in the public eye, but they also have the capacity to retain the enduring interest of the public. In 1953 the sculptor Gerhard Marcks created a rather less spectacular version of the *Town Musicians* outside the Town Hall in Bremen, more like a memo, reminding the citizens of the town's connection with the tale told by the Grimm Brothers. Cattelan on the other hand focuses on the actual content of the tale: it is about life and death, about solidarity, about the victory of the lowest of the low, for which they needed imagination, intelligence, and courage—albeit a victory which will not last forever, and which does not have to last forever. In Bremen people rarely discuss the underlying meaning of this tale. Almost every month new *Town Musicians* appear as souvenirs, and in the town's latest publicity they have been reduced to a logo.

Cattelan's version is a thorn in the flesh. Comparably complex works of art have repeatedly been identified by the media in Bremen as embodiments of certain critical (political) commentaries. But in the case of the Cattelan piece there are no reactions of this kind. The public in Bremen, once praised so highly for its sophistication, has fallen victim to the "collected silence" of Doctor Murke.

On Goetheplatz in front of the theater the first audience members are arriving for the evening performance. Most, coming from the center of town—including those that have arrived from elsewhere by bus—stop for a moment and walk round and between the glass showcases with the *Town Musicians*.

"… Is it possible to imagine a form of contemporary art that passers-by would respect, without underestimating it as its addressees; which would do justice to its location without any hint of obsequiousness; which would even embellish that location, without descending into decoration? And could modern art ever bein the position to go beyond its internal art-historical declarations of interest and to recount a narrative in a public space? Or, as the picturesque answer to a problematic housing situation, would it become little more than urban furniture?"[2]

The Senate's right-hand man, looking out through the window of the café, has the feeling that Cattelan's *Town Musicians* come close to this. But the void may also be filled—"with due care and attention"—with other things. As Jochen Gerz has said: the point of art is to change.

The answers to the question "What is the problem?" with respect to the "product group" public art can only be given by art. (Duchamp: "There is no solution because there is no problem.") The neo-Dada questionnaire issued by the Senate of the Free Hansa Town of Bremen—seen as a conceptual artwork—is perhaps an important step forwards.

In the handbook on public art *Zur Sache Kunst am Bau* (1998) there is an article by Jochen Becker with the title: "The twenty-five-year history of public art actually began in Bremen. A paradigmatic review." Münster gave an exemplary demonstration of the term, even if it barely if ever passed the lips of those responsible. And even if it should have ceased to exist by 2007—many are nevertheless already looking forward to their march through the next outbreak of mayhem in Münster.

1 Paul Veyne, "Zeitgenössische Kunst und ihre Betrachter," in: *Jahrbuch für moderne Kunst*, vol. 43, 1996, p. 38.
2 Walter Grasskamp, in exh. cat. *Skulptur. Projekte in Münster 1997*, p. 19.

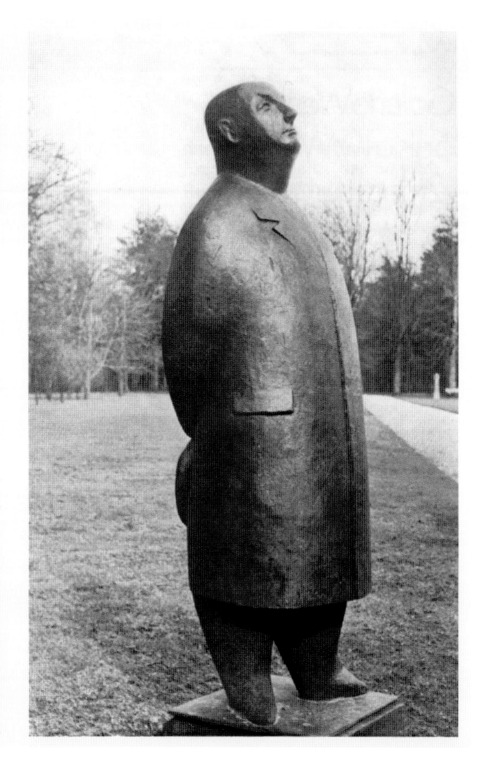

Oswald Wenckebach Monsieur Jacques, 1956 · Anzeige in Erinnerung an die Weltausstellung in Brüssel. 1958

Oswald Wenckebach, *Monsieur Jacques*, 1956
Advertisment commemorating the Brussels World's Fair 1958

Reprint from
Skulptur Ausstellung in Münster, July 3 – November 13, 1977, project area, catalogue 2, p. 100

For Klaus Bussmann from Kasper König

a little CONVERSATIONAL LEXICON on
Art and the City/Art and Architecture/Art and History/Art and Society/ Art and the Exhibition/Art and the Public
an outline

MANUELA AMMER, HEIKE EIPELDAUER, HEIMO ZOBERNIG

A

Where everything is bad/it must be good/to know the worst. (Francis H. Bradley, quoted by Hartmut Scheible, *Theodor W. Adorno*, Hamburg, 1989, p. 113, quoted from Theodor W. Adorno, *Gesammelte Schriften*, 20 volumes, ed. by Rolf Tiedemann, Frankfurt am Main, 1970–86, vol. IV, p. 92)

Radically seen, an artist who works in the public space must aim for the point at which his work as such is no longer noticeable ... (Jean-Christophe Ammann: "A Plea for a New Art in the Public Space," in *Parkett* 2, 1984)

Art in the public space as such must be powerfully present, yet also able to "disappear" ... (Jean-Christophe Ammann: "Art in the Public Space," in *Unerwünschte Monumente— Moderne Kunst im Stadtraum*, ed. by W. Grasskamp, Munich, 1993, p. 126)

We sound like city planners when we say that our drawings and diagrams as proposals that are supposed to express our opinion about what the hopes of others are. (Douglas Ashford: "Notizen für einen öffentlichen Künstler," in Christian P. Müller, *Kunst auf Schritt und Tritt*, Hamburg, 1997, p. 16)

B

The style, yes; the teenage uniform of white walls and flat roofs and oversize windows has gone, and many of the accompanying tenents of belief are now known to be illusions. But the process that produced both has proven to be irreversible, and the radical succession continues. That is why one can say that "if it is not modern, it isn't architecture." (Reyner Banham: "Modern," in *Age of the Masters. A Personal View of Modern Architecture*, 1962; New York, 1975, p. 16)

Painters cannot be social idiots. They are not somehow cut off from the conceptual structures of the culture in which they live ... active ideas do not maintain themselves, they must be brought to fruition. (Clementine Deliss, "Repräsentation von Skulptur im öffentlichen Raum: Die Rolle des Objekts im 'Ethnographischen Exotismus' im Paris der dreissiger Jahre und im 'Neo-Konzeptualismus' der amerikanischen Gegenwartskunst," in *Durch* 6/7, 1990, p. 71, quoted from M. Baxandall, *Patterns of Intention—On the Historical Explanation of Pictures*, New Haven and London, 1985, p. 76)

There is no division between the so-called "modern" and history, since "modern" is first the product of history itself, by which means alone is it possible to avoid the repetition of obsolete experiments. (Lina Bo Bardi, "Teach-

in: *Das Natur/Theater von Hütteldorf*, Photos by Hans Czarnik/Heimo Zobernig, in: *Falter* 6, Vienna, 1982, p. 5

ership," 1955/57, in Lina Bo Bardi, Milan 1994, p. 94)

All this about the modern movement having failed in its mission is not entirely true; there are other "histories" involved and some great ones—the future will tell. (Lina Bo Bardi, "Roadside Seat," 1967, in Lina Bo Bardi, Milan, 1994, p. 186)

Pierre Bourdieu came to an interesting conclusion about the tension between art and popular culture when he wrote: "Intellectuals and artists have a marked preference for the most risky yet also profitable strategies of distinction. These consist of aestheticizing unimportant objects—or even worse, objects that have already been dealt with as art in other ways, by other classes or fractions (as in the case of kitsch), in order to prove their own power. In this case, the method of consuming the object creates the object to be consumed. On another level, pleasure transforms the vulgar: from commonly consumed familiar goods (westerns, comics, family photographs, graffiti, etc.) into refined and culturally worthwhile works, which in turn, provide refinement." (Clementine Deliss, "Repräsentation von Skulptur im öffentlichen Raum— Die Rolle des Objekts im 'Ethnographischen Exotismus' im Paris der dreissiger Jahre und im 'Neo-Konzeptualismus' der amerikanischen Gegenwartskunst," in Durch 6/7, 1990, p. 73, citing Pierre Bourdieu, Die feinen Unterschiede—Kritik der gesellschaftlichen Urteilskraft, translation, Frankfurt, 1982, p. 441)

The attacks against art probably changed into the social function of art a long time ago. (Lieselotte Brodil, "Regierungskunst St. Pölten," in Zur Sache Kunst am Bau. Ein Handbuch, ed. by Markus Wailand, Vienna, 1998, p. 152)

Though distorted by it, no other phenomenon of social divergence (with the exception of the ethnic) knows how to liberate so subversively all of the qualities of the authoritarian character, as does art. In its role as the difference to what exists, art is naively obliged to fulfill the functions that it decisively seeks to resist and contravene ... (Benjamin H. D. Buchloh, "Vandalismus von oben," in Unerwünschte Monumente—Moderne Kunst im Stadtraum, ed. by W. Grasskamp, Munich, 2000, p. 110)

... anyone who has the courage and the foolhardiness to show what they have done to others, and in public on top of that, opens the door to analyses, to commentaries, to criticisms and to praise. (Daniel Buren, "Can art get down from its pedestal and rise to street level?" in Sculpture. Projects in Münster, ed. by Klaus Bussmann, Kasper König, Florian Matzner, transl. by Charles Penwarden and L.-S. Torgoff, Ostfildern, 1997, p. 483)

The very designation "public art" suggests a kind of contempt. Do we not in the same way call a prostitute a fille publique, a girl of the streets. (Daniel Buren, "Can art get down from its pedestal and rise to street level?" in Sculpture. Projects in Münster, ed. by Klaus Bussmann, Kasper König, Florian Matzner, transl. by Charles Penwarden and L.-S. Torgoff, Ostfildern, 1997, p. 484)

Most of these works are so insignifant that nobody, not even vandals, is interested in them. (Daniel Buren, "Can art get down from its pedestal and rise to street level?" in *Sculpture. Projects in Münster*, ed. by Klaus Bussmann, Kasper König, Florian Matzner, transl. by Charles Penwarden and L.-S. Torgoff, Ostfildern, 1997, p. 488)

In the museum, we are immediately and automatically confronted, spiritually, culturally, and palpably, with beauty. In the street, ugliness lurks at every step. (Daniel Buren, "Can art get down from its pedestal and rise to street level?" in *Sculpture. Projects in Münster*, ed. by Klaus Bussmann, Kasper König, Florian Matzner, transl. by Charles Penwarden and L.-S. Torgoff, Ostfildern, 1997, p. 499)

... visual pollution is at full blast. (Daniel Buren, "Can art get down from its pedestal and rise to street level?" in *Sculpture. Projects in Münster*, ed. by Klaus Bussmann, Kasper König, Florian Matzner, transl. by Charles Penwarden and L.-S. Torgoff, Ostfildern, 1997, p. 501)

In my view, one of the merits of public places is that they completely wipe out all the shibboleths about any autonomy of the artworks that are shown there. (Daniel Buren, "Can art get down from its pedestal and rise to street level?" in *Sculpture. Projects in Münster*, ed. by Klaus Bussmann, Kasper König, Florian Matzner, transl. by Charles Penwarden and L.-S. Torgoff, Ostfildern, 1997, p. 501)

C
Modernity is bound up with the question of the mask. (Beatriz Colomina, *Privacy and Publicity. Modern Architecture as Mass Media*, Cambridge, 1994, p. 23)

The total powerlessness of works indoors, their forced existence in clean, white rooms, creates the circumstances for a public sculptural experience in the limited framework of the common private place. (Douglas Crimp, *Über die Ruinen des Museums—Mit einem fotografischen Essay von Louise Lawler*, Dresden and Basel, 1996, p. 178)

Where the work of art refuses to play its assigned role, dishonestly reconciling opposites, it becomes the object of contempt. (Douglas Crimp, *Über die Ruinen des Museums—Mit einem fotografischen Essay von Louise Lawler*, Dresden and Basel, 1996, p. 196)

Whether in, around, or on a building, a mistake is made by placing art in opposition to architecture. The assumption is always that the building itself is not art. ("Der Kampf um die Oberfläche. Gespräch mit Hermann Czech," in *Zur Sache Kunst am Bau. Ein Handbuch*, ed. by Markus Wailand, Vitus H. Weh, Vienna, 1998, p. 83)

Today at any rate, art and architecture could have a critical relationship. The artist comes afterward and starts doing something unforeseen to the building. ("Der Kampf um die Oberfläche. Gespräch mit Hermann Czech," in *Zur Sache Kunst am Bau. Ein Handbuch*, ed. by Markus Wailand, Vitus H. Weh, Vienna, 1998, p. 83)

D

Almost all of the phenomena of collective life are to be translated with the help of objects. They are able to respond to the urge that has always driven people to leave material marks of their activities. (Cit. 1) A collection of systematically acquired objects is thus made up of many "persuasive pieces." The collection shapes written archives because the pieces are authentic and autonomous, not produced for practical purposes, and characterize the various types of cultural development better than others. (Cit. 2). (Clementine Deliss, "Repräsentation von Skulptur im öffentlichen Raum: Die Rolle des Objekts im 'Ethnographischen Exotismus' im Paris der dreissiger Jahre und im 'Neo-Konzeptualismus' der amerikanischen Gegenwartskunst," in *Durch* 6/7, 1990, p. 65, citing Marcel Griaule & Michel Leiris, *Instructions Sommaires pour les Collecteurs d'objets Ethnographiques, Musée d'Ethnographie du Trocadéro et Mission Scientifique*, Dakar-Djibouti and Paris, 1931, p.7)

What can be done in order to restore dimension to an action, to make cultural producers able not only to see what determines their productivity, but also to—at least temporarily—destroy it? Certainly, we should not allow the resurrection of either the genius-artist as an antidote to bogged-down projects, or of the project as the antidote for the idiocy of creativity. They were incorrectly assimilated but rightly abolished. (Diedrich Diederichsen, *Der Lange Weg nach Mitte*, Cologne, 1999, p. 227)

deconstructing deconstruction. (Helmut Draxler, "deconstructing deconstruction," in *Heimo Zobernig, Villa Arson*, Nice, 1991)

Does it make sense to go out into the public space with art, after the nineteenth-century monument has lost its meaning and abstract modern outdoor sculpture, which arouses the ire of passersby, has been branded as the "invasion from the studio"? (Walter Grasskamp). (Matthias Dusini, "Das Transparent am Bau," in *Zur Sache Kunst am Bau. Ein Handbuch*, ed. by Markus Wailand and Vitus H. Weh, Vienna, 1998, p. 170)

E

F

When they had to cross the heavily traveled street, Reik wrote, "Freud hesitated. I attributed the old man's hesitation to caution, but to my surprise, he took my arm and said, 'You see, I still have a little of my old agoraphobia, which troubled me a great deal in earlier years.' ..." (Theodor Reik, *Hören mit dem dritten Ohr. Die innere Erfahrung eines Psychoanalytikers*, German by Gisela Schad, Hamburg, 1976, p. 45, quoted from Thomas F. McDonough, "Die Architektur der Agoraphobie," *Texte zur Kunst* 24, November 1996, p. 111)

Deriving from the management term "headhunting," Alice Creischer and Andreas Siekmann once called an added value strategy "context hunting." (Judith Fischer, "Pension Stadtpark oder wie die Diskussion um Services zur Sozialskulptur verkommen kann," in *Hefte für Gegenwartskunst* II 4, December 1996–February 1997, p. 40)

Yet the automatic coding of apparent difference as manifest identity and of otherness as outsideness must be questioned. For not only might this coding essentialize identity,

but it might also restrict the identification so important to cultural affilation and political alliance (identification is not always ideological patronage). (Hal Foster, "The Artist as Ethnographer," in *The Return of the Real*, Cambridge, Massachusetts, 1996, p. 175)

G

Primarily in the public space, sculptures practiced a symbolic violence that responded to the physical violence of the iconoclasts ... (Dario Gamboni, "Kunst—öffentlicher Raum—Ikonoklasmus," in *Unerwünschte Monumente: Moderne Kunst im Stadtraum*, ed. by W. Grasskamp, Munich, 2000, p. 20)

Klaus Bussmann said, "We'd rather have no art at all than bad public art. Plant a couple of trees instead." ("Demokratisch Unentschieden—Gespräch mit Walter Grasskamp," in *Zur Sache Kunst am Bau. Ein Handbuch*, ed. by Markus Wailand and Vitus H. Weh, Vienna 1998, p. 89)

In mimicking a dispute, art that criticizes institutions is always in danger of losing its specificity of means in the field under investigation. ("Demokratisch Unentschieden. Gespräch mit Walter Grasskamp," in *Zur Sache Kunst am Bau. Ein Handbuch*, ed. by Markus Wailand and Vitus H. Weh, Vienna 1998, p. 90)

That's why I also understand the conservative positions, such as Markus Lüpertz's. He says there is painting, there is sculpture, there are graphics, and that's it. ("Demokratisch Unentschieden. Gespräch mit Walter Grasskamp," in *Zur Sache Kunst am Bau. Ein Handbuch*, ed. by Markus Wailand and Vitus H. Weh, Vienna 1998, p. 90)

Without the book, context art would be nothing. It would be nothing without installation photography accompanied by explanatory commentary. It would be nothing without the attendant discourse. One can say that art goes out of the museums, it goes out of the galleries, it goes out of the public space, but nevertheless, it needs a photographer who documents it all. ("Demokratisch Unentschieden. Gespräch mit Walter Grasskamp," in *Zur Sache Kunst am Bau. Ein Handbuch*, ed. by Markus Wailand and Vitus H. Weh, Vienna 1998, p. 90)

Because outdoor sculpture should also ultimately be understood as the symbolic occupation of a place—and, in a democracy, this occupation's claim to independence is a thoroughly touchy subject. (Walter Grasskamp, "Invasion aus dem Atelier," in *Unerwünschte Monumente—Moderne Kunst im Stadtraum*, ed. by W. Grasskamp, Munich 2000, p. 145)

The huge amount of writing in the city is the text that compensates for the beauty missing from façades and access routes—actually, from the entire city. (Walter Grasskamp, "Invasion aus dem Atelier," in *Unerwünschte Monumente—Moderne Kunst im Stadtraum*, ed. by W. Grasskamp, Munich 2000, p. 147)

To friends and opponents of modern art, autonomous and abstract art would unexpectedly and paradoxically make sense. For a long time, it often lacked the ability to make sure that it picks up and manifests the basic, all-encompassing tendency of industrial society to be invisible. Instead, it provided it with a reconciling, easy-to-understand façade, as do commercial and political advertising. One doesn't need to be surprised any more at the

attacks upon such artworks; after all, the idea of punishing the messenger for the message is older than the modern era. (Walter Grasskamp, "Invasion aus dem Atelier," in *Unerwünschte Monumente—Moderne Kunst im Stadtraum*, ed. by W. Grasskamp, Munich 2000, p. 148)

Ultimately, only the snowman can be regarded as the lowest common denominator in mixed residential neighborhoods, because he has a number of advantages that can cope with the problematic situation. He's popular, his symbolic content is anchored in the collective consciousness, he's cheap, and above all, he doesn't last long. (Walter Grasskamp, "Invasion aus dem Atelier," in *Unerwünschte Monumente—Moderne Kunst im Stadtraum*, ed. by W. Grasskamp, Munich 2000, p. 152)

The notorious criticism of public art—that it makes no sense—also ended the cultural narrative of the artist as hero. It led down the path to popular, trite esthetics, in which artists have played a blameworthy part ever since. (Walter Grasskamp, "Art and the city," in *Sculpture. Projects in Münster 1997*, ed. by Klaus Bussmann, Kasper König, Florian Matzner, transl. by Heather Estes and Stephen Reader, Ostfildern 1997, p. 9)

... nothing scandalizes a public space like a work of art; no political demonstration, no unsightly high-rise, no increase in street crime, and no ubiquitous dog-turds nor any evening rush-hour jam can enrage citizens and weld them into mutual solidarity as can a sculpture by Henry Moore in a small town in postwar Germany, or a monumental house of steel cards by Richard Serra on the station square of an industrial town like Bochum. (Walter

Grasskamp, "Art and the City," in *Sculpture. Projects in Münster 1997*, ed. by Klaus Bussmann, Kasper König, Florian Matzner, transl. by Heather Estes and Stephen Reader, Ostfildern 1997, p. 16)

Art outdoors, however, is the sole genre of modernism besides architecture to have to take an *involuntary viewer* into account. Thus it, more than any other, has the double nature defined by Adorno, of being both a "fait social" and autonomous; a state of affairs the political significance of which it is easy to underestimate. (Walter Grasskamp, "Art and the City," in *Sculpture. Projects in Münster 1997*, ed. by Klaus Bussmann, Kasper König, Florian Matzner, transl. by Heather Estes and Stephen Reader, Ostfildern 1997, p. 19)

It's enough to create a climate in which the artist imagines what the curator's expectation might be. The artist then, in turn, either resists or goes along with it. (Isabelle Graw, "Silberblick. Texte zu Kunst und Politik, Alte Gemeinschaften und neue Kathedralen," *Artis*, September 1993, p. 121)

At the beginning of his explorations of the subject, Descartes noted that the city in which one lives has grown over history. It is not built according to a unified plan, and is therefore necessarily imperfect; it cannot simply be completely torn down in order to build a new, sensible, perfect, methodically built city on the same location. (Boris Groys, *Logik der Sammlung, Am Ende des Musealen Zeitalters, Die Stadt auf Durchreise*, Munich and Vienna, 1997, p. 92)

H

Hainard's dry conclusion: "The history of the object is a history of power." (Clementine Deliss, "Repräsentation von Skulptur im öffentlichen Raum—Die Rolle des Objekts im 'Ethnographischen Exotismus' im Paris der dreissiger Jahre und im 'Neo-Konzeptualismus' der amerikanischen Gegenwartskunst," in *Durch* 6/7, 1990, p. 69, quoted from Hainard, *Temps perdu, temps retrouvé—Voir les choses du passé au présent*, ed. by Hainard & R. Kaehr, Musée d'Ethnographic de Neuchâtel 1985, p. 160)

The artwork is not exhibited at a place; the place itself is the work of art. ("Conversations with Heizer, Oppenheim, Smithson," in *Robert Smithson—Gesammelte Schriften*, ed. by Eva Schmidt and Klaus Vöckler, Cologne 2000, p. 240)

I work outdoors because that's the only location where I can move mass around. ("Conversations with Heizer, Oppenheim, Smithson," in *Robert Smithson—Gesammelte Schriften*, ed. by Eva Schmidt and Klaus Vöckler, Cologne 2000, p. 242)

Non-local locations and local non-locations. (Christian Höller, *Sharawadgi*, ed. by Christian Meyer and Mathias Poledna, Baden 1998, p. 169)

I

Identity

J

Every postmodern position in the culture, whether apology or stigmatization, is necessarily at the same time an implicit or explicit political stand upon the question of the multina-

tional capitalism of our day. (Clementine Deliss, "Repräsentation von Skulptur im öffentlichen Raum—Die Rolle des Objekts im 'Ethnographischen Exotismus' im Paris der dreissiger Jahre und im 'Neo-Konzeptualismus' der amerikanischen Gegenwartskunst," in *Durch* 6/7, 1990, p. 71, citing Fredric Jameson, "Postmodernism or the Cultural Logic of Late Capitalism," *New Left Review* 146, 1984, p. 56)

Aesthetic production today is integrated into the general production of goods. The blind economic impulse to produce fresh waves of inventive-looking goods in ever shorter periods of time allocates an increasingly structural function and position to esthetic innovation and experimentation. These economic forces are then echoed in instutional support of all kinds for new art, from foundations and stipends to museums and other forms of patronism. (Clementine Deliss, "Repräsentation von Skulptur im öffentlichen Raum—Die Rolle des Objekts im 'Ethnographischen Exotismus' im Paris der dreissiger Jahre und im 'Neo-Konzeptualismus' der amerikanischen Gegenwartskunst," in *Durch* 6/7, 1990, p. 71, citing Fredric Jameson, "Postmodernism or the Cultural Logic of Late Capitalism," *New Left Review* 146, 1984, p. 56)

The artist exposes things before society realizes they should be exposed. (Neil Jenney, "Earth (1969)—A Symposium at White Museum, Cornell University," in *Robert Smithson. The Collected Writings*, ed. by Jack Flam, 1996, p. 183)

The value of art—usually contrasted with a materially oriented use value—is the progressive value, since the use of a human being transpires via a process of provocation. (Asger Jorn, "Das Ende der Ökonomie und die Verwirklichung der Kunst," in *Durch* 3/4, 1987, p. 93)

K

To put the work of art "out in the world" would be more of a test, more the attempt, so to say, to do something ontologically exciting. In my earlier work, I was certainly not busy with the question of accessibility. It has to be talked about, even when the risk is that it will become what Freud called the "uncanny." ("Interviews. Joseph Kosuth," in *Plakat. Kunst. Über die Verwendung eines Massenmediums durch die Kunst*, ed. by Otto Mittmannsgruber and Martin Strauss, Vienna 2000, p. 172)

Has public art mutated to a kind of social program? Is it engaged in the business of supporting conservative city policies and helping the real estate market to increase the value of older areas? In the many community-oriented projects of the last few years, aren't artists finding themselves playing the role of educators again, who, as "preachers of aesthetics," help to hide the real power relations in the social spaces? (Miwon Kwon, "Im Interesse der Öffentlichkeit," *Springer* II/4, p. 30)

In opposing the routine of institutional habits and desires and the urge to make goods out of artworks, site-specific art resorts to strategies that are either aggressively anti-visual (information oriented, textual, explanatory, and didactic) or completely incorporeal (gestures, events, or performances, which are temporary). The "work" no longer wants to be noun/object, but verb/process, in order to demand the critical (not just the physical) attention of the viewers, to get them to consider the ideological prerequisites of their habits of observation. (Miwon Kwon, "Ein Ort nach dem anderen—Bemerkungen zur site specifity," in *OK—Ortsbezug: Konstruktion oder Prozeß?*, ed. by Hedwig Saxenhuber and Georg Schöllhammer, Vienna 1998, p. 23)

While site-specific art used to oppose its commercialization by insisting upon its immobility, nowadays it favors mobility and nomadism for the same reasons. (Miwon Kwon, "Ein Ort nach dem anderen—Bemerkungen zur site specifity," in *OK—Ortsbezug: Konstruktion oder Prozeß?*, ed. by Hedwig Saxenhuber and Georg Schöllhammer, Vienna 1998, p. 27)

The conjunction of art and site indicates an anxious cultural yearning to rid the world of the impression of loss and emptiness, which has crept up upon both sides. (Miwon Kwon, "Ein Ort nach dem anderen—Bemerkungen zur site specifity," in *OK—Ortsbezug: Konstruktion oder Prozeß?*, ed. by Hedwig Saxenhuber and Georg Schöllhammer, Vienna 1998, p. 37)

They [today's site-specific practices] have to work with the differences between closeness and distance instead of emphasizing their parallels by lining them up in a row. Those differences unfold between a thing, a person, a place, a thought, a fragment—all of which exist simultaneously. Only cultural practices that have a sensibility for this relation can change local encounters into long-term connections and make indelible and irreversible social markings out of temporal intimacies. In this way, the sequence of places we pass by and

live in do not become so vague that they turn into a row of indistinguishable places, simply one place after the next. (Miwon Kwon, "Ein Ort nach dem anderen—Bemerkungen zur site specifity," in *OK—Ortsbezug: Konstruktion oder Prozeß?*, ed. by Hedwig Saxenhuber and Georg Schöllhammer, Vienna 1998, p. 37)

L
Every political group, and particularly every apparatus, justifies itself with the help of ideology developed and upheld by itself: nationalism and patriotism, economics or state rationalization, philosophy, and (classic) liberal humanism. In this way, among other things, a few important problems are hidden: that of the urban society and the mutation (change or if necessary, revolution). (Henri Lefébvre, "Auf dem Weg zu einer urbanen Strategie," in *Die Revolution der Städte*, Frankfurt am Main 1990, p. 146)

Beauty and the bureaucracy have as much trouble coupling as all the rest of us. There is a mutual distrust and impatience between artists and officialdom that stems from the former's social naiveté and the latter's innate conservatism. Artists tend to delude themselves about the effect and communicability of their offerings and patrons prefer blandness. Good intentions notwithstanding, the term "public art" covers a multitude of economic and aesthetic sins. (Lucy R. Lippard, "Moving Targets/Moving Out," in *Art in the Public Interest*, p. 211)

M
Because, among other things, it competes with "art on architecture," public art space must also constantly legitimize itself by proving to be part of the system. A category such as

the general social good can become a weapon in the battle against competing fractions of higher futility. (Oliver Marchart, "Neue Kunst nach alten Regeln?" in *Zur Sache Kunst am Bau—Ein Handbuch*, ed. by Markus Wailand and Vitus H. Weh, Vienna 1998, p. 105)

The house without a kitchen. (Dorit Margreiter, Graz 1994)

In a certain way, art is like peppercorns scattered in scrambled eggs. It's somewhere on the edge, or unable to be seen inside the fluffy parts, attempting to intensify the taste in the mishmash of impressions. (Rainer Metzger, "Dabeisein ist alles—Monumente, Modelle, Mobiliare," in *Zur Sache Kunst am Bau—Ein Handbuch*, ed. by Markus Wailand and Vitus H. Weh, Vienna 1998, p. 52)

The term "city furniture," as pejorative as it might be meant, is absolutely right. (Rainer Metzger, "Dabeisein ist alles—Monumente, Modelle, Mobiliare," in *Zur Sache Kunst am Bau—Ein Handbuch*, ed. by Markus Wailand and Vitus H. Weh, Vienna 1998, p. 54)

The way things go, and the way the city goes around the things: it's a way to entropy. (Rainer Metzger, "Dabeisein ist alles—Monumente, Modelle, Mobiliare," in *Zur Sache Kunst am Bau—Ein Handbuch*, ed. by Markus Wailand and Vitus H. Weh, Vienna 1998, p. 52)

The very condition that allows art to come into being—the sites of its display, circulation, and social functionality, its address to spectators, its position in systems of exchange and power—are themselves subjects to profound historical shifts. (W. T. Mitchell, "Introduction—

Utopia and Critique," in ibid, *Art and the Public Sphere*, p. 3)

The notorious "anti-aesthetic" posture of much postmodern art may be seen, in its flouting of the canons of high modernism, as the latest edition of the iconoclastic public icon, the image that affronts its own public—in this case, the art world as well as the "general" public. (W. T. Mitchell, "The Violence of Public Art—Do the Right Thing," in ibid, *Art and the Public Sphere*, p. 33)

Much of the world's public art—memorials, monuments, triumphal arches, obelisks, columns, and statues—has a rather direct reference to violence in the form of war or conquests. (W. T. Mitchell, "The Violence of Public Art—Do the Right Thing," in ibid, *Art and the Public Sphere*, p. 35)

"Art on architecture" is an anachronism. (Christian Muhr, "Die Stadt als Benutzeroberfläche," in *Zur Sache Kunst am Bau— Ein Handbuch*, ed. by Markus Wailand and Vitus H. Weh, Vienna 1998, p. 74)

The change from the representative to the communicative as a design paradigm allows the establishment of multilateral conditions for the exchange and invention of signs, which substitutes for the static placement of very significant, unambiguous signs. (Christian Muhr, "Die Stadt als Benutzeroberfläche," in *Zur Sache Kunst am Bau—Ein Handbuch*, ed. by Markus Wailand and Vitus Weh, Vienna 1998, p. 74)

Beyond all of the concrete references to reality, it leads the shadowy existence of a historical monument. One would miss it if it weren't there, but one doesn't see it and usually doesn't have the slightest idea what it represents. (Gundolf Winter, "Ortsbestimmung, Richard Serras Trunk am Erbdrostenhof in Münster," in *Skulptur Projekte in Münster*, ed. by Klaus Bussmann and Kasper König, Cologne 1987, p. 409, citing Robert Musil, *Denkmale, Nachlaß zu Lebzeiten, II Unfreundliche Betrachtungen*, Hamburg 1957, p. 60)

N
Architecture itself is manufactured in the main by processing what the eye sees. In the modern era, sight is the principal system used to organize architecture and the constructed environment. And historically, the predominating viewpoint is male. (Irene Nierhaus, "Jalousie. Blick und Bild als Medien der Verräumlichung der Geschlechterdifferenz," in *Raum, Geschlecht, Architektur*, Vienna 1999, p. 35)

O
In any case, the relationship between architecture and artwork cannot be considered to be merely a harmonious, complimentary one. One possibility is to apply an artwork onto the architecture; another is to have the artwork interpret the architectonic intentions. Each can be done in two ways: with acceptance or in opposition. (Olga Okunev: "Beziehungskrise. Die Kunst am Bau der 80er Jahre: zwischen Manierismus und 'site specifity,'" in *Zur Sache Kunst am Bau—Ein Handbuch*, ed. by Markus Wailand and Vitus H. Weh, Vienna 1998, p. 50)

But I would like to see someday an art so closely knit with a societal framework that there is no concern with viewing, no concern with recognizing, no concern with making posters, but an art that is inside our head and inside our total system so that it will be out of the caves of the Manhattan lofts and spread across a vaster area. (Dennis Oppenheim, "Earth (1969)—A Symposium at White Museum, Cornell University," in *Robert Smithson. The Collected Writings*, ed. by Jack Flam, Berkeley 1996, p. 182)

P

A new type of society is forming right in front of our very eyes. (Alain Touraine, "La Société Post-industrielle," quoting Mathias Poledna, "Maßstäbe der Reorientierung," in *Florian Pumhösl*, Vienna 2000, p. 4)

The word "critique" has attained a bad name in the 1980s. The way in which the work was deployed was only in reference to that which beats its opponent into submission. But if we think about criticality as embracing a more expansive field of reading, I would think of my work as being a critique of site-specificity. The site-specific seems to be grounded in a very particular location and a particular time, and all information is related to this. But when you take any of these coordinates, space and time, and you compound them, the model doesn't seem to hold up. (Stephen Prina, in an interview with Camiel van Winkel and Mark Kremer, *Archis* 11, 1993, citing James Meyer in "Der Funktionale Ort, by Kim Paice," in *Springer, Hefte für Gegenwartskunst* II 4, December 1996—February 1997, p. 44)

Q

R

Public art isn't a hero on a horse anymore. (Arlene Raven, "Introduction," in *Art in the Public Interest*, 1993, p. 1)

Does art that wants to do good do good? Is it fair to expect work to be social work as well as art work? And does art in the public interest really interest the public? (Arlene Raven, "Introduction," in *Art in the Public Interest*, 1993, p. 1)

The fact that art may be created to cause social change for the better, of course, makes it neither politically effective nor good art. (Arlene Raven, "Introduction," in *Art in the Public Interest*, 1993, p. 26)

It has to do with unprotected art, abandoned for better or worse to its unwilling public, without the institutional safeguards provided by museums, galleries, or exhibition halls. And like the recipients, those giving commissions have usually not sought out their involvement with art. (Stella Rollig, "Kundendienst und Betriebsberatung," in *Zur Sache Kunst am Bau—Ein Handbuch*, ed. by Markus Wailand and Vitus H. Weh, Vienna 1998, p. 96)

In the current discourse, the artists' view is that they are the ones who conceive the entire situation. However, in real construction projects, this turns into an obviously hopeless competition with the architects. (Stella Rollig, "Kundendienst und Betriebsberatung," in *Zur Sache Kunst am Bau—Ein Handbuch*, ed. by Markus Wailand and Vitus H. Weh, Vienna 1998, p. 100)

S

It is true for most sculpture that the experience of the work is inseperable from its location. Separated from this condition, every experience of a work is a deception. (Richard Serra, "Extended Notes from Sight Point Road," in *Richard Serra—Recent Sculptures in Europe 1977–1985*, Bochum 1985, p. 12)

Site-specifity is the central term of the public art discussion. Robert Smithson introduced it for the first time in 1970, at the so-called *Earth Symposium* at Cornwall University. I developed a method of dialectic that includes what I call site or non-site. Site is a physical reality, for instance, the earth or the ground, which we don't notice when we are indoors. I decided to have a dialog, a kind of rhythm between inside and outside. As a result, instead of doing something in the landscape, it could be interesting to transfer the landscape indoors. Indoors is a non-site, an abstract container. (Andreas Sieckmann, "Timeline zur Ausstellungspolitik," in *Zur Sache Kunst am Bau—Ein Handbuch*, ed. by Markus Wailand and Vitus H. Weh, Vienna 1998, p. 68)

"Corporate image placement" developed from "art on architecture." It was supposed to satisfy the expectations of private business. (Andreas Sieckmann, "Timeline zur Ausstellungspolitik," in *Zur Sache Kunst am Bau—Ein Handbuch*, ed. by Markus Wailand and Vitus H. Weh, Vienna 1998, p. 72)

I think many artists are completely confused—most of all, people who work on site. They put an abstraction on top of something, instead of working on an aspect or cultivating something with a view to the ecological situation. Very,

very strange. ("Conversation with Robert Smithson," in *Robert Smithson—Gesammelte Schriften*, ed. by Eva Schmidt and Klaus Vöckler, Cologne 2000, p. 270)

By the way, everything important happens outside closed rooms. A room reminds us of the limits of our living conditions. ("Conversations with Heizer, Oppenheim, and Smithson," in *Robert Smithson—Gesammelte Schriften*, ed. by Eva Schmidt and Klaus Vöckler, Cologne 2000, p. 247)

"The selection of site" is still in its beginning stage as a form of art. To research a specific place, one must develop a concept using the given data of the senses produced by direct perception. In selecting or defining a site, perception preceeds the concept. One does not *present* the site, one *exhibits* it—that goes for indoor as well as outdoor space. Indoor spaces could be dealt with as if they were outdoors, and vice-versa. Artists are the best at investigating the unknown areas of a place. (Robert Smithson, "Anmerkungen zur Erschließung eines Flughafengeländes," in *Robert Smithson—Gesammelte Schriften*, ed. by Eva Schmidt and Klaus Vöckler, Cologne 2000, p. 88)

If one subtracts certain associations from a place when one is working directly with its visual appearance, with what Roland Barthes calls the "simulacrum of the object," then the goal is to understand a new type of "buildings" as an entirety that produces new meanings. (Robert Smithson, "Ein Ding ist ein Loch in einem Ding, das es nicht ist," in *Robert Smithson—Gesammelte Schriften*, ed. by Eva Schmidt and Klaus Vöckler, Cologne 2000, pp. 123 f)

The rats of politics are still gnawing on the cheese of art. ("Robert Smithson, Künstler und Politik: Ein Symposium," in *Robert Smithson—Gesammelte Schriften*, ed. by Eva Schmidt and Klaus Vöckler, Cologne 2000, p. 160)

Art should not be seen as just a luxury, but work within the actual processes of production and recultivation. (Robert Smithson, "Entwurf," in *Robert Smithson—Gesammelte Schriften*, ed. by Eva Schmidt and Klaus Vöckler, Cologne 2000, pp. 190 f)

Artists should not be hindered from doing their work and forced to live in the isolation of an "art world." (Robert Smithson, "Entwurf," in *Robert Smithson—Gesammelte Schriften*, ed. by Eva Schmidt and Klaus Vöckler, Cologne 2000, pp. 190 f)

Many of the works outdoors are a kind of escapism, because everything is so terrible. (Interview with Robert Smithson, *Robert Smithson—Gesammelte Schriften*, ed. by Eva Schmidt and Klaus Vöckler, Cologne 2000, p. 237)

So sculpture determines and visualizes space as the opposite, as uniform, as equal voids spreading out in all directions. In order to do this, the necessity here is admittedly to opt for the open form, that allows the articulation of the space, to make it a topic. It is necessary is to get rid of the dominant idea that places the sculpture in opposition to the empty volume of the space. (Cit. 1) This ideal form of matter (and also space)—traditionally oriented toward the human body—when concentrated (sublimated) to a closed, sensible whole allows the open form to seize the space, which now no longer appears to be an abstract necessity for existence, but an element constituting the work. (Christoph Schreier, "Plastik als Raumkunst—Zum Verhältnis von Architektur und Plastik als raumgestaltenden Künsten," in *Skulptur. Projekte in Münster 1987*, ed. by Klaus Bussmann and Kasper König, Cologne 1987, p. 338)

T

Reality is rationalized contingently and historically. The problem is representation. How to construct a non-meta, non-bracketing, transformatory progression of frames, such that, the frame of basic causal necessity is not fudged as a kind of natural image of superstructure? (Mayo Thompson, "What," *Durch* 3/4, 1987, pp. 9 f)

U

V

W

There continues to be a decrease in the tolerance for art "on architecture," but an increase in tolerance for art "on the construction site." There, nobody is competing with the art and sometimes it even serves as an obliging catalyst. (Vitus H. Weh, "Auf der Baustelle," in *Zur Sache Kunst am Bau—Ein Handbuch*, ed. by Markus Wailand and Vitus H. Weh, Vienna 1998, p. 167)

Between Scylla and Charybdis, between the presentation and the construction of the world—the classic dichotomy between powerless and powerful, between art and politics—there is a third path. Deconstruction and reconstruction, scanning and resynthesis. Instead of the presentation, which is always

a form of adaptation and confirmation, the aesthetic system and the social system could be a coupling system for taking things apart and putting them back together ... (Peter Weibel, "Öffentliche Bilder sind Bilder der Macht," *Durch* 6/7, 1990, p. 112)

Public images are media images. Media images are images of power. Public images are therefore images of power. To demolish power is the true intention of deconstruction: to bring the system to oppose and question the portrayals in media images. (Peter Weibel, "Öffentliche Bilder sind Bilder der Macht," *Durch* 6/7, 1990, p. 112)

To become ahistorical and apolitical is the result of a superficial, capitalist interpretation of acquisition, as is obvious in the neo-movements of art. Contrastingly, to understand acquisition as expropriation could mean rewriting history, a recreation of the world through historic and social analysis of the element of the image, of the process of creating images, of the presentation method of the image. (Peter Weibel, "Öffentliche Bilder sind Bilder der Macht," *Durch* 6/7, 1990, pp. 113 f)

Public media dominate, colonialize, and oppress and exploit the people. The spiritual colonization of the people, this brutal prolongation of the historical kind of exploitation and oppression, is the colonialization of wishes, consciousness, needs, and values, style and feelings, behavior and goals through the media, through public images. (Peter Weibel, "Öffentliche Bilder sind Bilder der Macht," *Durch* 6/7, 1990, p. 112)

Peter Weibel: "'art on architecture' makes me sick. Critically speaking, the cooperation between art and architecture is a lie. The ornaments stuck on out there are a crime. The artists are parasitically bound to the architects and go along with the financial game. It's a subdivision of the welfare department." (Wally Sallner, "Kunst am Bau—eine Meinungsumfrage," in *Zur Sache Kunst am Bau—Ein Handbuch*, ed. by Markus Wailand and Vitus H. Weh, Vienna 1998, p. 17)

Yet is the public space still the domain of architecture and city planning? Don't magazines, TV, and the Internet now create those virtual places where most people encounter each other? (Stephan Schmidt-Wulffen, *Von der autonomen zur relationalen Ästhetik—Anmerkungen zur Kunst im öffentlichen Raum*, p. 11)

The artist's role can only be outlined by artistic practice in a social context of action. The artists develop identity politics that legitimize their particular role in the community. (Stephan Schmidt-Wulffen, *Von der autonomen zur relationalen Ästhetik—Anmerkungen zur Kunst im öffentlichen Raum*, p. 131)

For me, that's one of the greatest problems in public art. Artists come, make something, disappear, and everything remains the same. ("Hinkende Pioniere—Gespräch mit Stephan Schmidt-Wulffen," in *Zur Sache Kunst am Bau. Ein Handbuch*, ed. by Markus Wailand and Vitus H. Weh, Vienna 1998, p. 123)

X

Y

Z

This aesthetic problem—"How long does the sculpture last?"—reveals itself, however, to be that economic deficiency, which makes the thing art ... (Caterina Zakravsky, "[Art Goes Caritas] der Kleidertausch als Soziale Skulptur? Eine Spekulation," *Springer, Hefte für Gegenwartskunst II 4*, December 1996– February 1997, p. 43)

Outside Whoosh, Inside Inconspicuous
Demands upon Art in the Public Space
WOLFGANG ULLRICH

Nowadays, it's a well-known fact that politicians like to think of themselves as managers, CEOs, or board members of their countries and communities. They not only copy behavior, rituals, and status symbols from the world of business, but also adopt its thought patterns and arguments. This is shown not least of all in the way they deal with art and most clearly when the discussion is about the sense and purpose of art in the public space. At any rate, the formulations used to promote art projects in parliament or in opening speeches strongly remind one of the expressions used by company chiefs who elucidate upon their interest in art in catalogue forewords and proudly introduce the company collection. However, apart from the similarities of the topics in such art encomiums (more on this soon), there appears to be one particular scheme that is almost always used. Namely, the argument takes two directions: the "inside" and the "outside." Thus a businessman explains, on one side, how art—inside the company—influences the employees. On the other side, he talks about how a company that is committed to supporting art gains—or at least expects to gain— an improved public image. In the same way, a government administrative head or a cultural official not only talks about how art can better the quality of life of their "own" citizens, but also emphasizes the positive impulses for the so-called "outward attractiveness" of the city or region.

And it is exactly here—in this "two directions" argument—where we can see that politicians have picked up a way of thinking from the business world. What has been a usual practice there for about twenty years—calculating the "public effect"—is, for politicians, a really new opportunity. A few years ago, every mayor or town council member understood the term "outward attractiveness" in the sense of the "attractiveness of the public space," which, in the meantime, however, primarily means a positive image of the city or region in the eyes of visitors, tourists, etc. The term "outward attractiveness" probably came into general use because the offices for city and regional marketing everywhere are booming and we are marketing cities like products. Accordingly, it is important to support a relatively new development—exhibitions of public art—because one would like to strengthen the community's power to draw potential guests. In the first flush of excitement at finding a new toy, some politicians sometimes even express themselves very one-sidedly and mention only the effect upon the community image that can be aimed for with public art events. Papers circulating in city halls bluntly state that "it is more important to produce events interesting to visitors than to take care of the needs of the majority of the city's inhabitants." Perhaps in an aside, it might be mentioned that the city will "naturally try" to get the citizens to accept an art event, but the goals are clearly weighted.[1]

If things continue on like this, the word "out-doors" will have a new meaning in a few years. It will mean something more like an outer

packaging—the stylish packaging of a city in accordance with packaging esthetics. Anyway, in a day and age in which almost all aspects of public life have shifted indoors,[2] we need new functions for public squares and terrain. So let them do a bit of advertising for the things that either stand or happen on public property, to lure the tourists who'd love to put a beautiful, originally draped city into their shopping carts. Because the outdoors hardly affects the ordinary lives of most citizens, it has become free to take on a representative function for guests—and also for art. Admittedly, art has come under the suspicion of being hardly more than a marketing tactic, a calculated atmospheric element, or something that a city can brag about in brochures. However, the question arises why is it that art is suitable for polishing images or acting as colorful bait? Isn't it—at least in its contemporary version—just something for a few specialists? For a scene that could hardly be bigger than the collectors of pedal cars or the fans of a local sports club? So isn't it a mistake to advertise with modern art? Yet, unlike other minorities' objects of passion, art—this is the only way to answer this question—acts as a strong signal even upon those who are not engaged with art. They can at least be impressed with it, since generally positive qualities are associated with art. So adjectives such as "progressive," "innovative," "surprising," "energetic," and "authentic" are firmly attached to art—an idea of art that is also shared by those who have nothing to do with it. Accordingly, a city that advertises itself with (contemporary) art in the public space suggests that it possess an above-average number of open-minded citizens and politicians, is modern, open, colorful, future-oriented, and certainly a good place to experience something

exciting. The topics that regularly appear in every foreword, speech, and planning paper characterize art anyway so that one immediately thinks of vacation and a change of pace. Again and again, it is emphasized that art liberates people from routine perspective, questions the usual ways of thought, and opens new, unknown areas of experience. Or a sponsor declares his commitment to public art with the statement that he wants to "dust a little of common, ordinary life from the soul" of the people.[3]

Many tourists don't come for the public art alone, but take it as an indicator for a generally stimulating climate that is different from what they are familiar with (or believe themselves to be familiar with). It is a paradox how art also inspires people to visit a city or a region—people who are not at all interested in art—because the positive ideas associated with it promise them change or relaxation. Therefore, via so-called roundabout cost-efficiency, it can even be economically rewarding to invest money in art. In the eyes of many people—and not just those of art freaks—a city such as Münster, for instance, which has hosted the *Sculpture Projects* three times, has become more modern, gaining quite a number of centuries and accordingly, a better image. There is another thing: art—apart from the qualities accorded to it by others—is regarded as something exclusive and unusual. Therefore, a community that proudly portrays itself as a home for contemporary art also gains a special aura. A sculpture in the public space functions as a status symbol for the city or region, just as the painting does in front of which a politician or manager places himself during a photo op, in order to appear more interesting.[4]

Placing sculptures or other works in the public space to increase the "outward attractiveness" is, however, an action comparable to other events in which the positive image of art is used for promotional purposes. So Renault presents a new model to the public in connection with an exhibition of video installations by Nam June Paik, or Windsor introduces a new collection with artists such as Rosemarie Trockel and Jörg Immendorff as star models. These kinds of settings also clearly impress more people than just the art business insiders and those who are interested in art. Perhaps they are even more effective with a majority, to whom modern art is strange, to those who are familiar simply with the positive ideas of art. This distance increases awe and invites speculation about how mysterious and unusual things might be in the art world. In view of the positive image factor that art has, works in the public space are no longer generally classified as "undesirable monuments" (Walter Grasskamp), as long as one still primarily pays attention to the "internal effect," that is, to the reactions of the city's population. The populace might continue to hardly notice it, or even reject it, when they come across a sculpture or installation on the way to work or shopping. They might doubt the value of the concrete work or the sensible use of their tax money, but they very probably do not remain unimpressed when they see art in another city's promotional brochure. And as I said before: for the lives of most of a city's inhabitants, the outdoor public space no longer plays an important role, so it can hardly seriously bother them when they don't like a piece of art on display. Perhaps this assessment seems cynical, since it denies that art has any higher value beyond being an advertising ploy. Where is the noble

desire of earlier generations of artists for their art to reach a wide public, which would otherwise remain distant from art, namely, the inhabitants of the city? To give them the experience of the educational, elucidatory, explanatory, or innovative dimensions of art? To use disturbance and provocation to set discussions in motion, in order to contribute to the practice of democratic virtues? "We're going to the art consumer, we won't wait for him" was, for instance, the solution offered by HA Schult, Günter Saree, and Ulrich Herzog. In 1969, without permission from the authorities, they took to the streets of Munich with several art actions—for example, throwing wastepaper into the streets. This provoked hefty protests and eventually they were tried in court.[5] Such an almost martyr-like attitude—the artist wants to shake up the people, do them some good, and thereby risks trial and judgment—is nowadays practically unthinkable. The artist's missionary urge to save the world is no longer quite so strong. Artists also no longer believe that the quality of their work is first proved by the amount of resistance shown toward official authority. Most importantly, those who consider only the "internal perspective" and, in the process of making their public art, have thought—at all or exclusively—about the citizens of the community are considered to be antiquated.

Art events nowadays happen as cooperations between artists and curators, officials and administrators, as well as the city marketing department. They are concerted actions that are run fairly routinely and in a business-like manner. Nevertheless, the artists in general have not adapted so much that they would cater to every wish expressed by the city-marketing managers. Rather, for some years now, they've been delivering sculptures that are

seldom photogenic and consequently not "outwardly effective." Many prefer small, almost invisible interventions on the periphery of perception, or consider themselves to be providing a service for a public that might include potential customers, and one would certainly not like to drive them off. So art is no longer staged as if it were the radical "other," brusquely opposing everything else that appears in the public space. Instead, one develops actions or events, which, at first sight, often do not (and are not supposed to) appear to be art. In their own way, artists seem to have learned that artworks in the public space were long considered to be "undesirable monuments" and therefore they prefer the little gesture; they are no longer carrying on a mission, aggressively and loudly demand attention. But in this way, they rob the visitor's bureau of the chance to impress people with promotional ads, books, or catalogues illustrated with imposing works that are clearly art. Paradoxically, then, the attitude of many artists determined to no longer be outsiders or rebels, but instead, friendly service industry workers, is what troubles the communal marketing interests (as well as the wishes of many businesses). These people want to display the most striking art possible in order to increase the "outward attractiveness." Of course, within the city or region, one seldom hears noisy complaints about the decency of public art, but that is exactly what threatens to destroy the outward image.

That such a dreadful thing has not come to pass can be credited to the now common methods of bringing art to the public space. What was still unusual—and to a great extent free of calculation about the community image—in 1977 in Münster during the first *Sculpture Project* was namely that a number of works by various artists were collected at one time (and temporarily, at that) in one city. This has proved itself to be not only the best way to gain attention outside the region, but also offers the opportunity to leave a strong mark, even when many of the individual works would hardly be (or want to be) noticed as artworks. Instead of great monumental sculpture(s), the parcourse of works and actions as a whole can be marketed as a large event, so the city can do things in a big way. The event trend of the 1990s has brought forth many of these events with many individual actions, so that a city hosting a public art spectacle can present itself as artistic and open, as well as stylish and fun-loving. Admittedly, the wandering circus character of these kinds of events—after all, the same artists are generally invited to various places— might have additionally supported the tendency to move away from monumental sculpture and toward careful interventions, to the service mentality, or to the mimicry of non-art. Though this kind of individual work would probably remain unnoticed on its own, when it is an element belonging to a large event, then it will receive attention and find its public. Placing it in the correct context makes it recognizable as art; indeed, it even needs such a setting, so that it does not sink out of sight. All in all, exhibitions such as the *Sculpture Projects* ideally meet today's needs and satisfy all participants. That also explains the enormous success of this type of presentation; in the meantime, almost every community is flirting with the idea of hosting one. The event locations receive a great deal of publicity, a positive image, and lots of tourists, even after the event is over. The events don't bother the local inhabitants, since most of the works are laconic, not monstrously conspicuous, and

not at all the unmannerly "other." Finally, the
artists can—under the protection of a large
event—search for or keep their niches, remain
independent, and work as subtly as they want
to on the periphery between art and non-art,
and yet provide the producers with a marketing
service. Are there any objections?

1 Paper No. 403 of the City of Wolfsburg, October 28,
1997, p. 3.
2 See Wolfgang Ullrich, "Die Eroberung des Außenraums
durch den Innenraum. Ein Manko moderner Platzgestaltung,"
neue bildende kunst 2/1997, pp. 34–39.
3 Gerhard Müller-Rischart, "Lokale Anwendungen,"
transferit, exhibition catalogue, Munich 2000, p. 5.
4 See Wolfgang Ullrich, Mit dem Rücken zur Kunst.
Die neuen Statussymbole der Macht, Berlin 2000.
5 See Eugen Thiemann et al, eds., HA Schult—Der Macher,
Cologne 1978, pp. 29–39.

It was astonishing to see how easily the public was able to come to terms with the unusual forms of art

making of video...
persuaded to cooperat...
...ptures like the installation he...

...n Avant-
...eld, und die
...erstmals als
...tanz für Welt-
...adt hat sich ge-

...n vorangegange-
...gen zeichnet auch
...ellungsmacher Kas-
...b bei seiner simplen
...eb bei seiner simplen

...fentlich...
einem kind...
chen. Anderseits...
die urbanen Realitäten in...
mender Weise bewusst: Der g...
tägliche Fußgängertunnel ist...
genteil jeden Kindertraums...
Auch zur Kunstgeschi...

Ernste Scherze

Lieber 99 Tage Münster als 100 Tage Kassel

A Public Playground for Invention

fornia redwood that juts in...
Lake. Others, like Richard...
have made blunt sculptur...

■ **Art review:** The citywide 'Sculpture

Pralle
Blase

Stadtkunst für Bedürftige:

...treten vorwärts und fahren rück-
...Andere schichten Häuschen aus
...n. Einer pumpt Löschwasser in den
...en. Am Alleerand eine bunte Piß-
Himmel hängt voller Wimpel. Die
...ne spricht. Es bedarf ja doch wenig,
...rdorrten Augen werden gleich grün wie
...erten Gräser, auf denen die U-Bahn-Be-
liegt. Soweit der Bericht vom heiteren
der Kunst.
...ndischer Sommer. Wer von drüben kommt,
...gallischen Exerzitium in Kassel, erlebt hier in
...ster die Zeitkunst in wunderlichster Enthem-
...ng. Auf einem Tankstellendach thront eine
...artenhütte. Eine Betonplatte markiert den
...Schwerpunkt der Stadt'. Am Teichufer schnüf-
...felt ein Stopfbär. Abends geht über dem Aasee

RT VIEW/Michael Kimmelman

Site-Specific Means
Soon-to-Be-Forgotten

EST OF ALL PO

...ructed a melancholic stage to contem-

THE EXCEPTIONAL PROJECTS HERE MAKE THE STRUCTURAL PARALLEL BETWEEN THE OUTDOOR EXHIBI- TION AND AMUSEMENT PARK MANIFEST IN THEIR CONCEPTION.

...late sculpture's lost possibilities and the

place in the '20s) are more likely to communicate the difficulties of sculpture in the present than a puristic and insis- tent articulation of a single paradigm. Undoubtedly, one of the extraordinary features of Carl Andre's work in the late '60s was to have subjected sculpture, as a mirage of industrial production, to the rigorous gridding of mechanical and sci- entific ordering systems; that he would now suggest a project for Münster in which he would collect garbage with res- idents bespeaks not only his genius at modifying paradigms but also perhaps his projection of what seemed urgent

Kopystiansky's surprising installation of twenty years a

A city sculpt
...l's spa

...'s Matzner,
...n Einsatz-
...te. Die stau-

From Official Art to Day-Trip Destination
Public Art Reflected in the Media and Opinion Polls
BIRGIT SONNA

To put a difficult question in a rather democratic, banal way: what should the public art of the future ideally look like? If one were to put this question to any arbitrary group of passersby in any given city, no doubt the result would be fairly shattering. The fact that "public spaces" have lately become such a favorite topic for style journalists nevertheless bears very little relation to the general level of awareness among the population at large when it comes to artistic efforts in public spaces. Even those who are moderately interested in culture are still often baffled by the genre. Moreover the very term "art in public spaces" can be seen as suspect; for some it smacks of official art. Let's take an example from the everyday life of an art critic attempting to research a topic in the archives of one of the major dailies. The interchange between art critic and archivist went more or less as follows: "Public art?" demanded the archivist who was otherwise unfailingly zealous and open to special enquiries. "You will have to give me something more to go on than that. Do you mean official art?—Or more broadly, perhaps, subsidized art?—Or do you mean art and architecture?" But when I went on tentatively shaking my head and continued to insist that there had to be something specifically on that theme, in the end I was met with a definitive denial from the increasingly irritated archivist, have scaled yet another sheer face of files. "No, there just isn't a separate file on art in public spaces," he declared. And this is all the more astonishing considering that there are folders of files

on every last James Bond film, overflowing with reviews from the international press. And when the despairing archivist in the end suggests looking under "art and politics" capitulation is the only course, however lofty one's aims had been. It almost seems as though the journalist who wrote an article on the new German Federal Minister of Culture was right after all. When Julian Nida-Rümelin laid down his scepter as Cultural Director in Munich, the journalist in question summed up the achievements of the new Minister of Culture designate by saying that he had always done his best to promote the cause of "the visual arts in public spaces, that exotic topos in the landscape of cultural politics."[1]

But to go back to our opening question. Even if one were to embark on a somewhat more subtle survey, if one were to offer some remedial lessons on art in public spaces, to provide selected members of the public (chosen according to certain demographic principles) with an overview of representative examples of public art from the last fifty years, the ensuing interest in public art that was at least moderately socially and aesthetically acceptable would no doubt still be as conventional as it was pragmatic. Artistic fountains and floral sculptures[2] seem to be permanent fixtures on the list of preferred objects in public spaces. Figurative sculptures are still the most popular of all—to judge by the garlands of flowers left on them—sculptures recalling not too long-deceased personalities in the life of the town. As well as this there is also the enduring

attraction of places—whatever sculptural form they may take—where the individual can publicly disport him or herself and communicate relatively freely with others, even if we, in our latitudes, can never quite achieve the relaxed atmosphere of the Mediterranean *piazza* with its concomitant overtones of trade and commerce. And not to be forgotten: the wider public prepared by the *Sculpture Projects* in Münster and other new forms of public art ("New Genre Public Art") has presumably come to accept the public service character of some works: foot massage, sushi culinary arts, second-hand sales are all to be found in the pragmatic armory without which the art strategist and communicator can hardly make an impact in public spaces today.

Of course these fairly general thoughts on the artworks that find greatest favor in public spaces are no more than pure speculation. De facto there are simply no reliable empirical studies. And yet there may still be more than a grain of truth in the above musings as to the kind of art that would do justice across the board to the sensual, communicative, everyday discursive and social needs of a post-industrial society. But lest there should be any misunderstandings: we are not talking here about some form of consensual art, intended to affirmatively oil the wheels of urban passivity. Yet, if one accepts the line Richard Sennet takes in *The Fall of Public Man*—already a classic—then the city, having lost its identity as a place, must at least to a certain extent be won back as a stage for its inhabitants to act our their lives.[3] In view of this, it is perhaps surprising that precisely those urban settings that are so eminently important for those sorts of human activity should have been so carelessly neglected on the part of artists. A forum is a forum is a forum. Almost two millennia after the decline of the Roman Empire it seems that—never mind about virtual space—artists are faced anew with the democratic challenge of creating public places and venues for a society that has long since splintered into a myriad of interest groups. But, aside from those artists operating in an avowedly hybrid field somewhere between art, architecture and design—people like such as Stefan Kern, Olaf Nicolai, and Tobias Rehberger—who dares to come up with objects or plans for public spaces that are to an equal degree functional, conducive to a sense of community, and of the highest aesthetic standard? For it is not only since the onset of modernity that all forms of design as such have been tainted with the blemish of applied art, which by definition cannot be countenanced by those artists blessed by oh such "true genius."

Paradoxically enough, people are no longer prepared to accept precisely those autonomous sculptures of which it is quite rightly said that they are in part responsible for the uncomfortable surroundings in our towns. More than twenty years of largely carefree dispersal of drop sculptures in public places did not come without a price, and for a considerable time now has found more or less unanimous disapproval, particularly in the specialist literature. As Walter Grasskamp disparagingly remarked, the sculptures positioned in urban space—apparently without reason and without any symbolic meaning for the place or the milieu—look all too much like "CARE packages dropped by extra-terrestrials."[4] And one would be sadly mistaken if one were to imagine that this widespread, anachronistic form of public decoration were any less prevalent now than it used to be. It's true there are cities like Berlin, Hamburg, and most recently Munich that initiate pilot projects to win the public over to different,

more discursive forms of public art, the so-called "New Genre Public Art." But such over-arching, generally ephemeral concepts are hardly the norm. So a recent "drop sculpture plan" launched recently by Thomas Stricker as part of an outreach project in Hamburg (enti-tled *Aussendienst*) is perfectly justified in its own subtle way. To quote Hajo Schiff in the *tageszeitung*: "How ironically charming of Thomas Stricker to place a meteorite in the environs of Hamburg. However, so that his noble Palladian concrete sculpture does not look too much as though it had been deposited there at the behest of outreach workers from some other planet, the Swiss sculptor has been toiling away at the sculpture for weeks on site in a dome-shaped meteorite workshop, helped by any passers-by who happen to turn up: for the process is almost as important as the nearly finished work."[5]

The *Sculpture-Projects* in Münster—unquestion-ably—did a great deal to win acceptance and above all interest for art in public spaces, and not only for in situ work. With every press report the number of visitors seemed to grow. In 1987, when *Sculpture-Projects* was put on for the second time, it was already clear that the summer revue of art in the old town of Münster had become an important tourist attraction. So it made perfect sense when the *Hannoversche Allgemeine Zeitung* published a review with the subtitle: "The third *Sculpture-Projects* show is the best PR coup Münster could wish for." The article itself goes on to claim that the list of sponsors reads like a "Who's Who of Westphalian business people, tradespeople, and taxi-drivers."[6] Once demand has been stimulated, then it also has to be met in the interim years when there is no Bien-nale, *Sculpture-Projects,* or *documenta.* How

else could one explain the fact that even hith-erto fountain-loving municipal cultural authori-ties are suddenly beset by an absolute deter-mination to put on a show of public art. Nowadays curators may be seen hauling their anti-museum ideas deep into the most distant provinces, in order to find a public berth for art, be it unorthodox or at times even some-what unctuous. "These days any art profession-als with aspirations have to put on art in the urban settings, in the rural surroundings or in the meadows, as though people were being taken on intellectual afternoon tea outings for those with an interest in the arts, and were being provided with entertainment, quality of life and even political education rather than cosy rugs for their knees."[7] And as even *art* had to admit, "Kabakov with salon music" is no longer a rarity and any self-respecting town has to splash out on a sculpture boulevard in the summer.[8] But—and this is the crunch, for all the splendor of public art events, vaunted above all in print—the hype only lasts as long as the tourist season. As soon as autumnal clouds start to scud across the sky one returns to the lower reaches of everyday artistic praxis in public spaces. No more do we see the fes-tive exception of a town ennobled by art, but sites left behind which have long been recog-nized as a blight on the face of the town and were only offered temporary succor by the visual arts. Usually a hopeless labor of love, and not only because (despite one's better judgement) so often those entrusted with the task resort to supposedly tried and tested yet bombastic sculptural solutions. The miserable problems of city planning cannot be temporar-ily off-loaded on to artists, unless these same artists are promptly invited also to enter into constructive discussions with architects and city planners.

The sociologist Wolfgang Welsch demanded in 1991 that art should refuse "to go on embellishing public spaces," in other words that it should elicit irritation: "When everything is beautiful, nothing is beautiful any longer, and constant stimulation only dulls our senses. In the midst of the hyper-aesthetics of public spaces we could do with a few areas of aesthetic desolation."[9] A suggestion that we can forget with a clear conscience bearing in mind the largely positive experience we have had with context and service art in the 1990s. For by what means can one be provocative, and above all whom would one want to provoke in our present-day "risk society" with its increasing homelessness and misery? In any case: are public spaces the right place for ideological cockfights in the arts? And the days are past when an established *enfant terrible* like Olaf Metzel could brutally pile up crowd-control barriers on Kurfürstendamm in Berlin and lure the conservative residents plus their political champions and the media out onto the barricades. In those days—in 1987—the Berlin Sculpture Boulevard induced a veritable "outburst of public anger," as Eduard Beaucamp reported. "Even lectures and discussions held on the premises of the organizers, the Neuer Kunstverein, took place under police protection."[10] Meanwhile, particularly in the big cities, there is a broadly tolerant attitude to the somewhat disturbing, unsettling art in some public spaces. Acts of vandalism against these works have rarely had anything to do with their supposedly or avowedly provocative content. In keeping with the law of probability, the irrational wrath of the hooligans is evenly distributed between telephone booths, park benches, car antennae, and sculptures. And the same goes for the graffiti artist with a spray can who will sooner or later target an art work, less with that specific object in his/her sights than in the hope of homogenizing the appearance of the entire city, which would ideally be completely covered from end to end in a brightly colored glaze. It is easy to see Gabriele Henkel's point in *Zeit Magazin*: "The aesthetic desolation of our public spaces, which should actually be the city's best room, makes it hard for inhabitants to really feel at home ... You could almost agree with the spray-can artists that their graffiti are improving our streets, even if their garish designs have a monotonous similarity to each other, be they in Dortmund or Calais."[11]

As we all know, the exception proves the rule. A fine way of sorely trying city residents' nerves was seen in 1998 in *Public Space*, an art project that was implemented in the Lehen district of Salzburg. The might of the car lobby in Central Europe is obviously as powerful as ever. The Antwerp artist Luc Deleu came up with the idea of excluding private cars from the otherwise chock-a-block Ignaz-Herrer-Strasse during lunchtime, every day for four weeks. As really the only controversial element in the Salzburg project, the plan had to be abandoned in part due to a concerted campaign by the *Neue Kronenzeitung*. As befits the mouthpiece of supposedly sane public opinion, this most widely read of all Austrian newspapers loudly declaimed: "And what's more, large sums of public money are to be spent on this ... a subsidized mega-jam!"[12] But maybe it is only in Austria that one finds cases of this sort, where negative press attitudes and public prejudice can egg each other on so effectively, particularly when it comes to rejecting artistic projects for public spaces. In its arts section the national paper often reports very positively on a supposedly new taste for art in public spaces, even if such art is already past its

recent heyday. For instance, the *tageszeitung* only paid any real attention to "public service art" when artists' interest in a public soup kitchen had noticeably declined. Which makes the writer Wolfgang Müller's comment all the more pertinent: "Perhaps the new trend will mean that exhibition makers could be retrained as furniture salespeople, artists could be offered permanent positions as personal development teachers in the areas where the skinheads live, and *art* could become the customers' news sheet for the Bakers' Guild: From now on your baker will be baking big, big rolls."[13] And in the late 1990s the *Süddeutsche Zeitung* had no alternative but to scramble up onto the long-departed "public space" bandwagon, when the then Director of Culture Julian Nida-Rümelin insisted on parading his hobby horse—public art—at every possible opportunity. Suddenly the newspaper was printing whole supplements scrutinizing the subject from all angles, with commentaries, critiques, historical outlines, interviews, background reports, and profiles.[14] Contrary to public opinion, public art does not receive a particularly good press in the specialist journals, with the exception of the more populist journal *art*. In his research on "cultural praxis, social spaces, and the public sphere" Ulf Wuggenig presents various statistics, figures and graphs showing that the professional art journals for the insider, be it *Flash Art*, *Artforum*, or *Parkett*, all maintain a "certain distance to art in public spaces." Wuggenig goes on to point to a project performing an interesting balancing act between art and science by the conceptual artist Christian Philipp Müller. The artist approached randomly chosen visitors to the Hamburg Art Mile and asked them about their opinion of public art. Even given that those asked were a self-selecting group who already

had an interest in art, the response was unexpectedly positive: "Only just over a quarter supported the view that ordinary people have no need of art in public spaces. Around three-quarters felt art in public spaces was more democratic than art hidden away in institutions, and an equally large number were in favor of more art in public spaces."[15]

So let us paint a picture of our possible future. The enthusiastic editors of a recent, widely reviewed handbook on art for new buildings conducted a survey looking into the standards applied by artists, curators, politicians, and art historians who have long been involved in this area. One of those interviewed was Heimo Zobernig. Not precisely known as a peace-loving representative of his trade, Heimo Zobernig responded with a plea: "Art in public spaces does not necessarily have to be recognized as art when it is incorporated into the architecture. Subtle interventions into that architecture—even pragmatic corrections—can also create a significant tension."[16] Who would want to contradict this: often mirror-like reflections, mild deconstructions of the circumstances of the building and its urban surroundings, in fact make the social situation wonderfully obvious. Insights into the at times desolate state of post-industrial towns are not necessarily only to be achieved by the daily tightening of some pedagogical thumbscrew. Social work—as Wolfgang Müller was implying in *taz*—should be left to those who know more about it, considering they have been professionally trained in the field. Since the universalists have in any case largely died out, cooperation should now be our goal. Today it is no longer a matter of understanding urban spaces for their history and the complexity of the social structures within them, but to look with an eye to the

future towards their permeability and alterability. In future the outskirts of Central European cities will not be impervious to largely unpredictable metamorphoses—of the kind seen in Tokyo. The ever-changing peripheries of our cities are of necessity coming under ever greater scrutiny. In a symposium during the Berlin Biennale in 1998, Dan Graham declared that nowadays he would rather spend his time in the suburbs than in artificially tarted-up inner cities. And thus artists are turning with new interest to the areas of nature being increasingly devoured by those suburbs. Perhaps this will provide the new challenge to art in public spaces: rather than simply pursuing its own interests, the challenge would be to make aesthetic sense of the fluctuations in urban structures. With precisely this in mind, the interdisciplinary Dutch architects' group MVRDV proposes a "lighter" mode of urbanism: "An urbanism that manifests itself, more with temporary and short-term behavior than with a frozen eternal condition. An urbanism that cultivates the unexpected and that can be more connected with the word landscape than with the word city."[17] At the Expo exhibition the Dutch pavilion became the public's favorite for its architecture. In the end visitors were standing in line for hours on end to get into what one writer feted as a "late Romantic veggie-burger in the age of virtual reality."[18] Who would now dare claim that more or less futuristic models necessarily have to fall foul of the notorious lack of comprehension of the public. It's really all the same if many interventions in public spaces are not instantly recognized as art. In the end what matters is an artistically reinvigorated surface tension in our surroundings that, it is to be hoped, will both communicate with the public and become a source of controversy too.

1 Franz Kotteder, *Der Münchner Kulturreferent wird deutscher Kulturstaatsminister*, in: Süddeutsche Zeitung, November 11, 2000, p. 18.

2 After endless protests against Richard Serra's sculpture *Titled Arc*, Jeff Koons' utterly undemanding *Flower Puppy* ironically confirmed public tastes. Unlike Serra's sculpture, which eventually had to be removed from the Federal Plaza in 1985, the *Puppy* was more or less adored by the public.

3 Richard Sennett, *The Fall of Public Man*, New York, 1974.

4 *Unerwünschte Monumente. Moderne Kunst im Stadtraum*, ed. by Walter Grasskamp, Munich 1989 (3rd editon Munich 2000), p. 142.

5 Hajo Schiff, *Enttarnte Beobachter*, in: die tageszeitung, July 5, 2000 (Hamburg Edition), p. 23.

6 Alexandra Glanz, *Die Kunst der Möglichkeiten*, in: Hannoversche Allgemeine Zeitung, June 30, 1997, p. 66.

7 Gregor Jansen, *Laube de Luxe*, in: die tageszeitung, September 9, 2000, p. 14.

8 Silke Müller, *Kabakov im Kurkonzert*, in: art, 9/2000, p. 74.

9 Wolfgang Welsch, *Gegenwartskunst im öffentlichen Raum—Augenweide oder Ärgernis*, introductory talk for a panel discussion at the University of Münster in 1991. Published in: Kunstforum International, vol. 118, 1992, p. 320.

10 Eduard Beaucamp, *Denkmäler am Pranger*, in: Frankfurter Allgemeine Zeitung, May 21, 1987.

11 Gabriele Henkel, *Gesichtslose Städte*, in: Zeit Magazin, no. 26, June 20, 1997, p. 5.

12 R. Redtenbacher, *Stau in Lehen von Künstlern geplant!*, in: Neue Kronenzeitung, Salzburger Lokalteil, December 20, 1997, p. 19.

13 Wolfgang Müller, *Resteessen in Ruinen*, in: die tageszeitung, May 27, 1998, p. 15.

14 See special supplement in: Süddeutsche Zeitung, 2/January 3, 1999, p. 16.

15 Ulf Wuggenig, *Kulturelle Praxis, sozialer Raum und öffentliche Sphäre*, lecture held on the occasion of the symposium, "Andere Orte. Öffentliche Räume und Kunst," organized by the Museum des Kantons Thurgau in spring/summer 1997, in: Andere Orte. Ein Internet Magazin für öffentliche Räume und Kunst, www.kunstmuseum.ch/andereorte/texte. See also: Christian Philipp Müller, *Kunst auf Schritt und Tritt. Public Art Is Everywhere*, Hamburg 1997.

16 Heimo Zobernig, in: *Zur Sache Kunst am Bau. Ein Handbuch*, ed. by Markus Wailand and Vitus H. Weh, Vienna 1998.

17 MVRDV, in: *FARMAX. Excursions on Density*, Rotterdam 1998, p. 36.

18 Niklas Maak, *Fahrstuhl nach Babylon*, in: Süddeutsche Zeitung, May 31/June 1, 2000, p. 17.

Culture

MUNSTER
VILLE D'ART

Pour son expo décennale, la cité allemande a disséminé dans ses rues et ses parcs 60 sculptures, de Nam June Paik à Daniel Buren. Visite, à pied ou en vélo.

Skulptur. Projekte in Münster 1997, parcours de sculptures dans la ville de Münster (Allemagne), jusqu'au 28 septembre. Renseignements, location de vélo, catalogue et exposition au Westfälisches Landesmuseum, Domplatz 10. D-4813 Münster, tél. 0049 251590 7/69. www.arthing.de/muenster

Ce matin, il y a bal à l'ancien château de Münster (Allemagne). Une vingtaine de grosses bagnoles sont garées devant la façade. Mieux vaut dire qu'elles ont atterri là: uniformément recouvertes de peinture argent, ces automobiles groupées en bouquets de quatre ou cinq ressortent visiblement de l'esthétique rétro (ce sont des modèles anciens des années 20 aux années 50), l'ensemble semblant tout droit issu d'un vieil ouvrage de science-fiction (ou de •••

ELISABETH LEBOVICI

ELISABETH LEBOVICI

Ci-contre en haut, la «Caravane immobile» de Thomas Hirschhorn. Ci-contre en bas, les «Fanions» de Daniel Buren. Ci-dessous, les voitures métallisées et musicales de Nam June Paik.

On the "Publicness" of Public Art and the Limits of the Possible

STEPHAN SCHMIDT-WULFFEN

In 1953, the director of the Hamburg Kunst-halle, Carl Georg Heise, and a professor at the State Art School, Werner Haftmann, wanted to organize an open-air international sculpture show in the Alstervorland. This idea was already in existence thanks to "the grow-ing popularity of 'anti-museum tendencies'"—"the usual methods of producing an exhibi-tion," as Heise writes with Hanseatic under-statement.[1] Nevertheless, it was one of the first public art events in the young republic—apart from the fact that it was an opening act for the *documenta* 1955.

In the center of the long, new park, the organ-izers had selected a trapezoidal path along the Alster, which came to an abrupt end at the promenade along the bank. Pedestrians could therefore decide to take a shortcut to the art. To the right and left of the path, some on flat stone surfaces, some on brick pedestals, between trees and flowerbeds, there were works by Arp, Bill, Calder, Giacometti, Heiliger, Kolbe, Laurens, Lehmbruck, Moore, Rodin, Wotruba, Zadkine, and others—about fifty sculptures in all.

Heise legitimized the open-air appearance of autonomous sculptures by saying that these works were designed for architecture and park landscapes anyway, and presenting them in a museum was merely a compromise. Haft-mann's argument was thoroughly idealistic. Because the modern sculptures were not created for any particular site, an exhibition in the park clarified their human purpose. "It demonstrates," writes Haftmann, "that in every object there is a link to contemporary humanity. These objects, delivered up to nature, give a clear account of the relationship to the world had by those who made them ... Each of the works shown here is the fruit of thoughtful work and life endured, and as such, carries its fame within itself. This requires awe and patient tolerance from the viewer. Intolerance is a sign of raw sensibility and barbarity."

This quote makes clear the ideological coor-dinates of this early escape from the institu-tional space of the museum. From humanity as a whole, it goes to the artist as an exam-ple—a connection that separates the sacred in art from the profanity of ordinary life, and in addition, demands from the latter patient, unquestioning acceptance. A differentiation between museum and external space proves to be superfluous, because if the principles of art in this universality are valid, then it really doesn't make any difference where art is positioned.

The development of public art during the past decades documents the loss of this idealistic perspective. If artistic principles are not spir-itual constants for humanity, but the result of historical circumstances and social agree-ment, then the question of the public that

Fiona Tan, *Schrottautokino* (Wrecked Car Drive-in), 2000, on the occasion of the exhibition *aussendienst* (Phase 1), Hamburg

makes these agreements and is simultaneously marked by these conventions, becomes increasingly important.

The Public and Publics

If Haftmann's missionary zeal had been somewhat less marked, he would have had to acknowledge that the role of casual observer in his park exhibition already considerably diverged from the usual role of the museum visitor. While the museum had manufactured an entire apparatus to create an idealized connection, cleansed of all coincidence, between the work and the recipient, the park allowed the visitor's attention to wander. So some of the visitors might have found comfort in the violets when the demands of modern art and its curators were too much for them. This distracted gaze appears today to be completely normal. Not only because the internal imperative—art is important and significant—no longer exists for most people, and as a result, the guilty conscience (to which Haftmann very directly appeals in his text) can no longer act as a mechanism of punishment. Not only because the medialization of society has caused the insistent gaze to be forfeited anyway, and sense is formed like a puzzle out of the many different sources instead of gradually forming itself from one source. It has more to do primarily with the fact that, since the middle of the last century, abstract reflection in our daily lives has increasingly turned into heuristic action. Nowadays, the disposition "thinks." While Haftmann's project still followed the tradition of enlightenment aesthetics and aimed to bring the park visitors in line with the leitmotif of an ideal, our reality is split into hundreds of lifestyle communities, whose attitudes can no longer be reduced

to a universal denominator. So which public are we dealing with today? And what role is left to art?

Jürgen Habermas's *Structural Transformation of the Public Sphere* is still the decisive source for a discussion about public structures. The importance of this text lies in that it defines the public as a discourse. It helps to avoid a few misunderstandings at the beginning, which occasionally still burden the discussions about public art: the public space is seen in opposition to private space or to the museum space. This mixes up three aspects: state, work world, and public discourse. Habermas's definition of the public space sketches a "theater" of the modern societies, where political participation occurs through the medium of conversation. This arena of discursive interaction is different from the state. It is also different from the economy, since it does not reflect market relations, but discursive ones. In this way, the concept of the public as discourse allows us to differentiate between the state apparatus, the market, and civil society groups. These differentiations are of central importance for interpreting art through a social theory. In addition, this terminology also allows us to recognize that the term "public art" can only serve in a very provisional and metaphorical way to differentiate these kinds of projects from an art exhibition in a museum. More precise observation shows that "public art" is about a transformation of the aesthetic practice in the twentieth century. It is about a new definition of the relations between art and public, and therefore affects the role of art *in* the museums as well as outside the exhibition halls.

Nevertheless, it is necessary to criticize Habermas's model, because after diagnosing the decay of the bourgeois public, he neglects to

Tita Giese, *Pflanzeninseln* (Plant Islands), 2000, on the occasion of the exhibition
aussendienst (Phase 1), Hamburg

develop a new post-bourgeois model of the public. And he never questions certain problematic assumptions that are perequisites for the bourgeois model. In any case, at the end of his text, the reader is left without a public model that would be appropriate for a contemporary critical theory. Opposing the image of a bourgeois public that Habermas draws, it can be argued that this public has never been completely public and generally accessible. Geoff Eley, for example, has shown that exclusionary mechanisms were essential for the liberal public.[2] The civil society, with its voluntary solidarity, was the breeding ground for the bourgeois public. This network of philanthropic or cultural communities was in no way accessible to everyone. On the contrary, it was the training field for a class of bourgeois males, who soon defined their own level as "universal" and propagated their governing qualities.

Because Habermas did not examine other publics, he idealized the bourgeois. Using as an example the women who managed to attain access to the public, sometimes through their commitment to the workers' movement, sometimes by forming groups that resembled men's, Mary Ryan[3] has proved that the bourgeois public was in no way the only public of that time. There were many differing publics existing simultaneously with the bourgeois public. There were women's groups, nationalists, unions, etc. So there were rival publics from the very beginning, not just at the end of the nineteenth-century. In any case, Habermas missed that conflict can be an instrument to construct a public. The result of such critical objections, which here can only be sketched, is an altered understanding of "public," with reference to Habermas' version. For Geoff Eley, the bourgeois public is ultimately the vehicle to describe the fundamental

Christoph Schäfer, *Revolution Non Stop*,
CD-Rom, 2000, on the occasion of the exhibition *aussendienst* (Phase 1), Hamburg

historical change of a repressive model of rule to a hegemonic one. It is important to note that the new model of political rule must make sure that a stratum of society dominates the rest, exactly as the old one did. Today, the public space is the center for debate aiming at a consensus that is a new form of hegemonic rule.

I see the role of the artist today as an intermediary between these publics, combining the different areas of public and private life, coupling production and living techniques in his works so that they function like commentaries. It is culture for a society that is in a process in which the ruling ideologies form conflicting positions in the discussions. The need for "common sense" thus continues to increase. In the future, artists could have the task of changing the identities of the various groups so that the needs of the conflicting partners could be balanced according to a democratic principle. Like the "organic intellectual" spoken of by Antonio Gramsci, the artist would have the task of cooperating in the development of this common sense, by influencing the placement of the subjects through shaping the definitions of reality.

Aesthetic Spaces for Action and Their Boundaries

For a number of years in Hamburg, the project *Park Fiction* provided a precise example of such a public role for the artist. When a church garden near Hafenstrasse was scheduled to be sacrificed to the interests of investors, neighbors began to organize themselves in protest against these plans. Among them were the artists Cathy Skene and Christoph Schäfer. With the help of artist friends who had knowledge about garden and leisure architecture,

they made it their artistic task to support the citizens' movement in the articulation of their wishes. Interventionist forms of expression also helped to revive the political fronts, which had quickly gotten bogged down. In short: the artists were the intermediaries between two social interest groups.

It would certainly lead to an impoverishment of our art if, in the future, one would demand that this kind of ephemeral practice become its single legitimate expression. Indeed, in the nineties, this kind of interventionist concept of art developed as the *ultima ratio* of "public art." However, it was soon subjected to harsh criticism by the protagonists of the movement. What was supposed to subvert dominance ultimately led to its stabilization.[4] If one assumes that, in *Park Fiction,* Skene and Schäfer not only put existing publics in touch with each other, but that they also intervened in the process of constituting these publics, then esthetic practices that were believed to be outdated once again become interesting. If one does not assume the "public" to be a given, but instead sees it as something that has to be re-shaped in every discourse, then a sculpture on a pedestal can be a catalyst that crystalizes a specific public. In the project *aussendienst* that Achim Könneke and I carried out in the urban space in Hamburg in 2000, the discussions with the artists always ultimately came down to the question of which materials on which site of the selected terrain would address which group. In Alsterpark, Thomas Stricker took the construction process of a meteor-like sculpture as an occasion to provide neighbors and joggers with conversational material about a "myth." The work was so successful that a group has now formed to lobby for its acquisition. Other artists directed their interest

toward the foreigners in the city (Jens Haaning), toward the consumers on Mönckebergstrasse (Katja Sander), toward the city's especially vital music scene (Nina Möntmann as the curator) or toward the fans of famous stars (Silvia Kolbowski).[5]

Some of the projects failed due to completely symptomatic reasons. That throws a light on the possible role of public art. For one, this space is saturated by rules of order, which, in the eyes of police and politicians, always have priority over art. Questioning these principles is quickly understood as an endangerment of public order. Nowhere else can the usual evaluation of art as decoration, beautification, and as a means of creating harmony, be so clearly recognized as in the discussions with city officials assigned to keep order. That affected the case of Jens Haaning's attempt to get free admission for foreigners to a swimming pool. The owner of the pool rejected the project because he already had had to battle with conflicts between various ethnic groups and was worried that German visitors would stop coming to his pool. Stefan Kern placed an apparently autonomous sculpture on a traffic island, which, however, was supposed to provide itinerant window cleaners with fresh water. In previous months, the police had spent considerable energy driving away these workers and did not want an artwork to produce a counterproductive effect. It's obviously true: an artist who concentrates upon relations between groups in the urban space has far more powerful rivals: politics and the police. They have long ago taken over the "shaping" of group relations and can seldom be moved to test their concepts of order through artistic experiments. For one thing, that demonstrates how ultimately ineffective the outdoor space is, upon which the defenders of public order allow public art to be shown. For another thing, it shows how problematic it is that art, which wants to question the established public order, is financially dependent upon this order. *Park Fiction*, too, which was at first a citizens' movement, wound up being financially supported by Hamburg's cultural officials. It came to a conflict between the cultural senator, Weiss, and the building senator, who saw his colleague thwarting his plans. Taking risks in order to be innovative, challenging old ways of thinking—those are principles that business has embraced. For the health of "public art," this kind of thinking must be developed in the city administrations. Narrow economic boundaries mean there is less hope to form new space for the visual arts. These boundaries are increasingly affecting our urban life; this became painfully visible in some of the projects. Silvia Kolbowski's proposal was to photograph a few stars in an empty shop, whose names would later be documented on the shop windows. She looked for an appropriate space in the inner city. There were actually suitable empty spaces, but no owner was willing to rent them for a short period of time. Everyone hoped for a long-term renter—and did not want to make it difficult for one to move in. Fiona Tan's drive-in cinema enjoyed great popularity. In fifty broken-down cars, visitors could follow an exquisite film program (dedicated to the topic of traffic) on two screens. Despite the fact that most of the shows were sold out, the event could only recover a small portion of the production costs. Here, "autonomy" has an entirely new sense: "realized, but economically not feasible." The floating swimming pool, based on old models, that Jorge Pardo wanted to erect on the Aussenalster would have cost close to three million DM (about 160 million

US dollars). Even if the pool had been full to top capacity during the entire summer season, it would not have recovered enough to pay even the interest for the bank loan. Pardo's position—"it's a sculpture that the city should simply buy"—highlighted the problem for which I don't seem to have a solution at the moment. If art is supposed to have an influence upon society, then it has to establish ethical standards in the way that it introduces actions or objects into the context of public order. Since the public order is, however, more or less dominated by economic standards, a conflict between money and art remains, which ultimately is probably the most difficult boundary between art and daily life to overcome.

1 *Plastik im Freien*, exhibition catalog for the International Horticultural Exhibition on the Alstervorland, Harvestehuder Weg, April 30–October 31, 1953. With an introduction by Werner Haftmann. *Plastik im Freien*. Hamburg 1953, with a text by C.G. Heise. In her overview of the development of public art, Claudia Büttner merely mentions the exhibition *Plastik,* which took place in 1931 in Zurich. See Claudia Büttner, *Art Goes Public. Von der Gruppenausstellung im Freien zum Projekt im nicht-institutionellen Raum*, Munich 1997.
2 Geoff Eley, "Nations, Publics, and Political Cultures: Placing Habermas in the Nineteenth Century," Craig Calhoun (ed.) *Habermas and the Public Sphere*, Chicago 1987.
3 Mary Ryan, *Women in Public: Between Banners and Ballots, 1825–1880*, Baltimore 1990.
4 See Dough Ashford, "Notes for a Public Artist," Ch. P. Müller/A. Könneke (eds.), *Kunst auf Schritt und Tritt*, Hamburg 1997, pp. 111 ff.
5 See the short guide *aussendienst*, Kulturbehörde Hamburg (ed.), Hamburg 2000. An extensive publication on the conception and production of *aussendienst* is in preparation and will appear in the fall of 2001.

THE ARTIST'S RESERVED RIGHTS TRANSFER AND SALE AGREEMENT

The accompanying 3 page Agreement form has been drafted by Bob Projansky, a New York lawyer, after my extensive discussions and correspondence with over 500 artists, dealers, lawyers, collectors, museum people, critics and other concerned people involved in the day-to-day workings of the international art world.

The Agreement has been designed to remedy some generally acknowledged inequities in the art world, particularly artists' lack of control over the use of their work and participation in its economics after they no longer own it.

The Agreement has been written with special awareness of the current ordinary practices and economic realities of the art world, particularly its private, cash and informal nature, with careful regard for the interests and motives of all concerned.

It is expected to be the standard form for the transfer and sale of all contemporary art, and has been made as fair, simple and useful as possible. It can be used either as presented here or slightly altered to fit your specific situation.

If the following information does not answer all your questions consult your attorney.

Interview with Daniel Buren, 1997

MARIA EICHHORN

MARIA EICHHORN (ME): Those who acquire your work have to sign a contract, the so-called "Avertissement." A Parisian lawyer, Michel Claura, helped you formulate it.
DANIEL BUREN (DB): When I began working as an artist, it became clear to me that as soon as a work was sold, it would be necessary to have some kind of control over the work that had been sold. Even then, when I was still doing work that more closely resembled painted objects, I intuitively felt that all of the objects—paintings or sculpture—could be manipulated in an incredible way. I thought that any kind of manipulation is damaging, bad for the work. My first thought was to protect the basic idea behind the work. That is much more important than, for example, receiving part of the profits from a resale, which is the chief difference between Seth Sieglaub's contract and my "Avertissement." I made my first contract in 1968. It was called "Certificat d'aquissisent," which means something like "certificate of sale." It was simpler, reduced to the fact that someone had acquired a work, and included directions for the installation. However, I noticed right away that it was too limited. And furthermore, I wasn't happy with the fact that signing this certificate was like signing a check. Ultimately, I only used it once, since in 1968, I didn't sell anything anyway. I don't work with the certificate anymore. Instead, I try to find something that is very

tricky. Without giving a signature, without signing the work, but instead, a paper, that makes the work valid, legally valid. Then I found the solution. The "Avertissement" was the result.
ME Do you sign the "Avertissement?"
DB I sign neither the work nor the "Avertissement." The person who signs the "Avertissement" is either the collector or the museum, or whoever buys the work. They recognize the conditions of the contract with their signatures. After it is signed, the contract is cut into two halves. I keep the signature of the collector. If someone buys a work, s/he receives this paper. On one side is the description of the work, the date, etc. They sign the other side and give me their address. I add a number, which is valid only for this particular work. The number is on both halves of the paper; then I make a sign, so that I don't make a mistake with the order. When they have this part, it is only complete with this other part. A little sign connects both parts. I keep the original signature.
ME Does that prove that it is an original?
DB That is how I prove that it is one of my works.
ME Do collectors want your signature?
DB Sometimes they want one. Since I don't give one, some withdraw their offers. This "Avertissement," which is actually very simple, has cost me dozens of sales.

Seth Siegelaub's Archive in the exhibition *Maria Eichhorn "The Artist's Reserved Rights Transfer and Sale Agreement" by Seth Siegelaub and Bob Projansky (1998)*, Salzburger Kunstverein 1998

ME Do you sign your drawings?

DB No. With drawings, I take a photograph of the drawing, giving authorization through the photograph.

ME Do you use your contract for drawings?

DB No, that would be too much work. It's like this: a lot of people don't stick to the rules. Occasionally, you find a work at an auction. At that moment, you have to interfere by saying, "sale forbidden." I am permanently involved in suits with auction houses. But they are slowly starting to understand that they have to follow the contract.

ME What do you do when the "Avertissement" is ignored?

DB When it's ignored—I've always found out, whenever one of my works is being re-sold— I withdraw the work from sale.

ME You forbid the re-sale of your works?

DB It's allowed, but only when they stick to the rules. First, they have to inform me of a planned public sale. Then they have to observe the reproduction rights. When they follow the rules, I would never forbid a re-sale. They're only doing their job; they can sell.

Long before my works ever came up at auctions, I was against auctions. An auction is one of the most hateful things in the commercial history of a work. The prices are manipulated at auctions. A work that was bought for $5,000 in a gallery can be sold two weeks later for $12,000. Or you can suddenly buy a work at an auction for almost nothing. The market price is raised or lowered using tricks and power games. For instance, in the nineteen-eighties, certain works reached high prices, but today are worth nothing. That's why I think auctions are extremely dangerous, very tricky, and not at all truthful. They pretend that the objective monetary worth of a work is here, but that's bullshit. They manipulate the way

they want to. Even if you were to take Richter, probably one of the most expensive painters these days, who would be so stupid as to speculate with his work? It's likely that you can do that with Cézanne—buy a Cézanne and then wait a while ... Especially in the eighties, many artists—mostly in America, thought that if you're not part of the boom and you don't have market value, you don't have any value at all. But that's not true; things change quickly, and market value has nothing to do with the value of the work itself.

ME Why don't you sign the "Avertissement?"

DB First, technically seen, where should I sign? That starts with the fact that there isn't any place to sign. But that was also the case with many others, with Carl Andre ... The other reason is the one I've already named. I was, indeed, part of "conceptual art." However, I was against much of what it brought with it. I chiefly opposed the opinion that art should no longer be visible, that it could only be an idea. I was and am still opposed to this philosophy. The certificate was created parallel to this. If you have the certificate, you can deal with that—and no longer with the work itself. Then you're in the midst of the capitalist system. People don't pay anymore with physical money, banknotes, but with plastic cards. A certificate is like a check, a paper. For instance, when you buy gold, you don't get the gold, as you once did, but a piece of paper. I always thought, if you make certificates for works that exist on the edge of the physical/ material world, then it is easy to imagine that, after a while, people deal with the work through the certificate, and not with the work itself. I try everything to avoid working with a certificate, in order to get around this problem.

ME A certificate doesn't exclude the physicality of a work. One can, for example, connect

the certificate with directions for, or the description of a work.

DB Yes, I agree, but I wanted to be radical, I wanted to exclude every possibility of replacing the work with something else. In the late nineteen-seventies, a lot of people were exploring—even though it's a stupid term—Immaterialism. Not with traditional, physical objects that had been used up until then to make art. The necessity of using certificates was, accordingly, immediately there, as a solution for dealing with these works. For Siegelaub, too—don't forget that he was a dealer. How could he sell Douglas Huebler? Sometimes his work was simply a dot on the wall, with the words "this dot is the center of the world," or whatever. Or Bob Barry's gas. How do you sell that? That is typically physical and invisible at the same time. A dealer is left with the certificate, in order to sell these works.

Then there are Ian Wilson's works, or Lawrence Weiner's little invitation cards. What are you selling? The invitation cards, when they are being sent to 2,000 people? Someone comes and wants to buy them; do you then sell the same cards? You're already in the trap: are we just joking, or are we serious about it? Let's take the case of Rauschenberg, who wanted to work with the Siegelaub contract when it appeared. He wasn't capable of following up on something like that for even two weeks; at that time, he was already very well established. Why should collectors stick to such agreements, when 200 collectors previously could do whatever they wanted, because they had never signed anything? To start with something like that in the middle of your career, still working with traditional objects— that's not meant to be criticism—that just doesn't work. The fact that Rauschenberg was interested in the contract means that he

wasn't dumb. He probably thought it was a clever thing to use the contract. But I think he would have had to have completely changed his work in order to use the contract. I think that as soon as one makes works like the ones mentioned, one needs a certificate or a contract. And it's typical for those times that this idea for a contract was created. Today, that's more widespread, and one often needs instructions in order to present works. Where does Richard Long sign his stones, or Dan Flavin his neon works? They sign a certificate. But that's the same thing as signing a painting, there's no difference. However, if you take a contract, like one of Siegelaub's, which was specially thought out for works such as mine, then the work only exists when collectors do what you say. I think that was new.

ME In this way, you address the role of the collector. If someone owns a work, then that happens—or doesn't—in agreement and correspondence with the artist's intentions. Siegelaub's contract and your "Avertissement" contain these questions.

DB A work can be spoiled by misuse. We don't live in a perfect world. There are battles and dirty tricks. At least I have the chance to say, "OK, you ruined my work, that's your right, but then it's no longer my work."

ME Next to the fifteen-percent resale profit, the main difference between your "Avertissement" and Siegelaub's contract is that when the collector doesn't abide by the rules, the work that s/he possesses is no longer a work by Daniel Buren. The next consequence is that the collector no longer owns the work. Is the "Avertissement" part of the work?

DB Yes, it's part of the work. You can't separate the one from the other. For instance, if I make something myself for a group exhibition, then there's no "Avertissement." As soon

as a work belongs to a public or private collection, the "Avertissement" becomes part of the work.

ME Can one exhibit the "Avertissement?"

DB No. But, for example, when you publish your interview, you can reproduce the "Avertissement." Up until now, no collector has asked me if s/he can exhibit the "Avertissement." It's published in catalogs. Not in my own, but in catalogs for group shows.

ME The owners of your works take on a certain role. Through the "Avertissement," they have another relationship with you and your work than they would have without such an agreement. Their ownership has an active part.

DB In my system there are two direct effects. One is: sooner or later, I meet my collectors and get to know them. I don't have many collectors. The second is, few have the energy to follow the rules that they have to agree to when they own my works. Most of them have many other works, and can hardly bother to deal with something that demands more than just being bought. Usually that leads to the sale being stopped. They can't resell without my knowledge. In addition, they often want or need my help. But I can't spend all of my time with that. All of these things don't help to multiply the collectors. But objectively viewed, that's the way I wanted it. It's not always fun, because I want to and must sell things, but it is fabulous protection for my work, and gives me control over use and misuse. The "Avertissement" is important for both sides. The collector has the proof that ownership has been officially transferred to him/her; no one can say s/he has made the work her/himself, or found it somewhere. And then the work itself: if something goes wrong, which it often does, then I can say, this is not my work. Then no one can exhibit the work or declare it to

be mine. Someone can buy a work without signing the "Avertissement," but s/he then has no proof, and a resale would be extremely difficult.

Just a little while ago, I discovered that one of my works was going to be auctioned in the north of France. My lawyer found out which work it was. The "Avertissement" existed, and the person had signed it. The person had not asked me—I have to be asked if my works are going to be reproduced, and then I decide how or if the work will be reproduced. The work in question was a piece of linen with yellow and white stripes. It was bought about ten years ago and never exhibited, and there is no existing photo of it. In order to reproduce the work for the auction catalog, the collector simply had the piece cut and part of it photographed. We forbade the auction house to sell it. We vetoed it. The collector had signed the "Avertissement" and broken all of the agreements. I could have sued him for destroying my work in an absurd and ridiculous way. But that often happens. The work was withdrawn from sale.

ME There are various types of ownership. Owning a table, for example, is a different kind of ownership than owning an object protected by copyright. Can an artwork be a possession?

DB In France, there is the "droit morale," and I think that something like that exists in all of Europe, something that protects everyone who makes art, such as musicians, filmmakers, etc. It dates from the French Revolution. It's one of the few laws left over from that period, and it's continued to develop over the course of time—in contrast to voting rights for women, for instance. Although during the French Revolution, talk was of the equality of men and women, voting rights were first introduced after

4. You and the Collector should each sign both copies, yours and his, so they will both be legal originals.

5. Before the work is delivered, be sure that a copy of the NOTICE is affixed to the work. DO NOT cut it out of one of the originals. Put it on a stretcher bar or under a sculpture base or wherever else it will be aesthetically invisible yet easily findable. It should get a coat of clear polyurethane—or something like it—to protect it. It won't hurt to put several copies of the NOTICE on a large work.

If your work simply has no place on it for the NOTICE or your signature—in which case you should always use an ancillary document which describes the work, which bears your signature, and which is transferred as a (legal) part of the work—glue the NOTICE on the document.

PROCEDURE FOR FUTURE TRANSFERS. For future transfers, the owner makes three copies of the TRANSFER AGREEMENT AND RECORD form from his original (without the words "SPECIMEN"). He then fills them out, entering the value or price that he and the new owner have agreed upon. Both the old and new owners sign ALL THREE copies of the dated TRANSFER AGREEMENT AND RECORD, each keeps one copy and the third is sent with the 15% payment (if any is required) to the artist or his/her agent. The old owner gives the new owner a copy of the original Agreement, so he will know his responsibilities to the artist and have the TRANSFER AGREEMENT AND RECORD form if HE transfers the work.

THE DEALER

If you have a dealer, he is going to be very important in getting people to sign the contract when he sells your work. The dealer should make the use of the Agreement a policy of the gallery, thereby giving the artists in the gallery collective strength against those few collectors and institutions who do not really have the artist's interests at heart.

Remember, your dealer knows all the ins and outs that go down in the business of the art world. He knows the ways to get the few reluctant art buyers to sign the Agreement—the better the dealer the more ways and the more buyers he knows and the easier it will be. He can do what he does now when he wants things for his artists—give the buyer favors, exchange privileges, preferential treatment, discounts, hot tips, time, advice and all the other things that collectors expect and appreciate.

The Agreement only formalizes what dealers do now anyway; dealers try to keep track of the work they have sold, but now they can only rely on exhibition lists, catalogues, hit-or-miss intelligence and publicity to keep them up-to-date. The Agreement creates a very simple record system, which will automatically maintain a biography of each work and a chronological record of ownership. It is private, uncluttered and no dealer should ever have to hire another secretary to administer it; if each work engenders a dozen pieces of paper over the entire life of the Agreement, it will be a lot. The requirement of giving a *provenance* to the current owner is no more than what goes on today, but under this system it will be accurate and almost effortless.

A dealer shouldn't be expected to do this for nothing; it seems reasonable to compensate the dealer with some part of the 15% he/she is collecting for the artist, perhaps one-third of it.

When, as is often the case, an artist moves from one dealer to a more prestigious one, the first dealer might continue to collect whatever payments are occasioned by the resale of the earlier work.

When a dealer BUYS work directly from the artist (for resale or otherwise), they should write the intended RETAIL value of the work in their Agreement, NOT the actual amount of money the dealer is paying the artist, which would be less.

Getting the contract signed is mostly a state of mind. If your dealer does not think the benefits of the Agreement are important for you, he will have dozens of reasons why he can't get those few reluctant buyers to sign it; on the other hand, if he seriously wants you to have these benefits he will be able to overcome all those obstacles without losing a single sale.

THE FACTS OF LIFE: YOU, THE ART WORLD AND THE AGREEMENT

The general response to the preliminary draft of this Agreement form has been extremely favorable; the vast majority of people in the art world feel it is fair, reasonable and practical. A few have expressed certain reservations about whether or not people will actually use it. These reservations can be summed up in two basic statements:

• " . . . the economics of buying and selling art is so fragile that if you place one more burden on the collectors of art, they will simply stop buying art . . .", and

• " . . . I will certainly use the Agreement—if everyone else uses it . . ."

The first statement is nonsense; clearly the art will be just as desirable with as without the Agreement and there is no reason why the value of any art should be affected at all, especially if this contract is standard practice in the art world—which brings us to the second statement. If there is a problem here, this statement reflects it; it is the concern of the individual artist or dealer that the insistence on the use of the contract will jeopardize their sales in a competitive market.

If we examine this notion carefully, we see it doesn't hold up.

ALL artists sell, trade and give their work to only two kinds of people:

• those who are their friends.

• those who are not their friends.

Obviously, your friends will not give you a hard time; they will sign the Agreement with you. The ONLY trouble will come when you are selling to someone who is not a friend. Since surely 75% of all art that is sold is bought by people who are friends of the artist or dealer—friends who dine together, see each other socially, drink together, weekend together, etc.—whatever resistance may appear will come only in respect to some portion of the 25% of your work that is being sold to strangers. Of those people, most will wish to be on good terms with you and will be happy to enter into the Agreement with you. This leaves perhaps 5% of your sales which will encounter serious resistance over the contract. Even this real resistance should decrease toward zero as the contract comes into widespread use.

In a manner of speaking, this Agreement will help you discover who your friends are.

If a collector wants to buy but doesn't want to sign the Agreement, you should tell him that all your work is sold under the contract, that it is standard for your work.

If he buys work only from those few artists who won't insist on using the Agreement he is being very foolish; non-use of this Agreement is a very dumb criterion for building one's collection.

3

THE ARTIST'S RESERVED RIGHTS TRANSFER AND SALE AGREEMENT

The accompanying 3 page Agreement form has been drafted by Bob Projansky, a New York lawyer, after my extensive discussions and correspondence with over 500 artists, dealers, lawyers, collectors, museum people, critics and other concerned people involved in the day-to-day workings of the international art world.

The Agreement has been designed to remedy some generally acknowledged inequities in the art world, particularly artists' lack of control over the use of their work and participation in its economics after they no longer own it.

The Agreement form has been written with special awareness of the current ordinary practices and economic realities of the art world, particularly its private, cash and informal nature, with careful regard for the interests and motives of all concerned.

It is expected to be the standard form for the transfer and sale of all contemporary art, and has been made as fair, simple and useful as possible. It can be used either as presented here or slightly altered to fit your specific situation. If the following information does not answer all your questions consult your attorney.

1

Seth Siegelaub's Archive in the exhibition *Maria Eichhorn "The Artist's Reserved Rights Transfer and Sale Agreement" by Seth Siegelaub and Bob Projansky (1998)*, Salzburger Kunstverein 1998

the Second World War. In comparison to other laws, copyright and the "droit morale" have progressed a great deal. Also, traditional painters and their heirs have the right to withdraw a work from an exhibition, if the work is being misused. You have to explain why, but you have the right to do it. In America, they're fighting for this and making some progress, but are still far away from their goal. In America, you can buy a work and make a shirt out of it. In France, if you've bought a Rouault for a few million and make a carpet out of it because you think it's nice to walk around on it, you'll land in jail, even if you have paid several million francs for it. You don't have any right to do that, even if it is your possession. The state punishes you for destroying a cultural good.

Dubuffet did a project for Renault. It was a big work for the company's property. They paid a fortune for it, but it was never finished. Later, a new company director wanted to destroy the work because it took up so much room. There was a lawsuit, and the company was obligated not only to retain the work as it was designed, but to have it finished. This case vastly improved the rights of the artist. At that time, the law was amended to include: a work that has been sold and begun must be finished and installed. That was about fifteen years ago. This new addition to the law helped me with my work at the Palais Royal; they had to have the work finished. This law is very active and established. But you only have this right when the grounds for it are plausible and make logical sense within the work itself. Naturally, the law doesn't obey any whims you might have, just because you don't like someone, for instance. You never buy the copyright from the author. My "Avertissement" obeys certain laws that are already

in existence. In America, there might be problems. The funniest paragraph is naturally this one: if you don't abide by the rules, you don't own a work by Daniel Buren any longer. The logic behind that is that, when in doubt, only the author can say that is or is not my work. In my case, it is even clearer, since there is no signature—you have nothing. I can forbid the use of my name.

ME Siegelaub's and Projansky's contracts don't go that far. They have no clause about the possible withdrawal of the author's claim to the work. Siegelaub was familiar with your "Avertissement" and had consulted you. What do you think of his contract?

DB I am completely against the fifteen percent resale profit. It reduces the transfer to money. My "Avertissement" demands the control over the idea behind the work, whatever the word "idea" means. This is more than the monetary value of the work. At first glance, it sounds great. A poor artist receives something when his/her work is sold, and s/he is financially better off. The problem is the following: when you're young and don't sell much, and that remains the case during your entire lifetime, then you'll never profit from the contract, because you don't sell anything anyway. So it doesn't matter if you've got a contract or not. If you sell little or nothing, nobody can resell, either. And if s/he does resell something, the chance is that the work will not fetch a higher price. The other possibility: you sell well, after a certain period of time, you're works are resold. Then it's ridiculous to participate in a resale. The contract protects those who sell well anyway, and those who don't, get peanuts. It doesn't work. It's an idealistic project; at first, it seems okay to get something when the collector makes a profit, but then you don't need it anymore.

ME Hans Haacke, for instance, doesn't sell much. He talks of resales, from which the fifteen percent is a great profit for him.

DB Sure, even if you're Rauschenberg, it's always good to have more money. I don't know how much Hans Haacke sells, but I would guess that he doesn't sell like crazy. But If, after fifteen years, a work is auctioned for a large profit, it means that he is famous and doesn't sell his works for $500. Haacke's works have their price, even if he doesn't sell much. He isn't Michael Asher, who doesn't sell anything.

ME A French lawyer first expressed thoughts on economic participation in an article in the "Chronique de Paris," on February 25, 1893. The basis for his idea was the development of the French art market. Due to increasing speculation with artworks, the profits earned by collectors and dealers clearly contrasted with the material poverty in which some of the artists and their families lived. He cited the example of the fate of the French artist Jean-François Millet. During his lifetime, he sold his paintings for 1,200 francs. Shortly after his death, the same paintings were auctioned for 70,000, then for 550,000, and finally for a million francs. At the same time, a granddaughter of his had to sell flowers at a vaudeville show. Why should everyone else profit from the increasing worth of the works, when the copyright owners and their descendents don't?

DB After death, that's another thing. If an artist's work is resold at a profit, it means that s/he already has enough money. No contract can be of help in this matter. If someone wants to swindle you, he can do it without your knowledge. The only thing that can be controlled is a public auction.

ME Are artists who make a lot of money with their art capitalists?

DB You can have a lot of money and not use it in a capitalist way. It's like this: anyone who sells a work is more or less happy about it, especially at the beginning. However, you can also say that the person who bought something so early on from you was courageous to spend even a penny on your work. How is s/he to know if something will come out of it later? The people who really make a profit are the gallery owners, not the collectors.

ME That depends upon the resales.

DB You sell your work to a gallery for fifty percent; the dealer sells its for up to 100 percent. You receive nothing from the fifty percent profit that s/he makes. So why do you want fifteen percent from a collector? And then, if you get fifteen percent, where does it come from? From the price that the dealer paid, or from the price that the collector paid to the dealer? It's all somewhat more complicated. The thing that Siegelaub formulated there is very idealistic and very simple. It looked really good, but ultimately, it's too idealistic; reality is another story. Then the contract doesn't go far enough.

ME Have you told him that?

DB I've told him all of that. And he understood it. But don't forget, he's an American. Business is business. And he was a dealer.

ME Do you think that his contract is about business?

DB I think it's about business.

ME Business for the artists, not the collectors. Siegelaub is on the artists' side.

DB Sure, but on the business side.

ME The contract is a product of its time. One attempts to change outdated structures, or to throw them overboard.

DB Yes, but in a very idealistic way. The contract doesn't have anything to do with the art world. I can still remember very well that I told Seth that artists whose works are resold already live well from their art. He said that there were exceptions and named one: Chamberlain, who is a multi-millionaire today. That's already a little bit of a joke. For those who really don't sell anything, the contract is worth nothing. But even Hans Haacke—naturally, he's happy about a small profit—he wouldn't starve without this fifteen percent. For those who really need the money, the contract is meaningless. That was my argument then, and as I talk about it, I see that I still have the same opinion.

ME *So-called conceptual art is still closely attached to the original, even though some of the Dada and Fluxus artists had already tried to get away from it. In the art market, unsigned works that are thrown on the market in great number have no value. The works of visual artists are not published as scores or books, like the works by musicians, composers, or writers, who get a percentage of the profits and royalties, and whose original manuscripts are kept in drawers and perhaps posthumously auctioned off.*

DB Seth and I have also talked about that, and I'm glad that you address that topic. If there is no longer an original, but just disks, records, or books, what does that mean? An original is expensive. A young artist sells her first works for perhaps $2500 or $5000. But what does a young writer get? Almost nothing. She has to sell eight to ten thousand books in order to earn the same amount of money. That was partially the practice in the late nineteen-sixties. But even today, thirty years later, artists make a single video, a single book. That's normal and has nothing to do with the contract. Even though some have thought about trying to get around the whole thing, the art market is still based on the original.

ME *Do you believe that the contract has changed something? Has it had a positive effect on the art market?*

DB I'm afraid not. First: with the exception of Hans Haacke, I don't know anyone who uses it. I know that many artists tried it and then gave it up; that's a bad sign. For one thing, it takes a lot of effort to maintain control over all resales. That is similar in my contract. In my contract I have control over all of my works. I can follow up on everything. Just because of that, a lot of people say "I'll just sign it and don't have to bother with it anymore." That goes along with the attitude of most artists: "when my work is done, I don't care about it anymore." When I went to your exhibit in Tokyo, I was interested right away, because that's the kind of work I like. I asked the dealer if the work was for sale. He told me all of the facts, and I was very pleased with them. Because I had previously thought, either the work is not for sale, or only under her conditions, which he named. Generally speaking, I've never understood how artists can be so indifferent to the works they have sold. And those who sell everything, even their shoes. Everything's the same.

ME *Why do you think that Hans Haacke works with the contract?*

DB Well, first, I think that he has a certain strictness, or strength, to be able to stick to something. I've never spoken to him about it, but he apparently has a strong character, to be able to say, I make a decision and stick to it. Then, the contract is finished, and covers everything, in general. He believes in the content of the contract.

ME Have you ever written about your
"Avertissement?"
DB Yes, recently, but it hasn't been published
yet. There's a part in a book that will appear
next year, about the meaning and use of the
"Avertissements."
ME Has anyone ever been interested in the
"Avertissement" and/or written about it?
DB No, up until now there's been no serious
discussion about it. When one first begins to
think about it, it touches upon many important
points. And I'm not interested in just saying
two sentences about it, because then it would
be too easy to mistake the "Avertissement"
for a certificate. However, it's more like a
warning, which means something like: "you've
bought a work, watch out!" It's a commitment,
an obligation.

That was always my argument with Beuys,
whenever works were sold that weren't for
sale. For example, the work that he made for
the Anthony d'Offay Gallery in London. D'Offay
bought it at that time. After Beuys' death, he
sold it to the Pompidou Center. Every time
the Pompidou showed it, it was a catastrophe.
The reason: it's impossible to show it. This
work should never have been sold away from
its original setting. Naturally, Beuys can say
that it's not my problem if you don't know how
my work has to be presented. Beuys never
thought about giving instructions on how the
works should be presented—not a single one
comes with instructions. The Szeemann ex-
hibition in Beaubourgh was like a catalog. The
works were presented as if they were printed
on high-gloss paper.

It's not as easy to mess around with my work,
because of the "Avertissement." Even after
I'm dead, it won't be difficult to follow my
instructions. There are descriptions, lots of
texts, etc. And I don't think that there are only
people who will simply want to make a profit
by showing the work. I hope there will always
be people who will deal with things the way
I would like them to. Broodthaers, who was a
close friend of mine, had a very difficult case.
The collectors who follow his rules protest
against the terrible misuse. They don't lend
their works, because they think they are
protecting Broodthaers' work. I don't share
this opinion.

ME Were you financially independent?
DB No, I had jobs until 1975/76. I've lived
from my work since 1976. Starting in 1968,
I've often been invited to exhibit. I never do
an exhibition without being paid for it. From
the first exhibition, I've always ask for an hono-
rarium, even from galleries—unless they sell
something, which doesn't happen often—
and from group exhibitions. Nowadays, many
people prefer to acquire a work, which is also
better for me, because it usually brings in
more money than a simple honorarium. The
first time that I asked for an honorarium was
in Italy. The person who invited me thought
I was totally crazy. I hadn't asked for much.
After six months, he came back to me and
said, "Okay, maybe you're right." He was an
older man, very well known. He discovered
Fontana and Yves Klein, Guido Le Noci. His
gallery was called "Apollinaire."

From Claudia Schiffer (H&M) and Oliviero Toscani (Benetton) to BILD
JEAN-CHRISTOPHE AMMANN

Late Autumn, 2000

Innumerable gigantic posters featuring *Claudia Schiffer* modeling for H&M appeared "overnight" in Frankfurt am Main. She was advertising bras and G-string string panties in (if I recall correctly) three positions: lying, sitting, and standing. Her intoxicatingly beautiful, almost naked body, her sometimes seductive, sometimes radiant, sometimes rather questioning smile enchanted passersby, subway and train passengers for over two weeks at a very cold time of the year. The fragile high-heels were not of direct importance to the ad, which was about the bra (about $9.95) and the panties (about $5). Then, once again, "overnight," the posters disappeared. It was as if one had dreamed these pictures—because in the moment one became really aware of them and wanted to examine them, they vanished.

Early Summer, 1999

Salma Hayek, wearing a remarkably elegant bikini, is on display everywhere in poster vitrines. There is a story behind the bikini. The actress appeared as a saloon dancer in *From Dusk till Dawn*, a vampire-Western film. She wears an astonishingly beautiful, tight-fitting, black bikini and dances with a snake, which she eventually hands over to two show girls. Her feet bare, she moves lightly over the tables. She kneels in front of a young man, grabs a bottle, flexes her foot toward the man,

pours the contents of the bottle over her knee down to her shin and foot, now in the man's mouth. He greedily sucks her toe. She pushes him backward with her foot, grabs the bottle again, pours the liquid into her mouth, moves toward the young man, pours the fluid into his mouth. There is a shoot-out, tumult breaks out, blood flows, and in that moment, her head (just her head) transforms into a monster. Bursting with strength, the woman jumps at the young man from behind and hacks into his throat with her teeth.

Late in the summer of 1999, we encounter an H&M poster featuring an actress who is confident of her erotic radiance. She is wearing a bikini that is practically identical to the one in the film. The poster of Selma Hayek was so successful that numerous poster vitrines in Frankfurt am Main were broken into. During the time that Claudia Schiffer was advertising for H&M, I gave a seminar. I asked the students (two-thirds of them were women) if they had seen the posters. Almost all of them had seen it, and those who had—men as well as women—were not only impressed, but also somehow shocked. We agreed that these images could not be accused of being sexist or voyeuristic. Some found fault with Claudia Schiffer, saying that it was beneath her to advertise cheap clothing. But it wasn't really about that. It was about the image, the photography, the point of view, the shot, the color. We came to the conclusion that today's prac-

Salma Hayek, advertisement for H&M

tice of aestheticizing daily life (from disposition and feelings to the various worlds of emotion) codifies the individual consciousness to the utmost. This aestheticization, including its infiltration processes, has become so common that, in the H&M ad, Claudia Schiffer embodies the function and the effect of an icon. She is a living sign in the incredibly condensed general esthetic space, in which things resonate. Claudia Schiffer is beautiful, hot, sexy, but at the same time, she is inapproachable, unretainable. As an icon, she belongs to everyone, men and women alike.

Another question we discussed was if all of the female students would now go and buy themselves a pair of panties for $5. Some of the young women said that of course they occasionally wore such panties. Others said they could not relate to such an item, but they would certainly be on the lookout for something fitting their own personal taste (appearance?). One male student reported that he'd given his girlfriend five such pairs of panties for her birthday.

I asked if the series could be seen as "art in the public space." Agreement was general and spontaneous.

Only a few recalled the poster of Salma Hayek. It became clear during the discussion that "bra" and "panties" were not the primary statements; perhaps even Claudia Schiffer was not—it could have been another attractive/famous model, too. The lasting impression was made by the *image itself*, the staging ("la mise en page"). This led me to ask the question: which criteria are necessary for durable art in the public space. The ad featuring Claudia Schiffer was a market-oriented, coordinated, temporary appearance and disappearance; the intent was that this image, based on two products, should be burned onto the retina. It is interesting that

the *products* (bra and panties) as lingerie, aim at a specific age group, yet *the image* itself, on account of its *innovative point of view*, has a lasting impact that goes far beyond the product. One therefore recalls the statement: an *image* always contains the document—here, the product—but a *document* (the product) in no way contains the image!

Now I'd like to talk about a diametrically opposed ad, which fundamentally polarized passersby and magazine readers in the first half of the nineteen-nineties. I'm referring to the Benetton posters, created by *Oliviero Toscani*. The strongest of this series of posters were those in which Toscani used images from photojournalism to introduce his educational arguments into the game. We showed these mega posters in three changes of scene at the Museum for Modern Art in Frankfurt am Main, in the reading room by Siah Armajani. These posters, seen during my many lectures, seminars, and symposia, inspired a rejection, even a hatred, which remains unforgettable. Precisely for the advertising branch, the claim that Toscani was a moralist through and through was highly unbelievable. Talk was of a mega-cynic. The hate campaign came to a head in 1995 with a decision from the *Bundesgerichtshof* (federal supreme court), which forbade the Benetton advertising. The gist of the highly juridical argument: it was improper to arouse pity using posters and advertising, thereby also coercing people into buying clothing in Benetton shops. In mid-December of 2000, the *Bundesverfassungsgericht* (federal constitutional court) lifted this decision in order to protect freedom of the press. The constitutional court argued that the *Bundesgerichtshof* had failed to explore the variety of possible meanings suggested by the Benetton ads. The *Bundesgerichtshof* must now under-

take this when the case returns to them for review (see the *Frankfurter Allgemeine Zeitung*, December 13, 2000, no. 2900, pp. 13 and 19).

Since I personally know Oliviero Toscani, I know that he is a moralist. He is an unusual warrior. Through his direct contact with Luciano Benetton, who made the campaign possible, he has stirred the public consciousness like no one else. His posters and ads have made him an unmistakable part of advertising history. Toscani's message actually is: only a company operating worldwide can afford to shake up our comfortable world using advertising means and methods. Anybody's daily perception is activated through direct or indirect advertising. Images of horror and catastrophe, the unutterable suffering of refugees, people dying of hunger and illness, create in us—from a certain moment on—a feeling of resignation, even helplessness. To a particular extent, we reject these images. And now, here comes Toscani's "scandalous deed": he forces these images upon us via advertising. He literally turns advertising upside down, creates educational advertising through anti-advertising. Indignation reigns. But since the images used are of extraordinary quality, the indignation allows them to stick in our minds, along with the green-and-white Benetton logo. People suddenly begin to perceive what an overdose of gruesomeness previously caused them to reject: namely, how much misery and suffering there is in the world. The indignation people directed against Toscani's Benetton posters is ultimately directed against their own resignation. The federal court also dealt in detail with the poster series *H.I.V. Positive*, dating from

Claudia Schiffer, advertisement for H&M

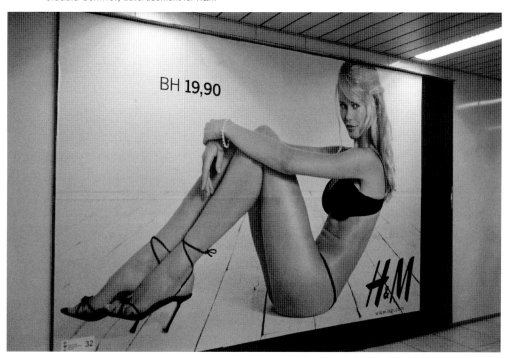

1993. Once again, the discussion in brief: Under the rubric "free speech," Maria Kilp from Mainz spoke out in the *Frankfurter Rundschau* of October 19, 1993 (no. 243) against the new posters:

"Recently, I stood in front of a poster showing an oversized photo of a lovely male rear end rubber-stamped with the words: 'H.I.V. POSITIVE.' The latest Benetton gag.

As I've read, a Frenchman suffering from AIDS has spoken out against it in *Liberation* (FR, October 12, 1993, 'An Argument Against Benetton'). AIDS self-help groups are protesting.

Whatever this company is aiming for by using this photo, apart from shameless advertising—I don't want to repress the nausea aroused in me: images of stamped animal parts on meat hooks in slaughterhouses; the tattoos of victims in German concentration camps. What else does such a photo encourage, other than the tendency to disassociate oneself from those so stigmatized?

I am a teacher. Acting as a teacher, I want and ought to teach young people about the inviolability of human dignity. The photo is such a brutal affront to this task that I have to defend myself. I must not abuse my office in order to speak out against this kind of profiteering—I am doing this as a citizen. If we can't stop this advertising, at least we don't have to accept it silently. I protest against it, indignant and worried about our common human culture."

On the other hand, filmmaker Peter Greenaway is of another opinion (see *Zeit Magazin*, no. 46, November 12, 1993). In answer to the question:

And the new campaign? Large-format color photos featuring skin rubber-stamped with the phrase "H.I.V. POSITIVE"...

"... naturally! London is full of them. But I haven't seen any of them here yet. Have you Germans forbidden them?"

No, but as in France and England, they are at least under heavy discussion. And many of the AIDS help organizations have criticized these images as being injurious and tasteless.

"Well, that's wonderful. They've attained their goal—everyone's talking about it. Just like we are now. One thinks about the topic. Is there something wrong with that?"

What people hold against Oliviero Toscani and Benetton is the fact that the ideas behind the images are grotesquely banal: namely, they want to sell more turtleneck sweaters.

"So, money! Where is the problem with that? Why do you think that Michelangelo took on the Sistine Chapel commission? For money. Ninety-nine percent of the images stored in our heads are produced in order to sell alarm clocks, screwdrivers, motorcycles, or toast. Toscani simply and courageously expanded this attitude. He suddenly tore away the curtain. In this stupid 'the-best-of-all-worlds' advertising, where all the families are smiling, where everyone has good teeth, and where there's an aspirin for every pain—into this world, he's suddenly brought topics such as fear, death, and sexuality. With one blow. That is highly interesting! I think it's idiotic to allow the artist to break taboos, but to refuse the same right to the ad man. Just because the artist has the pathos of commercial purity. No, all of these taboos have got to go! Self-censorship has to be eliminated as quickly as possible."

All three of the posters, monumental in size, show a youthful male body: the muscular upper arms, the pubic hair and the beginning of his sexual organ, his rear end. The "tattoo" *H.I.V. POSITIVE* refers to the possibilities of infection:

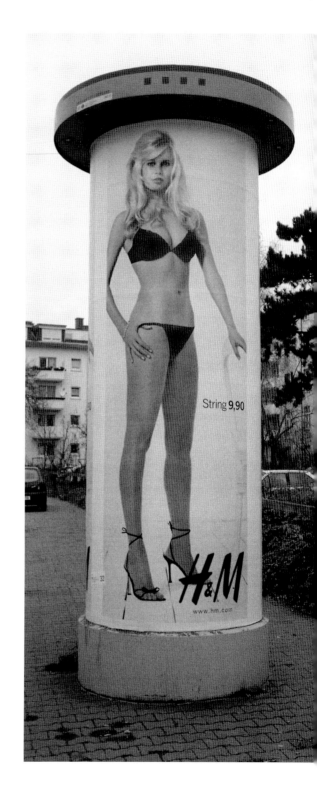

Claudia Schiffer, advertisement for H&M

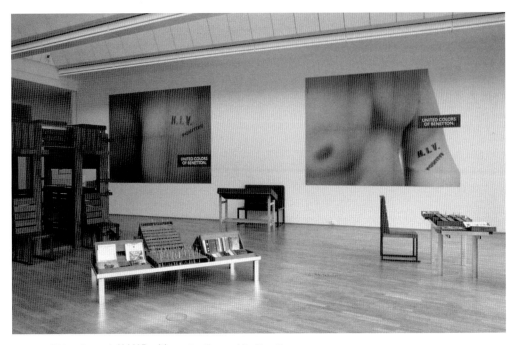

Oliviero Toscani, H.I.V.Positive, advertisement for Benetton,
installation in the Museum für Moderne Kunst, Frankfurt 1995

drugs and unprotected sexual intercourse. Ms. Kilp speaks of "stamped pieces of meat." Right, but she forgets how many young people nowadays are tattooed. Even more use washable symbols and images that deceptively resemble tattoos. *H.I.V. POSITIVE* uses pubic hair, the rear end, and the upper arm to refer to this. *H.I.V. POSITIVE* is the exact opposite of what tattoos aim for, that is, to create a subjective, identifiable "melody" for the emotional resonance space of the body. When I talk about tattoos, then it is because one has a tattoo for one's entire lifetime, and this is also true for the AIDS virus. Therefore, the rubber stamp *H.I.V. POSITIVE* can be clearly understood as just that. It is the sign that represents the tattoo. If one could not distinguish between them, the image would lose credibility, because someone who is actually H.I.V. positive would not tattoo himself.

Imagine if Benetton had printed the phrase "sponsored by Benetton" on the posters. This would have reduced the discussion to the so-called artistic level. Something along the lines of: artists make posters. The minute the Benetton logo appears, always close to the phrase *H.I.V. POSITIVE, advertising* has been declared. The "artistic" withdraws in favor of advertising. The distance between Benetton's palette of products (that is, clothing) and the motif is so great that it is difficult to react in the usual knee-jerk way. The observer has to completely readjust his criteria for perception and consciousness.

In 1993, in our latitudes, one always *had* to die of the AIDS virus. Then and now, a younger generation was affected—both men and women. This generation had to gradually learn to reflect upon and internalize the dangers of this illness.

The innovative power of advertising in the form of public images first became clear to me through the Benetton advertising at the beginning of the nineteen-nineties.

How intelligent, imaginative, and poetic advertising can be can also be seen in every BILD magazine.

Late Autumn, 2000

Three large-format posters are placed next to each other. In halftone, the following words are printed in a vertical column: ZUDIO/ZUMI ("zu dir oder zu mir?"—"your place or mine?"), LIDU/ MINO ("liebst du mich noch?"—"do you still love me?"), WAMA/DUHEU ("was machst du heute?"—"what are you doing today?"). The decoding can be seen over the vertical text "BILD dir deine Meinung"—"form your own opinion." These abbreviations are not just teen speech, but are also depicted as a cell phone readout. This BILD advertisement was created in conjunction for an SMS (short message) contest for the best short texts. I myself did not actually see the posters, but someone described them to me in detail.

Deductions

1 Good advertising, whether written or illustrated, is refreshing for the collective psyche of the urban passerby.

2 "Art in the public space" is completely different today than it was in the early nineteen-eighties, when I got involved with it (see *Parkett*, no. 2, Zurich, 1984, pp. 10–35). Even at that time I pleaded for a *function* for art in the public space. I still hold fast to that, though the difference is that today, the city planners and urban designers have developed a *sensorium*, which has made it superfluous to use

an artist, in the sense of a sculptural, though not necessarily situative, intervention. I also discussed this topic in detail in the catalog for the *Landesgartenschau* in Singen, 2000, *HIER DA UND DORT—Kunst in Singen*, pp. 9–16.

3 Learning a language of images is today an urgent matter of concern, because images transport content that cannot otherwise be transported. (This is exactly how the *Bundesverfassungsgericht* criticized the *Bundesgerichtshof.*)

attraction and affairs

ingold airlines

Short and mid-distance flying has gained a new dimension:
ingold airlines operates throughout Europe, using both public and
private transportation systems, and offering unique, individual
service and seamless transitions between transport and commu-
nications systems. These brand new concepts require completely
different kinds of permeable networks and many more peripheral
terminals.

The Right Time
On Using Work Materials in the Public
RES INGOLD

The terms art and public space have an intoxi-cating effect, though abuse can lead to a hang-over, to sobering reflection. These terms have seductive meanings that must be endlessly used, because they represent complex sys-tems. They can be very useful; as intellectual turnstiles, they bridge differences and create connections in thought traffic patterns, but they can also clear a path for misunderstand-ings and strengthen prejudices. As a pair, they stimulate an attraction that many feel, but which is felt differently by almost everyone.

In principle, our world is public space, and therefore political terrain. "Public space" tends to be everywhere. Art also. It is not long ago that this tense constellation coursed through the so-called "scene" in the guise of an anti-public space movement. Whatever kind of public space it was, it opposed the private, the closed, the non-public, but also opposed isolation and social uncertainty. The borders between these are fluid. Public space describes a system with-out a center, shape, or length. Everything is latently public space. The fiction of public space can exist as long as one does not bump into its invisible boundaries, violating the unwritten rules of the game. The boundaries of public space are conflict zones running along the con-trolled areas of interests, the areas that may be used as long as it is legitimate to do so. Usually, the middle-class ticket to these areas is consumption. So, *a priori*, the public space is not a question of legality or morality, but mostly a question of accessibility and usability.

ingold airlines

more than miles

ingold airlines customers will no longer have to adapt to the flight plan, but instead, the airlines will adapt to customers' wishes. Service focuses first on round-the-clock, assisted time management, and second, on flight or transportation services. The virtual reservation system is connected worldwide, guaranteeing optimal cooperation between logistics, partners, terminals, and fleets. *more than miles* means service tailor-made for enjoying top-level travel.

In the broadest sense, art is an important factor in a mixed social climate. Assimilated through influences in the creation of façades, buildings, squares, interior and exterior spaces, it was respected for a long time as something determining the form of things, which cities could pass on to their heirs. At least, artistic textures could always be found on the topography of every modern public space. Only the terms and symbols would change. What was once architecture or sculpture can also today be an interface manipulation. What was once a triumphal arc, the portal to an urbanity conscious of its history, has become, for instance, the label of a hyperactive global company.

The withdrawal of art from the urban public space into private and media space is not primarily a loss of quality, but a quantitative leap. The explosive development of the production of artifacts and images has a chiefly economic reason. Art, too, follows the market economy trends and is spread through the media, where the appropriate public spaces or markets are created. Its crucial point is at the threshold to the public space. Here are the boundaries, to privacy as well as social relevance. The museum is also in this transit area. It is the beautiful, protective place for art, as well as its marketplace. Like a hospital, the institution of the museum, however, has only certain zones open to the public. Altogether, it is more of a well-protected and controlled system, which aims for public relevancy only in selected areas, where it intersects with other systems. Nonetheless, without art, there's no art museum—but not vice-versa.

ingold airlines

high speed and stowdown solutions

The system is built upon a modular transportation strategy with
a broad range of standardized services, yet each travel package
is customized for the individual. Each contract is based upon a
standard model consisting of flight and computerized booking,
yet it can be modified by many different additions.

The points where art and the public space intersect can mark projection surfaces and free zones where specific things can be articulated. They are the officially declared and therefore legalized communal areas of interactions, or media situations, in which the officials or producers expect a greater tolerance for unexpected manifestations in the public. In such situations, open-air or whatever-it's-called art is tolerated as an intervention, in the face of a changing social reality. From this point of view, the public space can also be seen as an area of social life in which artistic intervention makes it possible to reduce normative control. It follows, then, that art would be a space of free articulation in a legalized framework. Art as the Other—a confusing system connected with other complex systems, all of which together means public space.

Decisive for this is the question of artistic freedom, the limits of tolerance for the unheard-of. When developing subversive strategies for artistic projects structured to make an impact, there is a question of responsibility and self-evidence. Self-evident art for the public space, therefore, means that it is less one of the possible variants derived from the fund of secure values than a non-fake form of the eventual. The eventual is potentially the new, and often the opaque—what is not yet understood. Perhaps, such new interventions are even disguised as intellectual and spiritual objects to be handed down as a symbol for a memory of times gone by. The contrast between factual social change and its perception will be even more finely leveled, and the interpretation of art will become a party coasting downhill.

ingold airlines

common knowledge

Reservations from throughout the entire network will be coordi-
nated around the clock and automatically redistributed to new
operations. Each configuration will be converted to an individual
contract, using the free capacity of the cooperative network. The
travel organization will take care to use an extensive checklist of
individual routes, services, and date combinations, as well as
create a personal profile for each customer. The automatic analy-
sis of the planning data will be compared with the available
capacity, and will result in the ideal service: travel management
with individually tailored timing and service for every budget.
more than miles even means that you can track the flight at
home, so that you have time for other priorities, while the crew
takes care of the business.

Only the useful—that is, accessible—areas are public space. For instance, public transportation can only be consumed within the framework of the services offered. Tolerance is over when passengers ride without paying. It is not possible to make private use of the rails. No one has any influence over the structure of the systems, etc. The situation in all areas that are in some way open to the public, including the Internet, is analogous. Ultimately, the only spaces that are public are those designed for public use. The more the design of a public area hints at its function, the more trustworthy and real the space appears to be, since the visible, scrutable appearance permits one to come to conclusions about the complex it represents. The more generally understandable its appearance, the more real its existence. The believability of an appearance is thus dependent upon the way its surface is designed, and less upon its function. Although images of surfaces point out the characteristics of the system in which the object ought to function, it has not been certain for a long time that function follows form and, correspondingly, that the characteristics of objects or situations can be guessed from their appearance. Nowadays, everything is designed. Complex systems are created, which do not have a background generally valid for and committed to understanding and emotions. Artificial identities and trends are constructed.

Complexity is perceived as being scarily obscure and too immense to calculate. The usual way out of a tight situation one cannot understand is to compare whatever is not understood with what is known, to retreat to secure, less complex memories. Taking the offensive, another way out of the dilemma is to use labels, icons, logos: signs, which are quickly comprehensible replacements for their identical interface objects. The relevance of symbols is nothing new; one can follow the history of the development of various languages of signs. Iconoclasm during the "Reformation" had disastrous consequences for the portrayed figure—in the identity of the object and its meaning. Perhaps the domestication of the art of the narrative began with printing, with the mass distribution of abstract, printed letters and the endless ways of putting them together. At least, the media saturation of the public began, and with it, changes in the meaning of articulation.

ingold airlines

efficient passenger response

Mobile terminals will be installed wherever it is unnecessary to have permanent *ingold airlines* counters. They will temporarily expand the network upon demand, independent of locations and technology. Normally, the customer must rely upon improvised, complicated solutions—often with uncertain results—but these mobile junctions will make fast and uncomplicated connections worldwide. They create connections and system transitions in air traffic, transportation and information services, since communications and transportation problems and questions often arise when traveling.

Technical signs demand their own milieu. Technology media always lean toward being mass media and demand time. The ability to decide and differentiate substantially depends upon the time needed to perceive something. Zapping is a postmodern expression of this. The less time the eye spends looking at something, the less information can be perceived; therefore, the individual sign must convey a greater context of meaning. Icons are more quickly understood than more complex types of communication. But the more intelligent the signs become, the more effective they are during clicking, scanning, or other forms of reading—the faster they are perceived and the more lasting they are in the perception, and thus, more information can be conveyed through simplified images. In this way, the transition from trust to belief in understanding of the symbol becomes just as fluid as that from information to manipulation.

Translating the technological term "interface" into the German word "Benutzeroberflache" ("user's surface") is interesting. All areas meant for controlled use are publicly accessible. Everything else is a question of power and exclusively the business of the people who control the operations. The surface of the computer screen is designed to simulate objects used in daily life and routine usage. It is simple and unproblematic to use. Clicking on symbols activates the operations leading to the desired results. Interventions in the operating system or the program structures are not foreseen. Only the surface is public space. The symbols on the screen are available. These are used to give commands that correspond to the content of the signs. The interface, the visible surface, coincides with the reality of its effect, that is, its usability. The illusion of icons on the interface generates reality. The forum of public space is a collective madness.

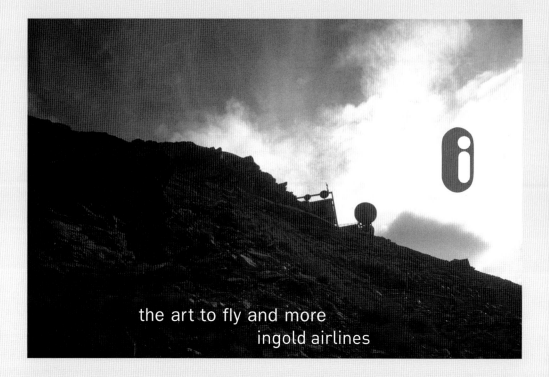

the art to fly and more
ingold airlines

The advantage of a flexible travel organization with mobile micro-distribution points proves itself in comparison to fully automated reservation systems, not least because attentive, friendly, and motivated personnel provide assistance throughout all stages of the journey. Travelers are often uncertain precisely in less-frequented areas, whether due to language difficulties, or because cultural differences lead to unforeseen misunderstandings. In such cases, a mobile terminal proves itself to be an extremely pleasant meeting spot—and more: it's like a tent for nomads between home and cyberspace.
Everything goes, provided you have the right ticket!

According to the same principle, computer screens are set up like public squares and normal apartments or offices—and vice-versa. Planned for normal use, they are also to be found exclusively in foreseen areas, spaces, enclosures, and courses of events. In this way, normality is neither an expression of healthy human understanding, nor of reasons of state, but is instead a structure consisting of what the majority will tolerate. It is the respectable norm of the masses, the trend of moving toward the center. To keep pace means to keep up with the fast-paced social changes, to be there. But hyperactively keeping up-to-date means rushing. So one is always either too late or just missing the mark. That is, the right time is the opposite of just in time. We need independence, leisure, a bit of impudence. In order to have that, we need parallel times. These are no longer created with money alone. It even appears that time is replacing money as the unit of measuring power, that is, independence. This process of replacement, however, is difficult, since the border between money and time, what is behind the equal sign standing between the two terms—is becoming a party coasting downhill into a dead-end trap. This border exists along the possibilities of either increase or regain. The idea of endless capital growth stands in stark contrast to that of the limited individual lifetime. But the more public areas are made to be processes determined by time, the more the possibilities for individual development disappear. The more that personal experiences are determined and thereby controlled by time-code-based communications systems, the more dependent on industry and politics one becomes, and thus, finally, the lower the social status and potential for change one has. The longer the media leash, the larger the relative freedom. Parallel times are islands of individual action; they conflict with consumption. They are intensive situations of unadulterated experience outside of ordained shows and infotainment. Access can be had, for instance, through the active substance known as imagination.

Not least, for such reasons, we speak of the freedom of art. The public needs it.

Richard Artschwager
Untitled
1987

Concrete, tree
Munster, Germany

Translation of the German text:
To each work of architecture, each "public sculpture," each such thing that is put under your nose
has to be ascribed a certain impertinence.
That is why, for the best reasons, including cowardliness, I have from the beginning tried to dedicate
my products—those which have to be in public space—to a GOOD CAUSE.
Which I have not always succeeded in doing. Useless, unemployed: that is art.

RICHARD ARTSCHWAGER
P.O. BOX 12
HUDSON, NY 12534
518-828-2735 tel
518-828-2828 fax

Hudson, 2/III/ ol

Dr Florian Matzner

FAX 49.89.273 59051

Dear Dr Matzner:

This responds to your letter of 17 December. Herewith my contribution:

Jeder Architekturarbeit, jeder "öffentlichen" Skulptur, jedes derartiges, dass einem unter die Nase geschoben wird, dem muss man eine gewisse Frechheit zuschreiben.

Deswegen, aus den besten Motiven, einschl. Feigheit habe ich seit Anfang versucht meine Produkte--die welchen die im Öffentlichen Gang liegen müssen-- also einem GUTEN ZWECK zuwidmen.

Welches mir nicht immer gelungen. Nutzlos, deswegen Arbeitslos: so heisst die Kunst.

Best regards *Richard A.*

Here's the slide. As I mentioned to you the person in the slide is my first cousin Hildegard Unckell, resident of Münster.

Index of Artists

Index of Authors

Vito Acconci (1940)
Artist, lives in New York

Jean-Christophe Ammann (1940)
Art historian, former director of the
Museum of Modern Art in Frankfurt

Manuela Ammer (1977)
Student of journalism and art history,
lives in Vienna

Siah Armajani (1934)
Artist, lives in Minnesota

Richard Artschwager (1924)
Artist, lives in New York

Michael Asher (1943)
Artist, lives in Los Angeles

Daniel Buren (1938)
Artist, lives in Paris

Eduardo Chillida (1924–2002)
Artist, lived in San Sebastián

Stephen Craig (1960)
Artist, lives in Hamburg

Richard Deacon (1949)
Artist, lives in London

Mark Dion (1961)
Artist, lives in Beach Lake

Bogomir Ecker (1950)
Artist, lives in Düsseldorf

Maria Eichhorn (1962)
Artist, lives in Berlin

Heike Eipeldauer (1978)
Student of art history, lives in Baden

Olafur Eliasson (1967)
Artist, lives in Berlin

Ayşe Erkmen (1949)
Artist, lives in Istanbul and Berlin

Peter Fischli (1952)
Artist, lives in Zürich

Paul-Armand Gette (1927)
Artist, lives in Paris

Dorothee Golz (1960)
Artist, lives in Vienna

Dan Graham (1942)
Artist, lives in New York

Walter Grasskamp (1950)
Art historian, lectures at the Academy
of Fine Arts, Munich

Ulrike Groos (1963)
Art historian, director of the Kunsthalle Düsseldorf

Hans Haacke (1936)
Artist, lives in New York

Katharina Hegewisch (1955)
Art consultant, lives in Munich

Thomas Hirschhorn (1957)
Artist, lives in Paris

Berthold Hörbelt (1958)
Artist, lives in Havixbeck and Frankfurt

Res Ingold (1954)
Artist, lives in Munich and Cologne

Ilya Kabakov (1933)
Artist, lives in New York

Per Kirkeby (1938)
Artist, architect and author,
lives in Copenhagen

Kasper König (1943)
Director of the Museum Ludwig in Cologne

Joseph Kosuth (1945)
Artist, lives in Rome and New York

Mischa Kuball (1959)
Artist, lives in Düsseldorf

Atelier Van Lieshout
set up 1995 in Rotterdam

Hans-Joachim Manske (1944)
Art historian, since 1974 organizer of the
program of public art in Bremen, lectures at
the University of Applied Sciences in Bremen

Florian Matzner (1961)
Art historian and curator, lectures at the
Academy of Fine Arts in Munich

Friedrich Meschede (1955)
Art historian, art consultant at the German
Academic Exchange Service (DAAD) in Berlin

Olaf Metzel (1952)
Artist, lives in Munich

Olaf Nicolai (1962)
Artist, lives in Berlin and New York

Maria Nordman (1943)
Artist, lives in Santa Monica

Giulio Paolini (1940)
Artist, lives in Turin and Paris

Hermann Pitz (1956)
Artist, lives in Munich

Marjetica Potrč (1953)
Artist, lives in Ljubljana

Tobias Rehberger (1966)
Artist, lives in Frankfurt

Ulrich Rückriem (1938)
Artist, lives in Clonegal

Allen Ruppersberg (1944)
Artist, lives in New York

Andrea Schlieker (1955)
Art historian and curator, lectures at the
Sotheby's Institute, London

Eva Schmidt (1957)
Art historian, director of the Gesellschaft
für Aktuelle Kunst in Bremen

Sabine Maria Schmidt (1966)
Art historian and curator, lives in Bremen

Stephan Schmidt-Wulffen (1951)
Academic in cultural studies,
1991 to 2000 director of the Kunstverein Hamburg

Hans-Peter Schwanke (1959)
Art historian, 1996 to 2000 head of the
Verbindungsstelle Kunst und Bauen in Berlin,
lives in Krefeld

Roman Signer (1938)
Artist, lives in Saint Gallen

Birgit Sonna (1969)
Art historian, curator, and art critic,
lives in Munich

Otto Steidle (1943)
Architect, lives in Munich

Bert Theis (1952)
Artist, lives in Milan

Wolfgang Ullrich (1967)
Academic in cultural studies,
lives in Munich

Angela Vettese (1959)
Art historian, curator and art critic,
lives in Milan

herman de vries (1931)
Artist, lives in Eschenau

Lawrence Weiner (1942)
Artist, lives in New York

David Weiss (1946)
Artist, lives in Zürich

Rachel Whiteread (1963)
Artist, lives in London

Wolfgang Winter (1960)
Artist, lives in Frankfurt

Heimo Zobernig (1958)
Artist, lives in Vienna

Text, Translation, and Photo Credits

Contribution Vito Acconci: Lecture for the International Congress on "Public Art" at the Academy of Fine Arts Munich, February 2000; Photos Stefan Müller-Naumann, Munich.

Contribution Jean-Christophe Ammann: Translation Allison Plath-Moseley; Photos Author and Museum für Moderne Kunst, Frankfurt.

Contribution Richard Artschwager: Photo Author.

Contribution Siah Armajani: Photos Author, Minneapolis.

Contribution Michael Asher: Text Reprint from *Camera Austria*, 59/69, 1997, pp. 3–13; Photos Kunstverein Hamburg.

Contribution Daniel Buren: Translated Version from: Daniel Buren, "Au Sujet de... Entretien avec Jérome Sans," *Flammarion* 4, pp. 184–194; Translation John Southard; Photos Author, Paris.

Contribution Stephen Craig: Photos Author.

Contribution Richard Deacon: Photos Author.

Contribution Mark Dion: Photos Author, Beach Lake.

Contribution Bogomir Ecker: Translation Allison Plath-Moseley; Photos Achim Kukulies, Düsseldorf; Roman Mensing/artdoc.de.

Contribution Maria Eichhorn, Daniel Buren: Text from Maria Eichhorn: "The Artist's Reserved Rights Transfer and Sale Agreement" by Seth Siegelaub and Bob Projansky, Salzburger Kunstverein, Salzburg 1998; Translation Allison Plath-Moseley; Photos Author.

Contribution Olafur Eliasson: Photo Roman Mensing/artdoc.de.

Contribution Ayşe Erkmen: Lecture for the International Congress on "Public Art" at the Academy of Fine Arts Munich, February 2000; Photos Author, Istanbul.

Contribution Peter Fischli and David Weiss: Translation Allison Plath-Moseley; Photos Authors, Zurich.

Contribution Paul-Armand Gette: Translation John Southard; Photos Author, Paris.

Contribution Dorothee Golz: Translation Allison Plath-Moseley; Photos Author.

Contribution Dan Graham: Photos Author, New York.

Contribution Walter Grasskamp: Text in English and Italian printed in Cat. *Arte all'Arte*, ed. Florian Matzner and Angela Vettese, Florence 1998, pp. 144–165; Photos Eduard Trier, Cologne.

Contribution Hans Haacke: Translation Allison Plath-Moseley and Author; Photos Author; Roman Mensing/Artdoc.de; Landesmuseum Münster.

Contribution Katharina Hegewisch: Translation Fiona Elliott; Photo Roman Mensing/artdoc.de.

Contribution Thomas Hirschhorn: Photos Author, Paris.

Contribution Res Ingold: Translation Allison Plath-Moseley; Photos Author, Munich.

Contribution Ilya Kabakov: Translation Cynthia Martin; Photos: Kees Brandenburg, Middelburg; Studio Blu, Turin; Roman Mensing/artdoc.de; Shigeo Anzai, Tokyo.

Contribution Per Kirkeby: Text Reprint from *Per Kirkeby, Nachbilder*, Bern and Berlin, pp. 88–103, Translation John Southard; Photos Roman Mensing/artdoc.de.

Contribution Joseph Kosuth: Photos Author, Rome.

Contribution Mischa Kuball: Translation John Southard; Photos Author and Hubertus Birkner, Cologne; Kelly Kellerhoff, Berlin, Nelson Kon, São Paulo; Ulrich Schiller, Düsseldorf; Kwanho Yuh-Zwingmann, Hannover.

Contribution Atelier Van Lieshout: Photos Author, Rotterdam.

Beitrag Hans-Joachim Manske: Translation Fiona Elliott; Photos Joachim Fliegner, Bremen.

Contribution Florian Matzner: Translation Fiona Elliott; Photos Peter Fischli/David Weiss, "Schneemann (Am Feuer)," Detail, 1989, Jenny Holzer, "Truism Bench," 1987, Installation Doris C. Freedman Plaza, New York 1989 (Photo David Regen).

Contribution Friedrich Meschede: Translation Fiona Elliott; Photos Author, Berlin.

Contribution Olaf Metzel: Translation Allison Plath-Moseley; Photos Author; Bayerische Staatsgemäldesammlungen München.

Contribution Olaf Nicolai: Lecture for the International Congress on "Public Art" at the Academy of Fine Arts Munich, February 2000; Translation Allison Plath-Moseley; Photo Felix Gonzalez-Torres, "Untitled (A Corner of Baci)," 1990, Detail.

Contribution Maria Nordman: Text, Translation, Layout and Photos Author, Santa Monica.

Contribution Giulio Paolini: Photos Roman Mensing/artdoc.de.

Contribution Hermann Pitz: Translation Fiona Elliott; Photos Landesmuseum Münster.

Contribution Marjetica Potrč: Lecture for the International Congress on "Public Art" at the Academy of Fine Arts Munich, February 2000; Photos Author, Ljublijana.

Contribution Tobias Rehberger: Translation Allison Plath-Moseley; Photos Author, Frankfurt.

Contribution Ulrich Rückriem, Florian Matzner: Translation Fiona Elliott; Photos Stefan Müller, Berlin; Ferran Freixa, Barcelona.

Contribution Allen Ruppersberg: Photos Collection of Postcards of the Author.

Contribution Eva Schmidt: Translation John Southard; Photos Margherita Spiluttini, Nick Tenwiggenhorn, Christian Richters, Ruedi Walti.

Contribution Sabine Maria Schmidt: Reprint from: Sabine Maria Schmidt, *Eduardo Chillida. Die Monumente im öffentlichen Raum*, Mainz and Munich, 2000, pp. 398–406; Translation John Southard; Photos Author.

Contribution Stephan Schmidt-Wulffen: Translation Allison Plath-Moseley; Photos Felix Borkenau, Hamburg.

Contribution Hans-Peter Schwanke: Translation John Southard; Photos Author, Krefeld.

Contribution Roman Signer, Ulrike Groos: Translation Allison Plath-Moseley; Photos Roman Signer; Stefan Rohner; Ernst Schär.

Contribution Birgit Sonna: Translation Fiona Elliott; Collage Florian Matzner.

Contribution Otto Steidle: Translation Allison Plath-Moseley; Photos Steidle + Partner, Munich; Tomas Riehle, Cologne; Reinhard Görner-Architekturfotografie, Berlin; Olaf Metzel, Munich.

Contribution Bert Theis: Translation Allison Plath-Moseley; Photos Mariette Schiltz, Milan; Roman Mensing/Artdoc.de.

Contribution Wolfgang Ullrich: Translation Allison Plath-Moseley, Photo Author, Munich.

Contribution Angela Vettese: Translation Katia Marano, Ann Hyland; Photos Attilio Maranzano; Dirk Pauwels.

Contribution herman de vries: Translation John Southard; Photos Author, Eschenau; Landesmuseum Münster.

Contribution Lawrence Weiner: Text and Illustration Author, New York.

Contribution Rachel Whiteread, Andrea Schlieker: Photos Anthony d'Offay Gallery, London; Mike Bruce, London; Votava/PID, Vienna; Sue Ormerod, London; Marian Harders, New York.

Contribution Wolfgang Winter/Berthold Hörbelt: Translation Allison Plath-Moseley; Photos Christer Hallgren, Skärhamn; Roman Mensing/artdoc.de

Contribution Heimo Zobernig a.o.: Translation Allison Plath-Moseley; Photo Author, Vienna

The realization of this publication
was made possible with
the generous support from

Akademie der Bildenden Künste, Munich
Akademieverein, Vereinigung der Freunde und Förderer
 der Akademie der Bildenden Künste München e.V.
Berliner Künstlerprogramm des Deutschen Akademischen
 Austauschdienstes (DAAD), Berlin
Böhmler Einrichtungshaus, Munich
Central Krankenversicherung AG, Cologne
Kulturstiftung der Deutschen Bank, Frankfurt am Main
Dresdner Bank AG, Munich
Freundeskreis des Westfälischen Landesmuseums
 für Kunst und Kulturgeschichte e.V., Münster
Hentrich-Petschnigg & Partner KG, Düsseldorf
Barbara Huygen, Bergisch Gladbach
Jens Imorde, Imorde Projekt- & Kulturberatung GmbH,
 Münster
Krüger Projekt Büro Wohnen, Münster
Kulturamt der Stadt Münster
Kulturstiftung Hartwig Piepenbrock, Berlin
Westfälische Provinzial-Versicherungen, Münster
Siemens Kulturprogramm, Munich
Sparkasse, Münster
Westfälischer Kunstverein, Münster
Klaus von Wild, Münster

as well as numerous supporters, who wish to remain
anonymous

For advice and support we thank

Rainer Bruckhaus, Düsseldorf
Paolo Conte, Asti
Caroline Eggel, Berlin
Sonnja Enzenhofer, Munich
Robert Fleck, Nantes
Walter Grasskamp, Weilheim
Rolf Grewe, Bochum
Petra Haufschild, Münster
Galerie Hauser und Wirth, Zurich
Markus Heinzelmann, Munich
Anke Hervol, Berlin
Barbara Huygen, Bergisch Gladbach
Jens Imorde, Münster
Joseph Kleinheinrich, Münster
Galerie Dorothea von der Koelen, Mainz
Immanuel und Reinhold Krüger, Münster
Saskia Helena Kruse, Munich
Annette Kulenkampff, Stuttgart
Katia Marano, Munich/Naples
Lukas, Moritz und Nora Matzner, Munich
Roman Mensing, Münster
Friedrich Meschede, Berlin
Michael Meuer, Munich
Daniel Müller-Hofstede, Münster
Galerie neugerriemschneider, Berlin
Elke Neumann, Munich
Julian Nida-Rümelin, Göttingen
Galerie Anthony d'Offay, London
Ludwig Peltzer, Münster
Juliane Rückriem, Cologne
Andrea Schlieker, London
Tas Skorupa, Stuttgart
Sophie Streefkerk, Paris
Susanne Witzgall, Munich

Edited by
Florian Matzner in commemoration of Klaus Bussmann's
sixtieth birthday, a part of the writings series of the
Akademie der Bildenden Künste, Munich

Translations
Fiona Elliott, Cynthia Martin, Allison Plath-Moseley,
John S. Southard

Graphic Design
Saskia Helena Kruse, Munich

Reproductions
Produktionsberatung Benz, Stuttgart

Printed by
Dr. Cantz'sche Druckerei, Ostfildern

Published by
Hatje Cantz Verlag
Senefelderstrasse 12
73760 Ostfildern-Ruit
Germany
Tel. 00 49 / 7 11 / 4 40 50
Fax 00 49 / 7 11 / 4 40 52 20
www.hatjecantz.com

Hatje Cantz books are available internationally at selected
bookstores and from the following distribution partners:

USA/North America – D.A.P., Distributed Art Publishers,
New York, www.artbook.com
France – Interart, Paris, interart.paris@wanadoo.fr
UK – Art Books International, London, sales@art-bks.com
Belgium – Exhibitions International, Leuven,
www.exhibitionsinternational.be
Australia – Towerbooks, French Forest (Sydney),
towerbks@zipworld.com.au

For Asia, Japan, South America, and Africa, as well as
for general questions, please contact Hatje Cantz
directly at sales@hatjecantz.de, or visit our homepage
www.hatjecantz.com for further information.

ISBN 3-7757-9148-5 (English edition)
ISBN 3-7757-9147-7 (German edition)

Printed in Germany

Illustrations pp. 10 and 464: Peter Fischli/David Weiss,
illustration p. 13: Jenny Holzer, illustration p. 15: M+M

HOW TO WORK BETTER.

1 DO ONE THING
 AT A TIME

2 KNOW THE PROBLEM

3 LEARN TO LISTEN

4 LEARN TO ASK
 QUESTIONS

5 DISTINGUISH SENSE
 FROM NONSENSE

6 ACCEPT CHANGE
 AS INEVITABLE

7 ADMIT MISTAKES

8 SAY IT SIMPLE

9 BE CALM

10 SMILE